Inka Bodies and the Body of Christ

Carolyn Dean

Inka Bodies and

the Body of Christ

Corpus Christi in Colonial Cuzco, Peru

Duke University Press Durham and London

1999

© 1999 Duke University Press

All rights reserved

Printed in the United States of America on acid-free paper ∞

Designed by Cherie Westmoreland

Typeset in Quadraat with Post-Antiqua display

by Tseng Information Systems, Inc.

Library of Congress Cataloging-in-Publication Data

appear on the last printed page of this book.

To Robert Y. and Esther D. Dean

Contents

Illustrations

Plates appear between pages 178–179.

Acknowledgments

Ten years have passed since I first began research on a series of paintings of the Corpus Christi procession in colonial Cuzco. I came to the topic as a curious student of pre-Columbian Inka art and culture who wanted to explore what happened in Cuzco—the Inka imperial capital—after the Spanish occupation. What I discovered was a festival that both brought together and sundered the residents of Cuzco and rendered impossible my efforts to consider any faction of the colonial city in isolation. I am grateful to a far-sighted advisor, Cecelia F. Klein, for encouraging me to transgress the boundaries between pre- and post-conquest worlds. I am indebted also to the Art History Department at the University of California, Los Angeles, which consistently funded my efforts. The personal encouragement I received from faculty, staff, and fellow students there was even more valuable. Dissertation research was also supported by the Center for Advanced Study in the Visual Arts, National Gallery of Art, Washington, D.C. Subsequent investigations which carried me far beyond a single series of paintings were funded by faculty research grants from the University of California, Santa Cruz. The precious time to write this book was made possible by a J. Paul Getty Postdoctoral Fellowship in the History of Art and the Humanities (1996–97).

During the past decade I have received the support of numerous individuals, especially the staff and faculty of the Department of Art History, the Arts Division and Porter College staff, and the Pre- and Early Modern Studies faculty at UCSC. I am also grateful to Monsignor Alcides Mendoza Castro, archbishop of Cuzco, and Sr. Aguiles Barrionuevo, director of the Archbishop's Museum of Religious Art in Cuzco, who provided access to the canvases of the Corpus Christi series. To Sr.

Ricardo Claro Valdés and Sr. Carlos Larraín Peña, and their families, my gratitude for their hospitality during my visit to Santiago de Chile. Archival research was facilitated by the assistance of Dr. Villanueva Urteaga, former director of the Archivo Departamental del Cuzco, Dr. Jorge Polo y La Borda, current director of the ADC, and, of course, all the archiveros who have helped me in both Cuzco and Lima.

I am grateful to those who have assisted me in Peru and beyond: Washington Callapiña, Moisés Callapiña, Jorge Flores Ochoa, Peter Frost, Elizabeth Kuon Arce, and Constance McCorkle. To my archival companions and mentors—Donato Amado Gonzáles, Brian Bauer, Kathryn Burns, Jean-Jacques Decoster, David Garrett, Thomas Krüggeler, Lynn Lowry, Patricia J. Lyon, Sabine MacCormack, Margareth Najarro Espinoza, John H. Rowe, and Michael Thomas—who, over the years, have shared their knowledge, brought to my attention a variety of textual treasures, and helped relieve the occasional tedium; and to those who have read or listened to portions of the text and provided invaluable commentary—Manuel Burga, Connie Cortez, Tom Cummins, Cecelia F. Klein, Dana Leibsohn, Jim Lockhart, Bruce Mannheim, Juan Ossio, Jeanette Peterson, Marie Timberlake, and Tom Zuidema—my heartfelt thanks. Finally, I acknowledge those three very special people who have given me unflagging support for more than four decades: my parents and sister.

Introduction

After military conquest and occupation, Spain introduced the Roman Catholic festival of Corpus Christi to the Americas. An important festival in all parts of the Spanish colonies, it was especially meaningful in Cuzco, Peru, the former capital of the Inka empire, which was America's largest pre-Hispanic state, spanning the South American Andes from Colombia to Chile (Bayle 1951, 251–298). In Cuzco, Corpus Christi, the festival that had been called "a triumph over heresy" by the Council of Trent (1551), frequently featured indigenous Andean Christians who embodied Peru's "pagan" past in their performances. Even as the European council encouraged all Christians—especially the newly converted—to participate in the triumph that was Corpus Christi, the first provincial council of Lima (1551–1552) barred Andeans from the Eucharist except by special authorization. Thus, natives in Peru were prohibited from partaking in that which Corpus Christi celebrated: the body of Christ transubstantiated in the wafer of the eucharistic host. Although the second and third councils of Lima (in 1567 and 1582–1584, respectively) relaxed these restrictions, in practice natives received the Eucharist only infrequently (J. Rowe 1957, 188).[1] Even as they danced, sang, and marched in celebration of Christ's transubstantiated body, Andeans were distanced from it.

Corpus Christi in the Andes was what I have termed *semiophagous*: it was a feast that dined on signs of difference, gaining sustenance for its triumph from the Andean subaltern. While from the moment of its instigation the ravenous festival fed on the colonized, consuming their markers of cultural difference, Andeans themselves could not ingest the Corpus Christi. Later, even after they were "invited" to consume the host, they were inscribed by the Corpus Christi celebration as sub-

alterns and denounced by colonization as incomplete converts. In part, then, this is the story of how Corpus Christi alienated the colonized and enacted colonization. This is also the story of how some Andeans, by embodying necessary difference, found ways to triumph as well.

Here I consider how both the colonizer and the colonized understood their participation in Corpus Christi in colonial Cuzco. By looking from multiple perspectives I hope to draw sustained attention to the spaces and moments between the dominating and the dominated, without homogenizing either group. For this multiperspectival approach, I am obviously indebted to several generations of poststructuralists who have explored the polysemy of symbolic form. I also build on foundations laid by the many and diverse postcolonial discourse theorists who have amply demonstrated not only how European colonization worked through language, but how the colonized took advantage of the multiple, fluid, and unfixable meanings of language to define themselves as something other than colonial subjects (see Seed 1991, 182–183). The languages I deal with here are primarily performative and visual, for it is through public presentations that Andeans articulated colonial identities.[2] Recently, Joanne Rappaport and Tom Cummins (1998, 8) raised the question of visual literacy, of how culturally diverse audiences understand images differently. Here, visual and performative literacy will be brought into question both implicitly and explicitly as we consider a set of specific historial conditions under which polysemous representations of a pre-Hispanic Andean past (be they alphabetic, visual, or performative) were created and received.

In the first three chapters I examine how the Spanish Corpus Christi became meaningful as a colonial festival in the city that had once been the capital of the Inka empire. The formal and festive language of triumph that was enunciated through the celebration of Corpus Christi not only encouraged but required the appearance of ethnic subalterns. This understanding contests the traditional scholarship on Corpus Christi in Cuzco which has tended to characterize its Andean aspects as either fossilized remnants of pre-Hispanic culture or as evidence of ahistorical native resistance.

Through its performance in Peru and because of the engagement of Peruvian actors and audience, Corpus Christi was Andeanized. By "Andeanized," I do not necessarily mean indigenized (made Indian), but rather that colonized Andeans understood and participated in Corpus Christi in Andean ways.[3] The Andean adaptation of the Spanish Corpus

Christi festival was neither uncomplicated nor unqueried. In fact, the Andeanizing of Corpus Christi prompted prolonged debates throughout the colonial period. The anxiety of colonial authorities over the necessary difference displayed by Andean participants in Corpus Christi is clearly evident both in early seventeenth-century extirpatory activity and in late eighteenth-century restrictions on festive evocations of pre-Hispanic royalty.

At the height of the colonial Corpus Christi, circa 1680, a series of canvases depicting the festival in Cuzco was created (Chapter 4). These provide us with a partial—but, importantly, not impartial—record of the midcolonial celebration. The paintings hint at the festive interculture that was created by and through both performance and records of performance—textual and pictorial. While this book is not about paintings, it does pivot around this extraordinary visual record, a record that is as polysemous as the festival it depicts. The many opaque, often contradictory, assertions of the painted record allow us to shift from a generally Hispanic vision to multiple envisionings, especially those of some native Andeans in Cuzco.

Chapters 5 through 7 explore how the Inkas occupied those spaces provided to them in Corpus Christi; that is, how they fashioned new, culturally meditative identities for themselves that were appropriate responses to Spanish cultural hegemony. Here the paradoxes of mimesis are confronted, and I question the notion that alienated references to the pre-Hispanic past represent a utopian nostalgia for the return to power of the Inka. A detailed examination of the costuming that Inka elites devised for Corpus Christi performances suggests that those elites strategically occupied cultural interstices. The bicultural signification of their costuming allowed them to embody alterity not as nostalgic references to an irretrievable past, but as a means of constructing new selves. Although the new selves were colonial subjects, they were absolutely not abject.

Rather than merely identify festive representations of the pre-Hispanic Andean, I want to understand how those representations signified alongside and inside European performative practices. Paraphrasing Frank Salomon (1982), I want to understand how Inkas and other Andeans performed the impossible; how they, as alienated subalterns, faced the triumphant Corpus Christi. I suggest that Inka nobles, in particular, responded to colonization with and through tin-kuy, a Quechua concept indicating the powerful conjoining of com-

plementary opposites. Framing their necessarily interstitial stance as a position of *tinkuy* allowed them to formulate puissant statements of mediativity in which the oppositions between Andean and European, pagan and Christian, past and present, empowered their new colonial selves.

In Chapter 8 I am concerned with the debates that arose within the multiethnic Andean community in Cuzco because of the multiple others—the subalternatives—that were performed for Corpus Christi. There were no *indios*, the homogenous Other, in colonial Cuzco's Corpus Christi; rather, the festival summoned the heterogeneity that Andeans recognized in themselves—the many ethnicities that made up the indigenous composite glossed by the term *indios*. While the colonial Inkas sought to extend their dominance over other Andeans in the colonial period, many of the formerly dominated used alliances with the Spaniards to shrug off Inka authority. The Andean voices that were elevated in protest to enacted Inka visions merit attention, for hearing the disharmonies in the colonial Andean community disrupts the legacy of colonialist ethnocentric homogenizing and spotlights Andean proactivity. Accordingly, Chapter 8 records concerns raised during Corpus Christi by Cañari and Chachapoya residents of Cuzco.

Any study such as this which considers colonial cultures must struggle with Gayatri Spivak's (1988) contention that subaltern voices cannot be recovered; she forces us to confront the contradictions involved in "speaking for" subalterns in ways that inevitably essentialize and flatten out, if not fictionalize, their experiences. Indeed, what we hear in the present book, in part, is the subaltern spoken by the subject(ed) position they occupied in colonial Peru (see Griffiths 1994; also Sharpe 1989). Yet, even though there was much about their circumstances that they did not control, they are not entirely spoken, defined, or brought into being by colonial culture. In the Andean case, indigenous leaders armed with *tinkuy* and other ways of understanding the transcultural web of significance produced by colonization were proactive as well as reactive. After all, *people*—not their circumstances—have agency. I do not argue that Andeans politicized Corpus Christi, but rather that they recognized that their Corpus Christi performances were implicitly political. The Andean perspectives and strategies in which I am interested are not conventionally recorded, however; the evidence I rely on is often indirect and anecdotal. Meanings and intentions are at best, and always at risk of being, interpreted through records that are, like the

paintings of Cuzco's Corpus Christi, doubly partial (i.e., both biased and fragmentary). In this work, it must be admitted, I listened primarily to Inka and other Andean male elites; the multiply subordinated groups—commoners and women at all levels—remain in this here and now, but one hopes not forever, silenced.

In Chapter 9, an epilogue, the distorted echoes of Inka voices reverberate in the festive life of modern Cuzco. This final chapter considers the curious offspring of the semiophagous colonial Corpus Christi and its consumption of native performative culture—the modern Inti Raymi festival. This twentieth-century version of the Inkas' June solstice festival was introduced in 1944 to promote *indigenismo* and generate tourist activity. Because some colonial-period authors linked Inti Raymi with Corpus Christi, the Inka festival (although considered "past") was kept forever present and was able to be "resurrected" when Peruvians desired/needed to find (or imagine) the Inka within themselves. Celebrated on June 24, the new Inti Raymi follows Corpus Christi and exceeds it in every measure of pomp and circumstance. It is the occasion to recall the glory of the Inka past. In the closing pages of this project I consider what is at stake, particularly for Peru's Indians (now uniformly called *campesinos*), when "ethnic" history becomes "national" history. While the imagined Inka of the modern Inti Raymi emerges triumphant on this day of celebration, his existence is transient. In fact, the transient triumph sustains current social inequities by hailing long-dead Inkas and denying living Indians agency in the here and now. Although for colonial Inkas the pre-Hispanic past was not a forfeited history, the popularity of the modern festival rests precisely on the irretrievability of the Inka past. My argument ends on a somewhat positive note, however, by recalling how memories of the pre-Hispanic era have had, in the past, a way of evading, if not subverting, totalizing triumphs. In fact, I recognize in *tinkuy* not only the hopes of the colonized, but the continuing hope of postcolonial Peruvians, for the imagined Inka—first created for colonial festivals—continues to nourish contemporary Andeans.

My colleague Shelly Errington (1990, 9) once observed that bodies are "constructed artifacts." The present book, which is ultimately about human beings as embodied identities, attempts to concretize her general observations by showing how Corpus Christi—the festival of Christ's body—framed the bodies of its participants in a particular place and time. Given that human bodies are historical, they are bearers

of meanings that they have taken on and that are put upon them (Foucault 1980 and 1990). An investigation of Corpus Christi in colonial Cuzco allows us to consider both how the bodies of the colonized—the subjugated—were asked to signify and how they signified themselves. This project is, therefore, profoundly historicizing. Only by recognizing subaltern activities as particularized can we begin to theorize subaltern proactivity in general.[4] It is my hope, then, that this examination of the ways Andeans were asked to embody difference, and the ways they chose to bear difference, will give birth to new ways of looking at and encouraging agency and self-definition outside of and beyond the historical and geographical limits of my project.

Chapter 1

Corpus Christi Triumphant

The Spanish celebration of Corpus Christi, introduced to native Andeans after the invasion and occupation of their lands, made room for indigenous performances and conditioned the meanings conveyed by them. A brief examination of the history and manner of celebration of Corpus Christi on the Iberian peninsula at the time of the colonization of the Andes indicates that the festival signified by means of an oppositional framework through which innumerable conquests were viewed. From its inception Corpus Christi, which celebrates the doctrine of transubstantiation, has specifically incorporated references to non–Roman Catholic beliefs and, frequently, peoples. It does so in the form of a triumph, a celebration heralding a victor.[1] In the case of Corpus Christi, that victor was Christ himself, embodied in the consecrated host. When the triumph of Christ's body was performed annually in colonial Peru, the Spanish conquest was rehearsed as well. Implicitly the colonizer's Corpus Christi celebrated military triumph and domination over yet another non-Christian people.

Celebrating the Body of Christ

The triumphal spirit of the Corpus Christi celebration inheres in its origins. Prior to the thirteenth century, there was no festival in the Roman Catholic church that specifically celebrated the Holy Eucharist, the con-

secrated wafer that, through transubstantiation, becomes the body of Christ in the rite of Holy Communion.[2] Early in the thirteenth century, according to legend, one Juliana, a virtuous woman who ministered at the leper hospital attached to the Praemonstratensian house of Mont Cornillon (in Liège, Belgium), dreamed repeatedly of a full, radiant moon disfigured by a black scar. Eventually (after some twenty years), Christ himself revealed to her that the moon symbolized the cycle of liturgical feasts of the Catholic church; the scar signified the absence of a celebration of the "Holiest of Holies," the consecrated host. Juliana related the vision to her superiors and eventually it came to the attention of the archdeacon of Liège (Jacques Pantaléon), who became Pope Urban IV in 1261. In 1264 he published the bull that instituted the feast of Christ's Body or, in Latin, Corpus Christi. In 1311, Pope Clement V designated Corpus Christi as an obligatory feast of the Catholic calendar, fixing the celebration to the fifth day after the Octave of Pentecost, which is the ninth Thursday after Easter Sunday, or the Thursday following Trinity Sunday.[3] Accordingly, the feast of Corpus Christi usually falls between late May and mid-June.

Initially, the Corpus Christi festival was instituted to affirm the controversial doctrine of transubstantiation, considered essential to the Roman Catholic faith, which held that Christ was embodied in the consecrated eucharistic host. The festival was useful in countering heretical assertions that the sacred host was not the actual Body of Christ (Epton 1968, 92).[4] In 1551, the Council of Trent (session 13, October 11) issued a decree characterizing the feast of Corpus Christi as a "triumph over heresy" and condemning anyone refusing to celebrate the Blessed Sacrament in procession (Addis and Arnold 1951, 787). Thus, the festival was conceived of as a joyous celebration of victory—not only of the Christian God over sin and death, but of the Roman Catholic church over heretics.[5]

Saint Thomas Aquinas (c. 1225–1274) has been credited with championing the new festival of Corpus Christi and devising the liturgy.[6] Throughout Europe, the celebration included processions featuring the display of the host; often there were mystery plays in which the doctrine of transubstantiation and its importance were explained. Because local celebratory customs were incorporated into Corpus Christi festivals, regional differences manifested themselves. The essential ingredient of Corpus Christi, wherever it was celebrated, was (and is) the triumphal procession of the consecrated host through city or village streets.[7] The

host—the Body of Christ—is held in a monstrance, a receptacle designed to display the wafer for adoration.

Spaniards were early celebrants of this "triumph over heresy." It was celebrated in Toledo in 1280 and Seville in 1282; both of these festivals antedate the papal bull of 1311 which made the feast mandatory (Epton 1968; Gascón de Gotor 1916, 6). Records of early festivals exist for Gerona (1314), Barcelona (1319), and Valencia (1348 or 1355) as well (Gascón de Gotor 1916, 11; Zumalde 1964, 37; Arias 1980, 30; Lleó Cañal 1980, 19). Corpus Christi rapidly grew to be one of the most important festivals celebrated on the Iberian peninsula in the early modern period.[8] In Seville, for example, Corpus Christi became known as the Thursday that shines greater than the sun ("Jueves que reluce más que el sol") and was the most important celebration in Madrid's early modern festive cycle.

Because the Corpus Christi celebration was one of the most elaborate festivals sponsored annually in any Iberian town of the early modern era, it was frequently the measuring stick against which other festivals were compared. In festive description it is common to find references to Corpus Christi vis-à-vis the size, participation, decorations, processional route, and other celebratory features of extraordinary (i.e., not annually recurring) festivals. In reports of festive decorations of the processional route for a special celebration, it is not unusual to find an author observing, "The streets of the town were decorated as they are for Corpus Christi." Corpus Christi was evoked as a common referent so that the reader would know just how richly adorned the route was; such analogies also suggest that the citizenry had outdone itself on a given occasion.

The Visual Vocabulary of Triumph

The celebration of Corpus Christi, like all other nonpenitential processions, employed a vocabulary of triumph derived from Roman imperial ceremonies that themselves were based on a variety of earlier, circum-Mediterranean celebratory practices.[9] Temporary triumphal arches and adorned processional paths were traditional visual cues that a victor was being heralded. In the case of religious processions, that victor was usually a saint in the form of a statue or reliquary; during Corpus Christi, the host, housed in its monstrance, was triumphant.

Temporary triumphal arches, erected along the processional route for Corpus Christi and many other festive occasions, were concrete references to the Roman imperial past. Canopies likewise bespoke special status. According to Christian tradition, a canopy (or baldachino) covers the consecrated host in the Corpus Christi procession. Canopies were the exclusive prerogative of high ecclesiastic authorities (archbishops or higher), sacred images, and officers of high political rank. The privilege connoted by the canopy was widely appreciated. In both profane and religious processions the canopy signaled the presence of the person(s) or object honored by the cortege. In Corpus Christi, the canopy designates the consecrated host as the supreme hero of the procession. Elevating the consecrated host on a litter or escorting it in a cart (carro) also conveyed its status relative both to those who walked in the procession and those who watched it.

Processional routes bedecked with banners, tapestries, and other festive garnishments, gun and flag salutes, fireworks, music and dance, all conveyed the celebratory nature of Corpus Christi. Each of these aspects of Corpus Christi was shared by other celebrations establishing a common festive vocabulary that was both visual and performative. The performed vocabulary of triumph was also shared with profane processions such as the advent, the reception of distinguished guests (Romeu Figueras 1957, 37–39). In advents, the visitor (or returning dignitary) would be welcomed at the outskirts of the city and escorted into the community, usually to the cathedral or major church, along decorated streets through temporary triumphal arches and past emphemeral altars constructed especially for the occasion.[10] The temporary altars, at which the cortege would pause, sanctified the path by echoing the structure of a church's interior. In church architecture the arch that leads from the nave into the choir or sanctuary is designated as the triumphal arch. In a church, then, passage under the triumphal arch signals that one is approaching the main altar. Because, in festive processions, the appearance of triumphal arches through which the cortege passes as it approaches temporary altars is reminiscent of sacred architecture, the pathway is transformed into a sanctified ritual space.

Processions were typically accompanied by music and dancing, fireworks, and short plays or dialogues, traditionally presented in the streets, that entertained and informed the public who celebrated the return or visit of prominent personages (Zumalde 1964, 39). The plays, which on profane occasions informed the public about the deeds of

the entering dignitary, became, by the end of the fifteenth century, the famous Spanish *autos sacramentales*, religious mystery or morality plays (Zumalde 1964, 54).[11] Advents and religious processions thus shared a festive structure through which divine and mundane personages were linked.[12]

The procession of Corpus Christi thus presents Christ as the supreme victor who is present at the celebration in his honor. Because Christ is actualized through transubstantiation, the Roman Catholic church and its particular representative who has the power to summon Christ also participates in the triumph. Traditionally, the celebratory cortege that escorts the consecrated host includes a broad spectrum of the community's religious and civic organizations, which display images of their patron saints or banners representing them. While all of these saints are themselves triumphant figures, on the feast day of Corpus Christi each is subordinated to the consecrated host. A divine hierarchy of the Christian God and his supernatural vassals (saints and angels) is thus manifested in the procession. Also implicit in the cortege is the community's social and political hierarchy, the order of the procession connoting the relative status of the participants.

In early modern Spain, Corpus Christi processions usually involved not only the highest religious authorities, but political leaders of the highest ranks as well. In Madrid, for example, the city's secular clergy, religious orders, and municipal council, who appeared in almost all of Madrid's religious processions, were customarily joined in the Corpus Christi cortege by all of the royal counselors, the royal house, lords and high nobility, as well as "other innumerable ministers" (*otros ministros que son sin número*) (Quintana 1629, 386–388). Records from 1482 indicate that Queen Isabela presided over the Madrid procession, and in 1498 Fernando and Isabela each carried a pole of the canopy that shaded the monstrance; in 1518 Carlos I, together with the ambassadors of England, France, Portugal, Venice, and others carried the poles of the canopy, and in 1641 Philip IV and Prince Baltasar Carlos joined the cortege (Gascón de Gotor 1916, 17–21; Azorin García 1984, 145).

Similarly, the Corpus Christi processions of other Spanish cities were attended by high nobility and civic leaders. According to records from 1424, Alfonso V of Aragón hoisted one of the poles of the canopy, as did Carlos I of Spain (by then Holy Roman Emperor Charles V) in Valencia in 1535 (Gascón de Gotor 1916, 12). In 1528 Carlos I attended the festival in Valencia, as did Philip II in 1585 and Philip III in 1612 (ibid.).

By parading in proximity to the host (the "Holiest of Holies"), a union of the highest sacred and profane, supernatural and worldly authorities was demonstrated—the body of the ruler and the Body of Christ unified. Spanish Corpus Christi processions thus manifested the inextricable union of divine and royal, heavenly and earthly, religious and political authorities. Traditionally these were supported by armed military battalions, further reinforcing the notion that the triumph portrayed was not restricted to symbolic and supernatural realms.

The Multiple Triumphs of Corpus Christi

To evoke the "triumph over heresy" in the spirit of the Counter-Reformation, most early modern Spanish Corpus Christi processions included the representation of non-Christian elements over which Christ (in the form of the host) would symbolically triumph; sometimes these figures were general references to evil, like the famous *tarasca*, the dragonlike serpent featured in the Corpus Christi processions of Madrid and other Spanish communities. In seventeenth-century Seville, for example, the *tarasca* was accompanied by *mojarrillas*—celebrants costumed as "savages" in brightly colored outfits who carried inflated cow bladders with which they made rude noises directed at the crowd (Lleó Cañal 1980, 39, 41). Their costumes were in accord with medieval conventions for the uncivilized, as was their behavior. The Corpus Christi in Seville also featured "giants," six figures who represented men and women of diverse nations, all of whom were subject to the triumph of Christ.

Often, Corpus Christi occasioned the celebration not only of the abstract notion of Christ's victory over death, and hence sin, but of Catholic Christianity over heresy, and Catholic Christians over nonpapists. Not infrequently, references were made to historical and/or contemporary political triumphs involving non-Christian peoples. Spanish Christians, dressed as Moors, Arabs, or Turks, would attempt to impede the celebrations (Gascón de Gotor 1916, 33); they always failed, of course. In early modern Madrid, the devils, who fought—and were defeated by—angels in a Corpus Christi dance, were dressed as Moors (Very 1962, 21). Famous battles were often represented by the celebrated *rocas* (or *roques*), processional carts, of Valencia and other Spanish cities. In the seventeenth century, one such cart was constructed in memory of

the conquest of Valencia (1238). It was accompanied by dancers dressed as Moors while another cart, dedicated to the archangel Michael, was constructed in memory of the *reconquista* (reconquest) with a dance of the infidels (Gascón de Gotor 1916, 12–13). In 1492, the Corpus Christi celebration in Murcia gave special attention to the recent reconquest of Granada in two special mystery plays (Rubio García 1983, 101).

The Spanish Corpus Christi festival explicitly linked the state's political and military victories with divine triumphs; divine will and royal will were inextricably intertwined. Because the "defense" of Catholic Christianity legitimized offensive or "conquest" activity, the triumph of the Corpus Christi was understood as the triumph of those who celebrated Corpus Christi. Many Spanish celebrations of this feast featured choreographed performances that were militaristic in nature. Dancers often appeared as combatants: angels and demons, Samson and the Philistines, and Christians and Moors are just a few of the warring factions presented in Spanish Corpus Christi festivals. By extension, the community of Christians participating in local ritual triumphs enlisted in this global war against nonpapists.

The celebratory structure of Corpus Christi in early modern Spain was confrontational: those who celebrated Corpus Christi (i.e., Roman Catholics) were characterized as victors, while those who did not revere the consecrated host were vanquished. This was especially the case in the late fifteenth and early sixteenth centuries following the capture of the southern Iberian provinces from the Muslim Moors. Corpus Christi in Granada, the last of the Muslim strongholds to fall to Christian forces (1492), involved particular references to the "reconquest." In fact, the celebration of Corpus Christi was introduced to Granada specifically to counteract Islam (termed "infidelism"), with the Catholic monarchs establishing a special endowment to help defray the costs of the Corpus Christi celebration in that city (Garrido Atienza 1889, 6). A decree (*cédula*) in 1501 commanded that the people of Granada celebrate the feast of Corpus Christi with "such great displays of happiness and contentment" that it would "seem as though they were crazy" (*la fiesta ha de ser tal e tan grande la alegría y contentamiento, que parezcais locos*) (ibid.). Thus, while promoting a sense of community among celebrants,[13] Corpus Christi also occasioned suspicious regard of potential "enemy" elements within the local society. A regulation from 1468 in Murcia, for example, gave Jews and Moors in the street at the time of the procession, especially during the passing of the Body of Christ, two

options: they could flee the streets and hide themselves, or kneel and demonstrate "due respect" (Rubio García 1983, 67).[14]

Importantly, early in the sixteenth century Queen Isabela had the monstrance that was used in the Corpus Christi procession in Toledo crafted from the first gold to reach Spain from the Indies, also a site of conquest (Epton 1968, 94).[15] American gold—again, the "first gold that came from the Indies"—was also formed into a cross displayed in processions in Seville (Lleó Cañal 1980, 30). Thus, the conquest of the so-called New World was integrated into a known pattern of historic confrontations with non-Christian peoples. Although Native Americans were not represented in human form as subjugated to the Body of Christ in early Spanish Corpus Christi celebrations, the wealth of their land was transformed into its supports. We might well read a metonymic "transubstantiation" of the bodies of American natives, not yet well known, into the gold which, when fashioned into monstrances and crosses, summoned their subjected and *doubly converted* presence in Spanish Corpus Christi festivals. At this early point in the colonization of America, their personal, bodily otherness hardly seemed to matter. It *did* matter, however, when Corpus Christi came to be performed on American soil.

Those Spaniards who recognized the triumph of Corpus Christi as the triumph of the Crown in southern Spain are the same Spaniards who were, in the same period of time, introducing Corpus Christi to the Americas following its "conquest." We now turn to the Andes to examine how the Iberian skeleton of Corpus Christi was fleshed out in one city in Spain's colonies.

Triumph in the Andes

The historian Sabine MacCormack (1985, 422) notes that the conquest of the Americas was, at times, perceived by those who participated in it as an extension of the *reconquista*, and that certain chroniclers frequently referred to the conquerors as Christians—not only echoing the centuries-old confrontation between Muslims and Christians in Spain, but fitting their New World experience into Old World tropes. What's more, Andean shrines are identified by early chroniclers of the conquest as "mosques" (*mezquitas*), and Inka customs are often compared

to Turkish and Moorish practices (ibid., 422–423). Importantly, Mac-Cormack also notes that "we are not merely dealing with patterns of perception which were carried over from the reconquest of Granada to the conquest of the New World: for the method which the conquerors of Peru used to organise newly subjected territory and people stems from that same origin" (ibid., 423). Certainly the performance of Corpus Christi in the Andes was organized according to reconquest strategies.

Just as Moors, the defeated opposition to Spanish Christians, were summoned in Spanish Corpus Christi celebrations, the native Andean presence in the Corpus Christi celebrations of colonial Peru was interpreted through the lens of colonization. Andean participation in Corpus Christi thus implicitly constituted conquest and colonization as well as the ongoing battle against satanic forces, with whom native Andeans were tacitly aligned (Silverblatt 1980, 173–174). For Spaniards, it was not only important to include native Andeans in Corpus Christi celebrations, but it was essential that they perform *as natives*, as the people over whom Christians had triumphed. In performing alterity— usually through Andean costume, song, and dance—they provided the necessary festive opponent whose presence affirmed the triumph.[16] Because Corpus Christi ingested, even gorged on, signs of alterity, we can recognize it as semiophagous. The feast of Corpus Christi, prepared in the Andes, not only served up Andean signs but defined its triumphant self by consuming them. Andeans and their festive practices were the necessary delicacies that enabled the Corpus Christi to shift from being the wafer consumed to the semiophagous consumer.

In the early years following the Spanish occupation it would have been impractical to expect Andeans to perfectly mime European celebratory practices, but that was never the goal (as we shall see). For now, it is sufficient to note that not only did Corpus Christi *need* a meaningful opposition, but native celebratory practices were not necessarily anathema to Christianity. Clearly Spaniards distinguished between the means of celebration and the object being celebrated. In other words, they divorced Andean festive forms from Andean religious beliefs. Once (or if) the divorce was finalized, Andean celebratory practices (such as dances) could be used in the celebration of Christian holidays. Evangelizers in the Americas used their knowledge of indigenous American deities to convert Native Americans more easily. One of the first Spaniards to observe that Andean religiosity was a good thing, even if he de-

cried the object of reverence, was the chronicler Bartolomé de Segovia (known as Cristóbal de Molina, "El Almagrista"). In April 1535 he witnessed the Inkas' harvest festival to the Sun. He concluded that

even though this [giving thanks to the Sun for the harvest] is an abominable and detestable thing, because this festival honors that which was created rather than the Creator to whom gratitude was owed, it *makes a great example for understanding the thanks that we are obliged to give to God* [emphasis added], our true Lord, for the goods we have received, of that which we forget how much more do we owe. (Molina "El Almagrista" [1553] 1943, 51) [17]

The chronicler thus recognized the value of the religiosity manifested in the harvest festival. It was not the giving of thanks to a supernatural entity that was "wrong"; rather, the focus of worship was "misguided" from a Christian perspective.

Spaniards recognized the value of maintaining certain native reverential behaviors in an effort to shift adoration away from native supernaturals (*wak'as* [sacred places and things], celestial bodies, thunder and lightning, and ancestors) to the Christian pantheon. The practice of substitution was nothing new to Europeans, who commonly associated Greek and Roman deities with members of the Christian pantheon. In fact, Greek and Roman deities made appearances in colonial celebrations.[18] Thus, Spaniards did not necessarily find reference to pagan deities anathema but used them to demonstrate the superiority of the Christian God; so, too, did they use certain Andean religious customs. The ecclesiastic councils of Lima, 1551–1772, emphasized not eradication, but utilization of native religiosity and the careful application of substitutions. The first provincial council of 1551 (called by Archbishop Jerónimo de Loayza) set forth the philosophy of substitution in the third of forty *constituciones*. It was dictated that, in Andean communities where there was some conversion, *wak'as* (or *huacas*) were to be destroyed and churches built over them or crosses raised in their place (communities without converts were problematic and were referred to the viceroy). The second council of Lima, convened in 1567 (also under Archbishop Loayza), decreed that, wherever possible, crosses should be erected at all *wak'as* or *pachitas* (indigenous shrines often located on hills or promontories) (Vargas Ugarte 1951, 253, constitución no. 99). The council ordered that "pagan" seasonal festivals associated with sowing, rain, and snow be refocused on temporally equivalent Chris-

tian celebrations. Priests were specifically instructed to surreptitiously observe native celebrations of Corpus Christi (celebrated at harvesttime [May–June] in the Andes) to make sure that Indians were not using the feast of the Body of Christ as a pretext for worshipping their "idols," however.[19] These seeds of doubt which later blossomed into extirpatory rhetoric and action will be examined below (Chapter 3). Civic authorities also condoned the practice of substitution. Viceroy Francisco de Toledo ([1572] 1921–1926b, 171), for example, in the latter half of the sixteenth century, gave his stamp of approval to the practical policy of substitution when he commanded that native images be removed and crosses and other Christian insignias be put in their place.

The didactic dialogue "El Dios Pan," written at the beginning of the seventeenth century for Corpus Christi in Charcas (Bolivia), is based on the substitution of the pagan Pan by the Christian God (the dialogue is reproduced in Vargas 1943, 1–26). "El Dios Pan" shows how readily Hispanics evoked non-Christian themes as evidence of their "true" religion. In the course of the dialogue it is demonstrated that Christ, in the form of the wafer consumed in the rite of Communion, is the true god Pan (*pan* meaning "bread" in Spanish). The substitution is furthered by the observation that the Greek god Pan was a pastoral figure and that Christ is known as the Good Shepherd; additionally, the Christian character in the dialogue notes that just as Pan was the god of Arcadia so is the Christian God the god of Arcadia because he was responsible for the making of two *arcas*, or "arks": Noah's ark and Moses' ark of the covenant. The dialogue also points out that Apollo, the Greek deity associated with the sun, is the servant of the Christian God. The same Hispanics who relied on fallen Greek gods to provide foundations for Christianity looked to Andean supernaturals to do the same.

Framing the Performative

Certain native celebratory forms—and the selectivity involved will be the subject of the next chapter—were integrated into Corpus Christi (and other festivals, both religious and profane) because the festive framework, that of a triumph, conditioned their significances to the colonizers.[20] The triumphal vocabulary allowed native performative enunciations to be heard by the colonizers in ways that were accept-

able, even gratifying, to them. The repeated use of a constructed and performed, three-dimensional triumphal vocabulary also ensured that native Andeans learned European festive rhetoric.

Of all the visible elements of the festive "frame," triumphal arches were the most frequently erected of all temporary architecture in vice-regal Peru (at least if the records we have remaining can be used to establish some kind of reliable sample). Although Valerie Fraser (1990, 144) contends that the arch was specifically religious in its resonances, temporary arches were constructed both for sacred and for profane occasions. Such arches decorated Andean streets for the arrival of civic and ecclesiastic authorities, the canonization of saints, and the celebration of religious feasts, royal births, accessions, marriages, and even deaths (Gisbert and Mesa 1972, 250–251). The journal kept in part by Josephe de Mugaburu, a sergeant (captain after 1672) of the palace guard in Lima, contains numerous descriptions of ceremonies that utilized the visual rhetoric of triumph in the viceregal capital.[21] He describes the triumphal arches erected for the advent processions of the viceroys Salvatierra (in 1648), Lemos (in 1667), and Castellar (in 1674) (Mugaburu and Mugaburu [1640–1697] 1975, 22, 121, 124). Arches were likewise erected over the pathways of an Audiencia president arriving in 1669 (ibid., 149). Religious processions in Lima, such as that of the Candlemas (celebrating the purification of Mary after the birth of Christ) in 1672, similarly utilized the passage through triumphal arches (ibid., 178). Mugaburu's descriptions of the advents of the new viceroys in 1667 and 1674 also detail the decoration of balconies and windows along the processional path with banners and tapestries.

Another chronicler of viceregal festivities is Bartolomé Arzáns de Orsúa y Vela who, circa 1735, composed a history of Potosí, a populous and important mining center located in what is today Bolivia.[22] Like Mugaburu, he frequently mentions the construction of triumphal arches and the decoration of processional passageways on religious as well as profane occasions (e.g., Arzáns de Orsúa y Vela [c. 1735] 1965, 1:70, 95–96, 210, 390–391; 2:253, 266, 347, 412; 3:47–49).

In Cuzco, the former capital of the Inka empire, triumphal arches and decorated passageways welcomed the two viceroys who visited the highlands: Toledo (February 1571) and the Count of Lemos (October 1668). Additionally, the entry into Cuzco of the victorious royalists under Pedro de Gasca at the end of the civil war in the mid-sixteenth century is described as consisting of acclamations from the public, the

construction of triumphal arches, and streets decorated with flowers and garlands (Contreras y Valverde [1649] 1982, 88).[23] Diego de Esquivel y Navia, *deán* of Cuzco's cathedral and from an old and prestigious Cuzqueño family, wrote a history of Cuzco in the mid-eighteenth century that includes numerous references to triumphs. His descriptions of the numerous entries of civic and religious personages repeatedly make use of the same celebratory vocabulary of arches, adorned streets, altars, and such. One of the most instructive is his discussion of the arrival of the Religious Order of the Bethlemites in 1698 (Esquivel y Navia [c. 1749] 1980, 2:169). He writes:

The entry of the Bethlemites into this city was Sunday, June 29, the [feast] day of the glorious apostles Saint Peter and Saint Paul at four in the afternoon. With them came their general, the friar Rodrigo de la Cruz. They were accompanied from the parish of Saint Anne [into the city] by both leaders and the most illustrious citizens [of Cuzco]. The streets were well adorned with tapestries and passageways which are called arches, but were not triumphal [arches], nor was there music in the balconies as is recorded in the *History of the Bethlemites*.[24]

Esquivel is careful to define the arches that spanned the passage of the Bethlemites as *not* triumphal.[25] Esquivel's quibble with the Bethlemite historians indicates that in viceregal Cuzco, as in Spain, to walk through an arch was understood as a high-status privilege granted only to holders of high office or to those widely recognized as heroic. The Bethlemites, while deserving of an escort that consisted of "the most illustrious citizens" of Cuzco, were not, according to Esquivel, entitled to pass beneath "triumphal" arches. Clearly, the Bethlemites chose to remember and record an interpretation of those arches that was more to their liking and that added more to their prestige.

Visual records augment textual descriptions. One of the most vivid records comes in the form of a series of canvases, painted circa 1680, that depicts the Corpus Christi procession in Cuzco. In seven of the canvases of this Corpus Christi series, which will be the focus of Chapter 4, the cortege threads its way through ornately decorated arches. The visual testimony matches contracts for these festive constructs, which were festooned with mirrors, ribbons, plumes, flowers, repoussé plaques, small figurines, candles, banners, and paintings (still lifes and landscapes) (Fig. 1; see also Figs. 17, 18, 19, and 24; Plate IV).[26]

Fraser (1986, 326–332; 1990, 34–35, 153), studying the significance

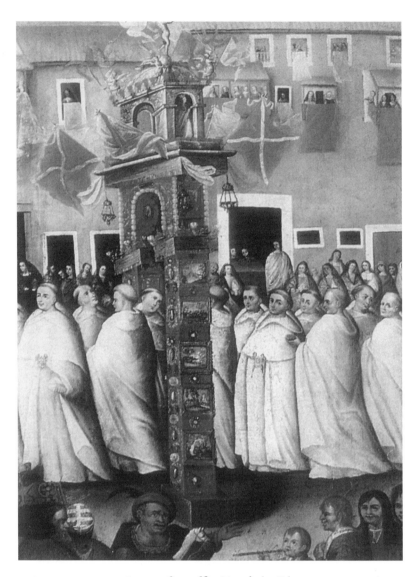

1. Anon., 1674–1680, *Mercedarian Friars*,
detail of the temporary triumphal arch, Corpus Christi series
(Museo del Arzobispo, Cuzco)

of arched portals in viceregal-period churches, argues persuasively that
the arch was, to the European colonizer, a symbol of his cultural and
technological superiority over the natives, who used post-and-lintel
construction. Extending her conclusions, we may surmise that the fes-
tive triumphal arch erected on Andean territory was doubly significant.

It stood not only as the symbol of triumph for those who marched underneath it but, more broadly, for the European people and culture that invented and erected it.[27]

In addition to arches, canopies, such as that shading the Corpus Christi monstrance, were part of the widely understood vocabulary of festive triumph. The privilege conveyed by the canopy was widely appreciated in the Andes during the colonial period. Mugaburu ([1640–1697] 1975, 22, 35, 58, 119, 121, 215–216, 266) mentions canopies held by *regidores* (city councilmen) over Viceroys Salvatierra (1648), Alba de Liste (1655), Santisteban (1661), Lemos (1667), Castellar (1674), and La Palata (1681). Salazar ([1596] 1867, 249–256) noted that Viceroy Toledo entered Cuzco under a canopy. Esquivel y Navia ([c. 1749] 1980, 2:126) does not provide as elaborate a description of the advent held in Cuzco for the viceroy Don Pedro Fernández de Castro, Conde de Lemos (1667–1672), on October 24, 1668, but he does indicate that Lemos was received by the members of the municipal council "with the grandeur of the canopy." [28] In detailing the tense meeting of the recently arrived Count of Salvatierra (García Sarmiento de Sotomayor, 1648–1655) and the outgoing viceroy, the Marquis of Mancera (Pedro de Toledo y Leiva, 1639–1648), Mugaburu ([1640–1697] 1975, 21) makes a point of specifying that the new viceroy sat under the canopy while Mancera, retired and replaced, sat outside.[29] Arzáns de Orsúa y Vela ([c. 1735] 1965, 1:112) is critical of the members of the Audiencia of Charcas, saying that they acted like deities in wanting to sit under individual canopies. He indicates that they should have been content to share a single canopy as a group, since it was as a group that they represented the king. A royal decree denied the use of canopies to bishops during advent ceremonies (Esquivel y Navia [c. 1749] 1980, 2:11). It is only as the escort of the consecrated host in the Corpus Christi procession that the bishop appears under a canopy. From such details, it is clear that Mugaburu, Arzáns, Esquivel, and, most likely, much of the colonial Peruvian audience, understood the canopy to be the privilege of only the highest officials, whether civic or ecclesiastic.[30]

The first triumphal cart did not appear in a Corpus Christi procession in Cuzco until the eighteenth century (Santisteban Ochoa 1963, 31; Flores Ochoa 1994, 57 n. 6).[31] Interestingly, the triumphal cart was a pictorial presence in the Andean highlands before it was made materially manifest. Printed images of triumphal carts must have circulated widely as there are numerous examples from the second half of

the seventeenth century of paintings featuring triumphal carts that had been derived from prints.[32] The series of Corpus Christi paintings mentioned above, for example, features five carts that were derived from an illustrated festival book from Valencia, Spain (Dean 1996a). Thus, even though the processional cart itself was not seen in Cuzco until the eighteenth century, the way was well paved for its triumphal presence.

Conclusion

We have examined aspects of the history, festive context, celebratory constructs, and behaviors that conditioned the meanings of Corpus Christi for those who celebrated it in colonial Peru. A triumphal vocabulary imported from Spain became familiar to Andeans through repetition, not merely as part of the Corpus Christi festival but as part of the ritualistic language used to address victors of worldly and supernatural origin alike.

The celebration of the Body of Christ was erected on an armature of triumphal signifiers widely recognizable owing to the visual and performative vocabulary that it shared with other religious as well as profane festivities. Because Corpus Christi was linked with political and military victory and because its triumphal vocabulary was utilized by profane authorities (in advents and other ceremonies), Andeans, although lacking familiarity with Spanish and Christian traditions, could not have failed to comprehend the significance of these forms and their triumphal overtones. To Spaniards, rehearsing the annual "triumph over heresy" was especially important in Cuzco: while Spanish eyes in Peru turned to Lima as the viceregal capital, native Andean eyes still looked to the imperial capital of the Inkas, Cuzco, as a cultural node of profound significance. Thus, as we shall see, triumph in Cuzco was triumph over the Andes.

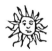

Chapter 2

The Body of Christ in Cuzco

The festival of Corpus Christi, one of the most significant feasts of the Catholic liturgical cycle, was introduced throughout Spanish America during the conquest. It was the focus of considerable expense and energy in most Spanish colonial settlements.[1] Ecclesiastic as well as civic authorities promoted Corpus Christi not only because it is the single festival in which God is literally present in the community, but also because Corpus Christi provided a festive forum in which the community's leading individuals and corporate groups "performed" their privileged status.

Although Corpus Christi was celebrated in the Americas wherever there were Catholic Christians, and frequently with "great devotion," nowhere in Latin America did Corpus Christi achieve as much renown as in Cuzco, the former capital of the Inka empire and its religious center as well. The conscious substitution of Christian symbols for objects and places of Andean religious reverence was especially pertinent there. Because the colonial identity of Cuzco rested heavily, albeit often uncomfortably, on its Inkaic past, the triumphal aspects of the festival of Corpus Christi resonated profoundly. As the former Inka capital, the city harbored memories of its pre-Hispanic past. Its central edifices—Spanish structures on Inka foundations—were visible, tangible metonyms of conquest. Framed by these structures, the Corpus Christi procession in Cuzco was understood, and written about, as the triumph of Christianity over the imperial Inkaic patron, the Sun. Further, be-

cause of the temporal correspondence between Corpus Christi, Andean harvest festivals, and the Inka festival of the June solstice, called Inti Raymi, the new Christian festival became inextricably intertwined with traditional Andean celebrations. The idea that Corpus Christi replaced an important Inka festival became crucial to the celebration of the Feast of the Holy Sacrament in Cuzco.

Metonyms of Conquest

On March 23, 1534, Francisco Pizarro performed the founding ceremonies for the city of Cuzco that symbolically transformed the Andean city into a Spanish and Christian community. In 1540, Cuzco was granted the right to refer to itself as "the head of the kingdoms of Peru" (la cabeza de los reinos del Perú), and this epithet was repeatedly confirmed by later grants.[2] Cuzco's postconquest prestige depended on its indigenous and imperial past. Unlike the Mexica (Aztec) capital of Tenochtitlán–cum–Mexico City, Cuzco was not designated as the viceregal capital. In October 1533, before Pizarro reached Cuzco, he founded the Spanish municipality of Jauja as the first Christian capital of Peru; later, in 1535, he founded the city of Los Reyes (Lima) as regional capital. When the viceroyalty was formed in 1544, Los Reyes was designated as its capital city. While Lima (officially Ciudad de Los Reyes) was the capital of the viceroyalty of Peru and outranked Cuzco in every measure of colonial power, Cuzco never relinquished the memories of the past and so the Inka and the city's Inka-ness was an integral part of colonial Cuzco's self-fashioned identity.[3]

Cuzco held prestige by virtue of antiquity: it was the symbolic "first city" of Peru, having the first seat and vote in viceregal affairs. When the chronicler Martín de Murúa ([1600–1611] 1986, 499–504) wrote his description of the Peruvian viceroyalty in the first decade of the seventeenth century, Cuzco was the first of the seventeen cities covered.[4] He explains his manner of ordering:

[E]ven though today Los Reyes is the principal city, having the most authority and glory of all of Peru because it is where the viceroys, Audiencias, archbishop and Inquisition are located as well as other circumstances that ennoble it even more, I shall speak first of the great city of Cuzco because it was the head of these kingdoms and today, by royal decree, uses this title,

and in writs and contracts of Spaniards is named as such, and because the Inkas from Cuzco brought civilization and urbanity to the provinces they conquered and had in Cuzco their seat, residence, and court and, finally, because Cuzco was the capital of all the kingdoms of the Inkas. (Murúa [1600–1611] 1986, 499) [5]

Likewise, an anonymous chronicler (in Mateos [1600] 1944, 2:7), writing in 1660, says that Cuzco "is called head of the kingdoms and provinces [of Peru] as much because of its extreme antiquity and nobility in all manner of things as because of the great multitude of Indians that live in the city and its surroundings, and particularly because it was the ancient seat and court of the Inka kings where the native leaders and nobility of Peru were and still are." [6]

Postconquest Cuzco was a concept as well as a geographical location. It was an "imagined" city of the imperial past and the symbolic heart of indigenous Peru.[7] Cuzco's colonial leaders had an interest in constructing remembrances of the Inkaic past because their prestige within the viceroyalty hinged on its historic glory. Cuzco, once the capital of the Inka, was transformed during the colonial period into a museum of the Inka, a place where the past was warehoused and brought out for occasional display. While Corpus Christi was not the only occasion on which the Inkaic past was exhibited, it was the most renowned festival of Cuzco's liturgical calendar because of its associations with pre-Hispanic celebrations (as will be discussed below).

Thus, Cuzco's viceregal position of preeminence derived from its imperial past, and Cuzqueño remembrances of the pre-Hispanic empire were more vital to postconquest identity than anywhere else in the Spanish colonies. Even if its colonial citizenry had wanted to put aside the past, the very materiality of the city would have made that difficult. Spanish municipalities such as Cuzco which were constructed of the stuff of indigenous settlements made use of the native labor and materials close at hand. In the case of Cuzco, the Spaniards used the Inkas' central plaza (haukaypata) as their own plaza mayor and they positioned their cathedral on this square. All around the central precinct Spanish edifices were erected on the foundations of Inka structures. Elsewhere I have discussed how the Inka architectural complex of Saqsaywamán, which overlooks Cuzco to the north, functioned as a quarry for the building of colonial Cuzco (Dean 1998). In the process, it became a "ruin." The mestizo chronicler Garcilaso de la Vega ([1609, 1617]

1966, 1:471), who grew up in Cuzco during the latter half of the sixteenth century, witnessed the process of ruination:

The Spaniards . . . demolished [the fortress of Saqsaywamán] to build private houses in Cuzco. And to save themselves the expense, effort and delay with which the Indians worked the stone, they pulled down all the smooth masonry in the walls. There is indeed not a house in the city that has not been made of this stone, or at least the houses built by the Spaniards.

The large slabs that formed the roof of the underground passages were taken out to serve as lintels and doorways. The smaller stones were used for foundations and walls, and for the steps of the staircases they sought slabs of stone of the size they needed, pulling down all the stones above the ones they wanted in the process, even though there might be ten or twelve rows and many more.

And so, Cuzco's most important colonial edifices—religious, civic, and private—rested on and/or consisted of Inka masonry from deliberately ruined Inka structures. In "edifying" Spanish Cuzco, the quarrying of Inka Saqsaywamán—the most widely heralded and impressive of pre-Hispanic monuments in Cuzco—was especially significant. While Cuzco's *cabildo* (municipal council) prohibited the removal of stones from Saqsaywamán in 1561 (Angles Vargas 1990, 23), their edict had little apparent effect. In 1571, the city's *corregidor* (magistrate) commented that Saqsaywamán could supply enough dressed stones to build four churches as grand as those of Seville in Spain, suggesting that the Inka architectural complex continued to be an exploited resource for dressed stone (Polo de Ondegardo [1571] 1916b, 107). Other officials and chroniclers affirm extensive use of stone from Saqsaywamán in the building of Cuzco (e.g., Sarmiento de Gamboa [1572] 1943, 137, and Toledo [1571] 1904–1907). Murúa ([1600–1611] 1986, 500) claimed that *all* Spanish structures built in Cuzco used stone from Saqsaywamán. He explained that the only reason any stones were left standing at the site was because the large boulders would have been too expensive to move and would have required the labor of too many natives.[8] Contracts from the sixteenth and seventeenth centuries provide hard evidence for the use of stone from Saqsaywamán in the building of Spanish Cuzco's symbolic center. The documents, dated October 6, 1559, and February 19, 1646, indicate that Saqsaywamán was the source of stone used in building the cathedral of Cuzco (Valcárcel 1935, 176; Cor-

nejo Bouroncle 1960, 147). An eyewitness account of the construction of Cuzco's cathedral details the Andean method of lithic construction employed by native laborers, and the natives that chronicler watched were undoubtedly using some of the same stones their ancestors had used to build Saqsaywamán.[9]

While Cuzco's cathedral was erected, Saqsaywamán was partially and imperfectly erased. Certainly Saqsaywamán was a convenient source of dressed stone, but its ruined state came to be understood not just as evidence of conquest and religious conversion, but as an actuation of those events. Viceroy Francisco de Toledo, writing in 1571 (1904–1907, 174), characterized Saqsaywamán as "a thing in which the power of the devil and his subjects is well demonstrated" (es cosa en que se muestra bien el poderío del diablo). By the middle of the seventeenth century, it is clear that the ruins connoted evangelical success. As one of the city's ecclesiastic authorities penned, "[Saqsaywamán] was once dedicated as a house of the Sun [the Inkas' patron deity] and in this time serves only as a witness of its ruin" (Fue dedicada al principio para casa del Sol y en este tiempo, sólo sirve de testigo de su ruina) (Contreras y Valverde [1649] 1982, 4).

The first Cuzqueño church was said to have been built on the spot in which the Virgin Mary herself had visited Cuzco. This most famous of saintly visitations was said to have occurred in 1535 during the long siege of Cuzco organized by the rebellious Inka ruler Manko. According to legend, both Santiago and the Virgin Mary appeared at critical points in the battle for the ancient Inka capital. Mary was acclaimed for having appeared atop the edifice in which Spaniards had taken refuge. She is said to have extinguished the fire set to the thatched roof by the rebels and to have flung dust (or hail) into the eyes of the enemy troops, causing them to flee.[10] Cuzco's first church was said to have been built on this spot, and in the seventeenth century the cathedral was constructed adjacently. The cathedral was finished in 1654 and the old church was converted into the chapel of El Triunfo (The Triumph) in memory of Mary's—and the Spaniards'—victory. Her apparition was celebrated annually on May 23.[11]

The cathedral was thus a monumental metonym of conquest, and its construction converted the sacred geography of pre-Hispanic Cuzco into a map of Christian triumph. The divine intervention by Mary and Santiago converted this site of "idolatrous" behavior into a city of Christian devotion while reaffirming the pre-Hispanic notion of Cuzco as a place acted on by supernatural forces.[12] Artists such as the native

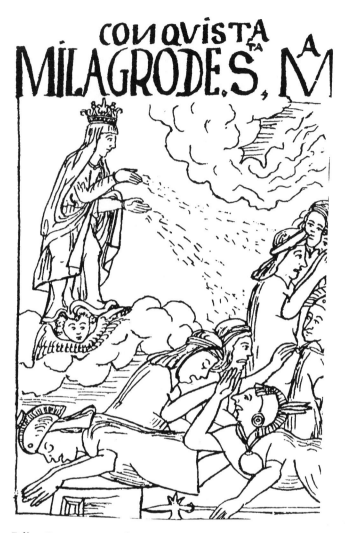

2. Felipe Guaman Poma de Ayala, 1613, folio 402, *Miracle of Saint Mary*
(Guaman Poma [1615] 1988, 374)

Felipe Guaman Poma de Ayala envisioned the appearances of Mary and
Santiago during the siege (Figs. 2 and 3).[13] By the late seventeenth cen-
tury, when Cuzco's bishop Manuel de Mollinedo y Angulo had a pair
of canvases made depicting the two miracles, the legend had become
widely accepted history.

The cathedral of Cuzco dominates the Inka's *haukaypata*, which be-
came the colonial city's *plaza mayor* or *plaza de armas* (Fig. 4). Prior to the

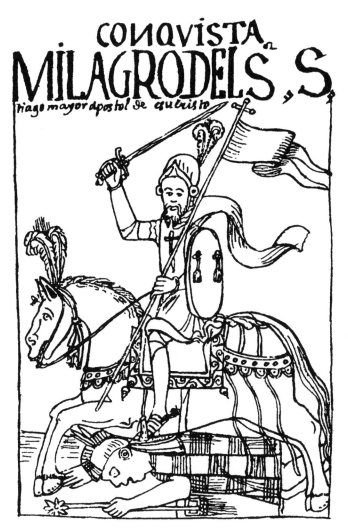

3. Felipe Guaman Poma de Ayala, 1613, folio 404, *Miracle of Saint James*
(Guaman Poma [1615] 1988, 376)

conquest, this space was the main square which the Inka used for major events such as victory celebrations, the installation of new rulers, and the culmination of various seasonal festivals. It was separated from the smaller *kusipata* by the Watanay River, which ran through the center of Cuzco. The *kusipata* ("place of joy") became the postconquest plaza rego-cijo ("plaza of joy or celebration").[14] The Hispanicization of the *kusipata* involved more than a translation of its name, however. The Spaniards,

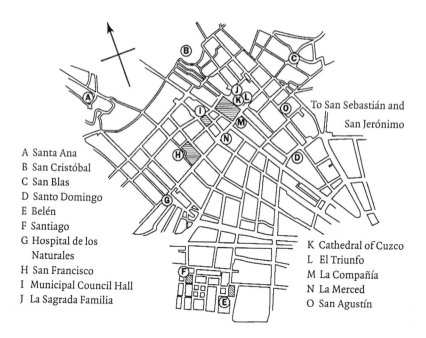

A Santa Ana
B San Cristóbal
C San Blas
D Santo Domingo
E Belén
F Santiago
G Hospital de los
 Naturales
H San Francisco
I Municipal Council Hall
J La Sagrada Familia

To San Sebastián and
San Jerónimo

K Cathedral of Cuzco
L El Triunfo
M La Compañía
N La Merced
O San Agustín

4. Plan of Cuzco

nonplussed by the spaciousness of the Inkaic double-plaza, resolved to restructure it by building edifices over the Watanay and decreasing the size of the *kusipata*. In 1548, the municipal council authorized the building of houses over the river running between the two plazas (Cornejo Bouroncle 1960, 322–323). In the latter half of the century, they observed that the two main plazas were still "disproportionate and so large that festivals and other public acts cannot be enjoyed in them" ([*Las dos plazas principales*] *están desproporcionadas y tan grandes que no pueden gozar bien en ellas las fiestas e otros autos publicos que se hazen en ellas*) (Toledo [1572] 1921–1926a, 70). They determined to reduce the *plaza del cabildo* by constructing houses and stores in front of the church and convent of La Merced. Construction stalled, however, in part because the Mercedarians strenuously objected to the plan, which would have eliminated their prestigious position facing the plaza.

Juan Polo de Ondegardo ([1571] 1916b, 110–111), magistrate of Cuzco in the latter half of the sixteenth century, refers in his *relación* to the alterations made in the plazas of Cuzco (specifically, the addition of four bridges over the Watanay as well as the erection of the cathedral)

saying: "The primary function [of these alterations] was to eliminate the great reverence [Indians] held for this plaza." He explains that the central plaza of Cuzco was revered not only by the local natives but by those living throughout the realm. Hispanicizing the appearance of the Inkaic double-plaza, he argues, would be a step in Hispanicizing and converting to Christianity not only Cuzco, but all of the viceroyalty of Peru.[15]

It was (and is) in this Hispanicized space that Christian festivals such as Corpus Christi were (and are) held. Converting the space of Inka *raymis* (festivals) into a space for Corpus Christi and other Catholic feasts seems to have been a calculated adjunct to the substitution of the celebrations themselves for native feasts. The festive vocabulary of triumph became doubly meaningful when enunciated on the stage constructed of native masonry reworked to provide foundations for Spanish-looking structures.

Corpus Christi in Cuzco

Within forty years of the conquest, Corpus Christi had become Cuzco's most important religious festival. Viceroy Toledo ([1572–1573] 1926, 87) acknowledged it as such in 1572, calling Cuzco's Corpus Christi "the principal festival and procession of the year because of what it represents—the body of Our Lord Christ, the true God-Man, taken in procession."[16] That, of course, is what Corpus Christi "represented" everywhere it was celebrated, so why was the Corpus Christi festival in Cuzco so significant?

Toledo himself may answer that query. He cautioned community leaders in Cuzco to take great care with the Corpus Christi celebration, to teach the newly Christianized indigenous audience, whom he termed "new plants," the true meaning of the festival that "replaced their idolatries" (Toledo [1572–1573] 1926, 87–91).[17] Such instructions suggest that Corpus Christi in Cuzco had some special relationship with the conversion of the Andeans from so-called idolatrous practices to Christianity and that, therefore, indigenous participation was essential to the festival's success in Cuzco.[18] Like Toledo, several chroniclers understood Cuzco's Corpus Christi to be a significant part of the conversion effort. Toledo's contemporary, the licenciate Juan Polo de Ondegardo ([1571] 1916a, 21–22), whom Toledo appointed *corregidor* of

Cuzco, for example, wrote that Corpus Christi was held at approximately the same time of year as the Inka festival of Inti Raymi (Intiraymi, Inti Raimi) and that "in some things [the two festivals of Inti Raymi and Corpus Christi] have some appearance of similarity (as in dances, performances, or songs) and that because of this there was and still is among the Indians that seem to celebrate our festival of Corpus Christi, a superstitious belief that they are celebrating their ancient feast of Inti Raymi." [19] A number of viceregal observers likewise associate Cuzco's Corpus Christi with Inti Raymi, the pre-Hispanic "Festival of the Sun." [20] This is the commonly held notion in Cuzco today, as we shall see in Chapter 9. Scholars prior to Carol Ann Fiedler (1985), whose work will be discussed later, have repeated it with scant analysis of the equation.

An examination of the correlation between Inti Raymi and Corpus Christi suggests that the identification of the former Inka feast in the latter Christian festival was meaningful to the colonialists in part because Corpus Christi, as a triumph, required the presentation of vanquished opposites. The temporal correspondence between Corpus Christi, pan-Andean harvest festivals, and the Inka June solstice festival known as Inti Raymi provided the Christians with the required symbolic opponent. That the former capital of the Inka empire was the center of pre-Hispanic religion added to the triumph of Corpus Christi in that postconquest center. Thus, while the indigenous dances and regalia that appeared in Cuzco's Corpus Christi were inherently no more "idolatrous" than indigenous presentations in other Christian festivals, there the meaning of these festive practices was magnified. Identifying Inti Raymi—or, for that matter, any Inka celebration—in Corpus Christi constituted a performative metaphor for the triumph of Christianity over native religion, and of Christians over "pagan" Andeans. Corpus Christi in Cuzco included performed remembrances of the Inka past that, when viewed through the triumphal framework of Corpus Christi, could be seen as the triumph of Christianity over the Inka solar deity and of Spanish Christians over the Inkas and their Andean subjects. Corpus Christi actuated superordinance.

A number of chroniclers recorded their understandings of the Andean festive cycle; unfortunately, the information they provide is inconsistent and sometimes contradictory.[21] According to these accounts, the Inka festive cycle was inextricably tied to the annual calendar. In general, chroniclers record one festival per month according to a twelve-

month calendar roughly consistent with the European months (reason enough for skepticism). While information about the Andean festive cycle is not consistent, it does seem to have had two main celebratory seasons timed near the solstices and associated with different climatic episodes. The December solstice was celebrated in Qhápaq Inti Raymi ("Festival of the Royal [or Great] Sun"); that of June in Inti Raymi ("Festival of the Sun"). For the Inka nobility, the December solstice celebration, highlighted by the coming-of-age ceremonies for noble Inka youths, was the more significant of the two solstitial celebrations. As Titu Cusi Yupanqui ([1570] 1973, 69), leader of the independent neo-Inka state in postconquest Vilcabamba, stated, Qhápaq Inti Raymi affirmed Inka status and power.[22] The June solstice, marking the onset of the dry Andean winter, was more meaningful to a greater number of Andeans, however, because of its links to the agricultural cycle. This pan-Andean aspect may have contributed to the preeminence and "longevity" of Inti Raymi in the viceregal period.

In pre-Hispanic times, the two solstitial celebrations had much in common. Guaman Poma de Ayala ([1615] 1988, 220–221, 232–233) obliquely compared the solstitial festivals of June and December in his heavily illustrated chronicle composed between 1587 and 1615. He calls the Andean month corresponding to June "Haucai Cusqui," saying that in this month the Inka ruler drinks with the sun and that the festival itself was dedicated to the solar orb: "This month they make the moderate festival of Ynti Raymi and much was spent in it and they sacrificed to the sun. And, in the sacrifice called *capac ocha*, 500 innocent youngsters and much gold and silver and shells were buried."[23] The same sacrifice of 500 children, gold, silver, and shells was performed at Qhápaq Inti Raymi in December (ibid., 233). Further, Guaman Poma relates that in both June and December, imperial magistrates (*tocricoc*) or judges (*michoc*) took a census of all the natives and their possessions. Thus, in ceremonial activities there was a logical linkage of the December and June solstitial feasts. Polo de Ondegardo ([1571] 1916a, 19) similarly records that the *raymi* of December was also held at the time of Corpus Christi (i.e., near the June solstice); in other words, the two solstitial festivals were formally similar.

While the two feasts were celebrated in like fashion, they were conceived of in oppositionary or, more likely, complementary terms. Guaman Poma, in his illustration of the June solstice ceremony (Fig. 5), depicts a small sun in the upper right (pictorial left); his drawing of

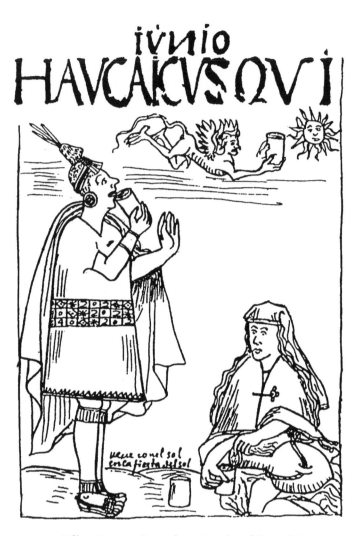

5. Felipe Guaman Poma de Ayala, 1613, folio 246, *June*
(Guaman Poma [1615] 1988, 220)

the December solstice portrays a large bearded sun to the pictorial
right (Fig. 6). The significance of pictorial positioning in the drawings
of Guaman Poma has been well established by numerous scholars.[24]
The artist employed traditional Andean spatial values to convey com-
plementary binaries such as superior/inferior and male/female, among
others. The small sun of the June solstice, the shortest day of the
year, located on the small/weak/female left contrasts with the elderly
large/strong/male sun of the December solstice, the longest day of the

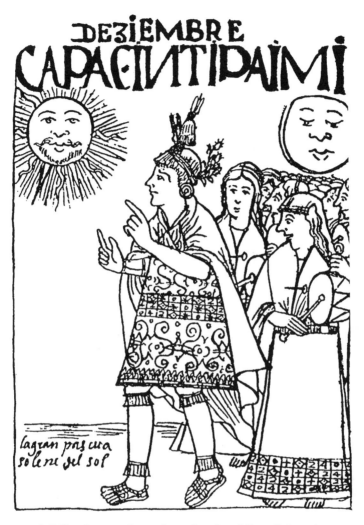

6. Felipe Guaman Poma de Ayala, 1613, folio 258, *December*
(Guaman Poma [1615] 1988, 232)

year. Additionally, Guaman Poma is careful to describe Qhápaq Inti Raymi, the celebration of the December solstice, as the great festival in which the "sun is king" (as suggested by the honorific "Qhápaq"). He specifically states that it was "more than Inti Raymi."²⁵ According to Guaman Poma, then, the two solstitial festivals were conceptual complements. Apparently, the December solstitial celebration honored the mature, powerful sun on the day of its longest diurnal journey, while its opposite was Inti Raymi, the festival of the young and weak sun on the

day on which it made its briefest appearance. Cristóbal de Molina, "El Cuzqueño" ([1574] 1943, 25–26), priest of the parish known as Hospital de los Naturales in Cuzco during the latter half of the sixteenth century, supports the pictorial testimony of Guaman Poma in his record of the Inti Raymi ceremony. He says that the "idol" of the Day Sun, called Punchao, celebrated at Inti Raymi, was addressed as "forever youthful" (*siempre mozo*).

The two solstitial festivals formed the two primary points of the Andean calendar. Molina ([1574] 1943, 25) designates the month (known as Hacicay Llusque) in which Inti Raymi occurs, as the beginning of the Inka year (specifically, he says that the Andean year began on the first day of the moon in the middle of that month).[26] While Guaman Poma places December's Qhápaq Inti Raymi at the end of the Inkaic festive calendar, Juan de Betanzos ([1551] 1987, 71), Polo de Ondegardo ([1571] 1916a, 17–18), and Antonio de la Calancha ([1638] 1974–1981, 850) identify December as the first month in the Inka year and Qhápaq Raymi as the first, and most important, feast. Perhaps explaining these differing perspectives, Murúa (1986, 450), writing circa 1600–1611, as well as the later Jesuit Bernabé Cobo (1979, 251), writing in 1653, specifically state that the Inka year began *and* ended at the December solstice. Regardless of when the regeneration of the solar year was perceived (if, indeed, Andeans recognized a single date for regeneration), the solstices were the two most significant festive occasions. Given the complementary structure of Andean society and cosmology, it is likely that the year consisted of two halves which began and ended at the solstices. Hence, the June solstice would be the beginning of one half and the end of the other, while the December solstice could be described in similar terms. This could have caused the confusion exhibited by colonial-period chroniclers who, given the European system, would have sought a single beginning and end.

Several chroniclers specifically associate Corpus Christi with an Andean harvest festival (which Inti Raymi was not). Pablo Joseph de Arriaga ([1621] 1968, 49), the Jesuit extirpator of idolatry who reported on the persistence of "pagan" practices in the archbishopric of Lima in 1616–1917, and whose activities will be discussed in greater detail in Chapter 3, correlated an important pre-Hispanic feast of that coastal district with Corpus Christi. The native feast marked the period prior to the June solstice as an agriculturally significant time. Arriaga gives its name as Oncoy Mitta (Oncoimita) and says that it celebrated the ap-

pearance of the constellation of Oncoy (the Pleiades). Homage was paid to Oncoy to prevent the corn from drying up just before harvest. Fernando de Avendaño (1904–1907, 381), writing in 1617, records a similar identification of Corpus Christi with "oncoimita." Hence, harvest festivals in general may have been celebrated in conjunction with Corpus Christi rather than with the Inka June solstice festival of Inti Raymi (Zuidema 1993).

Significantly, in the Southern Hemisphere the June solstice is heralded by the reappearance of the Pleiades, the inspiration for Oncoy Mitta, after a thirty-seven-day absence. R. Tom Zuidema (1977b, 228) concludes that the solstices were celebrated in the month prior to the event, with the reappearance of the Pleiades in May/June heralding the June solstice. Thus, this period was recognized as the end of the agricultural year and the time for the sun to regenerate (as does the earth) and it was apparently a festive time throughout the Andes. Betanzos ([1551] 1987, 71) explains that a month-long festival honoring the sun for a successful harvest was held by the Inkas from May (his Haucai Quosqui Quilla, or "moon of the rest after harvest") through June (Hatun Quosqui Quilla, or "moon of the great harvest"). This is similar to Guaman Poma's ([1615] 1988, 221) Haucai Cusqui ("rest after harvest"), which he locates in June. So May/June was apparently recognized as the time of celebrating the harvest as well as a herald of significant celestial events. In Cuzco, the Pleiades cannot be seen from approximately April 24 to June 9 (Randall 1982, 42). Corpus Christi, then, which falls between May 20 and June 23, coincides perfectly with momentous celestial events (the reappearance of the Pleiades and the June solstice) as well as with crucial terrestrial activities (harvest).

Not only was the harvest festival more pan-Andean in appeal than the festival of the December solstice, but Andean climatic conditions favored May-June festivities: the rainy season in the Andean highlands lasts from December to March (Zuidema 1992, 299). In terms of the agricultural cycle, May-June is also favored over December. The May-June festival was held between the harvest and the start of irrigation (Molina "El Almagrista" [1553] 1943, 28), which seems to have been a time of relaxation with respect to Andean agricultural production. According to Arriaga ([1621] 1968, 147), natives of some areas in the archbishopric of Lima "ventured out" to Christian towns, especially at the time of the festival of Corpus Christi, in order to obtain goods that could not be found locally. Thus, while December is typically character-

ized by inclement weather and is a time of labor for agriculturists, the month preceding the June solstice was a time of pan-Andean recuperation and relaxation.

Replacing Raymis

As discussed above, the temporal coincidence of Corpus Christi and Andean harvest festivals afforded Spaniards with an opportunity to redirect "misguided" Andean religiosity. The substitution of Christian emblems and practices for those of the native religion during Corpus Christi was put into practice early in the colonial period. Garcilaso de la Vega ([1609, 1617] 1966, 1:245), the son of a prominent Spaniard and an Inka noblewoman, writing about his childhood in Cuzco, details the training of youths for the festival of Corpus Christi in the mid-sixteenth century. He relates how the choirmaster of the cathedral in Cuzco composed a version of an Inka *haylli* (victory song) to be sung in honor of Corpus Christi by eight *mestizo* schoolboys who appeared dressed in Inkaic costume, each carrying a *chakitaklla* (the indigenous foot plow).[27] In pre-Hispanic times, an *haylli* was considered appropriate for celebrating military victory or agricultural success (the victory over nature).[28] The choirmaster of Cuzco had thus co-opted a portion of the native harvest ceremony (which Garcilaso mistakenly calls Inti Raymi); refocusing the victory song away from the sun and onto the Christian God, he had Christianized *mestizo* youth, with their plows, replace "pagan" Inka (adult) nobles who in pre-Hispanic times participated in an agricultural ceremony during the harvest festival.[29] The triumphal nature of the Inka *haylli* meshed well with the triumphal nature of Corpus Christi. The conversion of an Inka *haylli* performed by youth in the costume of agricultural laborers was a purposeful manipulation of Andean-harvest festive practices; Garcilaso specifically states that Spanish witnesses to this reinvestment of native practices with Christian meaning were "very pleased." He also says that Spaniards encouraged Andeans to don native regalia during Corpus Christi celebrations and states that the *caciques* (native leaders) from around Cuzco were to wear

all the decorations, ornaments and devices that they used in the time of the Inca kings for their great festivals. . . . Some came dressed in lion skins [puma skins], as Hercules is depicted, with their heads in the lion's

head, since they claim descent from this animal. Others had the wings of a very large bird called cuntur [condor] fixed on their shoulders, as angel's wings are in pictures. Similarly others came with painted devices, such as springs, rivers, lakes, mountains, heaths, and caves, from which they believed that their earliest forefathers had emerged. Others had strange devices and dresses of gold and silver foil, or carried wreaths of gold or silver, or appeared as monsters with horrifying masks, bearing in their hands the pelts of various animals they pretended to have caught, [. . .] With these things . . . the Indians used to celebrate their royal festivities; and in the same way in my time, with such additions as they were capable of, they used to mark the feast of the Blessed Sacrament, the true God, our Lord and Redeemer. This they did with great joy, like people now truly disillusioned about their former heathendom. (Garcilaso de la Vega [1609, 1617] 1966, 2:1415–1416)

Significantly, this description of indigenous costume displayed during Cuzco's Corpus Christi is almost identical to the same author's description of the Inka festival of Inti Raymi found in part one of his *Royal Commentaries* (Garcilaso de la Vega [1609, 1617] 1966, 1:356–357); the significance of his analogy will be discussed in Chapter 9 below. For now, suffice it to say that, according to Garcilaso, Corpus Christi contained many of the same practices as Inti Raymi. In Garcilaso's mind, memories of the Corpus Christi celebrations of his youth made him a vicarious witness to pre-Hispanic festivities (what matters here is not the accuracy of Garcilaso's report, but that he believed it to be true). At Corpus Christi, Garcilaso further relates, Andeans in Cuzco sang native songs accompanied by flutes, drums, and tambourines, but those songs were in praise of "Our Lord God." Corpus Christi, in the manner that it was celebrated in Cuzco (i.e., with costumed natives performing pre-Hispanic songs and dances), evidenced successful evangelization.

As Gisbert (1983) shows, the masquerades and dances in viceregal Peruvian festivals frequently featured native Andeans and Andean themes. Once the space for worship and the focus of worship were Christianized, Spaniards recognized certain indigenous reverential practices as conducive to Christian worship; the selective nature of the substitution will be discussed in the next chapter. Enacted alterity evinced successful evangelization, but also performed subordination.

The full range of Andean performative culture has been lost to us. However, we do have records of some of their performances, espe-

cially those which delighted colonists. From eyewitness accounts we gain some sense of what the colonists found most compelling in native presentations. They consistently comment on native costume (often described as *curioso*, meaning "strange" or "intriguing") and on novel, ingenious displays and performances. They also express delight in the simple fact that natives are celebrating, expressing joy and gladness. In their reception of indigenous celebratory practices we can identify their recognition of similitude between contrasting parties: the colonizer delighted in seeing the colonized celebrating imported festivals. The effects of cultural hegemony, as developed by Gramsci (1973), and of outright coercion are willfully ignored. For a time, despite the *curiosidad* of native appearance and behavior, the *reason* for their activities was thought to be understood. It is also clear that native joy was read as compliance. This will be queried in later chapters, but for now we shall focus on those aspects of native performance on which the colonists commented.

Elsewhere I have studied the battles that Andeans choreographed for festive performances (Dean n.d. b). I argue that these battles, which implicitly contained the threat of native militarism, were nearly always mitigated by demonstrations of subjugation to Spanish authorities. For example, in the 1610 celebrations held in Cuzco in honor of Saint Ignatius several acts of submission were made to the city's *corregidor* (Romero 1940, 16–18).[30] This celebration was held in early May and thus preceded Corpus Christi; it is likely that many of the dances were performed for Corpus Christi as well (Zuidema 1991, 821). In one instance a squadron of natives identified only as "Indian officials called yanaconas" (*los officiales indios que llaman yanaconas*) staged a military exercise under the royal standard of Spain. The author noted that the audience was extremely pleased by this professional display in service of the Spanish king.[31] A second choreographed skirmish occurred between ethnic Cañaris and Canas who reenacted a battle wherein the Cañaris, fighting for the Inkas, put down a Cana rebellion.[32] This choreographed battle ended with the capture of the Canas, who were then presented as prisoners to the *corregidor*; through this substitution of Spanish magistrate for Inka potentate, both the vanquished and the victors were understood to be loyal Spanish subjects. Thus could Spaniards understand these and other native militaristic performances not only as expressions of Andean joy and goodwill, but also of compliance and subjugation.

During these same celebrations, the presentation that "gave the most pleasure to the Spaniards" (*que dió mas gusto a los españoles*) (Romero 1940, 17), and that Cobo ([1653] 1979, 101) describes as a "great and splendid display," was a procession of Inka nobles who impersonated eleven Inka emperors from the first Sapa Inka (Manko Qhápaq) to Wayna Qhápaq, the last pre-Hispanic ruler. The impersonators were the descendants of the pre-Hispanic rulers whose identities they assumed. Each was accompanied by his kinsmen and displayed emblems that commemorated the victories and conquests of his famous ancestor. They were escorted by "the infantry," which were estimated to have numbered more than a thousand (Romero 1940, 17; Cobo [1653] 1979, 101). As each litter passed before the *corregidor* it was lowered in order to demonstrate respect. A second act of submission to the Spanish authorities was made after the parade when, following a reenactment of a famous Inka battle, the "defeated" were taken prisoner to the *corregidor* at the conclusion of mock combat.

Thomas Cummins (1991, 222–223), in his analysis of colonial-period processions of Inka emperor impersonators argues that they "instilled a sense of resignation in the face of an irretrievable past." It should also be noted that such presentations allowed Spain to vicariously subjugate Inka rulers prior to contact and so colonize Inka history. Cummins points out that these presentations usually featured members of the traditional dynasty from Manko Qhápaq (the founder) through Wayna Qhápaq (the last pre-Hispanic ruler), or one of his two sons (Wáskar or Atawalpa), ignoring the Inkas of Vilcabamba who maintained their independence from Spain until 1572. In the 1610 cortege, for example, Wayna Qhápaq was featured as the "last" Inka ruler.[33]

Cummins (1991, 223) also notes that the processions of Inka "kings" were often followed by representations of the Spanish monarchs, beginning with Charles V, who replaced the Inka emperor as ruler of the Andes. In Lima in 1724 the new king, Luis I, was impersonated by a "handsome youth" seated in a throne; he received words of praise and loyalty from each native ruler (in this case, Manko Qhápaq through Wáskar) and was acknowledged as "el gran Ynca"; that is to say, as the new "Inka" monarch himself. In fact, according to the witness Jerónimo Fernández de Castro (in Romero 1936, 84–89), cries of "Viva el gran Ynca Don Luis Primero" filled the air. The Inka emperor was neatly succeeded by the Spanish ruler. These performances anticipated eighteenth-century prints and paintings in which portraits of the Inka

rulers are depicted one after another until the Spanish advent ruptures the line; the images of Sapa Inka are then followed by, or give way to, portraits of Spanish kings starting with Carlos V, the ruler at the time of Pizarro's conquest.[34]

Choreographed battles sometimes alluded to the ultimate authority of the Spanish king as well. As noted above, the natives of Lima staged a battle in honor of the birth of the Spanish prince in 1659. In the words of the eyewitness Josephe de Mugaburu ([1640–1697] 1975, 52):

On Tuesday, the 23rd of the month [of December], the Indians held their *fiesta*, for which they built a fort in the plaza. The Inca king appeared and fought with two other kings until he conquered them and took over the fort. Then the three kings, with dignity, offered the keys to the [Spanish] prince who was portrayed on a float. [The representatives of] all the Indians of this kingdom came out to the plaza, each in his native dress. [. . .] It was a joyful *fiesta* for everyone, and it is said that they [the Indians] were the best of all.

In this performance, natives may have commemorated historic, pre-Hispanic conflicts; however, the allegiance of all Andeans to the Spanish throne was the climax of this festive episode, and the demonstration of subjugation was rendered in conventional European terms (the presentation of keys to a likeness of the prince).

In Cuzco, these types of displays were organized on special celebratory occasions (such as royal births). During the regular liturgical calendar there were two moments when native nobility of Inka ancestry appeared in the costume of pre-Hispanic rulers: Corpus Christi and the feast of Santiago.[35] Both occasions were associated with political and religious triumph. Santiago was the patron saint of Spain whose name was invoked as Spaniards rode into battle. He was said to have appeared in Cuzco to aid the Spaniards when they were besieged by the rebel forces of Manko Inka, just as he had aided the armies of the Spanish king Ramiro I against Muslim opponents at the battle of Clavijo in the year 903. In the Andes, Santiago was transformed from Santiago Matamoros (Saint James, Moor-slayer) to Santiago Mataindios (Saint James, Indian-slayer).[36] While I will argue in later chapters that Inka nobles exercised their own agendas on occasions when they dressed in ancestral costume, the colonialist audience nonetheless interpreted these appearances through a festive tradition that plotted its own su-

periority through a triumphal grid onto which the costumed celebrants were graphed.[37]

The demonstrations of submission made during many native performances as well as the European festive context served to mitigate possible revivals of the Andean past; the exhibition of ethnic and cultural alterity remained subject to the Christian God and Spanish overlords. What was represented by native militaristic performances was a certain kind of disorder: namely, the chaos prior to the arrival of the Spaniards and Christianity. Because this disorder was ultimately brought under control by the end of the festival, the prevailing colonial social and political order was not only restored, but was renewed and strengthened.[38] Thus could Spaniards generally regard Andean displays that included militaristic elements as entertainment. Even the ritual battles of Cajatambo—in which Andeans appearing in costume as Inkas would "battle" a group dressed as Spaniards—could be characterized as being held solely for purposes of entertainment (Duviols 1986, 350). In fact, Carlos Espinosa (1995, 86) is able to read such "dances of Conquest" as "validations of colonial power sanctioned by the colonial state" precisely because they never challenged colonial authority; rather, they acknowledged it and therefore rehearsed the subjugation of Andean peoples.

While Spaniards were aware of Inkaic sun worship and railed, at least rhetorically, against the "covert" celebrations of Inti Raymi during Corpus Christi, they did not discourage the display of solar imagery by indigenous leaders, specifically sun disks on their chests and often on their foreheads. Once it was established that the image of the sun served to refocus reverential attention onto Christian supernaturals (who themselves, albeit for entirely different reasons, sometimes wear solar pectorals in pre- and early modern depictions), these disks were understood as symbols of the affiliation of the postconquest Inkas with Christ, the new Inti, who, when in the form of the host, is displayed in his own golden sun disk. The whole notion of solar worship was refashioned in order to underscore the triumph of Christ over Inti, and of Corpus Christi over Inti Raymi as well.

The entire community turned out for Corpus Christi—either as respectful audience or compliant performer. In the cortege, processional order was crucial. It was understood as a function of the participants' rank in society. In the Corpus Christi procession, proximity to the host was a sign of the participant's relative importance in the community. In early modern Spain, Corpus Christi processions usually began with groups of entertainers (musicians, dancers, masqueraders, etc.), followed by guilds and confraternities, parishes (according to relative antiquity, with the last founded going first and the first founded going last), religious groups and personages (again according to relative antiquity), and then the highest religious personnel escorting the consecrated host; joining and following these high ecclesiastics were civic leaders.[39] Although this standardized order would seemingly preclude dispute among processional participants, in practice the order within celebrant groups occasioned considerable conflict, and status was continually negotiated between peers.[40] Remarking on Corpus Christi in Bolivia, Abercrombie (1990, 113) observes:

In Corpus Christi, the body politic paraded in its aggregate parts, divided neatly into its component guilds (brotherhoods of Spaniards and craftsmen) and *naciones* (urban *ayllus*). These marched in hierarchical order . . . behind the host, ensconced in its solar-disk monstrance, in an allegory of submission to God and divinely appointed king. [S]uch rituals also included dramatic presentations weaving sacramental plays (like Saint Michael's conquest of Satan and the seven deadly sins) into allegories of divine conquest (like the battle of Moors and Christians), just as in the processions of Spain at the time. Such scenes in the New World differed from those of the Old in their insistence on redoubling the hierarchy of estates and offices with that of native nations. Ambiguities in the determination of nationhood, inherent in the colonial situation itself, were to produce the most disfiguring blemishes on this body politic.

Eerily, Abercrombie's final metaphor—the disfiguring blemish on the body politic—echoes the imagery of Sister Juliana's dream in which the absence of a feast to celebrate the Corpus Christi was metaphorized as an ugly scar disfiguring the moon and symbolizing the incomplete liturgical calendar. Not to celebrate was a fault, but the manner of celebration—the marking of status and codification of subjugation—

pitted peers against one another in often destructive rivalry. Doubts about social stability could not help but surface in the festival. By honoring the Body of Christ, any faults in the body politic were invariably magnified.

In colonial Cuzco, the uneasy blend of acculturation and cultural difference was held up to yearly examination. Acculturated Inka nobles donned signs of their indigeneity while Andean songs and dances were performed. Perversely, then, because Corpus Christi highlighted difference, it exposed the rifts inherent in colonial society. The triumph of Corpus Christi was unsettled by its own semiophagous urge: Andean culture may have been ingested, but it was not necessarily digested.

Chapter 3

An Ambivalent Triumph

Andean subalterns escorting the Corpus Christi prompted contradictory responses from Hispanic authorities who witnessed natives insinuated into Spanish festive structures. The cultural and ethnic difference of Indian celebrants was emphasized through costume and performance, primarily songs and dances. Colonial authorities attempted to control and even legislated the manner of native participation in the festive life of Peru, establishing dancing and other choreographed performances as the appropriate means of expressing "joy." [1] The harvest songs sung by costumed *mestizo* youth, described by Garcilaso and discussed in Chapter 2 above, indicate how church authorities encouraged certain references to pre-Hispanic feasts. Viceroy Toledo ([1572–1573] 1926, 201–202), in his ordinances of 1573 (the fifth ordinance of título 27), specified that each parish in Cuzco would present two or three dances during the Corpus Christi festival. Hence, not only was native participation orchestrated by Spanish authorities, but songs and dances were selected as the appropriate native element.

These exotic displays, as exhibitions of difference, affirmed the success of the conquest and conversion of the Andean region, for they demonstrated the universality of the Christian triumph. The "curious" costumes so frequently noted by Spanish witnesses met the ethnocentric expectations of these same observers—to see ethnic and cultural alterity subject to the Christian God. In Spanish eyes the contribution of native dances filled a small but important—and traditional—role in the Corpus Christi format. Yet, because Andean dances and dancers were

necessarily different, misunderstanding and incomprehension blurred colonialist reception. The menacing shadow of doubt about exactly what Andeans were or might be celebrating dogged colonial authorities. As seen in the previous chapter, the colonizers expressed pleasure at this "proof" of religious conversion. Simultaneously, however, their words betray discomfort at the ways in which Andean alterity transformed the familiar—the Spanish Corpus Christi—into something that was somehow alien. Hispanics necessarily experienced the colonizer's quandary: the paradoxical need to enculturate the colonized and encourage mimesis while, at the same time, upholding and maintaining the difference that legitimizes colonization.[2]

Commentary on the subject of native dance rebounds from delight to dark suspicion. I shall argue here that the practice of substitution employed so readily in the sixteenth century encouraged—if not compelled—the colonizer to "see" Inka raymis in Corpus Christi. Thus, early evangelical and enculturative practices prompted the extirpatory activity that characterizes the first half of the seventeenth century in the viceroyalty of Peru and set the table at which colonialist insecurities would later dine. By the second half of seventeenth century, extirpatory rhetoric had hushed somewhat and native dancing and costumed performances had become, temporarily, an accepted aspect of Cuzco's Corpus Christi celebration; the potential for chaos was attributed to overindulgence in alcohol.[3] Colonial authorities averred that the inclination toward irrationality in natives, like women and children, justified close supervision. Such views of Andean performative culture established the colonizers as inherently and naturally superior, properly and necessarily in control. And yet, of course, the things they could never control—especially hearts and minds—would continue to provoke anxious moments, impotent gestures, and, finally, after an eighteenth-century uprising, desperate measures.

Imagined Raymis

Closer examination of those specific practices which were said to evince the presence of Inti Raymi in Cuzco's Corpus Christi reveals that, in fact, no set of rites solely identified with Inti Raymi—or any other particular pre-Hispanic festival—was displayed by indigenous Cuzqueños (at least in the public celebration). According to the chroniclers, it was

in the generic forms of native songs, dances, and festive regalia that Inti Raymi, or other *raymis*, was evoked.

As a distinct series of rites, Inti Raymi and other pre-Hispanic festivals did not endure in postconquest Cuzco long after the Inka religious and state apparatus disintegrated and Christian evangelization began. Chroniclers who discuss the pre-Hispanic rites of Andean fall (April–June) festivals emphasize, more than any other aspect, the great sacrifices made at that time; numerous chroniclers underscore the central act of human sacrifice.[4] These sacrifices were known as *qhápaq ucha* (also *capac hucha* or *capacocha*) and were not exclusively a part of Inti Raymi or any other particular festival, but were performed as part of many regular pre-Hispanic Andean festivals as well as on special occasions when sacrifice was needed (e.g., natural disasters or the succession of a new ruler).[5] Some chroniclers may be discussing *qhápaq ucha* when they use the term Itu (or Ytu) (see Fiedler 1985, 270). Murúa ([1600–1611] 1986, 453), for example, describes Itu as having no specific designated performance time and states that it could be done at any time of extreme necessity ("la cual no tenía tiempo señalado, sino que a grandísima necesidad se hacía para celebrarla"). Itu actually refers to a royal feast held at the beginning of November that always featured *qhápaq ucha* sacrifice; thus the festival (Itu) and the rite featured in that festival (*qhápaq ucha*) may have become so closely identified as to confuse informants, chroniclers, and modern scholars.

As Zuidema (1989) explicates, Itu, the November festival, was the spring complement of the fall festival of Inka Raymi or, as he now prefers, "Hatun Cuzqui" (Zuidema, personal communication). Zuidema (1989, 252) understands the festive calendar as follows:

While the Incas organized two feasts in honor of the Sun around the two solstices—the large feast around the December solstice [Qhápaq Raymi] and the small one around the June solstice [Inti Raymi]—they also celebrated two feasts before those events in which the king himself played the central role. These two other feasts [Itu and Inka Raymi/Hatun Cuzqui] may have been intended as an introduction to the solar feasts. The [Itu] feast could also be held irregularly at other times of the year; for instance, when a natural calamity occurred that would affect the health of the king and the kingdom, or when the king planned to go into war.

Guaman Poma ([1615] 1988, 220–221, 232–233), as noted in Chapter 2 above, specifically links child sacrifice to the two solstitial feasts.

According to all chroniclers who discuss qhápaq ucha, the central rite was this major sacrifice, although feasting, drinking, and dancing were companion activities. Because dances associated with the qhápaq ucha sacrifices held during Itu and Inka Raymi were, during the colonial period, performed for Corpus Christi, Zuidema (1993) argues that Corpus Christi in Cuzco actually celebrated the harvest festival of Inka Raymi/Hatun Cuzqui (the precursor to Inti Raymi).

Many, like the chronicler Antonio de la Calancha ([1638] 1974–1981, 851), suspected that Andeans celebrated their "raymis" specifically through the performance of dances.[6] Polo de Ondegardo ([1571] 1916a, 21–22, 25–26), for example, identified the Andean songs and dances performed during Corpus Christi in Cuzco as from Inti Raymi; he later identified them with the Ytu festival as well, which he says was non-calendric. His description of Ytu sounds very much like what other chroniclers identify as qhápaq ucha. Yet if those dances were qhápaq ucha dances or dances performed for both Ytu and Inti Raymi, then they were not exclusive to any particular Andean feast and were certainly not the sine qua non of any specific festival.[7] Because the songs and dances were generic festive behaviors, it may be argued that no particular raymi was actually hidden behind the veil of the colonial celebration of Corpus Christi. Rather, the Andean dances allowed suspicious Hispanic audiences to imagine occult raymis.

If the Andean elements "surfacing" in urban Cuzco were not exclusive to any raymi, why did many viceregal witnesses perceive them as such when they appeared within the context of Corpus Christi? I suggest that the spectral raymis loomed large in Cuzco's Corpus Christi precisely because Corpus Christi beckoned them. Much of the scholarship on Corpus Christi in Cuzco fails to recognize this fact and focuses on its hybrid aspects as occurring in spite of rather than because of Spanish expectations. Because Corpus Christi, as a triumph, required the presentation of a vanquished opposite, the felicitous temporal coincidence of Corpus Christi and Inti Raymi (as well as pan-Andean harvest festivals) provided Christians with that festive opponent. While in Spain Corpus Christi's "opposition" was frequently Spaniards dancing in Turkish or Moorish costume, in the Andes it was accepted practice for native Andeans to sing and dance; they embodied rather than impersonated the alterity they represented. Because their ethnic difference could not be shed with the festive costume, their performances reinforced the colonial social order. What we see in colonial Cuzco's Corpus Christi,

then, is the colonizer's imagined or mythologized *raymi*. Insinuated into the triumphal structure of Corpus Christi, costumed Inka bodies —parading, singing, and dancing—were invested with postconquest meanings. Thus, the participation of Andeans in Cuzco's celebration of the Corpus Christi feast could be perceived by some people as a reiteration of the subjugation of native peoples and, by others, as a sign of duplicitous resistance. For even though public celebrations are most often consecrations of inequality, they also and always contain the threat of disorder (Bakhtin 1968). In fact, festivity is predicated on the possibility of chaos. Thus could Hispanics—alternately and even simultaneously—encourage native dances and fear/suspect them.

Homi Bhabha (1984) has argued that cultural hybridity (such as that expressed by Andeans in Cuzco's Corpus Christi) can be recognized as the true product of colonization, for mimesis always involves a slippage or difference between the mimic and what is mimed. In this difference, Bhabha recognizes menace:

[C]olonial hybridity is not a problem of genealogy or identity between two different cultures which can then be resolved as an issue of cultural relativism. Hybridity is a problematic of colonial representation . . . that reverses the effects of the colonialist disavowal, so that other "denied" knowledges enter upon the dominant discourse and estrange the basis of its authority—its rules of recognition. (Bhabha 1994, 114)

Applying Bhabha's observations to our specific case, we find that Inka bodies did indeed occasionally menace colonial authorities precisely because of their compulsory alterity. Because difference is always accompanied by the possibility of subversion, anxiety was generated and it festered. Out of many anxious festive moments rose ambivalence. Even within the confines of a Christian festival, native dances and regalia became exotic spectacles pregnant with "pagan" possibilities, for Andean religious converts converted Corpus Christi into something quite different. Let us focus for a moment, then, on who was menaced and how they revealed their fears.

Because we have few detailed descriptions of native performances for Corpus Christi, it is useful to refer to the celebrations in honor of Saint Ignatius that were held in Cuzco just before Corpus Christi in May 1610 and that must have employed many of the same festive forms. The indigenous celebrations included several acts of substitution. The parishioners of Santiago, for example, sang a song of pre-Hispanic origin about a bird highly revered by the natives (the *curiquenque*), whose black feathers were compared to the black habits of the Jesuits and whose virtues ("probiedades buenas") were compared to those of Ignatius. Pre-Hispanic songs sung the following day by the parishioners of the Hospital de los Naturales parish were likewise applied to Ignatius; further, these parishioners were met at La Compañía (the Jesuit church) by the confraternity of the Christ child who brought out their statue of Jesus dressed in the costume of Inkaic royalty. On Saturday, the parishioners of San Blas evoked in song a famous battle of Inkaic times comparing Ignatius to a triumphant Andean war commander who was the hero of the battle. Similarly, the parishioners of San Jerónimo sung of the legendary victory of the Inkas over the Chankas, an ancient rival, applying the words of triumph to Ignatius. Of these substitutions, the anonymous reporter says that the twenty-five-day celebration performed by the natives of Cuzco *confirmed* that they were devoted to Father Ignatius (Romero 1940, 20–21). Because the object of veneration was Christian, the commentary makes it apparent, such fairly unadulterated Andean celebratory forms were not considered "idolatrous." [8]

Since indigenous performances frequently ended in demonstrations of subjugation to the Spanish magistrate, as discussed in Chapter 2, Spaniards generally regarded them favorably and interpreted them in accordance with their own celebratory traditions. The Inka emperors embodied by costumed Inka nobility were subjected rulers; they were always already-defeated non-Christians. The costume served as a sign of ethnicity which, given the colonial context, was inherently a sign of subjugation. However, sometimes the "triumph" was less than hoped for. As the sixteenth century came to a close and the influence of the European Counter-Reformation reached the Americas, Spanish clergy became, to their consternation, increasingly aware that indigenous religious content had not been separated successfully from the celebratory

form. Clearly, that which was thought—or hoped—to be absent (viz., Andean religious beliefs) was still casting a perceptible shadow.

Significantly, 1610, the year Cuzco celebrated San Ignacio with native presentations, marks the beginning of intensified extirpatory activity sparked by Francisco de Avila's uncomfortable discovery that Andeans in the archdiocese of Lima were secretly worshiping *wak'as* (sacred places and things) on Corpus Christi. Such suspicions changed the way Hispanics interpreted some substitutional practices. In the supposed absence of Andean deities, evangelizers discovered their own deficiencies: namely, the limitations of their ability to understand and to control the thoughts and faith of the colonized.

We can now recognize that the Spanish position regarding native performances during Cuzco's Corpus Christi was inevitably one of ambivalence, for ambivalence is built into the very structure of the Corpus Christi celebration they brought with them to the colonies. While Spaniards spoke of being wary of "idolatry" practiced under the guise of Corpus Christi, especially in the early decades of the seventeenth century, they also invited indigenous celebratory practices—the performative codes of which they only partially understood—into the festival. This apparently contradictory stance may have been a concession to their inability to monitor, much less eradicate, widespread native celebratory practices. It may also owe something to their remarkable ability to interpret indigenous behavior according to European norms: in other words, they saw in native dances (and other practices) what they expected to see given their own culturally grounded expectations. The Corpus Christi format, which encouraged local celebratory practices as well as non-Christian elements, conditioned the Spanish viewing of native dances and predisposed them to both accept and suspect the dances. Although the native steps may have been performed in pre-Hispanic times, the traditional dances when performed for Corpus Christi were not so much pre-Hispanic as they were *deliberately* colonial.

Sabine MacCormack (1991) has examined the intellectual history of the Spanish debate over the efficacy of the conversion effort in the sixteenth- and seventeenth-century Andes. The matter of substitution was a particular concern, for Spaniards could never be sure that the Christian God was the actual focus of native reverential practices. Many clergy came to suspect the "sincerity" of native conversion. While behavior could be observed, its meaning was opaque. Intentions and beliefs—hearts and minds—were beyond evaluation. In this atmosphere,

native dances were suspect and a debate ensued over their possible deleteriousness. The Augustinian Antonio de la Calancha ([1638] 1974–1981, 851) and the Mercedarian Martín de Murúa ([1600–1611] 1986, 450), both writing in the early seventeenth century, indicate, for example, that the natives continued to celebrate their *raymis* through the performance of dances in Christian contexts. Debates arose over the meaning conveyed by Andean dances. While the discussion never entirely quieted, voices were most clamorous in the latter part of the sixteenth century and the first half of the seventeenth. That is to say, from after the first stage of evangelization to the midcolonial period, by which time native Andeans had mastered many European systems of visual and performative signification (as will be discussed in Chapters 6 and 7).

Including native dances in Christian festivals such as Corpus Christi was an attempt to exercise control over Andean performative culture. A number of interesting studies examine how so-called New World inhabitants were interpreted through extant European mythologies (e.g.: Bucher 1981; Mason 1990; Greenblatt 1991). The European imaginary—a lexicon of mythologized Others—was drawn on to account for the unknown American Other and to make that unknown already familiar.[9] As Derrida (1967, 117–228) observes, "to understand the other by comprehension is to reduce other to self. It is to deprive the other precisely of the very alterity by which the other *is* other." Through interpretation, Europe attempted to deny the newness of America and Native Americans. The effort was futile, however, for alterity, as Bhabha has pointed out, was essential to Europe's colonizing project. Because difference was necessary, menace was inevitable. Ultimately, the colonizer was caught in an uncomfortable paradox of his own making. The Spanish position regarding native performances during Cuzco's Corpus Christi was clearly one of ambivalence. Ambivalence, in fact, was their only possible response; for ambivalence—the sign that their power was not only negotiable but was *being negotiated*—inhered in Corpus Christi.

Encouraging the necessary difference, but hemming in its expression, was a constant concern of colonial authorities. Ecclesiastic and civil authorities alike participated in this paradoxical pursuit. Viceroy Toledo reiterated earlier edicts of the Council of Lima with respect to native dancing in his ordinances for the natives of Charcas in 1575. While acknowledging difficulties, he allowed that native dances were an important element of Andean festivities and therefore suggested

that dances be performed for Christian festivals, but that they be approved by local *corregidores* and priests (Toledo [1575] 1921–1926d, 370). While colonial authorities commonly issued this sort of highly restrictive edict, they were seldom carried out—owing no doubt to the impracticability of the close supervision that would have been required.

That the extirpatory rhetoric impacted very little on actual festivals is reminiscent of the discourse against masked performances and other spectacles in European Christian festivals of the Counter-Reformation and even earlier. While church leaders wrote and spoke against popular Iberian celebratory practices as covers for pagan or idolatrous behavior, the church was unable to eradicate them. One of the most outspoken opponents of "pagan" (i.e., folk) spectacles was the Jesuit Juan de Mariana (1536–1624). In his *Tratado contra los juegos públicos* of 1609 he urged the prohibition of public performances rooted in pre-Christian celebratory practices (Mariana [1609] 1950, 413–462). His efforts resulted in no substantive changes, however. Others joined Mariana in debates about the "cuestión de la licitud de danzas." In seventeenth-century Seville, for example, denunciations of "abuses" (i.e., the revival of pagan and immoral practices) were constant. The carnivalesque, which is always a part of public celebrations, is also always the source of some suspicion on the part of those whose responsibility it is to see that order is maintained (Bakhtin 1968). Although some "extirpators" emphasized the eradication of all signs once associated with pre-Hispanic supernaturals, this was clearly not a practical solution to the evangelists' dilemma. It may not even have been recognized as a serious problem. Patricia Lopes Don (1997, 29), in her study of festivals in colonial Mexico City, has argued that "Spanish ignorance of the pagan origins of Indian festival practices was based not on a lack of information but on a fundamental misapprehension about the nature of those practices. This, in turn, created a delay in the Spaniards' ability to comprehend and articulate the practices in such a way that they would have to act upon them, that is, effectively suppress the idolatry."

While Spanish audiences were prepared to see choreographed performances as celebratory demonstrations for Christian ends, they feared any disorder that threatened to overwhelm their abilities to control it. What they failed to appreciate was how the composite cultures of colonial society are inevitably and necessarily full of menace. The Christian/pagan contrast "mythologized" differences between colonizer and colonized. It allowed native participants to be imagined.

Inka leaders in Cuzco created and performed as their royal ancestors for Corpus Christi and other Christian festivals. Whereas the pre-Hispanic Inka ruler was held to be divine, the performed ruler created for colonial audiences was gradually stripped of divinity. Although early in the century (1610) indigenous members of a Cuzco confraternity had, for a citywide festival, dressed an image of the Christ child as a pre-Hispanic Inka ruler—complete with a royal headdress whose scarlet fringe signified paramount authority (Romero 1923, 449)—by the end of the seventeenth century the identification of the Christian saints and God as "Inka" had been prohibited. Two moments—one of comfort and one of anxiety—reveal the ambiguity inherent in the Spanish position. Whereas the Christ child had been adorned with a royal Inka headdress in the celebrations of 1610, in 1682 Cuzco's bishop caused the headgear and a solar pectoral (a referent to Inti, the sun, and the Inka's patron deity) to be removed from a parochial statue of the child Jesus.[10] These two moments expose the menacing nature of difference. Christianity's monotheistic and exclusionary premises had not been accepted in the Andes, where religious ideas and practices were polytheistic and inclusive. And so, Christ in a royal Inka headdress could prompt the question: Had these converts to Christ actually converted Christ to Inka? The prohibitive gesture made by the bishop is a single but representative effort to control the imagined, invisible, and unprovable: the "race" of God.

Here we might be reminded of a controversy that erupted in March 1997 when an African American actor, Desi Arnaz Giles, was cast as Jesus Christ in a Passion play in Union City, New Jersey. White outrage —including death threats—made national headlines. Many Hispanics of the late seventeenth century, like many Anglos of the late twentieth, fiercely "protected" the ethnicity of the Christian God. In contrast to the God of the pre-extirpation era, the God of the midcolonial Andes wore a European crown and carried a European scepter; the Inka headdress was circumscribed as a marker of ethnic leadership and, under the colonial regime, marked a subjugated, ethnically "other" authority.[11] Inka imperial costume, once understood by Andeans as a universal marker of supremacy and divinity, was gradually converted into a sign of ethnicity. As will be seen in Chapter 6, by the midcolonial period Andeans and Hispanics alike came to understand Inka costume as a

declaration of bloodline and heritage, especially given the transcultural lexicon of heraldry that it deliberately employed.

Interestingly, while authorities stripped Inka regalia from the Christian God, no one seems to have objected to the festive Andeanizing of the Spanish king: calling him El Gran Ynca, as noted in the previous chapter, seems to have delighted Hispanics. Making the Spanish king "Inka" increased his prestige by adding a new dimension to his authority. While ethnic signs empowered the Spanish king, however, they enfeebled the Christian God, whose race and nationality was, and is, at stake in every representation.

After a rebellion from 1780 to 1781, references to the royal Inka past, circumscribed as they were by that time, were recognized as a threat to the colonial order because of the alternative political power they represented. The leader of the uprising was José Gabriel Condorcanqui Túpac Amaru (or Túpac Amaru II), who, as a descendant of Inka royalty, proclaimed legitimate Andean authority. Following his capture and execution, colonial authorities prohibited the wearing of royal Inka headdresses and garments as well as the display of portraits of pre-Hispanic Inka kings. The scarlet fringe that adorned the royal headdress was singled out as being especially problematic, as it was regarded by Andeans as "proof" of royal blood.[12]

Native dancing was also targeted at this time. Andean songs and dances—called takis—had been incorporated purposefully into Christian festivals since the early colonial period. Recall, for example, Garcilaso's account of an Andean haylli (victory and harvest song/dance) being performed for Corpus Christi in the mid-sixteenth century. The intense extirpatory campaigns of the early seventeenth century prompted debates about the inclusion of Andean takis in Christian feasts. Among those favoring the performance of takis within Christian festivals was the native Felipe Guaman Poma de Ayala, a onetime assistant of the extirpator Cristóbal de Albornoz. Guaman Poma ([1615] 1988, 288) argued, in the introduction to his chapter on native festivals, that "the holidays and taki dances of the Inkas and of powerful lords and nobles and common Indians of this realm . . . contain no witchcraft nor idolatry nor enchantment. They are things of fun, festival, and joy."[13] He maintained also that dance was a natural form of worship for which there were biblical precedents. Native nobility, their offspring, and followers, he says, should dance takis and sing hayllis as

PRINCIPALES
LOSHIIOS DELOSPRICIP

les ellos propios ande dançar delante
el sanctici mo sacra mento y se
cante dela uir genmaria y
delante delos sanctos —

7. Felipe Guaman Poma de Ayala, 1613, folio 783,
The Sons of Noble Indians Dancing before the Holy Sacrament
(Guaman Poma [1615] 1988, 730)

well as perform Spanish and African dances before the Eucharist and
saints on festive occasions, for they thereby serve God and obey the
church (ibid., 730–731, 783–784). By dancing they would be imitating
King David, who danced before the sacrament of the old law. Dancing,
argued Guaman Poma, was a proper reverential form when directed

An Ambivalent Triumph 57

toward Christian ends, and Andeans could dance without returning to "their idolatries."

It may be significant, however, that in his illustration for this argument Guaman Poma shows Andeans performing a dance of European origin: two Andeans are dressed and masked as Muslims (Fig. 7). Thus he suggests that the dances do demonstrate the triumph of Christianity over other religions, but he is careful not to implicate Andean religions and thereby raise the specter of covert idolatry. While debates may have raged, few actions were taken to restrict Andean dancing until after the eighteenth-century Túpac Amaru insurrection when, as mentioned above, symbolic form seemed to have real political consequences. At that time, Corpus Christi, because of its incorporation of native celebratory practices, was eyed suspiciously by edgy colonial administrators.[14] David Cahill (1986) has shown how Bourbon authorities, fearing the political potential of indigenous celebratory practices, tried to restrict Andean festive forms during Corpus Christi; the diocese of Cuzco, the former seat of autochthonous authority, was of special concern to them. Diatribes described the dances as threatening because the dancers were half-nude and drunk. Chuncho dances were explicitly named as problematic. (The Chunchos were Amazonian forest dwellers, considered both by Hispanics and by Andean highlanders to be savages.) Although Andeans clearly understood the distinction between highland and Amazonian "indios," Hispanic observers with their racial precepts were not so certain. *Imitating* Indians out of control and *being* Indians out of control seemed a little too alike—and perhaps that was precisely the point. Festive inversion exposed the limits of colonial power that had been too recently threatened.[15]

Drunken Indians

Interestingly, placing the blame on consumption of alcohol seems to have become a way of glossing over the menace and minimizing the threat of dancing Indians.[16] Early on, Hispanics chose to understand (and consequently dismiss) the discontent of the colonized as the irrational misbehavior of drunken Indians. As will be discussed further in Chapter 8, Garcilaso de la Vega ([1609, 1617] 1966, 2:1417–1418) relates how on Corpus Christi, 1555, the Cañari leader Don Francisco Chilche

reenacted his defeat of an Inka champion who was part of Manko's rebellion—an uprising that threatened the Spaniards who were occupying Cuzco in 1536. As part of Chilche's performance, he held aloft a replica of the head of the Inka warrior (whom he had beheaded). Ethnic Inkas who were present for the festivities took offense and a melee ensued. At the prompting of the Inka leaders, the Spaniards queried Chilche about his motives for reenacting his earlier triumph, and he replied: "Is it strange that on *such an occasion as today* [emphasis added] I should take pride in the deed I did in the service of the Christians?" (Garcilaso de la Vega [1609, 1617] 1966, 2:1418). Apparently Chilche well understood the triumphal nature of Corpus Christi and sought to use the celebration as a time to remind others of his own success in service of his Christian lords. While Garcilaso, sympathetic to the Inka position, interpreted Chilche's actions as provocatory, the Hispanic historian of Cuzco Diego de Esquivel y Navia ([c. 1749] 1980, 1:178) blamed inebriation. This may be a case of what James Lockhart (1985, 477) terms *double mistaken identity*, "in which each side of the cultural exchange presumes that a given form or concept is operating in the way familiar within its own tradition and is unaware of or unimpressed by the other side's interpretation."

Like Esquivel, Hispanic authorities commonly attributed violent eruptions on festive occasions to the consumption of alcohol and to Andean traditions that encouraged natives to overindulge during celebrations. Indeed, drinking is linked to dancing in pre-Hispanic celebrations by many chroniclers. Cieza de León ([1553] 1959, 183, 188, 191), in fact, (mistakenly) defines "taquis" as "drinking feasts." In an attempt to restrict this pre-Hispanic practice, a number of edicts were issued by the Spanish colonial authorities to prohibit festive drinking among native Andeans. Viceroy Toledo's edicts outlined above, for example, prohibited those "taquíes" which he linked with "drinking bouts" (*borracheras*) (Toledo [1575] 1921–1926d, 370). Many blamed "indios borrachos" for disrupting native dances that otherwise would have met Christian and state ends (Millones 1995, 11). Guaman Poma de Ayala ([1615] 1988, 288) echoed these concerns by saying of *takis*, "If it were not for drunkenness they would be a thing of beauty" (*Ci no ubiese borrachera, sería cosa linda*).

I do not mean to suggest that intoxication was not a disruptive influence in the celebrations.[17] I propose, however, that frequently drunk-

enness was a symptom of the internal strife that sometimes erupted on festive occasions, not a cause. Hints that this is the case are revealed by the Hispanic reports themselves. For example, Esquivel y Navia ([c. 1749] 1980, 2:183n333E) reports another example of Corpus Christi violence provoked by native dances; and, again, he blames overindulgence in alcohol. He writes:

[On] June 17, 1700, on the day of the Octave of Corpus Christi, in the afternoon at the time of the procession, the Indians of the parishes, *most of them inebriated* [emphasis added], engaged in a skirmish over the splendor of their dancers. . . . A disorderly fight ensued with rocks and slings interrupting the procession. The magistrate [Don Joseph de la Torre Vela] punished their insolence with 200 lashes. Some of them were flogged in public that same afternoon and others were flogged the following day. He also prohibited this type of dance in following years. The next year, 1701, only less boisterous dances were permitted in the festival of Corpus Christi.[18]

Unfortunately Esquivel does not tell us the nature of the dispute beyond that it had to do with parish rivalry as expressed by costumed dancers, nor does he provide the names of the dances or identify the groups performing. Esquivel, who found in alcohol a sufficient explanation, sought no further elucidation. Elsewhere I have argued that the dispute probably had to do with the performance of a battle dance in which a historic feat was re-created; the performers were carrying rocks and slings, which are traditional Andean weapons (Dean n.d. b). Very likely, the disputants disagreed over which (or whose) "history" was to be evoked through dance, just as the Inkas, 150 years earlier, had objected to Chilche's festive reenactment.

Placing the blame on inebriation allowed the colonizers to characterize the disruptive consequences of native performances as essentially irrational; this infantilizing and dismissive gesture legitimized patronizing attitudes as well as circumscriptive actions. Historically in the West, women, children, ethnic groups, and other subalterns have been characterized and consequently dismissed as irrational.[19] While drinking on the part of native Andeans was undoubtedly pervasive, an examination of those instances in which violence erupted indicates that the militaristic dances and choreographed battles often prompted violence not (or not only) because Andean celebrants had been drinking, but because the displays were often vehicles for negotiating the colonial social order within the subjugated indigenous populations. Although

such behavior may have been incomprehensible to colonial authorities, it was not irrational.

Maneuvering on the Margins

Because Andean performances were inscribed in a Spanish festive text, native celebrants were rendered exotic. Although their alterity may ultimately have been Spanish (since it was made "Other" by Hispanic festive structures) and although Andeans were compelled, either consciously or unconsciously, to objectify their own culture through performance, that does not mean Andeans consciously or willingly participated in the spectacle of triumph perceived by the colonizers. In fact, native dances presented Andeans with a festive arena that was often beyond the Hispanic purview because of a lack of understanding on the part of Spaniards. Unless the dances provoked violence — as they sometimes did — Spaniards gave little attention to form or content (costuming seems to have been their primary interest). Thus the dances, whether pre-Hispanic or colonial in origin, represent an authentic Andean contribution to colonial celebrations that was conceptually and culturally outside of the European festival.

As far as can be determined, native groups organized and performed their dances at the prompting of Spanish authorities. The records of the *cabildo* of the Hospital de los Naturales parish in Cuzco, for example, indicate that the organization of dances utilized *ayllu* (lineage) affiliations.[20] Not only did such performances extend certain pre-Hispanic festive traditions into the colonial period, but they also kept alive memories of specific events — and of Inka dominance. Other Andean ethnic groups likewise seized the opportunity provided by public festivities to celebrate their heritage. Accordingly, Andeans pursued their own agendas (individual and corporate) through performance (Dean 1993 and n.d. b).

Corpus Christi in Cuzco came to be an annual forum where various social groups and individuals — Andean, Hispanic, and others — negotiated their public image. Because a variety of political and social tensions charge the public life of any community, instability invariably haunts festivity. While festivals always appear to be planned and organized by those in control, they are occasions for visual and performative negotiation. In Cuzco, Corpus Christi was not only the celebration

of a single triumph—the triumph over heresy—it was also the assertion of multiple, sometimes contradictory triumphs. Although worlds of festive content and meaning are lost owing to the ephemerality of celebrations, we are fortunate to have a visual record, a series of paintings from Cuzco at the time when Corpus Christi reached its zenith. Because this pictorial account affirms the ambivalences we have just observed, it is to that record that we now turn.

Chapter 4

Envisioning Corpus Christi

Corpus Christi in Cuzco reached its colonial-period zenith during the tenure of Bishop Manuel de Mollinedo y Angulo (1673–1699). The Spanish bishop invested considerable time and expense aggrandizing the festival in imitation of those of Madrid, his home before relocating to Peru. Reflecting and advancing his project is a series of paintings from the last quarter of the seventeenth century that purport to document the glory and distinctiveness of Cuzco's Corpus Christi procession.[1] At first glance, these canvases—the rich details of which thickly describe the festive excesses of the city's enthusiastic celebrants—appear to have succeeded. All sectors of Cuzco society seem to be represented and the city appears to outdo itself for the festival. But the paintings tell of much more than just the triumph or failure of Mollinedo. In and through the painted canvas, we see how troubled a triumph can be.

The series of paintings suggests that many colonial social groups— not just the Hispanic colonizers and the Andean colonized—forged identities through the celebration of Corpus Christi. That Corpus Christi in Cuzco was viewed from a variety of perspectives may be obvious. That various individuals and groups have, at various times, attempted to authorize their views through performance is equally clear. By focusing on this series of canvases, we begin to sense how the "triumph over heresy" had been transformed through colonial and Andean performance into multiple, often competing triumphs. In fact, Corpus Christi seems to have prompted annual dialogues about who was actu-

ally "triumphing" in colonial society. Fortunately, this painted record allows us to listen in on a small portion of that debate.

The Corpus Christi Series

The canvases, although painted by at least two anonymous artists, constitute a stylistically coherent festive record. The paintings are sometimes referred to as the Santa Ana series because they were apparently made to adorn the walls of that Cuzqueño parish church. According to an early nineteenth-century parish inventory, there were once eighteen canvases in the series.[2] At present, only sixteen can be identified securely; twelve belong to the Museo Arzobispal del Arte Religioso in Cuzco, Peru, and four are in private collections in Santiago, Chile.[3]

The sixteen paintings vary in size from the smallest at approximately six feet square to the largest at roughly seven by eleven and a half feet. Each depicts an aspect of the Corpus Christi celebration in Cuzco. Eight of the canvases depict the procession of images of saints attended by their devotees, including five of the so-called Indian parishes (parroquias de indios) with standard-bearers dressed in the costume of their royal Inka ancestors. Four canvases feature religious orders: Franciscans, Dominicans, Augustinians, and Mercedarians. Also depicted is the secular clergy, as well as key political and ecclesiastic leaders of Cuzco. The background in many of the canvases is occupied by Cuzqueño elites and members of their households, who watch the passing procession. In the foreground of most of the canvases are members of the middle and lower economic sectors of Cuzco society. Each of the canvases features an array of personages; the least number of people portrayed in any single canvas is around thirty, and the most is above a hundred and fifty.[4]

The canvases purport to show aspects of a single Corpus Christi procession in serial fashion, although, as will be seen later, internal inconsistencies contradict the effort. Each canvas may be identified by its primary subject as follows:

The Last Supper[5] (Fig. 8)
Confraternities of four saints, two Jesuit and two unidentified[6] (Fig. 9)
Confraternities of Saint John the Baptist and Saint Peter[7] (Fig. 10)

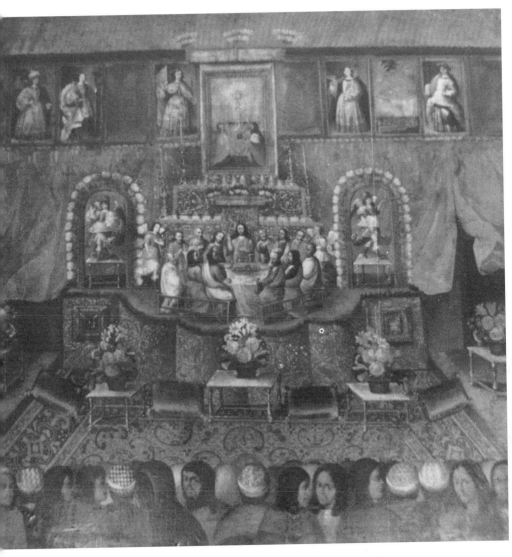

8. Anon., 1674–1680, *The Last Supper*, Corpus Christi series
(Museo del Arzobispo, Cuzco)

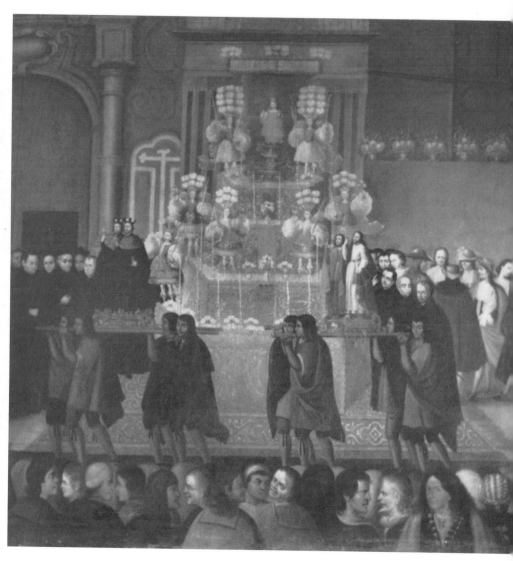

9. Anon., 1674–1680, *Confraternities of Four Saints*, Corpus Christi series
(Museo del Arzobispo, Cuzco)

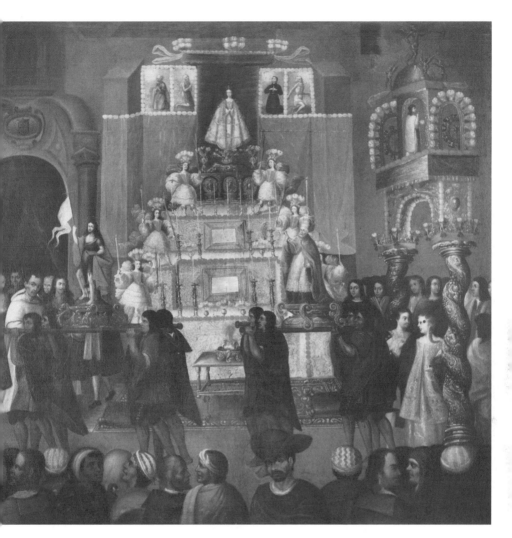

10. Anon., 1674–1680, *Confraternities of Saint John the Baptist and Saint Peter,*
Corpus Christi series (Museo del Arzobispo, Cuzco)

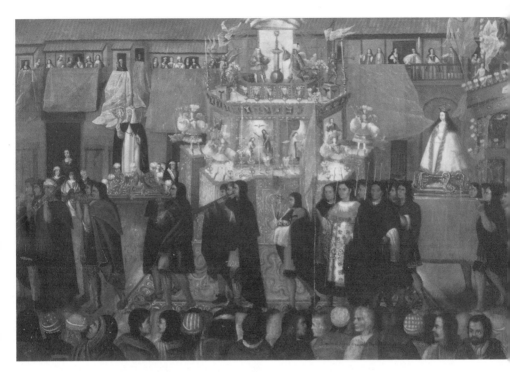

11. Anon., 1674–1680, *Confraternities of Saint Rose and La Linda,*
Corpus Christi series (Museo del Arzobispo, Cuzco)

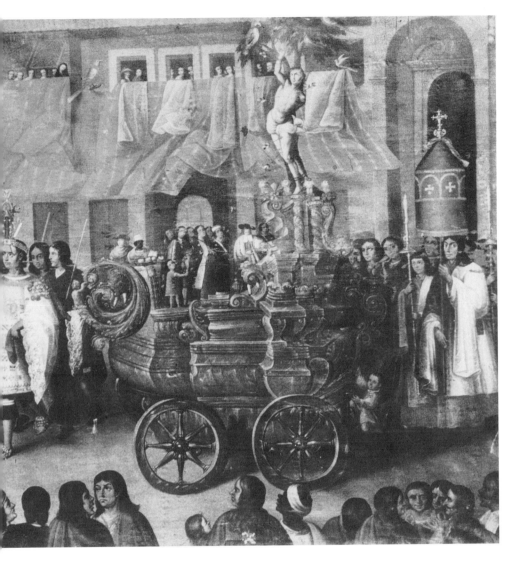

12. Anon., 1674–1680, *San Sebastián Parish*, Corpus Christi series
(Museo del Arzobispo, Cuzco)

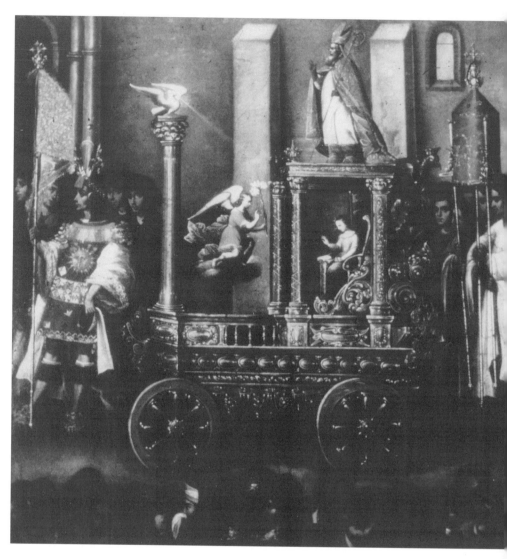

13. Anon., 1674–1680, *San Blas Parish*, Corpus Christi series
(Private collection, Santiago de Chile)

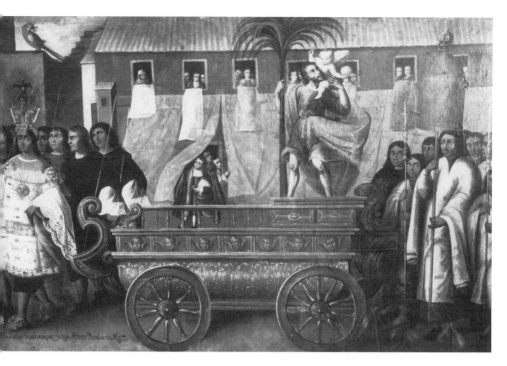

14. San Cristóbal Parish (above). 15. Hospital de los Naturales Parish (below).
Anon., 1674–1680. Corpus Christi series (Museo del Arzobispo, Cuzco).

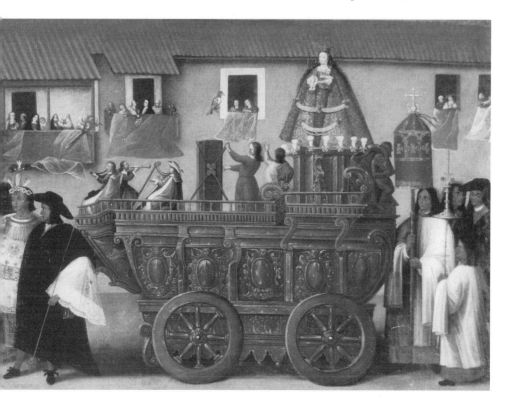

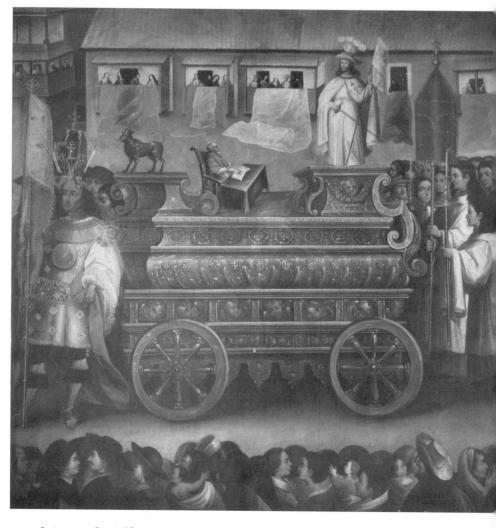

16. Anon., 1674–1680, *Santiago Parish*, Corpus Christi series (Museo del Arzobispo, Cuzco)

17. Anon., 1674–1680, Mercedarian Friars (*opposite above*)
Corpus Christi series (Museo del Arzobispo, Cuzco)

18. Anon., 1674–1680, Augustinian Friars (*opposite below*)
Corpus Christi series (*Private collection, Santiago de Chile*)

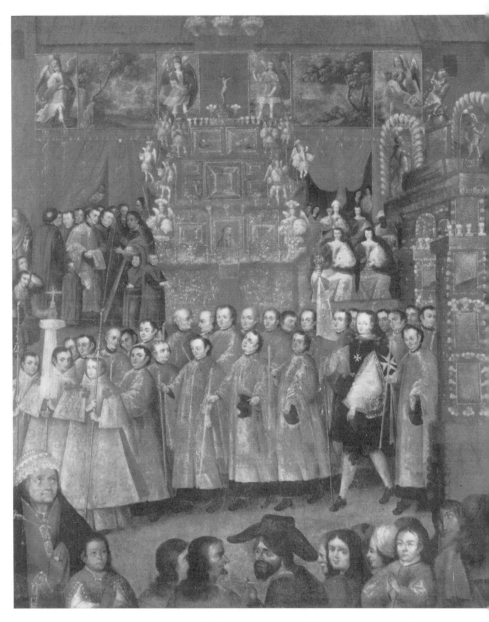

19. Anon., 1674–1680, *Corregidor Pérez*, Corpus Christi series
(Museo del Arzobispo, Cuzco)

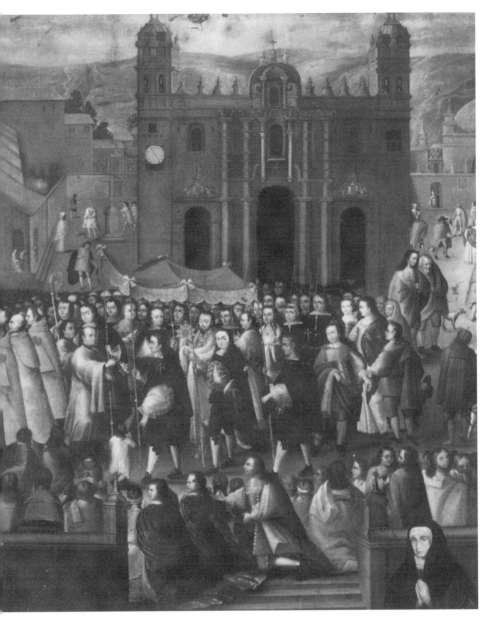

20. Anon., 1674–1680, *Bishop Mollinedo Leaving the Cathedral*,
Corpus Christi series (Museo del Arzobispo, Cuzco)

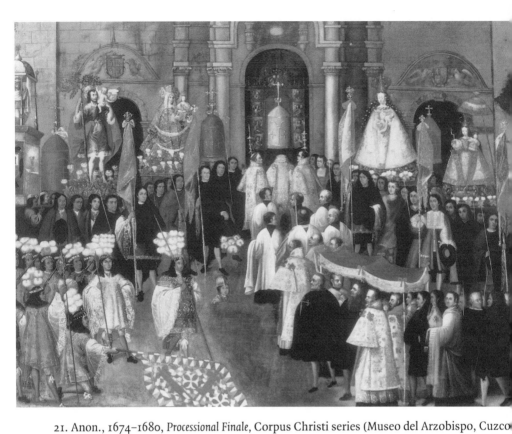

21. Anon., 1674–1680, *Processional Finale*, Corpus Christi series (Museo del Arzobispo, Cuzco)

Confraternities of Saint Rose and "La Linda," a Cuzqueño advocation
 of Mary (Fig. 11)
The parish of San Sebastián (Fig. 12; Plate I)
The parish of San Blas[8] (Fig. 13)
The parish of San Cristóbal (Fig. 14; Plate II)
The parish of the Hospital de los Naturales[9] (Fig. 15)
The parish of Santiago (Fig. 16; Plate III)
The Mercedarian Friars (Fig. 17; Plate IV)
The Augustinian Friars (Fig. 18)
The Franciscan Friars
The Dominican Friars
Corregidor General Don Alonso Pérez de Guzmán, carrying the banner of
 the Holy Sacrament[10] (Fig. 19)
Bishop Mollinedo, leaving the cathedral[11] (Fig. 20)

The processional finale, featuring Bishop Mollinedo, six indigenous parishes with their patronal statues, and the magistrate's Andean guard (Fig. 21; Plate V)

Indications are that the canvases were produced over a number of years. The presence of Bishop Mollinedo in two of the canvases and Corregidor General Pérez in a third helps establish an initial date. Mollinedo was bishop from 1673 to 1699 and Pérez served from 1670 to 1676. It is likely, then, that 1674–1675 marks the beginning of the series.[12] Only those three canvases include patron portraits: *Bishop Mollinedo Leaving the Cathedral* was sponsored by a Hispanic nun;[13] a native Andean man, probably a resident of the parish of Santa Ana, sponsored the canvas of the *Processional Finale* (for further discussion, see Chapter 8); and an elderly native-Andean noblewoman with two native male children appear as the patrons of the *Corregidor Pérez* canvas. It is significant that the only canvases in the series to include patron portraits are those which feature the most powerful individuals in Cuzco—the bishop and the *corregidor*. Their preeminent positions are underscored by the fact that others commissioned the canvases in which they are the central performers. The remaining canvases were likely sponsored by the individuals and groups who are the subjects of those paintings. While most of the subjects cannot be identified by name, two of the canvases do include inscriptions identifying the central personages: both are native Andean nobles.[14]

The diversity of patronage makes it likely that the paintings were done over a number of years; that there is no great stylistic or compositional diversity between these sixteen canvases suggests that the time frame would not have been much more than a decade, though. The series has been variously credited to a number of Cuzqueño painters.[15] There is a tendency to assign anonymous works of the so-called Cuzco School to either Basilio de Santa Cruz Pumacallao (a.k.a. Pumaqallo) or Diego Quispe Tito—the two most famous Cuzqueño painters of the latter half of the seventeenth century—or to their circles of influence. In the past, works considered stylistically and formally "naive" (such as the Corpus Christi series) were traditionally attributed to Quispe Tito, the "Indian" artist, while those more "sophisticated" (i.e., European-looking in the use of perspective and modeling) were assigned to a Basilio de Santa Cruz, who was thought to have been a Spanish friar, trained by European masters and proficient in the baroque style of the

period. The discovery of contracts by Jorge Cornejo Bouroncle (1952, 100–101), however, revealed Basilio de Santa Cruz to have been Basilio de Santa Cruz Pumacallao. The artist's Andean surname forced a revision of stereotypic assumptions about race, art styles, and abilities. It is in more recent scholarship that the influence of Santa Cruz Pumacallao has been recognized in the Corpus Christi series. Certainly the work of both these masters, who were responsible for some of the best-known paintings in Cuzco during this period, was highly influential. In 1962, Gisbert and Mesa noted the influence of Quispe Tito; in 1982, they concluded that the Corpus Christi series was produced by a group of painters working under the direction of a master who was much influenced by both Basilio de Santa Cruz and Diego Quispe Tito.[16] Both Mariátegui (1983, 17, 19) and Jorge Bernales Ballesteros (1987, 332) select Santa Cruz as the primary influence on the Corpus Christi artists.

From the stylistic and formal evidence, we may say that at least two hands contributed to the painting of the series. I have argued elsewhere that the sixteen known canvases can be divided into two groups based on stylistic grounds. The Andean parishes headed by Inka *caciques* (leaders) and the Hispanic nun, patron of *Bishop Mollinedo Leaving the Cathedral*, commissioned their canvases from one individual, while all the other canvases (those of the sodalities and religious orders, *Corregidor Pérez*, the *Processional Finale*, and *The Last Supper*) were produced by a different individual or, more likely, a workshop (Dean 1990, 69–72). The canvases in the first group bear some striking stylistic and formal similarities to works by the painter Juan Zapaca Inga; he must therefore be considered a likely contributor to the series (ibid., 72–77). Whether or not one of the participating artists was the Andean Zapaca, it is highly probable that the artists were indigenous. A conservative estimate, on the basis of extant contracts, identifies more than 75 percent of the artists working in Cuzco during the late seventeenth century as Andean.[17] In a study by Gisbert and Mesa (1971) in which forty-seven painters were documented, thirty-five were Andean, seven were Peruvian-born Spaniards or *mestizos*, four were Spanish-born, and one was from Italy. Undocumented, anonymous artists like those who worked on the Corpus Christi series are more likely to have been indigenous.

It is clear that there was no single patron of the Corpus Christi series; in fact, as argued above, it seems likely that each canvas had a distinct sponsor or group of sponsors.[18] A single individual or group of individuals must have coordinated the commissioning of the particular canvases that make up the series, however. The parish priest of Santa Ana, where these paintings hung, must have been involved. The *cura* was often present at contracts drawn up between patrons (usually *mayordomos* of *cofradías*) and artists for the works (paintings, retablos, statues, etc.) that were intended to enhance his parish church. Dr. Don Diego de Hontón y Olarte was the priest of Santa Ana parish from circa 1663 to 1678, when he was elevated to the position of prebendary in Cuzco's cathedral (Mugaburu and Mugaburu [1640–1697] 1975, 245–246).[19] He was followed by Dr. Don Juan de Herrera y Castro. In a report to the king in 1678, Bishop Mollinedo (in Santisteban Ochoa 1963, 35) writes that in the parish church of Santa Ana "large paintings, with cedar frames that are being gilded, have been made for the entire church" (*Se an hecho para todo el cuerpo de la iglesia pinturas grandes con marcos de cedro que van dorando*). Also in 1678, the *cura* Herrera was commended by Bishop Mollinedo for having decorated the parish church with a series of large canvases in gilded frames. Unfortunately, the theme of these canvases is not identified in either missive (Mollinedo in Santisteban Ochoa 1963, 35; Villanueva Urteaga 1959, 30, 51).

While the *cura* of Santa Ana received official credit for the decoration of his church, the actual orchestration and implementation was probably carried out with the assistance of parish leaders and a *mayordomo*. A contract, dated 1679, for work in Santa Ana is representative. It indicates that the *cura* Herrera was accompanied by four Andeans (Francisco Lucana; Francisco Pizarro, who was "Alcalde Ordinario de los Libres"; Francisco Huarilloclla, the "Alcalde Ordinario"; and Juan Uchucuma, the "Mayordomo de la Fábrica de la Parroquia") when a contract was drawn up for twenty-six statues to decorate the parish church (Cornejo Bouroncle 1960, 81). There was also a single noble Andean in Cuzco, the "Alcalde Mayor de las Ocho Parroquias," who would have been in a position to oversee such a project in conjunction with Santa Ana parish authorities.[20]

Santa Ana parish was the ideal site for the serial envisioning of Corpus Christi. The parish, located on the heights of the hill of Qarmenqa,

was regarded as the entry point to Cuzco, being the first church encountered as one entered Cuzco from the direction of Lima.[21] Cities in the viceroyalty conceptually "faced" the capital: Santa Ana thus became the "head" of Cuzco and its conceptual front door, and it was often referred to as the entrance or beginning of Cuzco. How Cuzco presented itself at that juncture is significant, and one documented advent ceremony is revealing in this regard. In February 1571, Viceroy Francisco de Toledo arrived in Cuzco, and his ingress was recorded by his secretary (Salazar [1596] 1867, 253). The advent ceremony officially began at the arch on the slopes of "Carmenga"; the arch, in ruins for over a century, has been restored recently. Before that point, Andean natives had performed dances and other "invenciones"; but, once Toledo reached the arch, he was delivered over to the Spanish municipal officials. Council members took the traditional loyalty oath at this point, and then escorted the viceroy along decorated streets into the plaza mayor. According to the performative code of the advent ceremony, Santa Ana parish was conceived of as native territory; the place where the road from Lima passed through the liminal arch was the beginning of Spanish Cuzco. Because this parish became the first stop on Cuzco's advent circuit, it was there that the arriving dignitary formed his first impression of Cuzco. It was, in other words, in the face of Santa Ana, made up and turned with a welcoming smile toward visitors, that Cuzco's Andean features were accented. Indigenous dances performed outside the arch metonymically recalled the pagan, preconquest Cuzco that was banished from Spanish Cuzco. Visiting dignitaries were escorted through history as well as space.

Because Corpus Christi, as discussed in previous chapters, was both a performed remembrance of the Inkaic past and concomitantly a triumph of Christianity, the Indian parish of Santa Ana—the primary threshold between the city's Andean outskirts and the Spanish center—was a meaningful place for displaying the triumph of Corpus Christi and all that it entailed. The idea that Corpus Christi replaced Inka raymis resonated in this location where Indian Cuzco was replaced by Spanish Cuzco. The paintings themselves allude to the triumph of Christianity over Inka religion in that the portrayed Indian parishes (Santiago, San Sebastián, San Blas, San Cristóbal, and Hospital de los Naturales) are led by standard-bearers who wear antiquarian costume recalling pre-Hispanic Inka rulers (Figs. 12–16); the standard-bearer of La Linda (the patron of a pseudo-parish of Indians attached to the cathedral) is simi-

larly dressed (Fig. 11). Parish council records from the Book of the Cabildo of Hospital de los Naturales parish indicate that it was the privilege of the *cacique principal*, or parish leader, to hoist the saint's banner in the annual procession of Corpus Christi (ACC, Parroquia San Pedro, Libro de Cabildo y Ayuntamiento del Hospital de los Naturales, 1602–1627, 30r). These costumed Christian Inka authorities thus embody the conversion of their ancestors (see Chapters 5 through 7 below); their painted evocations echo the city's performative conversion, which would take place just outside parish walls as the newly arriving passed under the arch, moving from Indian Cuzco to Spanish Cuzco.

The canvases of the Corpus Christi series allowed various individuals and groups to create and advance their own visions of themselves and their roles in the festive life of Cuzco. Having their public personae commemorated on the walls of the Santa Ana parish church allowed the subjects and sponsors of the canvases to introduce themselves to any dignitary stopping there for his official welcome to the city of Cuzco. Commissioning canvases to decorate public structures, especially churches, was a standard means of demonstrating religious devotion and was an action that was regarded favorably by community leaders, in particular by Cuzco's powerful bishop. Mollinedo, Cuzco's most renowned patron of the arts, launched an aesthetic campaign to refurbish and decorate churches in his diocese. The Corpus Christi series certainly responds to his aggressive patronage. Additionally, Mollinedo, as Christ's escort, is the central actor in the seriated procession, as he is the only individual to be portrayed twice. The series appeals to him in other ways as well. Because the interests and activities of Cuzco's fourteenth bishop are so intertwined with the series of canvases, a closer look at Mollinedo is required.

Mollinedo's Triumph

Bishop Mollinedo, born in Madrid to a wealthy and noble family, had been a prominent priest in that city before coming to the Americas. Significantly, Corpus Christi was at its zenith in Madrid in the seventeenth and eighteenth centuries (Azorin García 1984, 145); records from 1632 characterize it as Madrid's major festival (Gascón de Gotor 1916, 32). Mollinedo served as the priest of Nuestra Señora de la Almudena, also known as Santa María Mayor, the church from which the Corpus

Christi procession exited in order to make its circuit of Madrid (ibid., 17).²² That Mollinedo maintained a special interest in the celebration of the Holy Sacrament is suggested by an inscription on a posthumous portrait of the bishop painted in 1699 for the Hospital de los Naturales parish (now known as San Pedro) in Cuzco.²³ That inscription, which provides an account of the bishop's life and deeds, culminates by saying that he was an untiring promoter of the divine cult in honor of which he donated "many riches" to the churches of his bishopric. Also, he insisted that each parish have a sodality (cofradía) devoted to the Santíssimo Sacramento (i.e., the Eucharist).²⁴ Another example of Mollinedo's devotion to the Blessed Sacrament was his lengthening of the ceremonial circuit of the Corpus Christi procession in Cuzco. Prior to his time the procession had toured only the central plaza (the plaza de armas); he expanded it to cover the adjoining plaza del regocijo as well. The choice of Corpus Christi as the subject for the series of canvases in the Santa Ana parish church certainly reflects the bishop's particular interests. He may even have suggested as much to Santa Ana's cura.

Interestingly, in a painting in the church of Huanoquite in the department of Cuzco, Mollinedo is featured riding in a horse-drawn cart with the monstrance being escorted by King Carlos II (Gisbert and Mesa 1982, 2:figs. 134, 482, 496). Recall that the Corpus Christi procession in Madrid embarked from the church where Mollinedo served: this scene may refer specifically to Corpus Christi festivals of Madrid in which both the king and Mollinedo would have been present. It may also refer to a popular legend that maintained that the Spanish king had ceded his carriage to a priest whom he encountered walking (Wuffarden 1996, 80). The painting is clearly more projection than recollection in that both Mollinedo and King Carlos II are considerably older than they would have been at the time the bishop of Cuzco was actually in Madrid.

Although the pictorial king is centered in the Huanoquite painting, Mollinedo (as the host's escort) is positioned higher. The delicate balance of power between civil and religious authorities that is achieved in this canvas frequently failed in Cuzco, however. Mollinedo was almost habitually at odds with the magistrates of Cuzco. He and Corregidor Pedro Balbín (1682–1690) were particularly notorious adversaries; in one infamous Corpus Christi procession students at Cuzco's San Antonio Abad, "in order to please" Bishop Mollinedo, attached an animal tail to Balbín's cape which wagged behind him as he paraded with the Corpus standard (Esquivel y Navia [c. 1749] 1980,

1:175–176n312E).[25] Mollinedo not only prevented the students from being punished but later rewarded the ringleader of the prank (the vice-rector of the college, Don Cristóbal de Traslaviña) (Villanueva Urteaga 1986, 56).[26] It is no wonder that Viceroy Duque de la Palata (1681–1689) reported to the king that if Cuzco's *corregidor* were friendly with the bishop, Mollinedo ruled the city; if not, the city was divided into two opposing camps (Gibbs 1979, 208).[27] It may thus be significant that while Mollinedo could image/imagine himself sharing the Corpus Christi stage with the (absent) king, he would not share the canvases depicting himself in the local Corpus Christi festival with the city's *corregidor*, the (present) representative of the king.

In certain respects, then, Corpus Christi, which united the bishop and the Body of Christ, is about Mollinedo's triumph. Triumph was a notion with which Mollinedo was notably concerned. In addition to his advocacy of Corpus Christi, Mollinedo was especially associated with the popularity of the "Triumph" theme in paintings.[28] He was no doubt aware that the triumphal aspects of Corpus Christi could be conveyed not only through festive exercises, but through imagery that rendered the ephemeral celebration permanent. In one painting that dates to the period, the Body of Christ, housed in a golden solar-shaped monstrance, is held by a winged pope seated in the rear of a triumphal cart (Fig. 22). Whether he is Pope Urban IV or Clement V (the two popes responsible for instituting the festival of Corpus Christi), this figure certainly symbolizes the Roman Catholic church. Six angels, also in the cart, revere the eucharistic host. In the bow of the cart, holding a banner, is "Doctor Eucharisticus" (Saint Thomas), the individual thought to have scripted the Corpus Christi celebration; he holds an oval shield decorated with a monstrance. The cart is pulled by two armed seraphim and its progress is witnessed by the four evangelists (from left to right: Mark, Matthew, John, and Luke) and, in the foreground, four church fathers. All of these witnesses to the Triumph hold quill pens and books; Saint Matthew, in fact, is in the act of writing. Their pens have apparently come from the host itself as a flurry of quill pens shoot out, along with rays of light, from the solar circle of the monstrance. Crushed beneath the mighty wheels of the cart are five sprawling figures identified as "Jansenus," "Luterus," "Bolseus," "Calvin," and "Arrius"—all individuals who are associated with challenging the doctrine of transubstantiation. They point at their writings on the topic, but their quill pens (black in color) have fallen from their

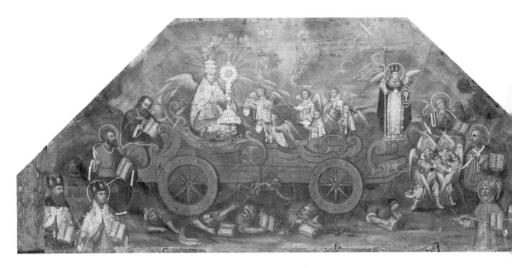

22. Anon., c. 1700, *Triumph of the Church*, Cuzco
(New Orleans Museum of Art)

hands and their inkwells have spilled. That Satan inspired their here-
sies is indicated by a winged demonic figure who, although chained to
the side of the cart, hovers above them and to whom four of the hereti-
cal authors look or point.

The theme of this painting—the Triumph of the Eucharist—strongly
suggests that the triumphal aspects of Corpus Christi were widely ad-
vanced in midcolonial Peru. Although this "triumph over heresy" had
originated with the Council of Trent more than a century before (in
1551), the festival continued to be thought of as such in the Andes
and, with the arrival of Mollinedo, particularly in Cuzco. That the "Tri-
umph" theme emerges in Cuzqueño painting during the tenure of
Bishop Mollinedo testifies to the power this notion had in the southern
Andean highlands. It was not just the eucharistic host that rode picto-
rial carts; Christ (as a person rather than in the form of the host), Mary,
Santiago, and various religious orders also appear in Cuzqueño paint-
ings aboard triumphal carts that crush their enemies.[29]

Because of the triumphal connotations of the processional cart, it
is particularly interesting that carts appear in the five Corpus Christi
paintings sponsored by Indian parishes (Figs. 12–16). *Carros* were not
a feature of Corpus Christi (or any other annually repeated festival) in
colonial Cuzco until 1733, when a *carro* was constructed at the direction
of Cuzco's bishop and *deán* to transport the consecrated host (Santiste-

84 *Inka Bodies and the Body of Christ*

ban Ochoa 1963, 31; Flores Ochoa 1994, 57n6). The statues of patron saints were traditionally elevated on *andas*, the contracts for which do exist.[30] The five *carros* in the Corpus Christi series were copied from a seventeenth-century Spanish festivity book written by Juan Bautista Valda and published in Valencia in 1663.[31] Valda's book documents a Valencian festival in honor of the Virgin of the Immaculate Conception held in 1662; it features thirty-nine prints of *carros* that were sponsored by Valencian guilds and sodalities (Valda 1663).[32] The five parochial canvases thus make a claim not only on the viewers' memory of Corpus Christi celebrations in which Inka *caciques* paraded in antiquarian costume, but also on their imagination—to a conceivable future in which elaborate Spanish *carros* rumble in procession around Cuzco's double-plaza.

How did these fictitious carts find their way into Andean canvases? As Gisbert and Mesa (1985, 243) have proposed, it was most likely Bishop Mollinedo who brought Valda's book to Cuzco when he arrived in 1673. At the time Mollinedo was in Madrid, the festive displays designed by a Valencian architect named José Caudí were well known. Valda not only praised Caudí as the "extremely skillful craftsman" (*distrísimo artífice*) who was responsible for "the most ingenious designs of the [Valencian] festival" (*los más ingeniosos deseños de estas fiestas*), but he also included four engravings by Caudí in his book (Pérez Sánchez 1981a, 1653).[33] In fact, Caudí engraved the image of the *carro* in Valda's book which was copied by the painter of *San Sebastián Parish* (Figs. 12 and 23). In 1673 Caudí was in Valencia, where he designed street decorations for the canonization of Saint Louis Bertrand (of Valencia), but by 1680 he had been summoned to the court of Madrid. There he designed the stage machinery for a play by Pedro Calderón de la Barca, the well-known author of numerous Corpus Christi *autos sacramentales* (ibid., 1654). Caudí's reputation grew in Madrid at least in part through Valda's book, and the book may have been responsible for his summons to court. Since Mollinedo (then a priest in Madrid) moved in courtly circles, it is reasonable to suppose that he came into contact with Valda's book, and possibly even with Caudí, shortly before assuming office in Cuzco in 1673.

While we cannot be certain that Mollinedo furnished Valda's book to parish leaders or the artist specifically to inspire the composition of the parochial canvases, he very likely did encourage the use of the Spanish festivity account as a model for Cuzco's religious festivals in general. Festivals were held to be signs of devotion; the more splendid Cuzco's

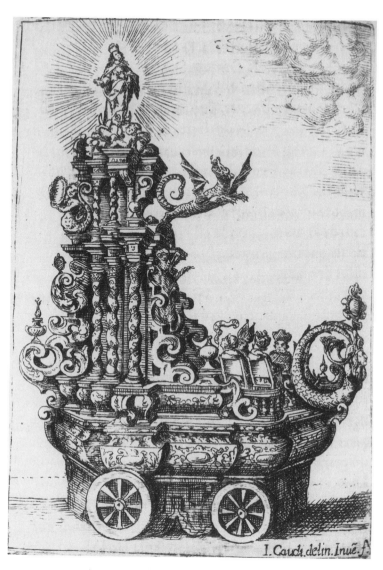

I. Caudi delin. Inue. f.

23. José Caudí, 1663, *Processional Cart of the Tailors' Guild*
(Valda 1663; The Hispanic Society of America)

festivals, the more noticed would be Mollinedo's diocese and Mollinedo himself. The festival so beautifully documented by Valda had garnered considerable praise and renown for Valencia; certainly the bishop would have aspired to similar achievements and hoped for similar repute. Mollinedo arrived in Cuzco to find that it—like Valencia—was famous for its Corpus Christi celebration. Some of the *carros* used on the

occasion of the 1662 Valencian festival and documented by Valda may well have been processional carts that had originally been constructed for Valencia's Corpus Christi celebration, but that had been revamped to honor the Immaculate Conception (Pedraza 1982, 77, 168, 169).[34] That Valencia was renowned for its Corpus Christi festival and that Mollinedo must have desired similar fame, makes the well-illustrated Valencian practices likely prototypes for colonial Cuzco's burgeoning "triumph over heresy."

When Mollinedo left Madrid, processional *carros* were a feature of that city's Corpus Christi celebration.[35] On one level, Mollinedo could well have regarded the appearance of the (fictive) *carros* in the parochial paintings as evidence of his own kind of triumph. In the canvases, we see costumed Inka leaders together with Valencian *carros*. Bearing the saint's standard while wearing (somewhat modified) pre-Christian Inka costume, the Andean *caciques* appear as successfully converted ethnic subalterns. Mollinedo himself played a role in hemming in the symbolism of Inka regalia such as that worn by the Inka *caciques*. He restricted the display of Inka imperial signs, converting them from claims of (pagan) supreme authority to evidence of subjugated ethnicity. The bishop caused signs of native authority to be removed from the statues of Christian saints in Cuzco, thereby denying their assertions of universal supremacy. The paintings even record the completed conversion. In the *Four Saints* canvas there appears an altar dedicated to the Christ child (Fig. 9). It undoubtedly represents the Cofradía del Niño Jesús, an indigenous confraternity located in La Compañía, the Jesuit church. Whereas that same *cofradía* had, in the 1610 celebrations for Saint Ignatius, presented the Christ child complete with a royal Inka diadem, in the painting Jesus clearly wears a European-style crown.

In the canvases of the Andean parishes (Figs. 11–16), the Inkas' imperial patron, the sun, worn pectorally by the costumed *caciques*, dims in contrast to the gilded monstrance held at chest level by Mollinedo in the canvases where he appears (Figs. 20 and 21).[36] Mollinedo's vision of Corpus Christi as a triumph over his Andean charges appears to have been articulated in these canvases. The allusion to Spanish festive practices, in the form of pictorial *carros*, suggests that Inka parish leaders aspired to grander celebratory displays than the ones they had been sponsoring; they appear to have been induced to mimicry. However, in the act of documenting Mollinedo's triumph, its failure was simultaneously assured.

Although Bishop Mollinedo's vision of Corpus Christi asserts itself in this series of canvases, other visions are manifested as well. As the product of numerous patrons, who did not share a single vision, the paintings offered their donors an opportunity to enter into the process of formulating local culture. The series represents several cultural strategies and performs less as a record of a historical condition than as a historical process. The canvases functioned as argumentation, speaking thickly in diverse tongues and sometimes employing contradictory terms (Dean 1990). We have already acknowledged the uneasy relationship between civil and religious authorities which often broke down in festive performance. In light of this discord, it is perhaps not coincidental that a child, pictured in the *Corregidor Pérez* canvas, aims his peashooter off canvas toward what can only be the approaching bishop (Figs. 19 and 24). The child appears near the right edge of this canvas, on the far side of the triumphal arch, where a group of people direct their attention not at the procession in front of them (which features Pérez), but rather to that which follows. All seem to be in the process of kneeling, as they lean forward on bended knees. Because the presence of the host by custom prompted onlookers to kneel, no doubt they have spotted the bishop bearing the monstrance. Additionally, a witness of African descent has doffed his hat—a traditional gesture made at the approach of the Body of Christ itself.[37]

The identification of the paintings as varying visions of the Cuzqueño festival undermines the credibility of any single canvas, or any single vision—even Mollinedo's—and ultimately prompts a reevaluation of how the documentary mode operates in the series as a whole. The canvases themselves argue that they record the festival as it happened, that they are a transparent representation of reality. Not only were well-known citizens of Cuzco—the bishop, the *corregidor*, ecclesiastic and civil council members, and parish leaders—portrayed, but actual edifices are recognizable as well. The cathedral, as it appeared in the late seventeenth century, is seen in two canvases of the series.[38] La Compañía (the Jesuit church) and La Merced (the Mercedarian church) are realistically portrayed as well.[39] Also depicted are the town hall, the arcaded edifices of Cuzco's center, and other recognizable structures such as the house of the chronicler Garcilaso de la Vega and the mansion known as the Palacio del Almirante.[40] In addition to recording

24. Anon., 1674–1680, *Corregidor Pérez*, detail of the *corregidor*,
the temporary triumphal arch, and a child with a peashooter,
Corpus Christi series (Museo del Arzobispo, Cuzco)

recognizable people and places, the canvases emphasize the diversity of an anonymous Cuzqueño society in the last quarter of the seventeenth century. Portrayed are representatives of the three "racial" groups inhabiting seventeenth-century Cuzco: indigenous Andeans, people of European descent, and people of African descent. Ethnic heritage is not always clear-cut, of course, and certainly persons of mixed ethnicity are portrayed. Also shown in these paintings are people of both genders as well as a spectrum of ages and social classes. It is through this complex assemblage of recognizable personages, and a diverse array of anonymous social "types," that the Corpus Christi series assumes the artifice of documentary objectivity, seemingly mirroring a community in all its heterogeneity and complexity.

While scholarly opinion about the series' aesthetic merits varies, the canvases have been unanimously hailed for their documentary value and have been cited frequently as a testimonial to seventeenth-century society in the culturally diverse Andean highlands.[41] Numerous authors of colonial art and history have regarded the series as a window to Cuzco's past rather than a construction of that past. It has been evoked repeatedly as a colorful document of viceregal culture, history, society, and religious practices. Because the construction of the vision has not been critically examined, though, the documentary enterprise floats free from the history it is held to record.

Traceable in the canvases is a debate about the identification of self and one's compatriots in a society where cultural signs could, and did, prove volatile. Identity was always constructed in relation to competing individuals and groups. Within the festive text, a variety of essays were offered. Part of the argument has to do with Cuzco's place in the viceroyalty, a place at odds with that of Lima. While Cuzco held first seat and vote in the viceroyalty and proclaimed itself as "cabeza de los reinos del Perú," the capital and de facto first place went to Los Reyes, or Lima. Cuzco, like all other cities in Peru, looked to Lima in admiration and envy. Pictorial sparring between Lima and Cuzco underlies *Saint Rose and La Linda*. In that canvas Saint Rose, a Limeña saint, appears with La Linda, an advocation of the Virgin Mary who served as patron of Cuzco (Fig. 11).[42] The two patronal images pass before a temporary altar dedicated to the Defense of the Eucharist—a theme that features the Spanish monarch at the time, young Carlos II, with a lion (the symbol of Spain) at his side, fighting off a saber-brandishing Turk and his demonic companion (Fig. 25).[43] Saint Rose and La Linda unite

25. Anon., 1674–1680, *Confraternities of Saint Rose and La Linda*, detail of the temporary processional altar, Corpus Christi series (Museo del Arzobispo, Cuzco)

with the king in his efforts. Thus the city, the viceroyalty, and the kingdom are, in this canvas, triangulated in service to the Corpus Christi. Yet, however united they might be in this canvas, Cuzco is preeminent. Saint Rose precedes La Linda in the procession—which means she is farther removed from the host and, therefore, of less importance. Also, and significantly, La Linda is transported on a pedestal of silver in contrast to the wooden *andas* that bear the Limeña saint. The canvas thus pictorially privileges the local patron and announces that one of the functions of the series is to spotlight the grandeur of Cuzco.

While this single canvas directs attention outward in order to locate Cuzco in relation to colonial governance, most pictorial advocacy takes aim at peer groups and is concerned with local hierarchies. In the paintings, actors are distinguished from audience. The interracial audience of commoners is, in general, placed in the foreground. Their backs to us, they encourage the viewer to recognize her/himself as one of the anonymous crowd viewing the passing spectacle. Like the viewer of the canvas, who is physically divorced from the painted activity, the audience of commoners is inactivated—often by the exclusion of their bodies from the canvas (Cummins 1991, 209). The leaders of Cuzco society, on the other hand, actively participate in the procession; they possess both bodies and faces with which they command attention.

Yet the pictorial actors do not present a unified front. The size and elaborateness of each of the canvases express the amount invested by each of the patrons. The similarity of peer-group representation allows for easy comparison. For example, among the four mendicant groups represented, it is clear that the Augustinian canvas (Fig. 18), by virtue of size and complexity, "outdoes" the Dominicans, Franciscans, and Mercedarians (Fig. 17), in that order. Similar superficial comparisons can be made with respect to the sodalities (all of which appear on *andas* and in pairs) and the parishes (all of which appear with the patron saints on *carros* preceded by parochial *caciques principales*, dressed in modified pre-Hispanic Inka regalia, who carry the patronal standards). By adhering to a template, the outlay of resources is more clearly apparent and invites (if not insists upon) a comparative viewing. Thus the canvases compete like actual participants.

We know that festive appearances referred to ongoing peer rivalries. Guilds competed to see which could construct the most elegant and unique temporary altar or triumphal arch.[44] Those groups which actually appeared in the procession had even more at stake. Competition

between native parishes was perhaps the most intense. The *andas* as well as the statue and its dress represented a significant investment of money and, therefore, of devotion (both to the Christian God and to the city). In the midcolonial period the embroidery on a saint's outfit alone, which was done in gold thread, cost more than 300 pesos.[45] The time and attention paid by the artists of the Corpus Christi series to the garments of the parochial saints and to the matching standards suggest that the audience was not unaware of the value of statuary dress.

In the modern Corpus Christi festival, the annual competition between San Jerónimo and San Sebastián, the two parishes to the south of the urban center, is renowned: the saints "race" from their home churches to the cathedral. The roots of this contemporary competition can be found in the colonial period. At the end of the seventeenth century, the parish *alcalde* and *principales* as well as the *cura* of San Jerónimo contracted with a local sculptor to make both a statue of their parish patron (Saint Jerome) and the *andas* to carry it in procession. The contract, which otherwise has very few details, carefully specifies that the *andas* of Jerome were to be larger than those which elevated Saint Sebastian, patron of the rival parish of San Sebastián.[46]

Perhaps the most powerful advocative statement is made in the final canvas of the series. In showing the processional finale with many of the parishes gathered, the parish of Santa Ana places itself front and center both by locating its patron on the right-hand side of the main altar and by spotlighting the festive participation of the magistrate's guard, who were prominent residents of that parish (Fig. 21; Dean 1993). The *carros* that make the individual parochial canvases appear so grand are, in this final statement, replaced by much more mundane *andas*, and the parish *caciques* do not wear Inka costume. The *andas* of the *Processional Finale* canvas remind audiences of the fictive nature of the painted *carros*. Because this canvas betrays inter-Andean rivalry and counters Inka preeminence, any fuller discussion must be delayed until after the Inka voice is heard (see Chapter 8 below).

Triumph and Failure

The *andas* by which the statues of the parochial patron saints are hoisted in the *Processional Finale* contradict the *carros* in those canvases which represent individual parishes. The final canvas thus exposes a picto-

rial fiction posited as fact by the five parish *caciques* and *principales* who so proudly escort the *carros*. The painted *carros* themselves contradict the documentary function of the Corpus Christi series and subvert the effort to record Mollinedo's accomplishments. The *carros*, as depicted in the parochial canvases, are functional enigmas: most of them are shown with only two wheels, and none is accompanied by any visible means of locomotion.[47] Because the Valencian *carros* are not represented as part of the cortege in Valda's book, an indication of how they were moved in that procession was unwarranted. When the Cuzqueño painter(s) placed the *carros* into their procession, however, those vehicles became curiously static forms interrupting the implied motion of the parade. For the most part, the *carros* appear detached from the painted procession and fit uneasily into the Cuzco context. As I have argued elsewhere, by inserting these enigmatic, nonfunctional curiosities into what purports to be a painted record of Cuzco's Corpus Christi procession, the Andean artists and their Inka patrons have drawn attention to the contrived nature of this pictorial document (Dean 1996a). In fact, the copied *carros* confound the artistic reportage and contradict the documentary mode of the series as a whole. This is surprising, given the degree to which the artists have endeavored to record a specific time and place, as noted above. Ironically, through the act of copying, the Corpus Christi artist departed dramatically from the documentary discourse that governed the writing and illustrating of Valda's book, his source.

Valda's account is an example of European festival reportage, a popular European (and European colonial) literary genre in which celebrations were recorded as their events unfolded, with acute attention to details of the display and the distinguished participants involved.[48] Typically, these texts would be sent to higher authorities, or published, in order to reach an even wider audience. The time and expense invested in an ephemeral event would thus be preserved for posterity and made available for absent superiors to "witness" vicariously.[49] The prints that sometimes accompanied festival descriptions were intended to complement the documentary effort by recording the sights and thereby helping transform the reader into a witness after the event. While such accounts attempt to orchestrate perception, to be sure, their essentially factual nature is critical to the genre. In fact, the most basic tenet of any festival text is that it records an experienced event as it actually happened. These accounts were held to contain eyewitness reports, and

their success depended on their credibility; blatant untruths—either pictorial or textual—would unravel their raison d'être.

With Valda's book in hand, Mollinedo could not have failed to appreciate certain similarities between the Corpus Christi series of paintings and the Valencian record. Surely he regarded the series to be a document of the city's festive efforts, which reflected on his own abilities to mobilize his flock. Both Valda's account and the paintings of Cuzco's Corpus Christi made permanent, through the act of recordation, an ephemeral celebration, preserving selected moments and the activities of certain celebrants. The localizing details of costuming, social types, specific individuals, and permanent and temporary architectural structures included in the paintings ensured that the community groups and civic leaders who sponsored the display were credited.

In general, the documentary mode utilized in festival reportage is a convention that structures reception and functions as a contract between the witness/reporter and his future audiences. In the five parochial canvases of Cuzco's Corpus Christi procession, the painters were forced to break that contract. The fictive carts compromise the essential premise of reportage—viz., that what is recorded is what the reporter witnessed—and call into question the operation of European documentary practices. Through the act of translation, from the pages of Valda to the paintings of Cuzco, authority was lost. The acculturative effect of Valda's book—Mollinedo's triumph—is mitigated by the Andean interpretation of it. By appearing with Valda's *carros*, the Inka *caciques* dismissed the essential premise of festival reportage and asked viewers to accept their vision, created in paint on canvas, in sharp contrast to the lived and remembered event. This action places the *caciques* at the center of festive actualization, a position that will be explored in the next three chapters.

For now, we need only note that according to Andean temporal concepts the future is located "behind" one: a person faces the past with the future at her or his back (Allen 1988, 226). That the fictional *carros* follow *behind* the Inka *caciques* articulates the position of these native leaders as festive actualizers, the ones who may bring the pictorial confection into being. As we shall see in the following chapters, noble Inkas created festive personae which underscored their crucial biculturality, being between the Andean masses and the colonial administrators. The pictorial contradictions we perceive between "real" and "fictive" forms are a product of European conventions governing docu-

mentation; it would appear unwise to impose those conventions on a reading of the Corpus Christi paintings. Clearly the native hand and mind were influenced, but far from controlled, by the acculturative pressures of political domination.

While on one level Andean mimicry of form responds to acculturation, it may also betray a profound difference of perspective between colonizer and colonized. Multiple readings inhere in Corpus Christi's evocation of Christian and non-Christian signs. The paintings of Cuzco's Corpus Christi, undercut by internal inconsistencies, may fail as a coherent document of an event, but they succeed as a document of process. How Andeans used the space of Corpus Christi to create, enhance, and maintain their own social spaces and identities can now be considered.

Chapter 5

Inka Bodies

The Body of Christ, transfigured as the consecrated eucharistic host, was displayed to the public during Cuzco's Corpus Christi procession in a golden monstrance shaped like the sun; the crafted rays of light emanating from the host signified its transcendent power. In two canvases from the Corpus Christi series discussed in the previous chapter, the solar monstrance with its sacred cargo is held by Bishop Manuel de Mollinedo y Angulo (Figs. 20 and 21). In other canvases of the series, the rayed disk of the monstrance is echoed by the solar pectorals resting on the chests of Cuzqueño parish leaders, often called *caciques principales*, who claimed royal Inka heritage (Figs. 11–16). When worn by Inka *caciques* in Corpus Christi and on other festive occasions, the solar disk referred to the patron deity of the Inka empire, Inti, the sun, and to the pre-Christian Andean past. Festooned as revived pre-Christian rulers, the followers of Inti, colonial Inka *caciques* tacitly negotiated their identities with the transubstantiated Body of Christ housed in its solar disk. The host, once consecrated by Catholic authorities, enables Christians to consume the Body of Christ; in this chapter and the two following, we consider the ways in which the so-called pagan Andean past was prepared for colonial consumption by the Inka *caciques principales* of mid-colonial Cuzco.

The sun-shaped monstrance displayed the transfigured Body of Christ triumphant while the Inka costume and regalia transfigured the bodies of colonial Christian Inka elites into Christ's festive opposition. In the colonial period, signs of Inka religion and history were config-

ured as signs of ethnic heritage and, more important, royal descent. Commemorating the past must always include some forgetting. Earlier, we were reminded of what was "forgotten" when colonial Inkas performed as pre-Hispanic Inkas. Specifically, by transfiguring themselves as Inka emperors for Corpus Christi, colonial Inkas abandoned notions of divinity and universal authority, so that what was once sacred and supreme became profane, ethnic, and subjugated. And yet, hemmed in by colonial administrators and only partially controlling the circumstances of their own authority, they were not enfeebled by the necessary alterity of their colonial bodies. Rather, they performed a memory of the past which, as we have seen, menaced their overlords. This could be done because, although the Spanish colonial administrators repeatedly attempted to bring natives under closer Spanish supervision, they had to rely to a great extent on Andean elites to conduct the daily business of colonial rule.

Importantly, through their performances of the pre-Hispanic past, colonial Inkas addressed not only colonial administrators but also peers, rivals, and constituents. With the disintegration of Inka imperial sociopolitical structures, challenges to the authority held by the descendants of the Inka ruling elite grew throughout the colonial period (J. Rowe 1957). The legal standing and official recognition of Andean nobles had not been codified until the 1570s under Viceroy Francisco de Toledo. At that time, the colonial administration determined that native lords (kurakakuna), who were generally referred to, and who referred to themselves, as caciques, would be confirmed as legitimate leaders of their communities on the basis of hereditary rights. They were accorded a number of privileges, the most important of which were exemption from tribute in labor and kind. Despite the legal recognition, the inherited positions of indigenous leaders were never unassailable, and Inka nobility in Cuzco (like other Andean elites elsewhere) had to contend with the breakdown of the traditional means by which they maintained their authority.

Around the middle of the seventeenth century, Inka nobility in Cuzco launched counterstrikes against those who made claims on their special rights and privileges. One of their most visible and public actions was to perform their royal ancestry. Inka caciques in Cuzco embodied pre-Hispanic Inka rulers for Christian celebrations and, in so doing, created and re-created their colonial selves. Manuel Burga (1992, 325–326) suggests that their festive characterizations were fundamental

building blocks in the colonial (re)construction of an "ethnic memory," a term he borrows from Jacques Le Goff (1986) to describe an organized remembering that, because it depends on oral histories, is mostly imagined. Through performed evocations of the past, Inka *caciques* transformed their own bodies into vessels of Andean history. Their incarnations simultaneously embodied the past and compelled Andean history to incorporate them. Thus they alleged a continuity between pre- and postcolonial worlds, between the authority of their imperial ancestors and their own roles in local government. Their performances—and the visual records they made of their displays—worked synchronically across history and against the progressivist stories proffered by the colonizer. The performance of ancestry also worked against rival Andean individuals and groups and became one of the primary mechanisms by which colonial Inka elites asserted and maintained their positions at the top of the subaltern pecking order.

Once Inka elites enacted "royalty," albeit ethnic royalty, they forged a tie with the Spanish Crown. Here, we attend to the beginnings of their enactments, the midcolonial move by Inka elites to claim the past in their own bodies, and consider what that gesture meant to their colonial selves. We shall see how they fashioned a festive characterization of their royal ancestors, which was, despite an anachronistic superficies, well fixed in the matrix of colonial society.

On/in the Fringe

In 1572, Túpaq Amaru, captured ruler of the sovereign and tenacious Vilcabamba Inkas, was paraded through the streets of Cuzco to the central plaza, where he was executed by the order of the Spanish viceroy Toledo. Not forty years later, in 1610, Inka leaders in Cuzco resuscitated the Inka royal lineage in a religious celebration.[1] Significantly, on this occasion Inka nobles impersonated Inka rulers from Manko Qhápaq, the mythical founder of the Inka state, to Wayna Qhápaq, the ruler who died just before the Spanish invasion (Romero 1940, 17; Cobo [1653] 1979, 101). Their enactment elided the existence of Túpaq Amaru and all postconquest rulers. The impersonators of the eleven pre-Hispanic Sapa Inkas were said to have been the descendants of the pre-Hispanic rulers whose identities they assumed. Embodying Wayna Qhápaq for this performance, for example, was Don Alonso Túpaq Atau (a.k.a. Don

Alonso Topaatauchi). Since the presentation implied that the line of Inka emperors ended with Wayna Qhápaq—there being no impersonators of later claimants to the imperial throne—Túpaq Atau, one of the leaders of the Inka elites in Cuzco, was implicitly characterized as the most direct heir.

The 1610 performance was held in May, just before Corpus Christi; it may well have been typical of Corpus Christi celebrations in the early seventeenth century (Zuidema 1991). Certainly by the second half of the seventeenth century, less than one hundred years after the death of young Túpaq Amaru, Inka aristocrats who served parochial posts were parading in the costumes of pre-Hispanic rulers for Corpus Christi. Unlike the performers of 1610, however, these were not impersonators assuming the identities of specific long-deceased rulers, and therefore claiming authority only indirectly, but were appearing as Inka sovereigns themselves. Who were these festive "rulers," and how did they negotiate such a role under colonial domination?

The Spanish colonial government officially recognized those Inka elites who were able to show "proofs" of their legitimate descent from Inka kings. Representing those privileged Inkas in Cuzco was a body of twenty-four electors; two electors were chosen from each of the lineages of the twelve pre-Hispanic rulers.[2] This was an exclusive group, membership in which was inherited.[3] Although the council of twenty-four electors was based on obscure Spanish precedents, this body was the functioning Inka aristocracy in colonial Cuzco. Their foremost annual duty was to nominate one of their number to carry the Spanish royal standard in the city's celebration of Santiago (July 25), the patron saint of Spain. The chosen individual was entitled *alférez real*, "royal standard-bearer," or, more formally, *alférez real de los Yngas nobles de las ocho parroquias de Cusco* ("royal standard bearer of the noble Inka of the eight parishes of Cuzco") to distinguish him from the Hispanic *alférez real*, who likewise hoisted the Spanish standard for Santiago's feast day.[4] In the mid-eighteenth century, the electors were known to colonial administrators in Cuzco as "electors of the royal standard."

In the late seventeenth century, however, the twenty-four were more commonly referred to as "noble Indians of the *maskapaycha*" or "legitimate Inkas of the *maskapaycha*."[5] The *maskapaycha* was the distinctive scarlet-colored fringe that covered the forehead of the Inka head-of-state in the pre-Hispanic and early colonial periods. Most chroniclers agree that this fringe was the foremost symbol of the ruler, and that it

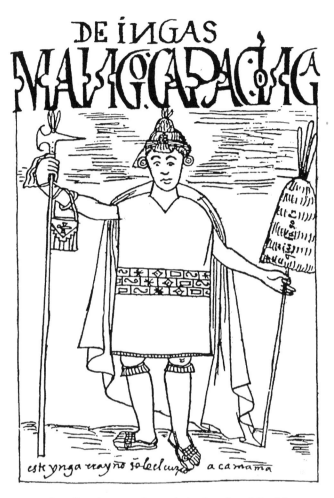

DE ÍNGAS
MANGOCAPACSA

26. Felipe Guaman Poma de Ayala, 1613, folio 86,
Manko Qhápaq, the First Sapa Inka (Guaman Poma
[1615] 1988, 67)

was by donning the *maskapaycha* that the designated heir took posses-
sion of the realm (e.g., Garcilaso de la Vega [1609, 1617] 1966, 1:58;
Cobo [1653] 1979, 244; Murúa [1600–1611] 1986, 350). Wearing the
scarlet fringe converted an Inka of the royal family into the Sapa Inka,
meaning "the unique Inka," a title by which the ruler was known. The
indigenous Andean artist Felipe Guaman Poma de Ayala shows Manko
Qhápaq, the first Sapa Inka, wearing the *maskapaycha* attached to his
headband (Fig. 26).

Wearing the scarlet fringe enabled certain colonial Inkas to personify the imperial past and summon their ancestry on festive occasions (see the *caciques* in Figs. 12–16). The passage of the fringe from the forehead of a single, paramount individual to the foreheads of numerous Inka parochial functionaries took less than a century. After Francisco Pizarro executed the Inka ruler Atawalpa (who had himself just recently assumed the imperial fringe after defeating the designated heir, his half-brother Wáskar), the fringe passed to Túpaq Walpa, who was the eldest surviving son of Wayna Qhápaq. Túpaq Walpa was invested as Sapa Inka in 1533 at Cajamarca, with Pizarro's blessing, but he died at Jauja during the march to Cuzco. His brother Manko (Inti Túpaq Manko Yupanki Inka, a.k.a. Manko II) greeted the Spaniards in Cuzco, assumed the fringe, and was temporarily an ally of the Spaniards. In 1535, however, he rebelled and laid siege to Cuzco; when the siege was broken, he retreated to the northeast, finally establishing an independent Inka state in Vilcabamba. The Spaniards elevated Paullu Túpaq Yupanki, another son of Wayna Qhápaq, as the new puppet ruler of the Inkas, but the identification of Manko as the legitimate Inka ruler and rightful possessor of the fringe never transferred to Paullu (Cobo [1653] 1979, 176–177; Molina "El Almagrista" [1553] 1943, 73).

When Manko was killed by a Spaniard (Gómez Pérez), his son Sayri Túpaq succeeded him as Sapa Inka of the Vilcabamba Inkas. In 1558 Sayri Túpaq left Vilcabamba, capitulated to the viceroy (the Marqués de Cañete, Andrés Hurtado de Mendoza) in Lima, then retired to Cuzco where he and his sister, Kusi Warkay, were baptized (he as Don Diego de Mendoza and she as Doña María Manrique) and, by special dispensation, married. The will of Don Diego Sayri Túpaq, who died shortly after his "retirement," proclaimed his brother Túpaq Amaru (also a son of Manko II) as his successor.[6] In 1571 Viceroy Toledo ordered the capture of the Vilcabamba rebels and Túpaq Amaru was brought in chains to Cuzco, where he was tried and sentenced to death. He died at age twenty-one, leaving no heirs to the imperial fringe (Mogrovejo de la Cerda [1660] 1983, 127).

The line of Sayri Túpaq ended with his daughter Doña Beatriz Clara Qoya who was given in marriage (as a genuine trophy bride) to Don Martín García de Loyola, the captain of Toledo's forces who had taken her uncle Túpaq Amaru prisoner;[7] the couple produced a single daughter. The heirless deaths of Túpaq Amaru and Doña Beatriz left no legitimate claimant to the scarlet fringe.[8] The highest Inka nobility

left in Cuzco were the descendants of Paullu, who had been baptized "Cristóbal" in 1543 and who had remained allied with the Spaniards after Manko initiated his rebellion.[9] Upon Cristóbal Paullu's death at midcentury his eldest son and heir, Don Carlos Inka (a.k.a. Carlos Inka Yupanki), married the Spaniard Doña María Amarilla de Esquivel of Trujillo; their heir was Don Juan Melchor Carlos Inka (Lohmann Villena 1947, 1:199–200). Don Juan Melchor Carlos Inka went to Spain, where he received a pension and was made a Knight of the Order of Santiago in 1606.[10]

With the extermination of the Vilcabamba branch of the royal line in 1572 and the dissipation of Inka rules of succession,[11] "Sapa"— meaning the unique—Inka became a meaningless designation. In fact, by the late eighteenth century, the *maskapaycha* was referred to as "El Orden de Regia Jentílica Estirpe" (Order of the Gentile Royal Lineage) (AGI, Audiencia del Cuzco, leg. 35, esp. 28, 1786).[12] That is to say, the fringe had come to be regarded as the Andean equivalent of a European knightly order.

Fringe Benefits

Despite the dilution of its significance, the *maskapaycha* was clearly meaningful in the efforts of midcolonial Inka nobility to affirm and protect their positions of privilege as descendants of kings. Sporting the *maskapaycha* in public was the consummate performance of royal Inka lineage; when unchallenged, it confirmed not only social status but the exemption from taxes and tribute both in goods and services that was the obligation of most other colonial subjects. Testimony from the second half of the seventeenth century indicates that, by that time, wearing the *maskapaycha* in public on festive occasions (such as Corpus Christi) without challenge *proved* the wearer's legitimate descent from Inka royalty.[13] Thus, by the late seventeenth century, not only was the *maskapaycha* an accepted sign of royal ancestry, but there must have been rules governing who could wear it and somebody (or bodies) who enforced those rules.

A 1655 accord indicates that although Hispanic authorities officially designated legitimate Inka nobility, it was the royal Inkas in Cuzco who themselves staunchly defended their "rights" to the *maskapaycha* and prosecuted those who wore it illegitimately (ADC, Martín López

de Paredes, leg. 138, 1655, fols. 981r–984v). On January 16 the leaders of the Yacanora *ayllu* (lineage) came to a written agreement with those of the Sucso *ayllu*; both *ayllus* pertained to San Sebastián parish. The Sucsos were legitimate descendants of Sapa Inka Viraqocha, having shown proofs and obtained a royal decree recognizing this; the Yacanoras were descendants of Apo Sauaraura, identified as a *capitán general* and a war chief of Viraqocha. Apparently, sometime around the middle of the seventeenth century, the leaders of the Yacanora *ayllu* managed to convince local colonial authorities that they were legitimate Inkas (i.e., descendants of a pre-Hispanic ruler) and were thereby exempted from tax, tribute, and personal service requirements (specifically named were building fences, repairing canals, supplying labor for the construction of the church and other public works). This compelled Don Francisco Suta Yupanqui and other *principales* of the Sucso *ayllu* to obtain a provision denying the exemption from tribute that the Yacanoras had acquired. In order to halt the legal actions taken against them, the Yacanoras acknowledged that they were not legitimate royal Inkas, had no right to wear the *maskapaycha* or carry the royal standard on the feast day of Santiago, and would not be exempt from tax and tribute. Further, if any one of them attempted to don the scarlet fringe or hoist the royal banner, the Yacanoras understood that either or both would be forcibly removed from the offender and that he would be punished "with all just rigor." [14]

That same year (1655) the Sucsos themselves were challenged by members of the other royal Inka houses in Cuzco. Led by the descendents of the Inka ruler Wayna Qhápaq, they accused Don Francisco Suta Yupanqui and his son of trying to obtain for themselves and the Sucso *ayllu* the exclusive rights to hold the office of *alférez real* ("an pretendido obtener en propiedad para ellos y . . . su familia el dho officio de Alferez Real") (ADC, Lorenzo Messa Anduesa, leg. 184, 1655, fols. 2151r–2152v). The plaintiffs make it clear that Inkas from each of the royal lineages have the "right" to serve as *alférez real* and, furthermore, that the lineages are to take turns bearing the royal standard.

The Corpus Christi series of paintings, also from the second half of the seventeenth century, hints that in addition to belonging to a royal Inkaic house, wearers of the *maskapaycha* must have met other qualifications as well. The only Inka standard-bearer who does not wear the scarlet fringe represents the confraternity of the Virgin Mary known as La Linda; the *maskapaycha* is borne on a pillow before him (Fig. 11). He

may have removed his headdress in a special show of respect, particularly since he is depicted passing in front of an image of the crowned Spanish king. Significantly, though, the standard-bearer of La Linda is also the only Inka standard-bearer who does not represent one of Cuzco's parishes. This may well indicate that, according to bloodline, he has the right to wear the royal fringe, but that his position as the head of a cathedral-affiliated confraternity, rather than an independent parish, does not permit him to do so.[15] It is also possible that because (according to the inscription on the canvas) the standard-bearer appears with his still-living father, it is the father alone who has the "right" to wear the *maskapaycha*. Although the son has apparently assumed the duties and responsibilities as head of the cathedral "parish," it is possible that he could not assume the fringe until his father passed away. Without more information, it is only possible to say that the standard-bearer did not feel justified in wearing the *maskapaycha* for this representation.

Colonial-period portraits of Inka women of royal descent, usually called *ñustas* (princesses), likewise depict *maskapaychas* as an indicator of the subject's royal lineage (e.g., Fig. 27; Plate VI); the portrayed *ñustas* never wear the headdress, however. As in the canvases of Corpus Christi, this manner of display suggests that to possess and exhibit the fringe was to claim royal heritage; to put it on was to proclaim "high" political authority (i.e., as high as the Spanish colonial government permitted Andeans in Cuzco to rise).[16] Specifically linking the wearing of the *maskapaycha* to both Inka lineage and political authority is a document in which Hispanic authorities in Cuzco in 1686 consulted the twenty-four electors about whether three plaintiffs, who claimed to be Inka nobles, were entitled to the rights and privileges accorded Inka royalty. In giving their approval, the twenty-four linked the wearing of the *maskapaycha* "without any impediment" to the fact that all three plaintiffs had held important parochial posts.[17] Thus, the scarlet fringe apparently retained, albeit in a vastly diminished fashion, the preconquest symbology of political supremacy possessed by male Inkas of royal lineage.

In Cuzco during the late seventeenth century, Inka nobles were deploying strategies of exclusion to ensure that only some Inkas could wear the royal fringe. Around 1680, a complaint was filed by four Inka nobles (*incas principales*) of the parish of San Sebastián: Don Luis Inca Roca, Don Melchor Sanac, Don Juan Ynca Maita, and Francisco Agustín

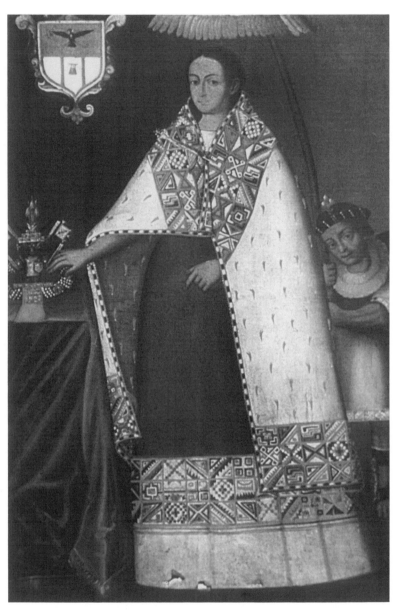

27. Anon., eighteenth century, *Portrait of an Unidentified Ñusta*
(Museo Arqueológico, Cuzco)

Maita. Very likely they were also of Sucso *ayllu*, since all four claimed descent from the Sapa Inka Viraqocha. The complaint was against Don Marcos Uña Condor, of the parish of San Cristóbal, for wearing the "insignia of the *maskapaycha*" in the Easter procession without presenting titles to prove he was a legitimate heir of a Sapa Inka and thereby entitled to wear it ("ha que presentase los titulos y rrecaudos por donde constase el que lexitimamente se la podia poner") (ADC, Corregimiento, Pedimentos, leg. 82, 1582–1699). The plaintiffs wrote their petition from jail, where they were imprisoned after having tried to remove the *maskapaycha* from Don Marcos by force. They requested their own release as well as the punishment of Don Marcos for his violation of the prohibition against non-Inka nobles and nonroyal Inkas from assuming the colonial *maskapaycha*. Their petition, which they claim to have filed on behalf of all the Inkas of Cuzco, indicates not only that all Inka *caciques principales* of royal descent were entitled to wear the insignia once reserved for the Sapa Inka alone, but that other indigenous leaders were testing the proscription and, consequently, that Inka *caciques* were closing ranks and sometimes reacting with violence.

A second document, dated 1679, also indicates that Inka nobles "policed" the wearing of the *maskapaycha* in Cuzco. That year, ten such nobles authorized a lawyer in Cuzco (Diego Ximenes del Castillo, a *procurador de causas*) to pursue their complaint against Don Pedro Quispe Amao, his son Don Francisco Quispe Amao, and all the other notables (*principales*) of the *ayllus* Pomamarca and Ayama(r)ca (in San Sebastián parish) (ADC, Diego Quiñones, leg. 283, 1678–1681). It seems the Quispe Amaos and others in the *ayllus* just mentioned were wearing *maskapaychas* (referred to as "la insignia de la mascapaicha de borla colorada") in public without ever having offered proof of their right to put them on. In November 1679, Don Francisco Quispe Amao and the other *ayllu* leaders, were compelled to sell some *ayllu* property (*un solar*) in order to pay the expenses they encountered "in defense of the *maskapaycha*" ("el dho solar se lo bendemos para con su prosedido pagarlos gastos que tuvimos en la defensa de la mascapaycha") (ADC, Alfonsso de Bustamante, leg. 12, 1679–1680, fols. 328r–332v).

Although the ten Inka plaintiffs who challenged Don Francisco Quispe Amao are not identified specifically as electors, a complaint filed by Doña Lorenza Calles against that year's *alférez real*, Don Carlos Inquil Topa, and the rest of the twenty-four Inka electors suggests that, by the late seventeenth century, that body of nobles ardently pursued "illegiti-

mate" wearers of the *maskapaycha* (ADC, uncatalogued document dated 1687). Doña Lorenza claimed that Don Carlos and another Inka noble, with approval of the twenty-four, took from her 20 pesos (all she had on her at the time) after fining her 100 pesos because her two sons (Don Pedro Solorsano and Don Felipe de la Cruz) had armed themselves with swords and daggers, a privilege granted only to native nobility, and had worn the Inka headdress on the feast day of Santiago in July 1686.[18]

Doña Lorenza had other informative accusations to make. She claimed that Inkas of low rank who had money were allowed to put on airs; but because she, though of noble heritage, was poor, Inka officials in Cuzco denied her sons the privileges to which they were entitled. She also alleged that, had she been able to pay the 100 pesos, they would have allowed her sons to exercise noble privileges such as bearing arms in public; she makes no mention of the wearing of the Inka head-dress, however. She also charged the two Inka nobles who "attacked" her with having been drunk and "motivando graves daños con sus embrigeses" (causing great harm with their drunkenness), thus echoing "official" Hispanic explanations for disruptions in festival proceedings (see Chapter 3). Because her case was never resolved, we cannot know whether she was able to "prove" (according to Spanish juridical procedures) the truth of her sons' nobility. We can say that, at the very least, the twenty-four electors maintained a close eye on anyone who enacted the role of Inka ruler in public.

Interestingly, spurious claims to the imperial fringe were not just offered in performance. The artist Diego Quispe Tito, who was a noble Inka, but probably not royal and certainly never a *cacique*, may have portrayed himself as a Sapa Inka wearing a *maskapaycha* in a painting of the Last Judgment that he did for the convent of San Francisco in Cuzco during the late seventeenth century (Gisbert 1980, fig. 113; Benavente Velarde 1995, 58–60).[19] Unfortunately, no records exist that comment on whether his depiction raised any protests, or even any eyebrows.

Apparently, the electors had to contend not just with aspiring Andeans but with Cuzco's Hispanic magistrate, who had the right to confirm succession to the body of the twenty-four as well as approve the electors' annual choice of *alférez real*.[20] While the *corregidor* normally rubber-stamped the nominee of the twenty-four, occasionally he challenged their selection. Such was the case in the early years of the eighteenth century. In November 1716, an Andean man was called to testify that a prominent Cuzqueño native, Don Melchor Alejo Guambo-

tupa, was an Inka of royal descent (specifically from the house of Sapa Inka Túpaq Inka Yupanki).²¹ Part of his testimony deals with an incident in which General Don Fernando de la Fuente y Rojas, *corregidor* of Cuzco in 1702–1703, allegedly wanted to name a wealthy but non-noble Indian as royal standard-bearer for the annual celebration of Santiago ("[El] corregidor . . . quiso a fuerza de favor nombrar por alferes real a un Yndio Rico nombrado Guaca Luis"). The witness recalled that both Don Melchor's father and his uncle, both of whom were electors, objected so strenuously that the *corregidor* had them imprisoned. They appealed to higher authorities, however, were released, and the right of the twenty-four electors to name one of their number as *alférez* was confirmed. (They elected the *cacique* of San Blas parish whose "rightful" turn it was.) The story was offered as proof of Don Melchor's legitimate royal bloodline; for, the implicit logic insists, his father and uncle could not have been electors nor would they have prevailed unless they were legitimate royal Inkas.

Clearly the *maskapaycha* was sometimes a hotly contested item of festive regalia for the privileges that accompanied its possession and display. While Spanish colonization had eliminated the uniqueness of the Sapa Inka and the right of a single individual to the royal fringe, Inka aristocracy understood the importance of maintaining restrictions over the wearing of the still-significant scarlet insignia. In the midcolonial period, few chances to exploit elite Inka heritage, no matter how remote the linkage, were passed over. To perform as befringed Inka, then, was tantamount to claiming local Andean authority and its concomitant rights and privileges, none of which was safe from challenge under a colonial regime that officially recognized native nobility but did little without vigorous prompting to differentiate between "indios." All evidence indicates that Inka elites invented the festive role of Inka ruler at some point after the demise of Túpaq Amaru and policed its performance as one means by which they could bolster their diminishing authority under colonial occupation.

Our Grandfathers, Ourselves

As we have seen, between the execution of Túpaq Amaru (1572) and the mid-seventeenth century, the scarlet fringe had passed from marking a single, paramount, and divine (non-Christian) ruler to designating

a host of diminished (but still prestigious and fairly powerful) local Christian authorities. The resignification of the *maskapaycha* required two critical moves: the first was to rid the fringe of its Inka religious content, and the second was to broaden its ability to convey royal lineage and nobility rather than absolute political supremacy. With respect to the first goal, the early decades of the seventeenth century seem to have been critical. Marking the end of the first decade of that century were the beginnings of vigorous extirpation campaigns around 1610, following the discovery by Francisco de Avila ([1648] 1904–1907) that initial religious conversions had been often superficial and that pagan Andean rites were being conducted covertly on the central coast of Peru.

Extirpatory activity had diminished in intensity in the southern highlands by the middle of the seventeenth century.[22] For the most part, evangelizers had concluded that the colonized—those whom they called *indios amigos* ("friendly Indians")—were Christian; signs of the "pagan" Andean past were precisely that, *past*. As Alberto Flores Galindo (1986a, 68) has argued, only then could Inka history be deemed "safe," only then could it be evoked by descendants of Inka royalty with pride despite the inherent ambivalences. This was not simply a change in perception, though: the move was made through small, but meaningful, restrictions placed on signs of the Inka past. Recall that whereas a sculpture of the Christ child appeared in a 1610 celebration in Cuzco wearing the *maskapaycha*, by the end of the seventeenth century the scarlet fringe had been restricted to representations of, and references to, an ethnic history. As we saw in Chapter 3, removing the fringe from the forehead of Christ "sanitized" it, ridding it of uncomfortable associations with pre-Hispanic religions. As far as the Hispanic audience was concerned, the political meanings attached to the fringe could be, by this and similar means, divorced from religious ones. The Inka electors, by limiting the use of the fringe to parochial leaders, appear to have encouraged this understanding. Their salvific embodiments of the pre-Hispanic age involved a careful exhibition of non-Christian signs within mitigating Christian contexts so that the political power of past pagans could be recalled without threatening to revive paganism. In this way, the fringe on their foreheads conveyed more than a memory beyond resuscitation: it was evidence of their own conversion.

Their resignification of the Inka headdress and other regalia was neither readily nor easily accomplished. In their efforts, the Inka nobles of Cuzco were preceded by the *mestizo* author Gómez Suárez de

Figueroa, the son of an Inka noblewoman (Isabel Chimpu Ocllo) and the conquistador and Cuzco *corregidor* Sebastián Garcilaso de la Vega (d. 1559). After a childhood in Cuzco, where he was raised as an *hidalgo*, Gómez relocated to Spain in 1560 at age twenty-one. He changed his name to "El Inca" Garcilaso de la Vega and wrote was has become the most influential history of the Inkas. His two-volume history was published in Europe at about the same time that extirpatory fervor was casting suspicion on signs of the pre-Hispanic era, such as the *maskapaycha*. In his work, Garcilaso inscribed a *pre-* (rather than *non-*) Christian Tawantinsuyu (the pre-Hispanic Inka realm) which anticipated Peru, a Christian, Spanish colony. According to his script, the Inkas prefigured the Spaniards in the Andes much as pre-Christian Rome prepared the way for the triumph of Christianity in western Europe.[23] Manuel Burga (1988) demonstrates how "El Inca's" utopian vision of the pre-Hispanic past was hailed in the viceroyalty because it satisfied the desires of postextirpation Peru by averring that persistent native Andean, non-Christian practices were neutral rather than anti-Christian.[24]

Coincidental or not, Garcilaso's clearly self-promotional and highly romanticized gesture of reconciliation between Inka religion and Christianity anticipated the ways in which noble Inkas living in midcolonial Cuzco would be able to value the Inkaic past. Whereas Garcilaso used the written word, Cuzqueño Inkas used their own performative bodies. By appearing as their royal ancestors in Christian celebrations, they rehearsed the conversion of their pagan ancestors. In fact, because wearers of the fringe (a once "pagan" sign) were parochial leaders (and by necessity Christian) they were always, already converted Inkas. By performing their ancestry, they converted their ancestors. Thus did the fringe, when worn on the foreheads of Inka *caciques*, reference conversion to Christianity rather than subversion of it.

Importantly, the role of Inka ruler was commonly assumed for the feast of Corpus Christi, the festival of Santiago, and those other major Christian feast days which were organized by civic *and* religious authorities. The intertwining authorities of God and Crown reinforced the power of local religious and civic leadership, which is what the performing *caciques* were. The past evoked by the Inka performers located the proper place of Inka elites in the colonial political administration as parochial leaders. From the Hispanic perspective, this was a highly successful performance of subjugated ethnic royalty. For midcolonial Inkas, it was also successful. As will be discussed further in Chapter 7,

it was as though Inka performers hollowed out Corpus Christi, or perhaps possessed the hollow that was Corpus Christi, not by denying or subverting its triumphal structure but by claiming a place for the Inkas in that triumph. This they accomplished by translating pre-Hispanic Inka signs of divine authority into transcultural indicia of nobility.

How the past was quite literally fleshed out in the bodies of colonial elites, was informed, if not inspired, by European notions of aristocracy; in fact, their re-creations of the past were prompted by the value Spanish colonizers placed on the idea of royalty. By adapting Hispanic conceptions of nobility, midcolonial Inka elites converted the scarlet fringe into a symbol of ethnic royalty rather than of universal supremacy. Much of the important work of transculturation was accomplished in the Jesuit school for the sons of *caciques*, El Colegio de San Borja, which had been founded in Cuzco in 1621, just after the period of intense extirpatory scrutinization of native performative and visual practices. At San Borja, noble Inka youth—future *caciques*—not only learned Christian doctrine, Castilian, math, music, and other "essential" categories of Western knowledge, they also learned the importance of their own nobility. While certainly aiming to acculturate native elite males who would be future leaders of their communities, the Jesuits also, simultaneously, encouraged the expression of a noble alterity (J. Rowe 1954, 19). The composite uniforms—consisting of an Andean *unku* (tunic) with hat, cape, breeches, shoes, and socks—in which students at San Borja dressed, anticipated the "Sapa Inka" costume that would be worn in Christian festivals such as Corpus Christi by many of these students when they had become Inka *caciques*. (The Sapa Inka costume they devised is examined in the following chapter.)

Certainly it can be said that the rebirth of the past by Inka nobility in Cuzco was midwifed by Jesuits who themselves linked their "family tree" to that of Inka royalty. While the interest of most Hispanic authorities in the history and culture of the Inkas declined noticeably over the course of the seventeenth century (Mannheim 1991, 71), the Jesuits were distinct exceptions. In fact, the Jesuits "joined" Inka royalty; they even displayed prominently at the entrance to their church in Cuzco a painting featuring marriages that united Inka royals and Jesuit founders. The painting depicts the Jesuit saints Ignacio de Loyola and Francisco de Borja flanked by two married couples: to the saints' right stand Don Martín García de Loyola, the grandnephew of San Ignacio, and Doña Beatriz Ñusta, daughter of Sapa Inka Sayri Túpaq; to their left

are Doña Ana María Lorenza García de Loyola, the daughter of Martín and Beatriz, and her husband, Don Juan Enriques de Borja y Almansa, the grandson of San Francisco Borja. Beatriz's royal parents and uncle (the doomed Túpaq Amaru) witness the marriage of the ñusta from the left background. The Jesuits had copies made of this painting, which they displayed elsewhere in Peru.[25] Inka elites in Cuzco also took up the theme, binding themselves to the then powerful Jesuits. The Inka noblewoman Doña Josepha Villegas Cusipaucar y Loyola Ñusta, daughter of Don Tomás Cusipaucar Villegas and Doña Antonia Loyola, says that she displayed in her home a large painting of the marriage of the Ñusta Beatriz ("un lienzo grande con su chorchola dorada con oro de nro padre San Ygnacio y San Francisco de Borja y el casamiento de Doña Beatris").[26] The alliance of royal Inkas and Jesuits was a union from which both profited and one that was inculcated at the Colegio de San Borja.[27]

The Cusipaucar family, like other noble Inka families, also displayed in their homes portraits of themselves wearing elements of antiquarian Inka garb. Such paintings responded directly to the performances of Inka *caciques* as "Sapa Inka" which, as seen above, were devised in the mid-seventeenth century, probably by the first generations of students educated at San Borja. There, these "sons of *caciques*" confronted the problem of how to express their royal (but ethnic and non-Christian) heritage in Western terms and nonthreatening ways. That is to say, they had to translate Andean authority into European terms, refashioning the Sapa Inka into a king. No doubt influential were the full-body portraits of pre-Hispanic Sapa Inkas, painted sometime after 1644, which hung in the Colegio. They not only provided a model of Inka royalty but argued for a certain, implicitly linear understanding of the past in which costume, and to a lesser extent pose and carriage, bore the significatory burden and linked generation to generation. Costume in these images was supremely important because the "portraits" of pre-Hispanic Inka rulers were not, and did not claim to be, physiognomic likenesses, there having been no Inka tradition of mimetic representation on which to base the colonial depictions. Rather, through analogies to the European practice of royal portraiture, these paintings *created* a royal Inka dynasty in the image of European royal lineages and were used to assert the legitimate descent of colonial-period Inka nobles from these partially fictive individuals. Although scholars are certain that Manko Qhápaq is largely or entirely mythical, many

colonial-period Inka elites claimed descent (in a direct line) from him and possessed portraits of him. Portraits that averred his existence allowed complicated and still poorly understood Andean systems of kinship to be concretized in European terms. The costume in the portraits and the costume on the bodies of colonial *caciques* forged the link across centuries.

Sapa Inka portraits, such as the series that hung in the Colegio de San Borja, followed the lead of Viceroy Toledo, who in the 1570s had commissioned portraits of the pre-Hispanic Sapa Inkas. The painting contracted by Toledo is described as illustrating the royal Inka lineage from Manko Qhápaq to Wayna Qhápaq and his son Paullu, each shown from the chest up, dressed in traditional costumes, and wearing the *maskapaycha* and ear spools for which Inka nobility were renowned.[28] Toledo's command to visualize the pre-Hispanic royal Inka dynasty in Western style and format—and fix the line of descent with Paullu rather than with the rebellious Manko II—prompted numerous portrait series, which have been studied by Gisbert (1979 and 1980, 117–120, 124–140).

Toledo's commission complemented efforts by the chroniclers to write Inka history in a way that conformed to European historical modes of recordation.[29] Andean oral histories concerning only partially historical rulers were tailored to fit the familiar pattern of conventional European histories composed as successions of male rulers and their major accomplishments. Portrait series of rulers likewise gave a visual face to the chronicles and reinforced Europeanized versions of Andean history in which past events were aligned and affixed to a single male ruler who had followed his father who was a single male ruler, and so on. Sapa Inkas, when visually inscribed in this manner and format, are objects of European self-reflection.[30] By contrast, in the Andean tradition, the powerful essences of rulers (rather than their superficial form) were housed in (rather than recorded on) rocks and/or bundles of their bodily excrescences (e.g., hair and nails); these were referred to as their *wawkis* (huaques), or "brothers."[31] In part because *wawkis* and mummies of the royal deceased were revered, kept, and treated as though they were still animate or capable of imminent animation, there was no Andean tradition of sublimational image-making because there was no absence to disavow.

After the mummies and *wawkis* were confiscated and destroyed by Hispanics in the sixteenth century, European-style surrogation was

adopted. The necessary substitutions were performed through proces-
sional embodiments of Sapa Inkas by their descendants and through
the so-called portraits. Whereas the actual deceased could no longer be
housed, displayed, and celebrated publicly, "portraits" of Sapa Inkas—
the virtual deceased—were not only owned privately but were displayed
on public monuments (Gisbert 1980, 126). Doña Juana Engracia Cusi
Mantar, for example, a very well-connected Inka noblewoman in Cuzco
who died in the early eighteenth century, owned three painted portraits
of Inkas.[32] Likewise, the testament of Don Pedro Sapero, *cacique princi-
pal* of Santa Ana parish (of the *ayllu* Guanca Chinchay Suio), indicates
that in 1725 he owned a large painting depicting the portraits of Sapa
Inkas ("un lienso . . . de rretrato de Yngas de dos baras").[33]

Although Toledo and other Hispanics sought to envision the pre-
Hispanic past while severely limiting the colonial Inka presence, An-
deans tended to link themselves with those whose portraits they kept.
While many of the Hispanic portrait series end the Inka line at the time
of the conquest, inserting Carlos V and subsequent Spanish monarchs,
Andean patrons tended to insert themselves into the royal lineage. The
two mid-seventeenth-century wills of Doña Isabel Ulypa Coca Ñusta,
an Inka noblewoman, for example, indicate that she owned eight life-
size full-body portraits of Inka rulers; among them was the portrait of
her own father, Don Juan Quispi Tito.[34] Similarly, the early nineteenth-
century inventory of the belongings of the deceased Doña Martina
Chihuantupa de la Paz refers to twelve portraits of "Inkas" from the
Chihuantopa (Chiguan Topa) family that had been hanging in the hall
of her residence ("dose retratos de los Yngas de la familia de Chihuan-
topa que estuvieron en el corredor").[35] Some of these images of the
Chiguan Topa family are now in the Museo Arqueológico in Cuzco.
The series was apparently either originally commissioned or at least en-
hanced by her father, Don Marcos Chiguan Topa, who is the subject of
one of the portraits (Fig. 28; Plate VII). Doña Martina may well be one
of the anonymous *ñustas* in the Museo's collection. The Chiguan Topas
traced their lineage to the Inka ruler Lloque Yupanki, and so the series
that hung in their Cuzco residence probably mapped their royal heri-
tage from that ruler to the time of Don Marcos. The family of colonial
Inka nobility thus intertwined themselves with mytho-historical Sapa
Inkas. Don Marcos and some of his relatives also display in their por-
traits the coat of arms granted to Don Cristóbal Paullu Inka. By linking

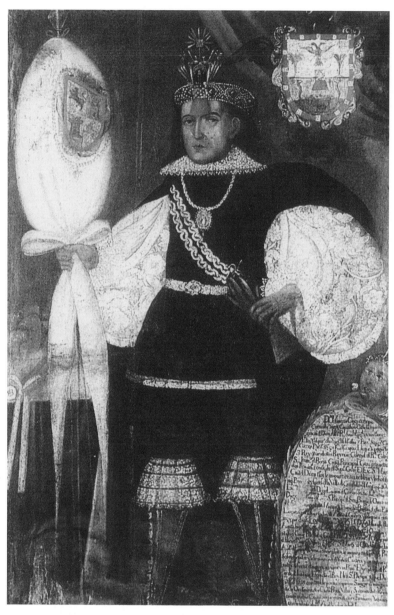

28. Anon., eighteenth century, *Portrait of Don Marcos Chiguan Topa*
(Museo Arqueológico, Cuzco)

themselves to a colonial-period royal, Don Cristóbal, who was loyal to the Spaniards during the uprising led by his brother, Manko II, they suggest that the Chiguan Topas were good Spanish vassals as well.

One of the portraits in the collection of the Museo Arqueológico in Cuzco is of an anonymous male standard-bearer wearing the *maskapaycha*. While it is impossible to identify the individual painted, this portrait (or one like it) might well be described in the will of Doña Antonia Loyola Cusi Tito Atau Yupanqui, whose husband (Don Thomas Cusipaucar Villegas) had once served as *alférez real* (and was, therefore, one of the twenty-four Inka electors). She had among her possessions a painted portrait of an Inka as *alférez real* ("lienzo del retrato del Ynga de Alferes Real de dos baras con su chorchola dorada nueva") and a second painting depicting a *ñusta* ("retrato de la Nusta de dos baras asi mismo con su chorchola dorada nueba").[36] These may well have been portraits of herself and her husband or, perhaps, ancestors. By themselves, the paintings appear to reinforce capitulatory identities by affirming colonial roles, but when aligned with portraits of pre-Hispanic rulers, such as those we know the Cusipaucar family possessed, they establish a dynasty that denies the Spanish invasion its purported power to sever the flow of Andean history.

Living the Part

The portraits of colonial-period male Inka elites record their festive roles and cannot be understood without reference to their performances as "Sapa Inka." Men are shown in their roles as performers, often with the standards they bore in procession; such is the case of Don Marcos who served as *alférez real* and who appears with the royal standard of Spain (Fig. 28). The men are thus visually inscribed as the descendants of Andean kings *and* as leaders within the colonial regime. Nowhere is this more clear than in the canvases of Corpus Christi featuring the costumed *caciques principales*.

The portraits of colonial Inka *caciques* paralleled the performances in which they became transient monarchs in the manner of performed effigies whose surrogation summoned multiple, ordinarily absent Inka rulers for festive celebration.[37] For the performers, "Inka ruler" was certainly a festive role, albeit one that was fabricated from more than costume and regalia; the part they played was fashioned from their own

bodies, as we have seen, for only Inka royals could assume the part. Since it was the body which was the inescapable, irreducible, visible sign of their colonial subjugation, the embodiment of pre-Hispanic authority became a hallmark of elite Inka identity in the midcolonial period.

In their festive personae—their costumed bodies—they reconciled the pre-Hispanic past with the colonial present in ways that were not, or at least were not solely, capitulatory. To incarnate the ruler in performance was to claim the power that his mummy and *wawki* had once possessed. Through personification by their heirs, the bodies of Sapa Inkas crossed into the colonial period refusing to recognize the Spanish invasion as an event that severed Andean history into "pre" and "post." The very act of periodizing, in fact, imposes a linear scheme that itself is a colonizing gesture—a gesture made often by Hispanics in colonial Peru as well as by contemporary scholars, but one not made by colonial-period Inkas.

Although detail is scant, representations of Andean history scripted and performed by colonial Inka elites are not like those presented by Hispanics. In 1555, for example, the death of the Inka ruler Atawalpa, who was executed by Francisco Pizarro, was organized by Hispanics in the mining center of Potosí (Arzáns de Orsúa y Vela [c. 1735] 1965, 1:98).[38] The climax of the drama was the death of the Inka and the triumph of the Spaniards. The embodiments of Sapa Inka performed by colonial-period Inka leaders, on the other hand, do not leave the Andean past in the past in the same way. In fact, they tend to mix pre- and post-Hispanic periods, confusing the European sense of diachronicity. In the reenactment of a pre-Hispanic battle performed in a Christian celebration (Romero 1940), for example, the Spanish *corregidor* was acknowledged as paramount authority, thereby collapsing history and alluding both to Inka conquest and the Spanish conquest simultaneously. Even more pointedly, when Inka *caciques* appeared as Sapa Inka in processions, they pulled the imperial past into the colonial period, performatively construing the Spanish advent as an "always, already" event. The ambivalences that inhere in these efforts will be considered in Chapter 7.

Because Andean history was substantiated by the royal bodies of colonial Inka elites, they projected a future consistent with Andean notions of time whereby the past inevitably forecasts the future. Costumed as their ancestors, they simultaneously represented the past,

present, and future. Inka elites, both in performance and in the records of those performances, also showed how well they balanced Andean and European demands on who they had to be. Even though it is certainly the case, as will be argued in Chapter 7, that these strategies of self-representation subordinated Inka elites to Hispanic authority (Cummins 1991), they were also self-defining and very different from Hispanic efforts to define the Inka. A comparison of images of the Inka—one Inka and one Hispanic—illustrates this point. The posthumous portrait of Don Alonso Chiguan Topa, from the Chiguan Topa family mentioned above, commissioned in the eighteenth century by his descendants, features Don Alonso dressed in the costume of a pre-Hispanic Inka ruler; he holds aloft a cross (Fig. 29). The sun pectoral on his chest dims in contrast to the cross which emanates light. According to the legend on the portrait, Don Alonso, a descendant of Sapa Inka Lloque Yupanki, was the first Inka to be baptized following the Spanish advent. Don Alonso is shown with the arms granted by the Spanish king to Cristóbal Paullu, the son of Wayna Qhápaq who remained loyal to the Spaniards during the rebellion of Manko II. The portrait was made by his descendants (probably Don Marcos Chiguan Topa, whose portrait, like that of Don Alonso, is in the Museo Arqueológico of Cuzco) in order to establish not only the noble ancestry of the Chiguan Topas, but the history of their compliance with and allegiance to the Spanish colonial government. Considered in isolation, the portrait could be read as a record of self-subordination that performs metonymically to record the religious conversion of all Inkas.

A canvas by the Hispanic painter Leonardo Flores, which hangs in the church of San Francisco in La Paz, provides a different perspective, however. In this painting, which is roughly contemporaneous with that of Don Alonso, Mary Immaculate triumphs over the world (Gisbert 1980, 80, fig. 72). America is represented, or rather embodied, as an "Inka." The generic Inka accepts the doctrine and a cross from a Franciscan who rides in the triumphal cart, its mighty wheels rolling perilously close to the Inka's supplicant form. The passive receptacle who is the anonymous "Inka" in this painting presents a very different figure from the staunchly erect Don Alonso Chiguan Topa, who holds high the cross *he has taken* rather than received.

In the portrait, Don Alonso is shown as a master of mediativity, an individual who has made a choice. He bridges the distance between the solar disk which recalls the Inti of his ancestors and the luminous

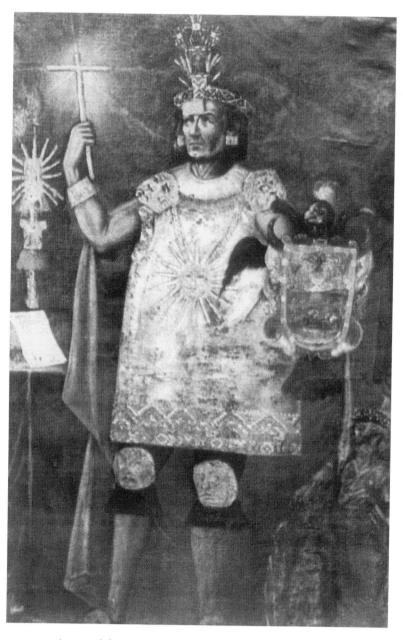

29. Anon., eighteenth century, *Portrait of Don Alonso Chiguan Topa* (Museo Arqueológico, Cuzco)

cross of his Christian descendants—his heart and his hand, his spirit and his body. His descendants, who caused his image to be recorded (or created), were themselves living in the interstices. By embodying their ancestors for Christian festivals, they not only recalled but rehearsed the moment of conversion. When the role of Inka ruler was assumed for public displays, the mediative stance of the Inka noble, the living ancestor, was articulated through an exquisite composite of Andean and European signs as well as systems of visual representation. Their composite personae utilized both convergence and juxtaposition;[39] as a consequence, they exploited similarity and difference. Nowhere perhaps is their strategic mediation so clearly articulated than in the costume they adopted for their role as colonial Inka ruler. They invested much—meaning and money—in the vestments in which they performed, and it is to that topic we now turn.

Chapter 6

Inka (In)vestments

The studied hybridity of colonial Inka *caciques* is nowhere so saliently articulated as in the costume that enabled them to embody the "Sapa Inka" in performance. The costume, pieced together out of Andean and European cultural fabrics, is best described as a cultural composite in that the parts exist together without necessarily blending. As composites, their vestments addressed their many different audiences. They declared ethnic difference from Hispanics and non-Inka Andeans alike, and class difference from their constituents and other commoners. Because composites represent diverse voices speaking simultaneously,[1] they are inherently conflicted. The colonial Inka vestments studied here, by juxtaposing Andean and European signs and styles, spoke to the mediative positions of festooned *caciques.* The ambivalence that inheres in their strategic interstitiality will be explored in Chapter 7. Here, I am concerned with how the "Sapa Inka" costume donned for midcolonial Corpus Christi and other festivals by Inka *caciques* characterized them — and, in fact, helped position them — as linchpins in Cuzco society.

Although in daily life Inka *caciques* commonly mimicked elite Hispanic fashion, they crafted a transcultural costume that underscored their mediative role between Inka past and Christian present, Hispanic colonial authorities and native constituencies, in order to participate in Christian festivals. In "voicing" two visual rhetorics, a third was created and, through it, mediativity was pronounced. This third voice is heard not by listening for pre-Hispanic Inka utterances and separating them from European sounds, but by attending to the cadence of the

interstices. By examining the costume worn by Inka nobles for Corpus Christi (and for other festive occasions as well as for portraits that recorded their festive personae), we come to see that colonial Inka elites understood how, being compelled to cultural hybridity, they could fashion their own bodies as empowered sites of cultural confluence.

In six of the Corpus Christi paintings are standard-bearers wearing antiquarian Inka vestments (Figs. 11–16). While the entourage of parish councilmen wear somber native tunics cloaked by dark-colored mantles, as well as European breeches, shoes, and hats, the *caciques principales* shimmer in rich and colorful fabrics with golden accouterments and ornate headpieces drawn from pre-Hispanic Inka fashion. In this context, the modified Inka costume functions as a robe of office, denoting superior status within the parochial hierarchy. Having emerged from the ranks of the native political structure, the *caciques* stand at the threshold between the Andean and European worlds. It is thus significant that these leading Andean personages, who literally bridge cultures, identify themselves with the Inka past in this public performance.

The *caciques principales* wear costumes based on that of the Inka head of state, the Sapa Inka. The costume of the Sapa Inka had been, with respect to garment type, basically the same as that worn by all pre-Hispanic Andean men; status differences were expressed through the quality of fabric, decoration, and the elaboration of regalia.[2] Over the breechcloth, the Sapa Inka wore a sleeveless tunic (*unku*), usually displaying *tokapu*. Tokapu, textile motifs associated with only the finest pre-Hispanic garments, are rectangular compositions of nonrepresentational, geometric forms. They are often aligned end to end and stacked to form a grid of repeated motifs, usually placed at the waist of the man's tunic (see Fig. 26). Murúa ([1600–1611] 1986, 225) refers to the fine tunic of the Sapa Inka, richly decorated with *tokapu*, as the *qhápaq unku*, or royal tunic. A mantle (*yakolla*) was worn over the tunic; sandals (*usuta*) and a woven headband (*llawt'u*), wrapped several times about the head, completed the outfit.

Gisbert (1980, 120–124) analyzes the postconquest costume elements associated with pre-Hispanic Sapa Inkas who were commemorated both in images of the Inka dynasty and in festive impersonations. The costume of the Corpus Christi standard-bearers is consistent with those she studied. Gisbert concludes that the tunic, pectoral, knee fringe, and headdress are based on pre-Hispanic costume elements,

while the solar-shaped medallion and the maskettes worn on the shoulders and feet were colonial-period inventions. The lace sleeves, a prominent part of the Corpus Christi costume as depicted in the paintings, were introduced in the colonial period as well. Comparison with Guaman Poma's portraits of pre-Hispanic Inka rulers (e.g., Fig. 26), as well as descriptions written by early chroniclers, indicates that the costume worn by the *caciques principales* for Corpus Christi was modified in such a way as to accommodate European notions about elite regalia and heraldry as well as European modes of visual representation.[3] For convenience, the costume elements will be discussed separately.

Garments

The colonial *caciques* wore tunics, probably of *cumbi* (*q'ompi*), the Quechua name for finely woven cloth, the use of which in pre-Hispanic times was restricted by sumptuary laws. While *cumbi* with *tokapu* ornamentation had been restricted to Inka royalty, once the Inka state was dismantled the restrictions on royal regalia were loosened so that in colonial times any noble who could afford it wore this fine fabric (J. Rowe 1979, 242–260). *Cumbi* retained its high-status connotations into the colonial period. The Spaniards appreciated the quality of *cumbi*, most commonly comparing it to silk (e.g., Xérez [1534] 1985, 89). When Toledo visited Cuzco in 1571, for example, his secretary exclaimed that the *cumbi* worn by native nobility who formally greeted the viceroy was esteemed no less than silk ("ino de menos estima que la seda!") (Salazar [1596] 1867, 253).[4] *Cumbi* was used not only for vestments of pre-Hispanic types (*unkus, aksos, lliclias, yakollas*), but for bedspreads, wall hangings, and other home furnishings both in Andean and in Hispanic households. *Cumbi* fabric was even used at least once by Hispanics of the Cuzqueño artists' guild to decorate their Corpus Christi triumphal arch.[5] Clearly the status connotations of this fine cloth were not exclusively linked to Andean usages in the colonial period. *Cumbi* signified cross-culturally.

Each of the six tunics depicted in the Corpus Christi series is distinct; all have been delicately and tightly worked with a remarkable attention to detail. Isabel Iriarte (1993) studies the standard-bearers' tunics as part of her examination of the modifications to, and resignification of,

Inka *unkus* in the colonial era.[6] She notes modifications in both the "vo-cabulary" of motifs (iconic elements) as well as the representational and formal "syntax" (the arrangement of motifs on a single garment). Colonial tunics, she found, were more extensively decorated than their pre-Hispanic antecedents: while pre-Hispanic garments frequently featured decorative elaboration of the neck, waist, and borders, the decorative motifs on colonial tunics invade the body of the garment.[7] This is certainly the case with respect to the tunics of the Corpus Christi standard-bearers. Decorative motifs include isolated rectangles of *to-kapu*, flowers (esp. *ñuqchu*), insects, *maskapaychas*, quatrefoils, trefoils, and butterflies. The elimination of undecorated zones, to which Iriarte refers evocatively as "silent areas," produces a busier surface which, to extend Iriarte's metaphor, produces a more vocal garment. The multiplication of motifs, all of which refer to Andean nobility, insistently reiterates the status of the wearer. Iriarte (ibid., 70–78) suggests that the colonial-period innovations, in degree of decoration as well as in the extent of surface decorated, may have been inspired by European brocade (or the European manner of decorating fine cloth in general) and that these innovations were introduced in order to emphasize the royal heritage of the *unku* (and, therefore, I would stress, the nobility of the wearer of the *unku*).

While it appears as though the tunics depicted in the Corpus Christi series must have been colonial-period creations, there are suggestions that some *cumbi* tunics worn by Inka elites in the colonial period were, in fact, of pre-Hispanic date. In the inventories and wills of Inka elites, it is not unusual to find references to "camisetas de cumbe [i.e., *cumbi*] del uso antiguo."[8] "Antiguo," when used in this way in colonial-period documents, usually refers to pre-Hispanic times. These garments, then, may well have been Inka *unkus* that were used in colonial festivals such as Corpus Christi.

To the basic *cumbi* tunics postconquest Inkas often added flowing lace sleeves. Lace is, from an Andean perspective, much like *cumbi*, being intricately decorated, labor-intensive, and costly. These sleeves, while of European cloth, are not of a European cut; they are uncuffed, free-flowing, and untailored, suggesting that the introduction of lace sleeves should be understood as a product of the traditional Andean appreciation of fine fabric. The lace has been adapted to an Andean system of costuming, rather than serving as a means of Hispanicizing the

native tunic. If anything, the flowing sleeves allude to church vestments and make the composite whole an Inka equivalent to robes of parochial office.

Over the tunic, each of the standard-bearers wears a mantle of a solid color. This garment is a traditional element of pre-Hispanic Andean male costume as well as being a standard part of European fashion. The costume is Hispanicized by the wearing of breeches which convert the tunic into a long shirt, or from an Inka *unku* into a Spanish *camiseta* (used in this context to mean a long, loose-fitting shirt). The breeches end at the knee; a fringed band (*saccsa* or *antar*), based on elite pre-Hispanic Inka fashion, encircles the leg at this point.

Ornaments

All six standard-bearers in the Corpus Christi series wear colorful collars. Feather collars (*sipi* or *sipe*) were part of pre-Hispanic Inka fashion and may have been the prototype for this costume element.[9] In two colonial-period wills, "sipe" (derived from the verb *sipini*, to choke) refers to pre-Hispanic collars or necklaces of *mullu*, shells of the genus *Spondylus*, which are orange or purple in hue, and which must have been kept as heirlooms of a sort. Don Martín Quispe Topa Ynga, lists "an ancient collar of *mullu* that is worn around the neck" (*un mullo sipe antiguo que se pone al cuello*) in his will of 1678; and, in her will dated May 30, 1759, Doña Antonia Loyola Cusi Tito Atau Yupanqui values "an ancient Inka collar of *mullu*" (*un sipe de mullo antiguo del Ynga*) at "nada," suggesting that it had been passed down in her family for some time, probably dating from before the conquest, but that it would not, or could not, have been sold.[10] The Corpus Christi collars, all of which have orange-colored elements, likely consist of some *mullu*. Interestingly, Don Martín lists his *sipe* right after a *cumbi* tunic ("camiseta de cumbe"). It is probable that he linked the two as part of an "Inka" costume.

Below the collars worn by colonial Inkas in the Corpus Christi paintings is the solar pectoral. While that of the *cacique* of Santiago appears to be a polished but undecorated disk, the others have modeled, Europeanized humanoid faces from which numerous rays emanate. Juan de Betanzos ([1551] 1987, 68) describes large gold "badges" (*veneras*) that Inka nobles wore on their chests in pre-Hispanic times. Cobo ([1653] 1990, 185) similarly reports that Andean elites displayed silver or gold

patines, called *canipos*, which were the size of European plates, on their chests and heads. The chest ornament of the Santiago standard-bearer apparently retains the unelaborated Andean form, while those of the other Corpus Christi standard-bearers have been Europeanized in the manner of an anthropomorphized solar disk.[11] Interestingly, the solar visage was likely inspired by the anthropomorphic sun which frequently adorned the chest of the Christian God—the creator and source of all light—and that of Christian saints, suggesting their illuminating abilities. Saint Thomas Aquinas, one of the great scholars of the church and the presumed author of the Corpus Christi liturgy, was frequently depicted with a sun on his chest, sometimes with an entire solar monstrance (Fig. 22). It is both logical and ironic that the model for the colonial Sapa Inka's solar pectoral—which, in the context of his antiquarian costume and festive role, was understood by colonial witnesses such as Murúa and Cobo, not to mention Bishop Mollinedo, to reference Inti, the Inkas' patronal deity—was ultimately derived from Christian iconography, where it signifies Christianity as the source of true light. The modified solar pectorals thus exemplify transculturality and multiple hybridities; the European utterance (the anthropomorphic sun) is voiced in Andean syntax (a pectoral on the chest of an Inka *cacique*). Whether the audience was Andean or European (and it was both), the colonial Sapa Inka pectoral signified successfully.

Zoomorphic maskettes, worn at the shoulders and ankles of all the painted Corpus Christi standard-bearers except that of La Linda, have less specific pre-Hispanic precedents, although they became a standard element of postconquest Inka ornamentation. They are, like the solar pectoral, clearly Europeanized in terms of formal articulation. Cobo ([1653] 1990, 185) does record that Inka costume included silver and gold maskettes worn on the shoulders, knees, and feet. Similarly, Arzáns de Orsúa y Vela ([1735] 1965, 1:99) describes the Inkas as wearing ornamental pumas on their shoulders, knees, and ankles. Both of these descriptions, however, written in the mid- and late colonial periods, respectively, could well have been based on colonial-period processional garb, rather than on any direct knowledge of preconquest costume.

Only the standard-bearer of San Blas displays the large golden ear spools (*tulumpi*) diagnostic of pre-Hispanic Inka elites. Inka nobility were differentiated from commoners by their pierced and elongated lobes, and this practice inspired the Spanish nickname *orejones* ("large ears") for male members of the Andean elite. According to Cobo ([1653]

1979, 245), the Sapa Inka was distinguished by having larger holes in his ears so that he could sport grander, more ostentatious earplugs. While the second council of Lima (1567–1568) prohibited native nobles from boring their ears and wearing large disks in them, the practice did not cease with this edict. As late as 1600, at least some Inka nobility were still having their ears bored (Mateos [1600] 1944, 2:9).[12] In urban areas, where native nobility were more rapidly subject to Hispanicizing pressures, the practice did not persist long after the conquest, however; and, indeed, the large ear spools of the standard-bearer of San Blas clearly hang from his headband.[13]

Headdress

As discussed in the previous chapter, Sapa Inka wore a distinctive headdress with a scarlet fringe covering the forehead called the *maskapaycha*. Pedro Pizarro ([1571] 1986, 66), an eyewitness to the first meeting between Spanish *conquistadores* and the Inka head of state, describes the headdress worn by the ruler Atawalpa, saying:

This Indian wore on his head some *llautos*, which are braids made of multicolored wool half a finger thick and a finger wide . . . made in the manner of a crown, round, but without points, a hand's breadth wide and encircling the head. At the front was a fringe sewed on this *llauto*, a little more than a hand's breadth in width, made of very fine scarlet wool, very evenly cut, and adorned with small golden tubes cleverly placed at the midpoint. This wool was spun, and below the tubes was untwisted, and that was the part that fell over the forehead, for the little tubes were enough to fill up the whole *llauto*. This fringe fell to just above the eyebrows, and it was a finger in thickness and covered the whole forehead.[14]

The royal headdress consisted of the *llawt'u* (*llauto* or *lyawt'u*) a braid wrapped repeatedly around the head to which was appended the scarlet *maskapaycha*, each strand of which may have been thought to have represented a subjugated enemy (Murúa [1600–1611] 1986, 64). So significant was the fringe that the entire headdress was also known as the *maskapaycha*.[15] Above the fringe was the *tupaqochor*, a gold plaque, and rising above that, on a stick, was a feathered "pompon" from the top of which three distinct feathers emerged (J. Rowe 1946, 258). Guaman Poma de Ayala ([1615] 1988, 67–69, 82, 88), who incorporated this

"pompon" in the headdresses of the Inka emperors Manko Qhápaq, Sinchi Roqa, Inka Roqa, and Pachakuti, refers to it as a "feathered parasol" (*pluma de quitasol*). It appears to be a smaller version of the staff, an insignia of the Sapa Inka, held by Manko Qhápaq and labeled by Guaman Poma "quitasol," which is Spanish for parasol or sunshade (Fig. 26). Apparently, this tuft of feathers worn above the forehead was a referent to the feathered parasol which was the exclusive insignia of Inka elites.[16] It may have been called the suntur pawqar.

The Inka imperial headdress is shown in several distinct forms in colonial-period images. Not surprisingly, the most consistent element is the scarlet fringe over the forehead. Fortunately, there are a number of images that purport to show actual colonial-period Inka nobles dressed in the fashion of the emperors, rather than fictive portraits of the pre-Hispanic rulers or allegorical Inkas (as in colonial Andean paintings of the Magi, one of whom is sometimes rendered as a Sapa Inka).[17] The headdresses of "real" Inka nobles are remarkably consistent and appear to approximate the actual headgear worn by Inka nobility in Cuzco during the later half of the seventeenth and early eighteenth centuries. These colonial *maskapaychas* are modified, yet structurally similar to, pre-Hispanic headdresses. That is to say, we can recognize not only the fringe, but the *tupaqochor*, *llawt'u*, and *suntur pawqar* elements. These four basic elements of the colonial royal Inka headdress are best discussed individually, as they are subject to varying degrees of modification.

The Llawt'u

Diego González de Holguín ([1608] 1901, 194–195), the Jesuit author of the Spanish-Quechua dictionary published in Lima in 1608, translates "llauttu" as "crown" (*corona*) and "llautto" as "the cingulum (band) that is worn as a hat" (*el cíngulo que traen por sombrero*). Garcilaso de la Vega ([1609, 1617] 1966, 1:56) describes the llawt'u as a woolen braid wrapped many times around the head; he further explains that the llawt'u of nobility was multicolored, while that of Inka subjects was black. Bernabé Cobo ([1653] 1979, 245) also describes the llawt'u of the Sapa Inka as multicolored in contrast to the single-color bands of other members of the Inka lineage. Guaman Poma ([1615] 1988, 68–89) specifies that the llawt'u of Manko Qhápaq (the legendary first Sapa Inka) was green, that of Lloque Yupanki (the third ruler in his list) was

red, and that of Pachakuti (his ninth emperor) was pink. Martín de Murúa ([1600–1611] 1986, 349–350), however, describes the llawt'u (which he spells "llaitu") as being two fingers in width and decorated with precious stones and plumes.[18] Arzáns de Orsúa y Vela ([c. 1735] 1965, 1:99) describes the llawt'u of the Inka ruler Atawalpa as similarly modified with wide threads decorated with pearls and emeralds; but he, like Murúa was, in this case, almost certainly describing postconquest, Hispanicized representations of pre-Hispanic Inka rulers, most probably festive impersonators.

The canvases of Corpus Christi in Cuzco that represent parading caciques depict the type of modified llawt'u discussed by Murúa and Arzáns. In them, the wrapped, multicolored woolen llawt'u of the pre-Hispanic Inkas has become a single, jewel-encrusted band; undoubtedly, the colonial-period bejeweling of the llawt'u mimicked European royal crowns. Although pictorial descriptions offer the best evidence, we do have an inventory (dated February 16, 1655) of the belongings of the Inka noblewoman Doña Isabel Ullpo Palla, of San Blas parish in Cuzco, which lists a "llautu de yndio guarnesido con aljófar a trechos" (an Indian's llawt'u garnished at intervals with seed pearls) (ADC, Alonso Diez Dávila, leg. 56, 1655–1657, fols. 109r–111v). Additionally, a will dated in Cuzco on August 8, 1775, refers to an Inka costume complete with maskapaycha and a llawt'u decorated with coral and blue beads and a sun made of silver.[19] Another document describes the headdress worn by an Inka standard-bearer at the festival of Santiago in the early eighteenth century as being of gold set with precious stones.[20] Apparently, the postconquest Inkas preserved the essence of the pre-Hispanic llawt'u while bringing it in line with a European aesthetic. Through the addition of gems and precious stones, colonial Inkas cite the European crown, but they do not quote it (the crucial difference between visual citation and quotation will be taken up in Chapter 7).

The Maskapaycha

It is not surprising, given the symbolic importance of the scarlet fringe known as the maskapaycha, that, on the colonial-period headdresses, it is the component that appears to have undergone the least alteration. Rather than in its form, it is in its meaning that the maskapaycha was most modified. As seen in the previous chapter, displaying the fringe indicated legtimate descent from an Inka ruler and wearing it was re-

stricted to those Inka elite males who held positions of authority in local parishes.

The Tupaqochor

González de Holguín ([1608] 1901, 369) defines *tupaqochor* as the gold plaque, adorned with precious stones and jewels, that was part of the imperial headdress and that held the *maskapaycha*.[21] The *tupaqochor* fastened the fringe to the *llawt'u* and supported the *suntur pawqar* portion of the headdress. In Guaman Poma's depictions of pre-Hispanic Inka rulers as well as in colonial-period paintings of postconquest Inka headdresses, the *tupaqochor* is roughly square and decorated with geometric motifs reminiscent of *tokapu* designs on royal textiles. Zuidema (1990b, 164) suggests that the name *tupaqochor*, derived from the verbs *cuchuni*, "to cut," and *cuchurccarini* or *cuchurccayani*, "to cut in many parts" or "to quarter," may refer to the grid-like decoration of this portion of the headdress.[22] Pedro Pizarro ([1571] 1986, 66) describes this portion of the imperial headgear (which he saw worn by the ruler Atawalpa) as a series of golden tubes "cleverly placed" ("metida . . . muy subtilmente") so as to order and fix the yarn of the *maskapaycha*.[23] The *tupaqochor* appears to have been elaborated in the colonial period; the precious stones and jewels described by González de Holguín were likely a colonial-period modification. This plaque may also have been known as the *accorasi* (Barnes 1994, 232).

The Suntur Pawqar

According to Guaman Poma's illustrations, the Inka imperial headdress could be elaborated by the addition of flowers, feathers, and metal ornaments. Some of his illustrated Sapa Inkas wear what John Howland Rowe (1946, 258) characterizes as a "pompon" above the forehead. As mentioned above, both Guaman Poma and Murúa show this pompon as a miniature version of a feathered scepter, labeled "parasol" by Guaman Poma. According to some descriptions, this feathered staff and the "pompon" of the headdress that is modeled after it may have been known as a *suntur pawqar*. Chroniclers do not agree as to the identity of the *suntur pawqar*, however. Cobo ([1653] 1979, 114, 246), for example, describes it as a staff covered with short, colorful feathers and having three large feathers at the top, and he notes that it was one of

the king's most important insignia; elsewhere he describes it as a standard or pennant (Cobo [1653] 1990, 128–129). Whatever he thought it was, he did know that it was a "highly venerated object" (ibid., 139).[24] Sarmiento de Gamboa ([1572] 1943, 53) identified it as a colorful insignia of feathers carried on a staff; González de Holguín ([1608] 1901, 347) defines it as a decorated edifice ("casa galan y pintada"); and Murúa ([1600–1611] 1986, 64) describes the *suntur pawqar* as an elegant flower ("flor muy galana"). It has also been understood to mean a type of weapon and a shield (Pardo 1953, 7–8; Arzáns de Orsúa y Vela [c. 1735] 1965, 1:99). The only thing all definitions have in common is the significance of *suntur pawqar* as an insignia of the Sapa Inka. I use the term here to mean that portion of the postconquest headgear which is an assemblage of elements rising above the *tupaqochor;* there seems to be no other term for this portion of the royal headdress.

Zuidema (1990b, 162–163) has attempted to bring several of the colonial-period definitions together, suggesting that *suntur pawqar* refers to a feathered sunshade (which would have been brilliantly colored, or "pawqar," and circular, or "suntur"). He argues that *suntur pawqar* could thus describe *a)* a parasol, *b)* a miniaturized version of a parasol which fit onto the Inka's *llawt'u,* and *c)* the roof of a circular edifice which formally mimicked the feathered parasol—all of which have been identified by colonial-period authors as *suntur pawqars.* Significantly, all things shaded by such a device were considered by the Inkas to have been sacred.

According to numerous depictions of colonial-period headgear, the *suntur pawqar* element had become a complex assemblage of icons by the second half of the seventeenth century. When worn, these elaborate composites rose a foot or more above the head of the wearer. The icons constituting the colonial *suntur pawqar* varied from one exemplar to another, but a number of the same icons were shared. After describing the fourteen *suntur pawqars* known through colonial-period representations, we may then consider the significance of the component parts. We shall examine only those representations which purport to depict colonial-period Andeans wearing actual colonial-period headdresses, not the numerous fictitious representations of pre-Hispanic rulers in concocted headdresses.

1. The forehead assemblage of the standard-bearer representing the confraternity of La Linda (Corpus Christi series, *Confraternities of Saint*

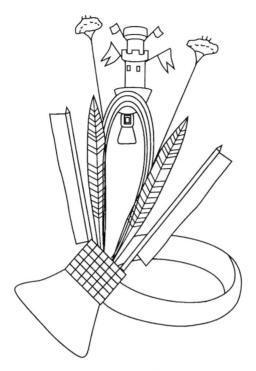

30. The standard-bearer's headdress in *Confraternities of Saint Rose and La Linda*, Corpus Christi series (Museo del Arzobispo, Cuzco)

Rose and La Linda, Museo del Arzobispo, Cuzco, c. 1680), borne on a pillow, is topped by a miniature castle that appears to sit on the apex of an elongated rainbow (Figs. 11 and 30). Under the rainbow's arch is a miniature *maskapaycha*. Flanking the rainbow are feathers and fringed staffs. Unlike all of the other headdresses considered here, the ornaments appear to rise directly from the headband itself rather than from the supporting platform of the *tupaqochor*.

2. Topping the headdress of the standard-bearer of San Sebastián (Corpus Christi series, *San Sebastián Parish*, Museo del Arzobispo, Cuzco, c. 1680) is a silver globe from which a tuft of feathers and banners spring (Figs. 12, 31, and 32). The globe appears to balance at the apex of a rainbow. The arch of the rainbow spans a miniature *maskapaycha*; its ties are held in the beaks of two *curiquenque* birds. All of these elements appear to be supported by a single stick, although a large black feather may obscure any additional support structure. Arranged in the front,

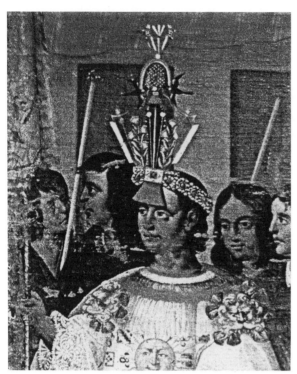

31. Anon., 1674–1680, *San Sebastián Parish*,
detail of the standard-bearer's headdress,
Corpus Christi series (Museo del
Arzobispo, Cuzco)

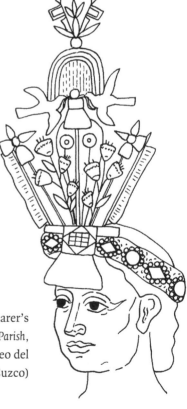

32. The standard-bearer's
headdress in *San Sebastián Parish*,
Corpus Christi series (Museo del
Arzobispo, Cuzco)

and distributed symmetrically, are flowers, ax-scepters, and fringed staffs. These elements are affixed to the back of the small, geometrically decorated tupaqochor.

3. Atop a long stick in the center of the headpiece of the cacique from Cuzco's San Blas parish (Corpus Christi series, San Blas Parish, private collection, Santiago, c. 1680) is a silver globe with a tuft of feathers (four red bracketing one white); below the globe is a miniature maskapaycha with its red ties flying free (Figs. 13, 33, and 34). An elongated arching rainbow rises to just below the fringe. In front of the rainbow, on either side of the central stick, is a black-and-white feather; ax-scepters and flowers, symmetrically arranged, complete the assemblage.

4. The headdress of the standard-bearer from San Cristóbal (Corpus Christi series, San Cristóbal Parish, Museo del Arzobispo, Cuzco, c. 1680) is surmounted by a crowned black condor or eagle which perches atop a miniature maskapaycha; the ties of the fringe are held by serpents (Fig. 14 and 35). This complex of motifs rises behind a large, jeweled black feather. A miniature castle on a stick occupies the front and center of the suntur pawqar assemblage. Feathers, flowers, Inka ax-scepters, and fringed staffs are arranged symmetrically on either side.

5. A feather tuft (two red flanking three white) springs from a silver globe at the apex of the suntur pawqar worn by the cacique principal of the Hospital de los Naturales (Corpus Christi series, Hospital de los Naturales Parish, Museo del Arzobispo, Cuzco, c. 1680) (Figs. 15 and 36). Beneath the globe is a miniature maskapaycha, its ties held by two curiquenque birds. Below this arches an elongated rainbow visible behind what may be a large white feather. Arranged symmetrically on either side of this central collection of objects are ax-scepters, flowers, and fringed staffs.

6. Three flowers crown the headpiece assemblage of the standard-bearer of Santiago (Corpus Christi series, Santiago Parish, Museo del Arzobispo, Cuzco, c. 1680) (Figs. 16, 37, and 38; Plate VIII). They emerge from a miniature maskapaycha, the ties of which are held by two serpents. All this rests on a stick camouflaged by a large, black-and-white, jeweled feather. A miniature castle rises on a stick from the supporting platform. Lounging atop the castle is a puma. This central motif is flanked by flowers, ax-scepters, and fringed staffs.

7. In the portrait of an anonymous ñusta (Museo Arqueológico, Cuzco, eighteenth century), a colonial Inka headdress is placed on a table and the princess rests her right hand on it (Fig. 27). The suntur

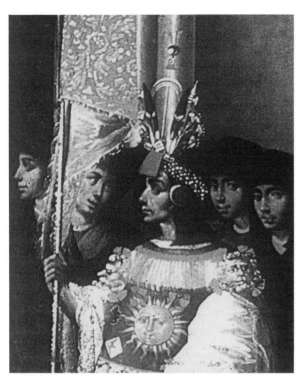

33. Anon., 1674–1680, *San Blas Parish*, detail of the standard-bearer's headdress, Corpus Christi series (Private collection, Santiago de Chile)

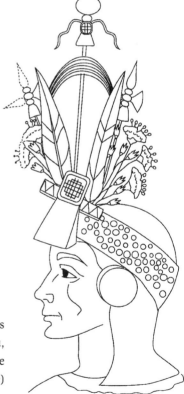

34. The standard-bearer's headdress in *San Blas Parish*, Corpus Christi series (Private collection, Santiago de Chile)

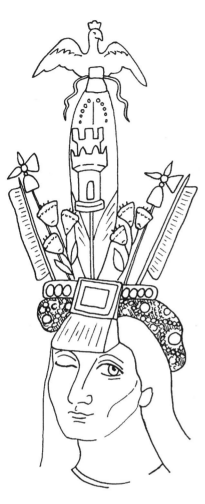

35. The standard-bearer's headaddress in *San Cristóbal Parish*, Corpus Christi series (Museo del Arzobispo, Cuzco)

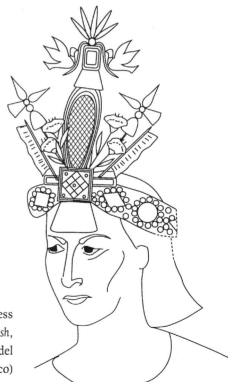

36. The standard-bearer's headaddress in *Hospital de los Naturales Parish*, Corpus Christi series (Museo del Arzobispo, Cuzco)

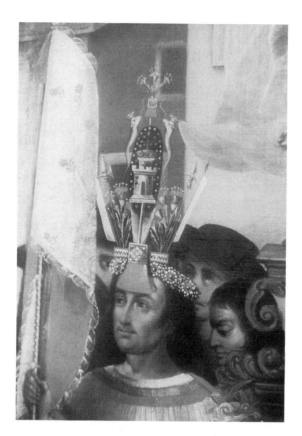

37. Anon., 1674–1680, *Santiago Parish*, detail of the standard-bearer's headdress, Corpus Christi series (Museo del Arzobispo, Cuzco)

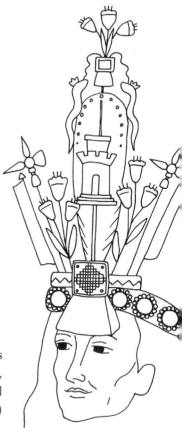

38. The standard-bearer's headdress in *Santiago Parish*, Corpus Christi series (Museo del Arzobispo, Cuzco)

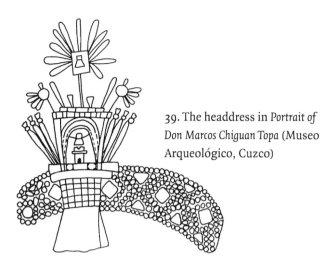

39. The headdress in *Portrait of Don Marcos Chiguan Topa* (Museo Arqueológico, Cuzco)

pawqar consists of a miniature Sapa Inka who dresses in pre-Hispanic fashion with a shield in his left hand and an ax-scepter in his right. Above him is a three-step pyramidal form which supports three flowers. Feathers, banners, and miniature shields are distributed symmetrically on either side of these central devices.[25]

8. In a second eighteenth-century portrait of a ñusta (whereabouts now unknown)[26] an Inka headdress sits on pillow to the subject's right. The central icons, from bottom to top, are a castle, a double-headed Hapsburg eagle, and a shield topped by a bouquet of feathers. Flowers, feathers, banners, and shields are distributed symmetrically at the sides.

9. In his portrait (Fig. 28), Don Marcos Chiguan Topa Coronilla Ynga (Museo Arqueológico, Cuzco, after 1745) wears a headdress which appears to be substantially the same as that associated with the anonymous ñusta discussed above whose portrait is now lost (Fig. 39); Gisbert (1980, 150) suggests that she may have been the wife of Don Marcos. The *suntur pawqar* contains, as a central element, a castle. It sits inside a frame which supports a *maskapaycha*. The headdress is topped by a trio of fringed shields. Flowers, banners, and feathers flank the central icons.

10. In the portrait of Don Alonso Chiguan Topa (Museo Arqueológico, Cuzco, eighteenth century) (Fig. 29), the subject appears to wear the same headdress as that shown with Don Marcos (Fig. 28) and the anonymous ñusta of the lost portrait.[27] Since he is clearly of the same

Inka (In)vestments 139

lineage as Don Marcos, it is likely that this particular headdress was utilized to identify members of this Inka family.

11. In the portrait of an anonymous nobleman (Museo Arqueológico, Cuzco, eighteenth century), a headdress sits on a table to the subject's right; its *suntur pawqar* element is very much like that of the Chiguan Topa clan. It features a castle as the central icon, and three fringed shields fly from the upper portion.

12–14. El Triunfo, the chapel connected to the cathedral of Cuzco, houses a painting from the first half of the eighteenth century, probably by the artist Marcos Zapata (or Sapaka). It depicts the legendary Marian apparition in which the Virgin appeared during the siege of Cuzco in order to save the Spaniards who were threatened by the rebel Andean followers of Manko Inka. In the foreground of the painting are three indigenous male donors, each of whom wears a colonial-period *maskapaycha*. Their *suntur pawqars* are identical, consisting of a central castle with protruding banners and feathers.[28]

Most of the elements found in these fourteen colonial *suntur pawqars* are named by various sixteenth- and seventeenth-century chroniclers as insignia of pre-Hispanic Inka nobility or royalty. Tucked into many of the headdresses are red and yellow flowers. Guaman Poma de Ayala ([1615] 1988, 150ff) shows similarly shaped blossoms in the headdresses of Andeans; apparently, flowers were a relatively common pre-Hispanic head adornment. Cobo ([1653] 1990, 185) identifies flowers as a standard part of Inka headgear. The Inkas revered several species of flowers, especially the *ñuqchu* and the *kantuta*; both have been identified as part of the headdresses of Inka nobility in the viceregal period (Pardo 1953, 16). Since flowers are present in most of the pictured colonial-period *suntur pawqars*, it is interesting to recall that Murúa ([1600–1611] 1986, 64, 84) defined *suntur pawqar* as a beautiful flower that, along with the *maskapaycha* and the *tupa yawri* ("royal pike"), was emblematic of the Sapa Inka's authority.[29] Miniature *tupa yawris* may be represented by the fringed staffs that appear in many of the pictorial headdresses.

The ax-scepters featured in most colonial headdresses are miniature versions of the weapon that Guaman Poma ([1615] 1988, 68ff) calls a "conga cuchona" (*kunka kuchuna*, "beheader") and depicts in the right hand of Sapa Inka Manko Qhápaq (Fig. 26). Pardo (1953, 7) identifies this weapon as "suntur pauccar"; like some of the chroniclers, he

seems to have confused emblems consistently featured in colonial Inka headdresses with other parts of the headdress assemblage.

Miniature pennants flying from some of the headdresses are likewise emblematic of Inka royalty. Cobo ([1653] 1979, 246) describes the Inkas as having "royal banners," which were small pennants of about fourteen inches square. Zuidema (1990b, 164) notes that some of these miniature banners display the *casana*, a design of four squares arranged inside a larger square, which was a significant motif on pre-Hispanic men's *unkus*. Other geometric decorations on the tiny banners are similar to other *tokapu* motifs. Apparently, then, many of the elements of the colonial *suntur pawqar* are miniaturized versions of emblems and objects associated with the authority of the Sapa Inka. The miniature *maskapaycha* fringe featured in so many *suntur pawqars* is, of course, the most salient of these. The suspension of a diminutive fringe in the *suntur pawqar* parallels the migration of *tokapu* from the waistband of the colonial tunic to spaces that, on pre-Hispanic *unkus*, had been left plain. The replication of both *tokapu* and the royal fringe, as well as scepters or weapons that were once held in the hand of the pre-Hispanic ruler but that became part of the colonial headdress, visually reiterated the royal heritage of the wearer. The colonial Inka headdress, like the tunics commented on by Isabel Iriarte (1993), were many times more vocal about the aristocratic heritage of those they adorned than pre-Hispanic garb and regalia had been.

Where, in pre-Hispanic times, the Sapa Inka would have been accompanied by a retinue of vassals carrying the various symbols of his rank, in colonial times those vassals have vanished and he bears all signs of authority—miniaturized and tucked into his headdress—himself. The headdress, especially the *suntur pawqar* portion, represents a telescoping of a procession featuring the Sapa Inka in which the colonial *cacique* performs not only as Sapa Inka but also as his own royal escort. The vocal vestment seems a poor substitute for the multitude of minions— vassals and armies—that once had evidenced the might of the Sapa Inka. While the colonial headdress certainly iterates authority, its subtext ironically articulates the diminished status of being an Inka noble under colonial rule, or of being a parish *cacique* in provincial Cuzco as opposed to being the ruler of the largest pre-Hispanic empire in the Americas.

Like the scarlet fringe, black-and-white *curiquenque* feathers of the

type that appear in several colonial *suntur pawqars* were also once an exclusive symbol of the Sapa Inka. These are seen most clearly in the headdress of the *cacique* from San Blas parish. The headdresses in the canvases of San Sebastián and the Hospital de los Naturales parish contain miniature *curiquenques* themselves. The *curiquenque* is a red-breasted Andean hawk, native to the highlands, whose feathers were prized by the Inkas. González de Holguín ([1608] 1901, 181) describes it as a white-and-black bird of prey ("ave de rapiña blanca y parda") and Garcilaso de la Vega ([1609, 1617] 1966, 1:374–375) relates how each succeeding Sapa Inka received two *curiquenque* feathers, his exclusive prerogative as head of state. Garcilaso (ibid.) saw these black-and-white feathers worn by the postconquest Sapa Inka Sayri Túpaq, who could rightly lay claim to them; he also writes:

They tell me that nowadays many Indians wear them and assert that they are descendants of the royal blood of the Incas, while the rest make fun of them, since the blood of the Incas has almost completely disappeared. But the introduction of foreign fashions has caused them to confuse the insignia they used to wear on their heads as a mark of distinction, and has emboldened them thus and in many other ways: all of them now say they are Incas and Pallas.

Of course, Garcilaso himself, whose mother was a *palla* (Inka noblewoman), had every reason, as did the twenty-four electors of Cuzco, to protect his own status against a rising tide of would-be Inkas. Clearly, display of these feathers was significant throughout the colonial period—from the sixteenth century, of which Garcilaso writes, until the eighteenth century, when some of the portraits discussed above were painted.

Several colonial *suntur pawqars* feature large feathers, centrally placed, that are either black or black and white. From their tremendous size they must be either condor or eagle feathers. Both the condor and eagle—and either one of these may appear in the *suntur pawqar* of the headdress depicted in the canvas of San Cristóbal parish—were revered Andean birds. The eagle symbolized Inka warfare, and the condor symbolized fertility and the underworld (Zuidema 1971, 37).

Many elements of the colonial *suntur pawqar* are zoomorphic, and all the animals depicted had special significance in pre-Hispanic times. The *curiquenque* is a part of what is identified as an Inka coat of arms

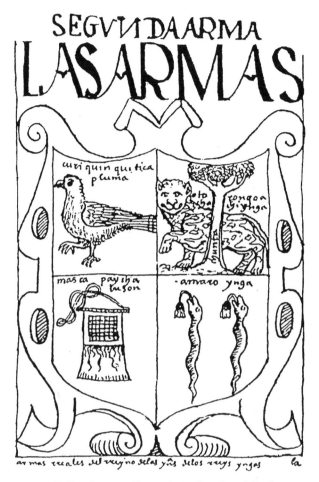

40. Felipe Guaman Poma de Ayala, 1613, folio 83,
Second Arms of the Inka (Guaman Poma [1615] 1988, 65)

in the chronicles of Guaman Poma ([1615] 1988, 65) and Murúa ([1600–1611] 1985, II) (Figs. 40 and 41).[30] These crests likewise contain serpents (*amarus*) and felines (puma and jaguars), animals that, like the condor, were symbols of fertility and the underworld and that were associated with times and places of transition and transformation (Zuidema 1983); significantly, in depicted *suntur pawqars* snakes are positioned just as were the *curiquenques*, holding the ties of the miniature *maskapaychas*, and snakes and pumas can both be found in blazons and in *suntur pawqars* at the ends of rainbows.

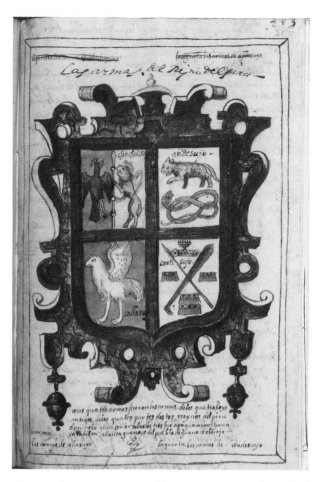

41. The J. Paul Getty Museum, Felipe Guaman Poma de Ayala (?),
Royal Arms of the Inka from *Historia general del Perú* by Martín de Murúa,
c. 1611–1613, pen and ink and colored washes on paper, 11³/₈″ × 7⁷/₈″

The rainbow (k'uychi) was a potent pre-Hispanic symbol. There was
a chapel devoted to the rainbow in the Qorikancha (the Inkas' main
temple) in Cuzco. While Murúa ([1600–1611] 1986, 438–439) and Ca-
lancha ([1638] 1974–1981, 857) describe it as a dreaded portent, the
native chronicler Joan de Santa Cruz Pachacuti Yamqui Salcamaygua
([1613] 1950, 214) describes it as a propitious sign. Cobo ([1653] 1990,
175) records that the appearance of a rainbow could mean either good
or bad fortune, that it was highly venerated, and that most Andeans did

not dare look at one. Significantly, the end of the rainbow was a *wak'a*, a sacred, powerful place.[31] The rainbow is also a mediating symbol (Zuidema 1977a; Isbell 1978, 209–210). Standing under the rainbow, as did the Sapa Inka in a chapel of the Qorikancha, was to claim to mediate between this world, the Upper World, and the Lower World.[32] The rainbow is not only itself mediative, but alludes to the mediative position of the *caciques* over whose heads it arches. Mediation, as we shall see, is one of the primary functions of the colonial *caciques* and one of the essential messages of the modifications they made to the colonial-period Sapa Inka costume.

While most of the elements of the colonial *suntur pawqar* are derived from pre-Hispanic symbolism, one key motif—the castle—would certainly seem to be European. It appears in four of the six Corpus Christi headdresses and in five of the portraits. J. Rowe (1951, 263) notes that the miniature castle, which he calls a "trophy castle," was a popular motif appearing on headdresses, coats of arms of native nobility, textiles, and *k'eros* (wooden drinking vessels) of the viceregal period. The castle, a conventional European heraldic device readily adopted by colonial Andeans, seems to have been based specifically on the coat of arms of Cuzco and therefore probably refers to the city itself. Zuidema (1990b, 164) suggests that the castle recalls the pre-Hispanic edifice known as the *sunturwasi*, a circular tower located in the *haukaypata*. The *sunturwasi* was used as a solar observatory by the Inkas in pre-Hispanic Cuzco and was a sacred structure sheltered by a special roof which, as it would have resembled the parasol that shaded the Inka and other sacred people and things, Zuidema argues, might have been called a *suntur pawqar*. His proposition is certainly interesting, and it might be that some in colonial Cuzco likened the castle on the city's coat of arms to a vaguely remembered *sunturwasi* (which had been destroyed in the sixteenth century).

Whatever edifice may have been called to mind, the most likely *visual* source for the castle in the *suntur pawqar* was the coat of arms for the city of Cuzco. King Charles V, on July 19, 1540, awarded to Cuzco a coat of arms featuring a castle of gold on a red background surrounded by eight condors (Fig. 42). In Spanish heraldry, the castle not only represented the kingdom of Castile but was a generic referent to a fortified city, and was, therefore, an allusion to warfare (particularly battles won). The grant itself, however, suggests that the castle on Cuzco's

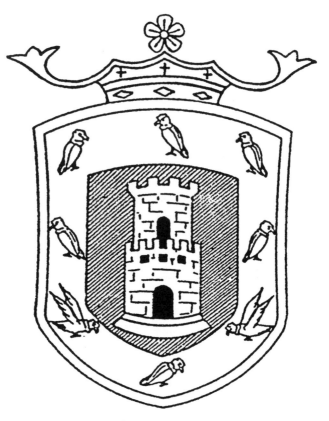

42. Coat of arms of the city of Cuzco

coat of arms referred specifically to the Inka architectural complex of Saqsaywamán, which towers over Cuzco on a promontory to the north. The grant reads:

In Madrid on July 19, 1540, a grant of arms is awarded to the city of Cuzco in which the arms that are given consist of a shield inside of which is a golden castle on a field of red in memory that this city and its castle were conquered by the might of arms in our service. It shall have a border of eight condors that are great birds, resembling vultures, that they have in the province of Peru, in memory that at the time this city was won, these birds gathered to eat the dead that died there.[33]

Referred to in this grant is the battle for the so-called fortress of Saqsaywamán which was fought in 1536 between Spaniards and rebellious Inkas under the command of Manko II, a son of the last pre-Hispanic

Sapa Inka (Wayna Qhápaq) and heir to the postconquest royal fringe. The retaking of Saqsaywamán by the Spaniards and their Andean allies was held to be the crucial success during this rebellion, in which much of the city was destroyed.[34] The castle on Cuzco's coat of arms thus refers specifically to Saqsaywamán, which was commonly called "the fortress" (la forteleza) by the Spaniards; and the castle form was, for residents of Cuzco, a shorthand reference to Saqsaywamán, the most notable of Inka remains in postconquest Cuzco (Dean 1998).

While Saqsaywamán did have at least one circular tower (Garcilaso de la Vega [1609, 1617] 1966, 1:468) that might have resembled European castles, the circular tower on Cuzco's coat of arms probably does not pretend to represent any specific structure.[35] Rather, the generic castle form came to be a symbol of the "fortress," the city in general, and its Inka past; it could therefore simultaneously have signified Saqsaywamán (and its circular tower), the sunturwasi, and the city of Cuzco in general, depending on the memories and interests of the interpreter.[36]

The symbolic replacement of the city and its Inka masonry foundations by a generic European fortress was a tacit conversion of Cuzco from Inka capital to Spanish colonial provincial seat (Dean 1998). This transformation was not accomplished readily, however, and for some time Cuzco's coat of arms, displayed within the city, incorporated Inka symbols. Gisbert (1980, 158) reports that the oldest coat of arms of Cuzco featured a tower with the sun and a bicephalic eagle on either side. Atop the tower were two condors. Over all was a rainbow, the ends of which emerged from the mouths of two serpents. At the zenith of the rainbow's arch was placed the Inka maskapaycha. The early shield was thus based extensively on Inka symbols, with the new European shorthand for a fortified site placed in the center. According to Mogrovejo de la Cerda ([1660] 1983, 131), the maskapaycha positioned above a castle was in his time (the mid-seventeenth century) still featured on Cuzco's coat of arms. Likewise, the shield displayed by the University of San Antonio Abad in the latter half of the seventeenth century contained a castle over an Inka diadem; two condors perched above the tower.[37] All of these coats of arms closely resemble colonial suntur pawqars. Since there is so much common ground between the colonial suntur pawqar of Inka ceremonial headdresses and the city's coat of arms, the sharing of symbols requires some discussion.

Ricardo Mariátegui Oliva (1951, 27), in his extensive study of the Corpus Christi series of paintings, first identified colonial *suntur pawqars* as akin to coats of arms. Indeed, colonial-period Andean nobility seem to have recognized a kindred symbol system in the European coat of arms and used the *suntur pawqar* as one of the spaces where they could develop a composite language of heraldry. Other chroniclers also speak of, but do not illustrate, Inka coats of arms or insignia, suggesting that pre-Hispanic Inka elites displayed certain heraldic symbols. Cobo ([1653] 1979, 246), for example, states that pennants bore emblems of the Sapa Inka, such as rainbows, serpents, pumas, and eagles. While postconquest-period chroniclers were undoubtedly interpreting pre-Hispanic practices in terms of European concepts, it does seem that individual Inkas, or noble families, were associated with particular images or combinations of images in such a way as to be conceptually similar to European heraldry.

After the conquest, the Spanish Crown awarded high Inka nobility with titles and coats of arms. In general, the conditions were these: being a male of royal Inka blood, serving the Spanish monarch in some distinguished way, and being Christian. Once granted, the arms could be displayed by the recipient and his legitimate heirs. Not surprisingly, the arms incorporated many of the same Andean emblems already discussed with respect to postconquest headdresses. The shield granted in 1545 to Cristóbal Paullu Inka, the son of Wayna Qhápaq (and the younger brother of Wáskar and Manko II) who had allied with the Spaniards against the rebel Inkas in the insurrection of 1535, for example, had a black eagle bracketed by two palm trees, a "tiger" (puma) flanked by two crowned serpents, the *maskapaycha*, and the legend "Ave Maria." [38] The two green palm trees symbolize the status of a loyal vassal (Santisteban 1963, 76), the words "Ave Maria" celebrate Christian conversion, and the crowned eagle is a traditional European symbol of royalty (the eagle was also significant in Andean terms, as mentioned above). The other motifs are entirely Andean in origin.

Also awarded in 1545 to members of the family of Sapa Inka Túpaq Yupanki, was a blazon divided vertically into two equal fields and then quartered by a centered horizontal band with the words "Ave Maria"; in the quarters were depicted a rampant royal eagle flanked by two "lions,"

each holding the ends of a rainbow, a *maskapaycha* held by crowned serpents, a castle, and a helmet (Montoto de Sedas 1927, 300).[39] These "official" coats of arms were proudly displayed both by legitimate and not-so-legitimate heirs throughout the colonial period. The coat of arms just described, for example, was painted on the residence of Don Francisco Guambo Tupa, who claimed descent from that lineage, in San Cristóbal parish during the early eighteenth century.[40] Don Marcos Chiguan Topa and members of his family, whose eighteenth-century portraits we have discussed, availed themselves of the arms granted to Cristóbal Paullu Inka even though they were only remotely related to him.[41]

Inka nobility eagerly adopted coats of arms as symbols of nobility; they also readily ignored European conventions regarding their proper exhibition. It is not at all unusual to find, in wills and in inventories of the belongings of the deceased, references to paintings of coats of arms that adorned the walls of elite residences in Cuzco, whether they had the "right" to be there or not.[42] The Inka noblewoman Doña Juana Engracia Cusi Mantar Roqa displayed at her early eighteenth-century home in Cuzco a painting of the arms of the then viceroy Don Fray Diego Morcillo Rubio de Auñón to which she had no "right"; she had his blazon hung near three canvases, each of which portrayed Sapa Inkas.[43] Her exhibition linked prior Andean royalty to the then "ruler" of Peru, constituting for herself a curious "lineage" in the halls of her home.

Inka coats of arms, such as those granted in the mid-sixteenth century, established a vocabulary of heraldic motifs that would, by the middle of the seventeenth century, migrate to the *suntur pawqar* portion of the colonial Inka headdress, where they enabled lesser nobility (or those with less clear pedigrees) to display heraldic motifs as evidence of their royal Inkaic heritage. European heraldry resonated with Andean elites, who did not wait for the Spanish Crown to award them rights to heraldic exhibition.[44] By the midcolonial period, nonofficial coats of arms became an important means of communicating Andean concepts of aristocracy. It is significant that Guaman Poma ([1615] 1988, 62–66), in his efforts to "write" an Andean history that would parallel that of Christendom, manufactured two so-called Inka coats of arms by filling in the European escutcheon with native heraldic symbols. While Europeanizing Inka heraldry, he maintained an essential

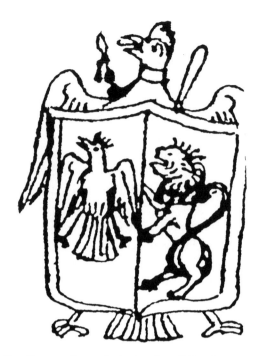

43. Felipe Guaman Poma de Ayala, 1613, folio 165, *Capac Apo Guaman
Chaua of Chinchaysuyu*, detail of the coat of arms
(Guaman Poma [1615] 1988, 144)

Andeanness—particularly in the fact that he fabricated *two* Inka bla-
zons, thereby responding to an Andean sense of necessary duality or
complementarity.[45]

Guaman Poma was not the only Andean to create fictive coats of arms
for the pre-Hispanic Inka emperors.[46] There is a painted blazon in a pri-
vate collection in Lima displaying what the legend says are the "Armas
de gran Manco Capac Inga Apo Tezse premero rei del cuzco" (Gisbert
1980, 158). In the eighteenth century, those who claimed descent from
Sapa Inka Sinchi Roqa obtained the right to use his "crest," which was
obviously of post-Hispanic invention. A version of Sinchi Roqa's coat of
arms is sculpted on a portal in Maras, near Cuzco; it includes a *maska-
paycha*, rampant lions, Christ's IHS monogram, and a cross (ibid., 166).
Also, nobles living in the parish of Belén, who claimed descent from
Sapa Inka Túpaq Yupanki, guarded a painting of that emperor's coat
of arms.[47]

Colonial nobility—and those claiming noble status—also invented

coats of arms for themselves. Guaman Poma devised a blazon for his own family which consists of a falcon (waman or guaman) and a puma (poma). He shows this crest accompanying his pre-Hispanic ancestor Capac Apo Guaman Chaua; elsewhere he avers that the falcon-puma design is also the arms of all of Chinchaysuyu, the quarter of the Inka empire from which the native artist himself hailed (Fig. 43). Diego Quispe Tito, the Cuzqueño painter of Inka heritage who may have audaciously portrayed himself wearing the maskapaycha, also painted himself a blazon on the outside wall of his house in the parish of San Sebastián (Gisbert 1980, 164).

Through the fabrication and display of crests, Andean elites re-created themselves in the image of European nobility. Thus, although Andeans were clearly the movers behind this explosion of "new" heraldry, they were encouraged by Hispanics who valued the notions of aristocracy that blazons expressed. Not surprisingly, the Jesuits are situated in the midst of this heraldic hybridity. The lintel of the entrance to their Colegio de San Borja displayed an "Inka" blazon alongside the conventional Jesuit monogram (IHS) and the shield of Spain (Fig. 44). The lintel can be read as a sort of heraldic Rosetta stone for the Andes.[48] Juxtaposed with the castle and lion of Castile and León is the "Inka" coat of arms featuring a bicephalic eagle with a helmet, holding a shield divided in thirds. In the lower left of the shield is another bicephalic eagle and the legend "Ave Maria"; in the lower right is the tower of Cuzco and, in the upper half, the royal fringe is held by two crowned serpents under a rainbow which emerges from the mouths of two pumas (Fig. 45). This crest may well have adorned the tunics of students at San Borja (Cummins 1991, 219).

A similar parallel presentation of Spanish and Inka arms can be found in Juli, a small town in the southern highlands of Peru that, after 1576, was the seat of a Jesuit college, where, on an early eighteenth-century portal, are displayed the arms of Spain paired with those of the Inka (in this case the chambi, Inka helmet with a sun, the maskapaycha with two feathers, a castle, two serpents, and two pumas) (Fig. 46).[49] Thus, modified Inka heraldic motifs made the transition into the colonial period, assuming a place alongside traditional European heraldic elements much as the Inka caciques themselves as modified pre-Hispanic Inkas entered into the Corpus Christi procession. Through juxtapositioning, encouraged by the Jesuits, Andean concepts of aristocracy were equated with those of Spain, and through such displays Andean heral-

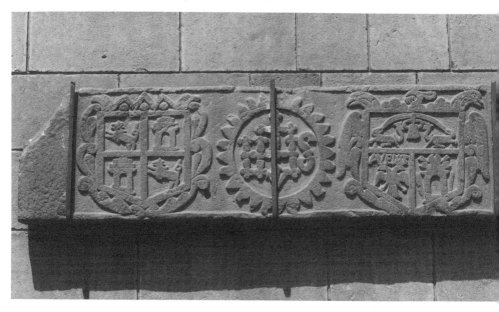

44. Lintel (*above*), c. 1670, Colegio de San Borja, Cuzco
45. Lintel (*below*), c. 1670, detail of Inka crest, Colegio de San Borja, Cuzco

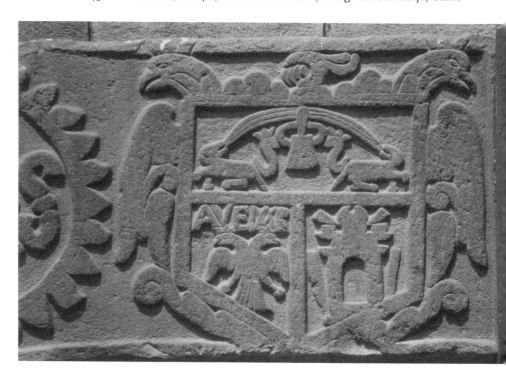

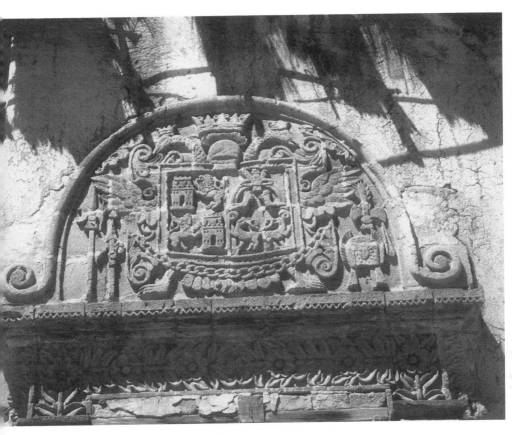

46. Portal crest, midcolonial period, Juli

dic motifs (such as the *maskapaycha* and rainbow) became part of the colonial vocabulary of heraldry. Not surprisingly, then, colonial-period documents frequently identify the *maskapaycha* and other royal insignia as the "armas" of the Inka and they became thought of in that way.

Although coats of arms were granted to natives of royal descent in New Spain (Mexico), the inventive vigor and insistent display that occur in the colonial Andes, but not elsewhere in the Spanish colonies, suggest some special convergence of Andean and European symbol systems. The language of heraldry combines pictographs and logographs with symbolic, abstract shapes and colors; the motifs are often metonymic (as in the medieval tower which signifies a fort which, in turn, indicates a fortified city and often a specific battle for possession of that location). This nonnarrative presentational mode operates mnemonically: the colors, shapes, and images can *commemorate* but not *record* per-

sonages, places, organizations, events, and even states of being. That is to say, the heraldic pictorial record utilizes a semistandardized vocabulary of colors and designs, but depends on the presence and memory of a knowledgeable interpreter. Knowing "rules" of heraldic grammar allows only a partial interpretation of heraldry. Given the abstract and mnemonic nature of pre-Hispanic Inka recordation (including *tokapu* and the *quipu*, a device on which data were recorded in a variety of knots on colored string), which likewise depended on a remembering or memoried interpreter, it is not surprising that Andeans rapidly appreciated the field of signification offered by the European coat of arms.

If Andean motifs became part of the language of colonial heraldry, it must be noted that the rhetoric of Andean heraldry shifted significantly. Whereas European heraldry is primarily (though far from exclusively) pictographic, Inka heraldry was much less naturalistic. *Tokapu*, the woven rectangles displaying intricate abstract designs, may be our best examples of Andean heraldry. Zuidema (1982, 447–449) has characterized *tokapu* as heraldic emblems corresponding to Andean political groups, while David Vicente de Rojas y Silva (1979 and 1981) interprets *tokapu* as symbolic referents to specific noble lineages (*ayllus* or *panacas*).[50] Interestingly, in the early eighteenth century an Inka noble-women's *cumbi* shawl (*lliclla* or *lliqlla*) was described as displaying "arms" ("una lliqlla de cumbe . . . con sus armas en medio") (ADC, Alejo Fernández Escudero, leg. 100, 1720, fols. 877r–895r, Inventory of the belongings of Doña Juana Engracia Cusi Mantar Rocca, October 1, 1720). Since colonial *lliclla*s (like those of the pre-Hispanic period) commonly featured rows of *tokapu*, these abstract motifs may well be referred to as "armas" in this description.

Andean abstract heraldry constituted a portion of the colonial composite language of heraldry. The pre-Hispanic *casana* design, for example, consisting of an arrangement of four squares within a larger square and symbolizing the Sapa Inka's identity as Axis Mundi, was incorporated into colonial headdresses where it appears on miniature banners in colonial *suntur pawqars* (Zuidema 1990b, 164). Andean abstractions such as *tokapu* on colonial-period garments are often juxtaposed with motifs, such as flowers, that are represented naturalistically following the European visual regime (Iriarte 1993). Representational imagery also invades the *tokapu* space in colonial garments. European-style heraldic motifs occasionally appear in surviving colonial Inka tunics. Also, in one of the copies of the painting depicting the marriage

of the Inka princess Doña Beatriz to Don Martín García de Loyola, the ñusta's garment features rows of abstract tokapu; framed by one of the rectangles is a naturalistically portrayed maskapaycha.[51] Similarly, in the portrait of an anonymous ñusta, one of the tokapu rectangles contains not Inkaic abstractions but a crescent moon, a gold disk, and two black birds holding a waraka (an Andean slingshot weapon) (Fig. 27). Significantly, black birds flanking a gold disk are featured on miniature banners tucked into the suntur pawqar portion of the headdress on the table to her right. Tokapu as well as suntur pawqar became sites where pre-Hispanic Andean heraldry and European heraldry were forged into colonial Inka heraldry.

Visual Rhetoric

While pre-Hispanic Andeans and Europeans seem to have possessed like heraldic practices, the heraldry differed in formal terms. All of Guaman Poma's illustrations of shields and banners held by Inkas show only abstract, geometric motifs akin to tokapu. Thus, although Europeans and Inkas held kindred heraldic concepts, they were probably markedly different in formal articulation. The naturalistic motifs gracing colonial-period coats of arms and suntur pawqars, and invading tokapu space, are a translation of Inkaic heraldry into a Europeanized system of mimetic representation.

Tom Cummins (1988) has explored this transformation in his study of k'eros—pre-Hispanic and colonial-period wooden ritual drinking vessels (see also Cummins 1995). He concludes that the primarily abstract, geometric, and hieratic heraldic system of the Inkas was transformed into a European naturalistic mode after the conquest, indicating the Europeanization of the native elite, who manipulated European as well as Andean signs to their own benefit. He points out how k'eros, suntur pawqars, and textiles produced during the colonial era share a set of motifs regularly featured on viceregal coats of arms. Each of these items was a colonial-period forum for the invention of a new Andean heraldry, one that forged a complex significatory network of European and pre-Hispanic Inkaic heraldic elements.

The colonial suntur pawqar composites European motifs (e.g., the castle) and Andean heraldic substances (special feathers and flowers), along with new transculturative hybrids such as naturalistic representa-

tions of animals (*curiquenques*, pumas, serpents, etc.) which symbolized Inka royalty but which were not part of pre-Hispanic headdresses. The miniature weapons, banners, and *maskapaychas* likewise represent colonial articulations that came to reiterate nobility cross-culturally. Analysis of the composition and arrangement of these elements of the colonial headdress suggests that while European modes of representation gained a formal foothold, pre-Hispanic Andean structure continued to order and empower the colonial *suntur pawqar*.

Colonial *suntur pawqars* always feature a central motif or collection of motifs framed by supplementary icons that fan out above and to the sides. In structure they are very similar to what the indigenous chronicler Joan de Santa Cruz Pachacuti Yamqui Salcamaygua drew in the second decade of the seventeenth century as the main altar inside the Qorikancha, the Inka's main temple in Cuzco (Fig. 47).[52] In that image, which appears to represent a diagram of the cosmos, the oval Wiraqocha (Viracocha), the Andean creator deity, is the central motif. Also along the central axis are two stellar constellations (one above and one below the oval creator), a human couple (*q'ariwarmi*), and a grid labeled "collcapata" (storage place) and "coricancha uaçi" (house of the Qorikancha or house of the golden compound). Comparing the drawing to the *suntur pawqar*, we find that both feature a strong central axis with an array of supplementary motifs which are symmetrically balanced. Further, the oval of Wiraqocha echoes the central condor feather or oval space formed by a rainbow while the grid visually approximates the *tupaqochor*. It is not unlikely that the colonial *suntur pawqar* was an assemblage whose structure echoed the ideal organization of the Andean cosmos.

Although Duviols (in Pachacuti 1993, 30–58) suggests that the Christian *retablo* provided the model for the Pachacuti drawing and offers persuasive evidence that Christian doctrine determined the elements of which it is composed, the distribution of those elements and their gender associations seem to be distinctly Andean (Dean n.d. a). Many scholars have observed the complementary distribution of motifs in which "male" elements (the sun, morning star, summer, mountains) appearing on the right-hand side (from the perspective of the drawing itself) are balanced by "female" elements (moon, evening star, winter, the sea) on the left (see esp. Isbell 1976). This arrangement echoes the organization of the pre-Hispanic Inka imperial headdress in which the feather from the right wing of a male *curiquenque* was worn to the

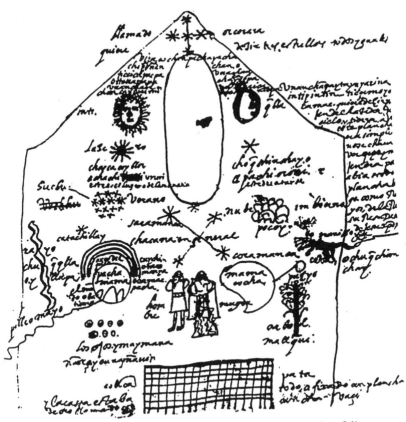

47. Joan de Santa Cruz Pachacuti Yamqui Salcamaygua, c. 1613, folio 13v,
"Interior wall (altar) of the Qorikancha" (Pachacuti 1993, 208)

right of the fringe, while the feather from the left wing of a female curi-
quenque was worn to the left (Esquivel y Navia [c. 1749] 1980, 1:20).[53]
Some colonial headdresses feature feathers arranged in pairs on either
side of the central axis; it is likely that these feathers were gendered as
in pre-Hispanic times. That all supplementary motifs composing the
colonial *suntur pawqar* are mirrored by their doubles across the central
axis suggests that the colonial *suntur pawqar* itself was conceived of as
consisting of complementary pairs and thus maintains an interest in
symmetry that—as Cummins (1995, 69), who observed this organiza-
tion of motifs in other colonial Andean artifacts, points out—parallels
and actuates Andean sociopolitical organization around complemen-
tary opposition.

According to Pachacuti's diagram, the center represents an androgy-

nous space (Isbell 1976 and 1978). At the top, the oval Creator, identified as being both male and female, represents the same unity that is expressed in the human couple lower in the diagram. In many highland Andean communities the couple is still regarded as a single unit and is referred to in Quechua as q'ariwarmi (man-woman) or warmiq'ari (woman-man), and in Aymara as chachawarmi (man-woman) (Harris 1978; Platt 1986; Allen 1988, 72–77). The center space of the diagram thus witnesses tinkuy, a Quechua word that signifies a highly charged coming together of complements.[54]

Since the supplementary elements in the colonial suntur pawqar are carefully balanced, suggesting a conceptual complementarity akin to Pachacuti's diagram, can we read the central sector as a site of convergence, of tinkuy? That the rainbow and feline which are placed centrally in some colonial suntur pawqars have already been identified as emblems of mediation allows at least for this possibility. The most frequent central element in the colonial suntur pawqar—the castle—also suggests tinkuy. If we accept that the castle represents the city of Cuzco, then it is significant that Cuzco was built at a tinkuy—the meeting of the Watanay and Tullumayu rivers. Like most Andean communities, Cuzco was divided into two complementary sectors (anan and urin). Garcilaso ([1609, 1617] 1966, 1:44–45) and others hint that these sectors were conceived of as male and female since, according to the legend of Cuzco's Inkaic founding, the anan (upper) sector was settled by a male (Manko Qhápaq), while the urin (lower) sector was settled by his sister and mate. The city, then, was a powerful site of convergence and we may at least hypothesize that the castle was planted in the center of the colonial suntur pawqar to suggest that that site represented a place of tinkuy as well.

Significantly, that "site" was the colonial cacique. The body of the Inka cacique is visually described by the suntur pawqar as a site of convergence, a place empowered by the bringing together of complementary opposites. In fact, in the Inka blazon on the lintel of San Borja and elsewhere, the royal fringe is appended to the rainbow; this converts the rainbow, a sign of mediativity, into a llawt'u and suggests that the wearer of the maskapaycha occupies an interstitial position. When these motifs span a castle—as happens in coats of arms and in suntur pawqars—the castle and the cacique's body become visual metaphors for one another. That in one colonial headdress the primary motif along the central axis—where so often one finds a castle—is a miniature Sapa Inka instead,

seems to confirm that the colonial Inka *caciques* presented themselves as locations of powerful conjoining.

Because of the complementary structure of the Andean universe, mediation and things (including individuals) that mediate have profound significance in Andean culture.[55] The colonial-period festive vestment, especially the *suntur pawqar*, worn by Inka *caciques* announced their bodies as sites of both cultural and political mediation. Their costume, like their heraldry, was designed for a colonial context in which many elements are Europeanized in appearance but organized in a way that makes Andean sense. Whereas European visual discourses tend toward the illustrative, Andean traditions are processual, emphasizing the act rather than the outcome; in colonial vestment and regalia, the Andean is manifested in the dynamic between forms as well as in some of the forms themselves. This arrangement foregrounds the cultural mediativity of the colonial *cacique* and places him precisely between colonizer and colonized. Thus did Inka *caciques* continue the identification of the Sapa Inka—their public selves—as Axis Mundi.[56]

In the colonial Sapa Inka costume devised by Inka *caciques* to define their public personae, the individual elements—Andean, European, and cultural hybrid—speak simultaneously about nobility, but neither in unison nor in harmony. In pulling the argumentative pieces together, *caciques* actuated mediativity. Their composite vestments did not so much *illustrate* interstitiality as *demonstrate* it. They are Andean. They are Christian. They are Inka rulers. They are Spanish subjects. And they are all these things simultaneously. As shall be seen in the following chapter, theirs was an ambivalent place—a subject, but not abject, space.

Chapter 7

The Composite Inka

John Howland Rowe (1954, 18ff), responding to the numerous colonial-period evocations of the pre-Hispanic Inkas by colonial Inkas, characterized the second half of the seventeenth century in the southern highlands as the beginnings of an Inka renaissance. Because many of the references to the Andean past were made in a Europeanized form—that of mimetic representation—it was a regeneration born of acculturation (Cummins 1988, 563n28). In much the same way that early modern Italians understood themselves as giving new life to classical antiquity, midcolonial Inkas selectively reinterpreted pre-Hispanic motifs and concepts, and so "gave birth" to a new way of being Inka. By investing the past with new meanings, they reinvented their ancestors and thereby invented themselves (or, at least, their festive selves) as their ancestors reborn. Although "renaissance" does not, perhaps, adequately describe all the nuances of their cultural strategy, it does highlight a significant portion of their agenda.

Elsewhere, I have used the term "renewal" to characterize the colonial process of investing traditional forms derived from one culture with new, transcultured meanings (Dean 1996b). Andeans renewed European imagery at the same time as they "renaissanced" pre-Hispanic motifs. In the previous chapter, we investigated how, in festive costume, Inka *caciques* juxtaposed both renewed and renaissanced forms, thereby creating cultural composites. In this chapter, I focus on how the process of creating cultural composites positioned Inka *caciques* ambivalently in colonial culture by figuring them, paradoxically, as subjected rulers.

Considerable attention has been devoted over the past two decades, especially by theorists of postcolonial discourse, to whether the cultural work of colonial elites is empowered or enfeebled by its inevitable hybridity or, as I call it, its *composite nature*. Although I am wary of essentializing generalizations, the specific case of midcolonial Inkas argues not for an "either/or" scenario but for a "both/and" situation in which the colonized simultaneously recognized their subordinate positions and resisted the totalizing claims of colonial authority. In addition, the dialectic concerning the submission to, versus the subversion of, dominant discourses has tended to focus only on the relationship between colonizing authorities and a certain elite sector of the colonized. In this discussion, male Inka elites have been centered. Examining their strategies, it becomes clear that much of their cultural work engaged not just Hispanic authorities but other Andeans. As noted above, Inka *caciques*, in an effort to enhance their own positions, employed strategies of exclusion designed to alienate their Andean rivals from colonial discourses of power. In the present chapter, then, the consequences of these strategies for the male Inkas who enacted them, as well as for Inka noblewomen and other Andean ethnic groups, will be considered.

The Inka Reborn

Cummins (1991, 218ff) uses the pejorative "bastardized" to condemn the colonial *maskapaycha*. "Bastardized," a highly charged adjective, both genders and pacifies Inka culture, marking it as the feminized victim of illicit, potent European male sexual conquest. However, the colonial *maskapaycha* (as demonstrated in Chapter 6 above) was an affirmation of mediativity which asserted an Andean appreciation of the in-between. Rather than being the shameful product of cultural miscegenation, the colonial *maskapaycha* celebrates the interstices. To deny its Andean value and structure because of its partially Europeanized appearance is necessarily to perpetuate Western colonial discourses wherein hybridity is denounced as impurity.

Colonial Inka leaders were compelled, both by subtle and by not-so-subtle acculturative pressures, to Hispanicize. Yet, as Homi Bhabha (1984) has argued, although colonized elites are often induced to *mime* the colonizer, they can never *be* the colonizer. Thus, hybridity is the inevitable and ultimate product of colonization. Because colonization

deliberately produces cultural hybrids, hybridity ought to be understood as the cultivated fruit of colonization, rather than deprecated as a polluted by-product (or, for that matter, applauded as a felicitous happenstance). Expressions of pre-Hispanic indigeneity were not an option for Andeans once the Spanish colonial presence was brutally established. Any search for the "authentic" Inka, the Inka untouched by colonization, fossilizes the Inka in the past and denies the colonial transformation of Inka lives. The fetishization of "the authentic" dismisses a priori subaltern activity which must necessarily be hybrid.[1] Hence, colonial "Sapa Inka" costume is Inka despite all its hybridity; it is simply (or not so simply) not pre-Hispanic Inka.

Because colonial Inka costume could never be mistaken for pre-Hispanic Inka costume, we profit by attending to what has changed and why it changed (Stastny 1993). The previous chapter has shown how the modifications in vestments ought to be regarded as solutions to colonial cultural hegemony rather than problems of (in)authenticity. The visual citations of pre-Hispanic motifs contained within the hybrid or composite vestments are neither evidence of some valiant (albeit ahistorical) resiliency nor of stubborn resistance, but rather are measured responses to the pull and push of colonial cultural hegemony, the contradictory command to be like Spaniards, only different. The same can be said of the Europeanizations made to the costume and its formal articulations. In colonial Inka costume we see that Inka leaders not only recognized the mimetic trap—the inevitable composite nature of their social and political identities—but positioned mediation as central to their public personae.

With their Hispanicized and ethnic bodies, colonial Inka caciques bridged both cultures and eras. In a certain aspect, their way of occupying the in-between space anticipated modern (re)considerations of nepantlism, a concept introduced by Miguel León-Portilla (1974, 24) and amplified by Jorge Klor de Alva (1982, 353–355) and others. Nepantlism, derived from nepantla, the Nahua (central Mexican) concept of the middle, or being in the middle, was originally defined and discussed as the colonial and postcolonial predicament of belonging nowhere, of being stuck in the in-between. Recently, Chicano theorists have begun to recuperate nepantlism by defining it as belonging manywheres and refusing to be split (e.g., Anzaldúa 1987 and 1993). In redefining nepantlism, contemporary activists are expanding the Nahua nepantla to approximate the Quechua tinkuy;[2] they are reconceiving

the place of meeting as a site of empowerment. Colonial Inka elites, armed with the ancient Andean concept of *tinkuy*, appear to have foreshadowed recent appreciations, if not celebrations, of the in-between —Gloria Anzaldúa's "borderlands" or what Bhabha (1988) has termed the "Third Space." Although Bhabha refers to *words* spoken from this Third Space, the colonial Inkas found, if not the words, the *images* through which they could position empowered, interstitial selves. As I argued in the previous chapter, valuing mediation is a quintessentially Andean gesture in its validation of the in-between. Viewing the interstices from an Andean perspective, then, requires one to abandon the European notion—arguably a racist one—of mixture as impurity and inauthenticity.

It has been asserted that for the colonial Inka elites to utilize the significatory system of the colonial regime, as they did in portraits of themselves and in the modifications they made to pre-Hispanic Inka costume, was to self-subjugate, to make themselves the Other of the European gaze. Cummins (1991, 208) concludes that portraits of Inka elites in the colonial period, and we may assume their performances as well, permitted Andeans to celebrate their Indian heritage "in such a way as to inculcate passive acquiescence to Spanish rule and relentless economic exploitation." As one critic has queried, how can we reconcile Cummins's alienated, acculturated, and compliant *caciques* with John Rowe's (1954) utopian visionaries who strengthened their colonial hands by evoking the pre-Hispanic past (Majluf 1993, 242)?[3] Rowe (1954 and 1957, 158), in fact, understands midcolonial evocations of the pre-Hispanic imperium as incipient Inka "nationalism." He sees them as anticipating, if not fostering, eighteenth-century rebellions against the colonial government, such as that of José Gabriel Túpac Amaru (1780–1782), in which the notion of a reborn Inka empire furnished inspiration. Similarly, Angel Guido (1941, 18) recognized in the same material an "esthetic rebellion" that foresaw the political insurrections of the following century. Did Inka *caciques* evoke their heritage out of strength or out of weakness?

Given the fact of colonial domination, the ethnic body is inevitably a disempowered body. Why, then, in performance and portraiture, did Inka *caciques* emphasize their "ethnicized" heritage? Inka *caciques* appear to have recognized the ambivalence inherent in their mediative positions—the necessity of being both native nobility (therefore pedigreed to retain political positions) and Christian (therefore "suitable" for Spanish service). On the one hand, the Inka elites' indigenous ancestry gave them status within Cuzco's political hierarchy; on the other hand, political power was explicitly granted through the Spanish system. Certainly, Inka leaders recognized that Andean signs of status had political value in part because the Inka *caciques* who administered local populations for the Spanish colonial government had status precisely because of their pre-Hispanic heritage. It was in their interest, therefore, to be members of the indigenous nobility and to render the signs of Andean nobility in a manner easily apprehended by the Spaniards.

Since their bodies (in their ethnic alterity) were always, already marked, Inka nobles played the royalty card—and for them it was, in no way, a game. They used European notions of royal privilege, pictorially voiced in partially Europeanized visual rhetoric, to elevate themselves above other subalterns. In the colonial portraits, through conventionalized European pose and gesture, Inka subalterns imag(in)ed themselves into Spanish society as noble lords (Cummins 1991). The Inka past, as it was imagined by Inka *caciques* and created for audiences in midcolonial Cuzco, served to bolster Inka positions within, rather than challenge, the colonial structure. Thus, the elite Inka body of midcolonial Peru was *simultaneously* enfeebled by ethnic markers *and* empowered through associations with the imperial past.

I do not agree, however, that the "formal similarities [between colonial portraits of Inka elites and Western portrait traditions] mitigate the 'Indianness' of these Peruvian figures" (Cummins 1991, 211). The formal aspects of the portraits mitigate the *fear* of alterity which constantly menaced colonial authority (see Chapter 3 above), not the *fact* of their alterity. Indigenous elites understood very clearly their role as Christian and Christianizing forces, and as linchpin figures in local colonial administration. Their performances of "being Inka" necessarily manifested a paradoxical position by acknowledging subservience to Spanish authority, yet proclaiming privileged status as descen-

dants of Inka rulers. In formulating a postconquest identity, they did not jettison their ethnicity (or their own understandings about being Andean) but, rather, flaunted it in such a way as to appeal both to their constituents and to their superiors. *Caciques* in the artfully modified dress of Sapa Inkas could simultaneously commemorate a proud past and "fit" their present, for it was owing to the past that they held status in colonial society. As Vicente Rafael (1993, 136) states in his study of Tagalog in the colonial Philippines, "To recognize the authority behind the ensemble of Christian signs was not necessarily to accede to Spanish signifying conventions and the interests they implied." He also notes, however, that many of the colonized *did* submit to colonial authorities and subordinate their own interests to those of the authorities who held power over them.

Regardless of the intentions of the individual (whether to comply, resist, or cope), the performance of "Sapa Inka" was, in the end, defined by the regime of mimesis out of which it was generated. The Inka *cacique*, dressed for festival as his royal ancestor, was a "mimic man," a term coined by Jenny Sharpe (1989) to describe a "contradictory figure who simultaneously reinforces colonial authority and disturbs it." Whether intentionally or not, the costumed *caciques* of Cuzco's Corpus Christi vexed colonial authority because their mimicry was always, necessarily insufficient to erase alterity. Because hybrid articulations of the colonized subject necessarily menaced the colonizing authorities, "nationalist" or "rebellious" sentiments could be located in mid-colonial evocations of the pre-Hispanic Inka by eighteenth-century insurgents. As Bhabha (1984) points out, every discourse of domination contains the tools with which it may be dismantled. Indeed, resistance was *there*, embedded in the performances of Inka *caciques* and in the pictorial records of those performances, insofar as those evocations, though utilizing Europeanized modes of signification, were partial acts of self-definition by the subaltern.

Whether intentional or not, the appropriation of the colonizer's visual rhetoric by Inka *caciques* was essentially a subversive strategy, for the adaptation of European visual language to the demands and requirements of the place and society into which it had been appropriated amounted to a subtle rejection of the political power of unmodified European visual discourses.[4] Simon During (1987) has explored the problem of how the colonized might use the colonizer's language to "speak" themselves—that is, to articulate native identity—without, in

the end, being spoken by it, without having it define them. He writes: "For the post-colonial to speak or write in the imperial tongues is to call forth a problem of identity, to be thrown into mimicry and ambivalence" (ibid., 43). His essay boils down to this question: Do subalterns (or any human beings) use cultural tools to express themselves, or do the tools inevitably shape those who use them? Although the tools—European modes of representation—used by the midcolonial Inkas defined the perimeters of what they might create and how they created, in the end the tools did not determine what the Inkas created and certainly did not determine the colonial Inkas themselves. Inka *caciques*, in composing and wearing the costumes we have studied here, fully exploited their compulsory mediativity, turning Europe's flaccid impurity into Quechua's puissant *tinkuy*. As stated earlier, the visual record of their response to acculturative pressures suggests that although they were indeed subject, they were emphatically not abject.

W. H. New (1978, 362–363), considering much the same question as Simon During would address later, concludes: "Writers who imitate the language of another culture . . . allow themselves to be defined by it." He goes on to say, however, that the "best" postcolonial authors who write in the language of the colonizer do "more than just use the language; they have also modified it, in the process generating alternative literary possibilities." Similarly, Edward Kamau Brathwaite (1984, 13) uses the term "nation language" to describe how the Caribbean English of some postcolonial Caribbean writers is not the same English as that which is a tool of colonial authority: "English it may be in terms of some of its lexical features. But in its contours, its rhythm and timbre, its sound explosions, it is not English, even though the words, as you hear them, might be English to a greater or lesser degree." He goes on to note that people, not languages, have agency. Thus, European visual lexicons can and did communicate very non-European things when "spoken" by Andeans. Representational realism, in the European manner, when used by Inka *caciques* in their costumes, portraits of themselves, and other midcolonial artifacts, did not impart only European perceptions of the world. The "style" may have been partially non-Andean, but the order, structure, and message were not.

Visual Citation

Although colonial Inkas (carefully and selectively) *cited* European visual discourses, they cannot be said to have *quoted* Europeans. Quotation, like During's "imitation," comes from a point of weakness, giving, as it does, the voice and authority to another. Citation, in contrast, utilizes the knowledge possessed by another for one's own ends. It therefore implies at least limited control over enunciation. Inka *caciques* exercised discrimination in what and how they Europeanized their public personae. Although their choices were limited and circumscribed, the very fact of choosing allowed them to evade the triumph of the *Spanish* festival and participate in the triumph that was the *Cuzco* festival.

The visual language in which midcolonial Inka *caciques* "wrote" cannot be characterized accurately as a visual dialect of either Spanish or imperial Quechua.[5] It is a third language enunciated from the Third Space, a visual interlanguage that gives voice to the hyphen implicit in Andean-Hispanic forms. Borrowing Brathwaite's formulation, then, the composite costume worn in Corpus Christi can be viewed instructively as a "nation language" of colonial Inka *caciques*. Even though participation as Inka *caciques* in Corpus Christi and other Christian festivals involved compromise, midcolonial Inka elites were less capitulatingly, or even accommodatingly, Christian than they were Inka Christians who defined their ethnic alterity in their own (Andean) ways. Or perhaps colonial Inka elites can be said to have both resisted *and* capitulated: by neither opposing nor complying they occupied the Third Space and visualized the hyphen. They thereby eluded the totalizing triumph of the imported Corpus Christi festival.[6]

Inka *caciques* negotiated a new Andean nobility, inventing a visual language that was Andean in many of its sources and certainly in its structure, but legible to Europeans by virtue of the shift to naturalistic modes of representation. This shift in representational systems can be seen in many aspects of the colonial Inka costume, from elements of the *suntur pawqar* to the anthropomorphized solar pectoral. Cummins (1995, 69) has characterized the colonial Andean introduction of Western forms into what he terms "the syntagmatic chain of Andean metaphor" as "appropriation." Appropriation, like citation, proceeds out of the ability and power to self-define.[7] As Cummins recognizes, and eloquently explicates, this is an Andean way of understanding European things, rather than a Europeanization of Andean expressive modes.

The self-defining gesture seen in colonial "Sapa Inka" costume is more than and different from a translation of Andean concepts of nobility and interstitiality into European expression. Inka *caciques* have not, or not just, rendered Andean forms in European style; rather, they have attempted to re-create the character of Andean visual composition in European terms. To borrow a useful notion from Chantal Zabus's 1991 study of postcolonial West African authors who write in French and English, the colonial Inkas have "relexified" Andean signs of nobility by rendering Andean visual tropes into recognizable European signification. Relexification is neither translation nor transcodage, for the source is not absent; rather, its meanings, concepts, and thought patterns are expressed. Zabus (1991, 106) notes that "relexifications" are "palimpsests for, behind the scriptural authority of the target European language, the earlier, imperfectly erased remnants of the source language are still visible." Similarly, the Andean ideal of *tinkuy* orders the colonial *suntur pawqar* and is perfectly perceptible despite its altered form.

Colonial Inka *caciques*, when dressed as festive Sapa Inkas, demonstrated their ability to self-define by reclaiming their bodies from the mimetic trap set for them by compulsory participation in Corpus Christi and other major Christian festivals. Rather than appearing as passive Others, defined by Europeans, they highlighted their crucial mediativity. They did this not by bringing the Andean in line with the European, nor vice versa, nor by combining—syncretizing—the two. In fact, it was very much in their interest to keep the two worlds apart, in contradistinction, and therefore in potential (but never actual) conflict. In that way, their value as intermediaries was actuated. Rafael (1993, 166), in his study of Tagalog in the colonial-period Philippines, perceives a similar phenomenon and makes the critical observation that colonized elites have a vested interest in maintaining a separation of European and native cultures: "The interests of the [native elites] lay not in synthesizing these two registers [Spanish and Tagalog], as most scholars have suggested, but in keeping them separate. Keeping them apart—submitting to Spain while continuing to invest in Tagalog life— was then a matter of seeing in one the possibility of appropriating something from the other." By keeping the Andean distinct from the European, Inka *caciques* bolstered their place in between.

While, for the most part, native nobility retained status owing to their pre-Hispanic heritage and needed to maintain some traditional Andean

values and practices through which they exercised authority, they were also compelled to acculturate in order to hold those offices. Hispanicization, however, did not come about solely because it was compulsory; in fact, European and Europeanized clothing and objects spoke to the privileged interculturality of native nobles and other wealthy Andeans.[8] Furthermore, compulsory Hispanicization did not preclude Andean agency in the choices of costume elements or the ways they were composited on the indigenous body. By underscoring cultural differences in their composite costumes, they highlighted their privileged positions at the interstices.

The "donning" of cultural difference in festive costume also exposed the inherent contradictions of colonial culture, in particular the imperative to "be like the Spanish, but never be Spanish." The caciques' costume rendered visible the ironies of mimesis. That is to say, the more Hispanicized members of Andean society—and those who were supposedly more educated in Christian doctrine and more demonstrably devout—made their ethnicity and pagan ancestry more explicit through the special dress they wore for Corpus Christi. Irony, which reveals a contradiction between expectation and actuality, has been recognized as a frequent rhetorical strategy of postcolonial writers (Hutcheon 1989). Irony lays bare uncomfortable truths; it also offers an alternative which is both and neither compliance and/nor resistance. In the case of those who participated in Corpus Christi as pagan emperors/Christian caciques, the visible ironies eased passage through the mimetic thicket of the colonial celebration.

The role of Inka caciques under colonial rule was both acknowledged and imagined in the public personae they created for themselves. The "Sapa Inka" costumes actuated mediativity, articulated self-definition, and demonstrated irony. They could do these many things only by being transcultural and multivalent. Only a composite identity could accomplish this critical declaration of self. Many terms—syncretic, mestizo, hybrid, pastiche, and others—have been offered in the literature to describe colonial Latin American cultural forms such as these. Composites, as demonstrated in our examination of Inka caciques "Sapa Inka" costume, are combinations and juxtapositions, new forms comprising renewed and "renaissanced" elements.[9] But, unlike "pastiche," for example, the composite is not haphazard; it has an order and an organization that prioritize its parts and give meaning to the whole within cultural and historical bounds. The composite necessarily speaks ironi-

cally of mediativity; it also speaks of authority—the ability to use different, often conflictual, significatory systems.

Heretofore, we have focused on how the Inka *caciques* modified Andean icons and ideas by strategic Europeanizing, revealing their role as supreme manipulators. They were also masters of compromise. Inka *caciques* necessarily adjusted their use of those costume elements which might be misunderstood or misinterpreted by Hispanic authorities. The addition of breeches to accommodate European notions of "manly" dress and modesty is one example. This does not mean that postconquest Inka elites were victims of a significatory crisis—the collapse of Andean norms of civilization—or collaborators in the dissolution of Andean cultural systems. The Inka nobility could not reinvent themselves in whatever way they chose: they were constrained by the hegemonic culture produced through colonization. It should be clear that, insofar as the Inka composite costume discussed in Chapter 6 is concerned, the colonial Inka elites do not abandon indigenous systems of signification, but instead modify them, changing the visual rhetoric, demonstrating an awareness of their new Spanish audience and a full recognition of the importance of being noble, of being *hidalgos*, in Spanish colonial society. They did this not only by modifying the elements in their colonial costumes, but also by restricting the elements of which it was constituted. The use of feathers in colonial costume illustrates some of the ways compromise between cultural systems worked.

Compromising Plumage

For early modern Europeans, brightly colored plumage signaled the savagery of an untamed America. For pre-Hispanic Andeans, on the other hand, feathers were status indicators of a high order. The feathers from tropical birds were especially valued components of pre-Hispanic elite clothing and regalia (Martínez Cereceda 1995, 79–84). Considering the status implications of tropical birds and their plumage, it is interesting to note the conspicuousness of colorful birds in several of the canvases of the Corpus Christi series (Figs. 12, 14, and 15). They are oversized, prominently placed, and pictured only in canvases featuring Inka *caciques*.

Tropical birds were apparently not unknown in colonial-period Cuzco. Mogrovejo de la Cerda ([1660] 1983, 24), for example, writing

in the mid-seventeenth century, commented on the numerous singing birds in Cuzco as well as on the brightly colored indigenous parrots and flamingos. Thus, the inclusion of resplendent birds in the Corpus Christi paintings may be nothing more than a function of the documentary detail so important in these canvases. Where depicted, however, the birds are well beyond life-size—in one instance, larger than humans located nearby. Whereas a monkey perched on a windowsill in *Hospital de los Naturales Parish* is depicted in proportion with the people pictured near it, the tropical birds dominate their human neighbors (Fig. 15). Also, and significantly, avian Titans do not appear in any of the canvases featuring Hispanic or uncostumed Andeans and, when depicted, the birds perch just above the heads of the costumed *caciques*. It is likely, then, that their presence in the series is owing to the traditional Andean association of Amazonian birds with Inka elites. If so, in these specific canvases the tropical birds work in tandem with the Inka regalia worn by the standard-bearers as special markers of ethnic and status difference.[10]

As we saw with respect to costume, at the same time as Inka elites drew on traditional Andean visual rhetoric, they adopted and adapted to European significatory systems; in fact, and ironically, certain of their expressions of Andeanness were Europeanized. Inka elites manipulated visual forms to create sites of self-representation, but they did so with the awareness that European authorities interpreted their presence differently than their Andean constituents. The use of feathers is interesting in this regard. While large tropical birds perch in association with *caciques* in the Corpus Christi series, feathers were not a significant part of the postconquest Inka costume. In particular, they were plucked from the headdresses that, in pre-Hispanic times they had once proudly adorned.[11] Aside from the large condor or eagle feathers (both are highland birds) that appear in some colonial headgear, plumage is sparse. In other instances, Andeans apparently adopted white plumes of the types that decorate the hats of Hispanic elites; see, for example, the native military corps in *Processional Finale* (Fig. 21) or the Inka dancers in the Corpus Christi in Cuzco painting at the Museo de Osma in Lima.[12] The pictorial tropical birds with their colorful feathers placed *near* the *caciques* in the Corpus Christi paintings appear to function as displaced costume elements. In their dislocation, one can see traces of the compromises Inka *caciques* made and how they turned their ability to conciliate into a valued aspect of their colonial identities.

Although feathers were salient ornaments on pre-Hispanic and early colonial-period Andean heads, feathers of tropical species were seldom worn by highland Andeans in the late colonial period except when imitating Amazonian "savages," whom they called Chunchos or Antis.[13] Chunchos were labeled by Andean highlanders—and by the Spanish chroniclers who were informed by them—as "barbarous and warlike" (Cieza de León [1553] 1959, 61). Thus, Bernabé Cobo ([1653] 1979, 43–46, 142) classified the Chunchos as among the "most crude and savage" of American natives, described them as "extremely barbarous and inhumane," and pointed out that many of them were still "infidels" at the time of his writing. In the colonial period, Andean highlanders imitating the "uncivilized" and "non-Christian" Chunchos, in feathered costume and wielding bows and arrows, were featured in religious festivals (Dean 1996b and 1997). Given the European association of feathers with the uncivilized, a bias that highland Andeans may well have become aware of (esp. through European engravings), native highlanders may have chosen to abandon conspicuous plumage, especially later in the colonial period, relegating it to the representation of "their" savages—the forest-dwelling Chunchos.

Importantly, tropical birds and their feathers continued to be associated with Andean females throughout the colonial period. Tropical birds appear in two of Guaman Poma's ([1615] 1988, 110, 112) portraits of Qoyas (Inka queens). Two of the Qoya portraits accompanying the final version of Murúa's ([1611] 1985, XII, XXI) chronicle likewise feature birds, as do other colonial-period portraits of Inka noblewomen. It is instructive to compare the eighteenth-century portrait of a ñusta, commissioned by a noble Inka family (Fig. 27), with an engraving of Anne Bracegirdle showing the English actress as an American Indian queen in the late seventeenth century (Fig. 48). That the two images share a number of features suggests that late colonial Andean conceptions of feminine elites aligned themselves with those of Europe. Although feathers do not adorn the brow of the Andean ñusta, Andean noblewomen are nevertheless associated with brightly colored birds and we can see how the depicted bird in the Andean portrait displaces Bracegirdle's feathered regalia.

To Europeans as well as Andean highlanders, the feathers of tropical birds suggested fecundity and alterity. Yet Andean highlanders conceived of the Amazonian lowlands, the homeland of tropical birds, as female in complementary opposition to the male highlands; the Chun-

48. R. B. Parkes (engraved after the picture by J. Smith and W. Vincent),
late seventeenth century, *Portrait of Anne Bracegirdle as an Indian Queen*
(Howard-Tilton Memorial Library, Tulane University)

chos, who dwelt in the forests of the Amazon, were likewise femi-
nized. Guaman Poma, for example, repeatedly doubts and defames,
both in text and image, the masculinity of Chunchos and Antisuyus
(Dean 1997).

In pre-Hispanic times, the juxtaposition of complementary forces

such as masculinity and femininity was empowering (Martínez Cereceda 1995, 189–196). However, in the colonial period, feathers—signs of the feminine—became, over time, stigmatized as indicia of weakness and were thus rendered inappropriate for male display (except when males were dressed as the uncivilized, feminized Chunchos). Consequently, in the colonial period, feathers (along with femininity itself) were devalued. Feathered parasols, once sunshades for male as well as female elites, were, by the end of the seventeenth century, generally relegated to females.[14] As in Europe, and in contrast to preHispanic notions of sexual complementarity, definitions of difference in the colonial Andes were born in and born by the female body; as elsewhere, the female in the Andes became the repository of difference.

In the Corpus Christi paintings, only the Virgin Mary is shaded by a feather parasol. The only prominent mid- to late colonial exceptions that I know of in Cuzco are the Vilcabamba Sapa Inkas, Sayri Túpaq and Túpaq Amaru, who are shaded by feathered parasols in the painting of the marriage of Doña Beatriz (discussed in Chapter 5). These two Inka rulers are not only on the feminine side of the canvas (being the ancestors of the bride) but were, of course, from Vilcabamba, located in the forested lands of the Chunchos and Antis northeast of Cuzco. It is not unreasonable to suspect that highland males generally abandoned the wearing of tropical feathers as they became aware of European stereotypes and androcentric prejudices. The Corpus Christi series suggests how Andean male elites gradually pushed aside the traditional Andean value and signification of tropical birds. First, colorful feathers were removed from their bodies and placed nearby (on parasols and/or the bodies of nearby birds); later they were banished from the *caciques* altogether, becoming attached almost exclusively to pictorial females and performative savages.

By Europeanizing the symbolism of feathers, Andean highlanders doubly sidelined Andean noblewomen, who were generally excluded (following European custom) from festive performance. As a consequence, indigenous females became repositories of Andean tradition, an identity that they retain to this day.[15] The displacement may have been as much figurative as it was actual, though, and it was certainly more of an urban than a rural phenomenon. On k'eros (ritual wooden drinking vessels), in contrast to urban costume and paintings, a more traditional Andean view of the feminine prevailed throughout the colonial period. The most frequently found design on colonial k'eros features

an idealized male Inka and his female mate standing under the arch of a rainbow, where they express the complementarity necessary to cosmic continuity (Cummins 1991, 220).[16] In one of the colonial *suntur pawqars* described in Chapter 6 above, the lone figure of a Sapa Inka replaces the male and female pair so frequently seen on k'eros. In their costume, then, male Inka *caciques*, by virtue of the position of privilege granted them by Spanish androcentrism, asserted their new identities as mediators who downplayed (if not erased) the feminine role.

Although some scholars have characterized the position of mediator as a "predicament" and have emphasized the ambivalences inherent in the position (e.g., JanMohamed 1984), it should also be acknowledged that this was a predicament born of privilege. Inka *caciques*, informed by their Hispanic education (which was denied to native noblewomen and commoners), skillfully manipulated their new and exclusive knowledge. While they were themselves marked as subalterns, in performance and in pictorial records of performance Inka *caciques* consistently pointed the alienating finger at females and at other Andean ethnicities. The self-defining efforts of Inka *caciques* were, as a consequence, not without casualties.

Other Others

Another of the ways that Inka *caciques* of midcolonial Cuzco avoided being "triumphed over" in Corpus Christi was to identify other Andeans as subalterns over whom they themselves could and did triumph. In the end, Inka nobles were just as interested in participating in triumph as were the Hispanic bearers of Christ's transubstantiated form. When Cummins (1991) concludes that colonial-period visual and performative references to the Inka imperium prompted only nostalgia, and were therefore permitted by Hispanic authorities, he is considering the Hispanic audience as the *only* audience, or at least as the only audience of significance. The audience to which colonial Inka *caciques* addressed themselves, however, was both Hispanic (colonial administrators and others) and Andean (their constituents, compatriots, and rivals).

It is clear from the descriptions of performances in which the pre-Hispanic Sapa Inkas were impersonated that they were rarely (if ever) elegiac. During the 1610 celebrations marking the beatification of Igna-

tius Loyola, for example, each "Sapa Inka" was accompanied by his kinsmen and displayed emblems that commemorated the victories and conquests of his famous ancestor. The authors of these performed histories, the descendants of Inka rulers and Inka nobility, understandably described themselves as heirs apparent. As noted in Chapter 2, colonial processions of Inka kings usually included displays of allegiance to Spanish political figures, thereby affirming the conquest that, Cummins (1991, 222) has argued, "instilled a sense of resignation in the face of an irretrievable past." While the past may well have been irretrievable, and therefore safe (memorable but not revivable), the performers were in fact being more than nostalgic. By embodying their grandfathers, they invented themselves as Inka rulers, albeit on a vastly diminished scale. Their performances always implicitly—and often explicitly—identified those over whom they still ruled.

Frequently the enacting of the past involved the reenacting of historic feats. During the celebrations of 1610, for example, a squadron of warriors accompanied the elites who impersonated the pre-Hispanic monarchs. At the end of the parade of rulers, the Inka forces reenacted the infamous battle of Yawarqocha in which the troops of Wayna Qhápaq had suppressed a Caranqui rebellion in what is today Ecuador (Romero 1940, 18).[17] In the battle, the fighting was intense and many on both sides were killed; Wayna Qhápaq determined that the captured rebels were to be beheaded in a large lake on the edge of their territory. The water turned red as thousands of rebels were put to death, and the lake was thereafter known as Yawarqocha, or "lake of blood." [18] The chronicler Cobo ([1653] 1979, 157–159) identifies the slaughtered as Cayambes, who were neighbors of the Caranquis. Interestingly, in 1614, the Inkas of the Hospital de los Naturales parish (now San Pedro) reenacted a battle between the Inkas and Cayambes on the occasion of the feast of their parish patron (ACC, Parroquia San Pedro, Libro de Cabildo y Ayuntamiento del Hospital de los Naturales, 1602–1627, 51v–52r); their festive confrontation may well have been referring to the epic battle of Yawarqocha.

Chunchos were also identified through performance as colonial-period sub-subalterns, as were the Araucanians (Chilean natives who, like the Chunchos, proved famously difficult for the Spaniards to rule). Not only had both groups troubled the pre-Hispanic Inkas, they also constantly threatened the borders of Spanish territory during the colo-

nial period. By identifying with the goals of Spanish administrators, Inka elites collaborated in the colonization effort.

While Hispanic witnesses may have been comforted by the notion that such enactments served only to recall a past that discouraged anticolonial aggressivity, the performances did more than evoke nostalgia and induce resignation. They bolstered Inka positions at the top of the subaltern hierarchy by sustaining notions of Inka supremacy among indigenous Andeans. Only when viewed from a strictly Hispanic position can these performances be regarded as "nostalgic." Colonial-period Andeans did not see the world as composed of *indios* in opposition to *españoles*. To interpret their activities—including their festive performances—as though the Inkas were *indios* is to allege homogeneity where it had never existed. Noble Inkas performed as noble Inkas. The simple binaries produced by the colonizer failed to contain the heterogeneity of Cuzqueño society. It was that heterogeneity which resonated in the performance of Inka supremacy.

Before turning to a consideration of other Andeans in Cuzco and their receptions/rejections of the performance of Inka triumph, it is interesting to note that what was locally strategic in midcolonial Cuzco may have proved ultimately self-defeating. So customary was the place of the "Inka" in Cuzqueño festivities that, by the second half of the eighteenth century, Inka heritage became an almost generic Andean heritage. Costumes of the Sapa Inka are referred to in late eighteenth-century wills and inventories as just another type of dance livery—to be put on and taken off without the kind of debate that took place in the midcolonial period. The Inka noblewoman and costume-maker Doña Nicolasa Inquiltopa, for example, lists as her possessions a "vestido de Ynga" along with livery, "bestidos de marcha," and other dance costumes (ADC, Corregimiento, Causas Ordinarias, leg. 57, exp. 1305, 1777). Apparently "Sapa Inka" costumes could be rented out to anyone, or possibly any Inka (regardless of heritage), who wished to assume the role on a festive occasion. Restrictions, so apparent in the midcolonial period, were not enforced or were not enforceable by the second half of the eighteenth century. The numbers of "legitimate" Inka royalty were also dwindling. By 1820 there were only twelve electors present to vote for that year's *alférez real;* the houses of the rulers Sinchi Roqa, Inka Roqa, Yawar Wakaq, and Pachakuti were all vacant (ADC, Corregimiento, Causas Ordinarias, leg. 29, 1711–1721, exp. 620). Spanish

administrators, pressed by the need for more tax-paying subjects, also made it more difficult for Inka elites to establish their royal lineages.

However, this does not mean that late colonial evocations of the pre-Hispanic Inka era were impotent. As mentioned earlier, the notion of a revitalized Inka monarchy was a spectral utopia that inspired several eighteenth-century insurrections against the colonial government, most notably that of José Gabriel Túpac Amaru in 1780 to 1781. After that uprising, the Spanish colonial government restricted or prohibited the display of aristocratic Inka heritage, including the wearing of Inka costume and the display of Inka portraits.[19] This they did despite the fact that many Inka nobles had sided with the royalists. In fact, one Inka elector—Don Sebastián Guambotupa, *cacique* of San Cristóbal parish—served as captain of the Andean nobles of his parish in the war against the forces of Túpac Amaru (ADC, Intendencia, Gobierno, leg. 133, 1786).

The 1804 will of the native noblewoman Doña Pasquala Quigua, who made and rented out costumes, includes the bequest of "bestimenta de Ynca en terciopelo," indicating that the order prohibiting the wearing of Inka vestment was not entirely obeyed. Indeed, she ordered her executor to rent out the Inka costume to pay for masses for her soul (ADC, Pedro Joaquín Gámarra, leg. 76, 1804–1805, fols. 569r–571v, Testamento de Doña Pasquala Quigua, March 19, 1804). Clearly, *somebody* was still assuming the festive role of Sapa Inka; by that late date it was too embedded in Cuzqueño culture to be excised by an order from on high.

Midcolonial Inka *caciques* created an Inka noble who was a ruler-subject occupying the hyphen, a cultural and political middle ground where *tinkuy* could take place. So successful were they in creating a respected royal image that, in the eighteenth century, "Inka" became synonymous with "native Andean." Such was their failure at *protecting* their privileged status that the histories which were designed to be exclusive to the Inkas became, by the late eighteenth century, those of virtually every Andean (Silverblatt 1995, 286–288). In hindsight, non-Inkas appear to have adopted the "if you can't beat 'em, join 'em" strategy by becoming "Inkas" themselves. Life is never lived so simply as it appears in retrospect, however. We now consider a few of the cultural strategies employed *against* the Inka *caciques* by their fellow Andeans.

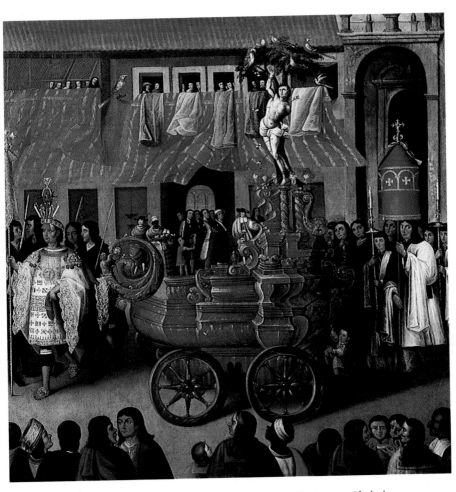

Plate I. Anon., 1674–1680, San Sebastián Parish, Corpus Christi
series (Museo del Arzobispo, Cuzco)

Plate II. Anon., 1674–1680, San Cristóbal Parish, Corpus Christi series (Museo del Arzobispo, Cuzco)

Plate III. Anon., 1674–1680, *Santiago Parish*, Corpus Christi series
(Museo del Arzobispo, Cuzco)

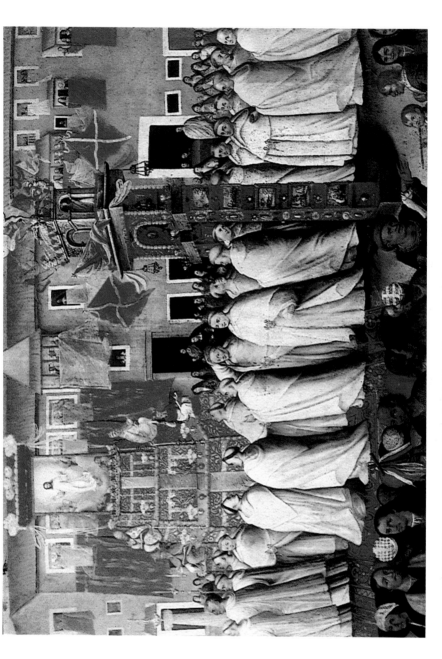

Plate IV. Anon., 1674–1680, *Mercedarian Friars, Corpus Christi series* (Museo del Arzobispo, Cuzco)

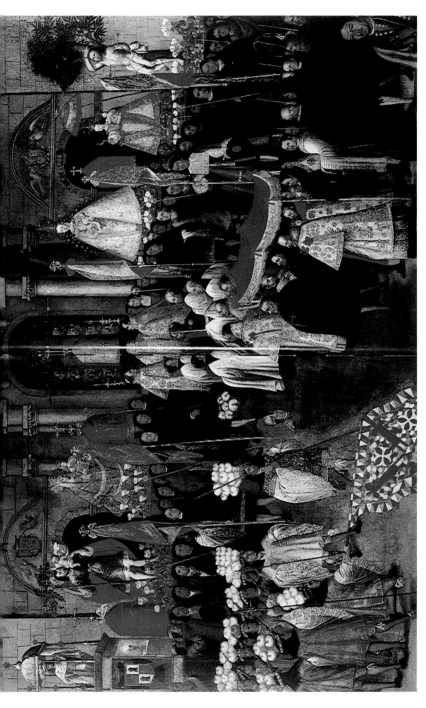

Plate V. Anon., 1674–1680, *Processional Finale*, Corpus Christi series (Museo del Arzobispo, Cuzco)

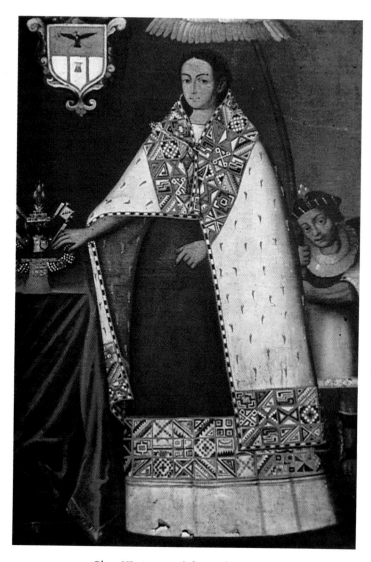

Plate VI. Anon., eighteenth century,
Portrait of an Unidentified Ñusta (Museo Arqueológico, Cuzco)

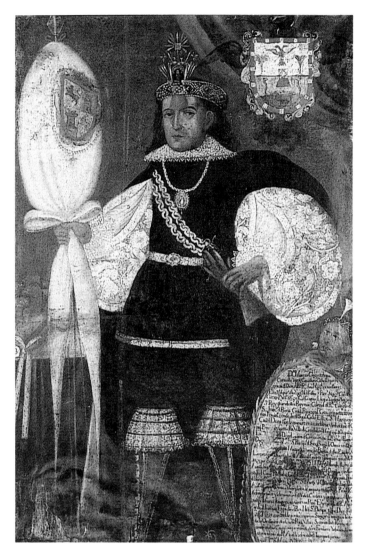

Plate VII. Eighteenth century,
Portrait of Don Marcos Chiguan Topa (Museo Arqueológico, Cuzco)

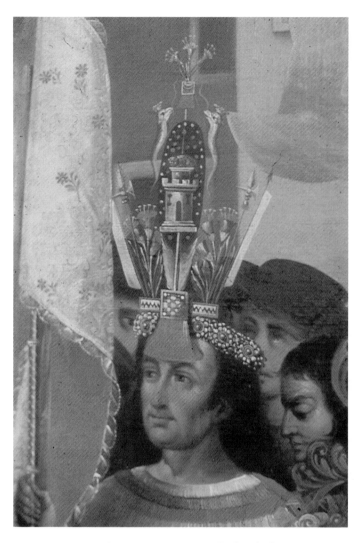

Plate VIII. *Santiago Parish*, detail of
the standard-bearer's headdress, Corpus Christi series
(Museo del Arzobispo, Cuzco)

Chapter 8

Choreographed Advocacy

Although subaltern communities share certain histories of deprivation and discrimination, those communities are neither homogenous nor fixed. Among the Andean community in Cuzco were profound antagonisms, some of which had roots in the pre-Hispanic imperialist agenda of the Inka state and were aggravated by competition for space in the Spanish colonial order. The Inkas, in the century prior to the Spanish invasion, had both compelled and enticed other ethnic groups to their cosmopolitan capital. Those groups did not share the Inkas' pre-Hispanic vision of an Andean empire ruled from Cuzco, nor did they aspire to bolster Inka claims to authocthonous authority in colonial times. When Inka *caciques* invoked memories of pre-Hispanic authority by embodying the Sapa Inka and reenacting military triumphs, they rehearsed the historical domination of the Inkas over other Andean ethnicities. Their performances were gestures of dominance.

Because the Inkas succeeded so well in equating Peru's indigenous past with the Inkaic past, aided as they were by the Spanish will or need to homogenize the colonized, the voices of their rivals have been nearly silenced. We do see hints of some of the antagonisms within the subaltern community in Cuzco, however. In particular, festivals occasioned rival presentations in which performers sparred with one another over pre- and post-Hispanic identities. Clearly, performance on the public stage of civic festivals was advocacy. As mentioned, every act of remembering necessarily means suppressing aspects of the past; in performance, points of view were choreographed so as to persuade

viewers (in particular, Hispanic authorities and native constituents) that certain visions of the past were worthy of recall while others were best disregarded. In the present chapter, I trace, through the actions of the Cañari *cacique* Don Francisco Chilche and his descendants and comrades, performative challenges to Inka supremacy among certain subaltern groups in Cuzco during the colonial period. This discussion first appeared in an article in *Colonial Latin American Review* (Dean 1993); it is presented here in revised form.

Ethnic Conflict and Corpus Christi

On Thursday, June 6, 1555, during the Corpus Christi festival in Cuzco, Peru, a fight erupted between some Inka nobles and an ethnic Cañari chief. The hostilities are mentioned by the eighteenth-century Hispanic chronicler of Cuzco, Diego de Esquivel y Navia ([c. 1749] 1980, 1:178) but are related in great detail by Garcilaso de la Vega, the *mestizo* (Spanish and Inka) author who called himself "El Inca." While Esquivel blamed the Corpus Christi violence on an overindulgence in alcohol, Garcilaso—an eyewitness and Inka partisan—understood that the incident grew out of profound and historical inter-Andean ethnic rivalries. In his history of Peru, which includes incidents from his childhood in Cuzco, Garcilaso describes how the Cañari Don Francisco Chilche (named by Garcilaso as Don Francisco Chillchi Cañari) provoked and insulted the ethnic Inkas attending the Corpus Christi festival. He writes:

As the [Indian tribal groups] were passing by [the cathedral] in the procession, that of the Cañaris arrived: although their province is outside the jurisdiction of the city, they have their own float, for a great many Indians of the tribe live in the city. Their chief then was Don Francisco Chillchi Cañari. . . .

This Don Francisco went up the churchyard steps with his cloak round him and his hands hidden in its folds: his [*andas* were] not decorated with silk or gold, but painted in various colors, with four battle scenes of Indians and Spaniards depicted on the four panels of the canopy.

As he mounted the steps [of the cathedral] on the right of the city councillors where my lord [and father] Garcilaso de la Vega, then [magistrate], was with his deputy Monjaraz, a lawyer of great wisdom and skill, the

Cañari dropped the blanket he was wearing as a cloak and revealed his body with another blanket girt round it as [Indians] do when they intend to fight or engage in any other important affair. In his right hand he carried a model of an Indian head which he held by the hair. As soon as the Incas saw it, four or five of them attacked the Cañari, and lifted him up in the air so as to dash his head on the ground. The rest of the Indians on both sides of the platform with the Blessed Sacrament were now in a turmoil, and Licentiate Monjaraz had to go among them and pacify them. He asked the Incas what had upset them, and the oldest of them replied: "This dog of an *auca* [savage or traitor] instead of celebrating the festival comes with this head to stir up memories of the past that are best left forgotten."

The deputy then asked the Cañari what he meant, and he answered: "Sir, I cut that head off an Indian who challenged the Spaniards when they were surrounded in this square. . . . None of them would go out and accept the Indian's challenge, thinking it was a disgrace and not an honor to engage a single fight with an Indian. So I asked their permission to go out and fight, and the Christians said yes, and I went out and fought the challenger, and beat him and cut his head off in this square." As he spoke, he pointed to the place of the battle, and then resumed his story: "The four pictures on my float are pitched battles between Indians and Spaniards, in which I saved the latter. Is it strange that on such an occasion as today I should take pride in the deed I did in the service of the Christians?" (Garcilaso de la Vega [1609, 1617] 1966, 2:1417–1418)

The fight referred to by Don Francisco Chilche had taken place in 1536 during the rebellion against the Spaniards led by Manko II. At one point during the siege of Cuzco organized by Manko, an Inka captain challenged the Spaniards to meet him in hand-to-hand combat; while none of the Spaniards was willing, Don Francisco Chilche—a Cañari— accepted, fought, and beheaded the challenger.

The Corpus Christi festival in Cuzco—the former capital of the Inka empire—frequently occasioned ethnic discord. It is within this con- text that Garcilaso and the Inkas on hand took offense at the Cañari's performance, calling him a "treacherous dog" and insisting he be pun- ished for his display, which seems to have been designed purposely to antagonize the Inka elites present (Garcilaso de la Vega [1609, 1617] 1966, 2:1418). Thus, Don Francisco Chilche's exhibition was not (as Esquivel suggested) the alcohol-induced boasting of a vainglorious old war hero, but a manifestation of the rift between rival Andean ethnic

groups during the colonial period. Nor was this incident an isolated expression of such rivalries. In the present chapter, I elucidate the "anti-Inka" sentiment expressed in one of the paintings of Cuzco's Corpus Christi series—viz., *Processional Finale*—more than a hundred years after the incident described by Garcilaso. The content and formal arrangement of this canvas, like Don Francisco Chilche's festive display and performance, was generated by, responded to, and participated in Cuzco's interethnic dialectic.

The visual counterpoint to those canvases of the Corpus Christi series which portray Inka *caciques* as resuscitated Sapa Inkas (Figs. 11–16), is the final canvas of the series (Fig. 21). It is the largest canvas of the Corpus Christi cycle, measuring more than seven feet by eleven and a half feet; its subject is the conclusion of the Corpus Christi procession. The cortege itself comes from the lower right and enters the open doors of the cathedral at center canvas. The processional line is composed entirely of Hispanics, including priests, the bishop (Don Manuel de Mollinedo y Angulo), and members of the municipal council. Priests with the high cross and candlesticks lead the procession. The bishop, sheltered by the canopy, conveys the Blessed Sacrament in a golden monstrance while behind him a priest carries a miter (the symbol of the bishop's office). City councilmen hoist the poles of the canopy and bring up the rear of the procession; at least five of them carry staffs— their traditional symbols of office.

Natives, representing six local parishes, witness the procession with their patron saints elevated on *andas*. From left to right are representatives of the parishes of Santiago, San Cristóbal, Santa Ana, Belén, Hospital de los Naturales (with their patron, the Virgin of the Candlemas), and San Sebastián. In the lower left of the canvas is a military company of thirteen natives. A youth with a silver helmet and red crest precedes this group. His body unfortunately has been destroyed by a tear in the canvas; restoration efforts to reconstruct his body below the neck were unsuccessful. The patron of this canvas—recognizable by hairstyle, skin color, and dress as native—is depicted in the far-right foreground. He assumes the prayerful attitude diagnostic of patrons. While the identity of the patron is unknown, I suspect that he is not ethnically Inka. Most likely he is a Cañari or Chachapoya resident of the parish of Santa Ana. As discussed in Chapter 4, the Santa Ana parish church was the original location of this series and, as I shall demonstrate in more detail here, the composition of this particular canvas privileges the

parish of Santa Ana over the other parishes represented. It also highlights the festive participation of ethnic Cañaris and Chachapoyas who resided in the parish of Santa Ana. Furthermore, this canvas articulates ethnic rivalry between Inka and non-Inka ethnicities, a rivalry that frequently surfaced during Corpus Christi celebrations in colonial Cuzco.

The parishioners of Santa Ana occupy the preeminent position in this canvas. They are located to the immediate right of the high altar which is visible through the open doors of the cathedral. That is to say, Santa Ana is on the altar's right-hand side, which is the most prestigious of locations. Significantly, this is not the order taken by the parishes according to seventeenth-century written documents. They consistently rank Santa Ana behind the parishes of Belén, Hospital de los Naturales, and Santiago (Dean 1990, 155–156). In addition, the ethnicity of the Inka *caciques*, so proudly featured by means of costume and regalia in those canvases where they are pictured "front and center," is not highlighted in this canvas. In *Processional Finale*, all Andean standard-bearers are dressed in Europeanized lace shirts, breeches, cloaks, and shoes.[1] Only the standard-bearers of Santa Ana and the Hospital parish wear European-style stockings; Santiago's standard-bearer is not visible, and those of Belén, San Sebastián, and San Cristóbal are shown without that item of European elite apparel. Whereas the Inka *caciques* proudly display the *maskapaycha* in the canvases of which they are the probable patrons, here those displaying headgear (which they have doffed) hold broad-brimmed and plumed European felt hats.

It is readily apparent that the identities of the individual participants depicted in the canvas of the processional finale differ from those celebrants depicted in the Inka-sponsored canvases. Note, for example, that the standard-bearer of the parish of San Cristóbal (first standard-bearer from the left in *Processional Finale*) is not Don Carlos Huayna Capac Inka, who leads that parish in its parochial canvas; the former is younger and possesses two good eyes, whereas Don Carlos is one-eyed (see Fig. 14). Not only are the Inkaic costumes absent and the identities different, but a pictorial fabrication found in the parish paintings is exposed in *Processional Finale*. As discussed in Chapter 4, five of the canvases featuring Inka standard-bearers, including that of San Cristóbal, depict the statue of the parochial patron riding on the large, intricately carved *carros* that the artist(s) copied from a seventeenth-century festival book from Valencia, Spain. Whereas the parish leaders aggrandized the painted records of their festive presentations by introducing

imagined elements, the canvas of the processional finale replaces the fabulous—but fictive—processional carts with *andas* of the sort actually used in seventeenth-century Corpus Christi processions in Cuzco. Thus, the last canvas of the series is, at best, exposing the visual hyperbole of the Inka canvases or, at worst, accusing them of painted falsehoods.

The final canvas of the series closes the pictorial procession by contradicting those canvases featuring Inka standard-bearers. Reasons for this pictorial interlocution can be traced to the sometimes stormy relations between Inka and non-Inka natives of Cuzco. Essential to the recognition of the ethnic discord encoded in this canvas is the featured role accorded the military corps in the lower-left foreground. They are clearly a significant pictorial presence as their position eclipses that of all of the assembled parish representatives and they share center stage with the procession of the Blessed Sacrament (the Corpus Christi) itself. While the return of the Blessed Sacrament is the ostensible subject matter, the formal elements of the canvas ultimately guide the viewer's eye from the procession proper—and from the Body of Christ—to the men firing their guns. The white robes of the clergy dim in contrast to the whiter plumes and lacy sleeves of the corps members; their light-colored uniforms contrast sharply with the somber tones worn by the other native celebrants. Furthermore, the artist has chosen to record the moment of the firing of the guns: flame and smoke issuing from the discharged weapons are clearly visible. Many of those in the procession, including the bishop and those carrying the canopy, look in the direction of the corps, as do many of the parishioners; as a consequence, the viewer's gaze is directed there as well.

Their manner of dress—embroidered tunics, matching breeches, and voluminous lace sleeves—characterizes this group as a unit. The color and decoration of paired tunics and breeches are uniform; light blue and salmon are the two prevailing colors. A few of the outfits appear to be nearly identical; but, for the most part, it is through the style of the uniform, rather than in decoration, that group identity is established. All wear jeweled headbands with high, white-feather plumes; some bear insignia on their foreheads, as will be discussed below. They can be identified as native Andeans on the basis of their straight black hair, dark skin, indigenous-style feathered and ornamented headbands, and the distinctive indigenous embroidered collars that can be glimpsed

beneath their brocade tunics. These loose, unfitted, elaborately embroidered tunics are native in styling though not in material or decoration; they are worn over flowing lace sleeves of the type also adopted by colonial-period Inka nobility (seen in the background of this canvas as well as in the canvases of their own patronage). While lace is a European fabric, the untailored construction of the sleeves is more Andean than European in concept, as noted in Chapter 6.

At least five of the company are discharging arquebuses, and one holds the barrel of his weapon.[2] At the front of the corps stand two individuals bearing halberds, weapons that combine a spear with a battle-ax. The halberd-bearer farthest to the left holds the ax head upright while his complement holds the head to the ground. Another of the group kneels, lowering a standard as the bishop with the consecrated host passes. The standard can be identified as a royal banner featuring the red saltire, the emblem of Burgundy.[3] In front of the corps, its leader holds a long staff (possibly a halberd), the lower end of which is obscured by the flag. Closest to the bishop's cortege is a helmeted youth. Despite the damage to the canvas, he appears to have traces of shoulder straps. These possibly supported a drum; the identification of this boy as a drummer would be consistent with the processional appearance of a military company.

While this corps has been identified as both a group of dancers and as a confraternity devoted to the archangel Michael, I am convinced that they are the Spanish magistrate's elite guard.[4] Because of the royal banner and the military aspect, this Andean corps must be associated with the Spanish civil government. The most renowned corps of this sort in Cuzco was the Spanish magistrate's guard, a company consisting primarily of ethnic Cañaris and Chachapoyas. Confirmation of their ethnic identification can be found in the insignia worn in the headgear of some members of the corps. At least three display crescent moons of silver on their native-style headbands. This insignia was identified as an emblem of the Cañaris of Cuzco in a chronicle of 1610 (Romero 1923, 450). The author describes a battalion of Cañaris whose leaders wore silver "canipos" shaped like the moon. *Canipu* is the Quechua term for a small silver or gold badgelike plate worn on the forehead to signify noble status (González de Holguín [1608] 1901, 51). Additionally, at the end of the seventeenth century, the Audiencia had awarded the Cañaris with a coat of arms described as a cross on a silver shield which they fre-

quently wore on their headbands (Rendon 1937, 54). One of the members of the corps in this canvas displays just such an ornament. These headband insignia thus identify some of the corps as ethnic Cañaris.

The Cañaris and Chachapoyas were two prominent Andean groups whose alliance with the Spaniards during the early days of the conquest garnered them privileged positions in colonial society. It also made them rivals of the Inkas. The history of these two ethnic groups is interwoven and has its roots in their pre-Hispanic relationship with the imperial Inkas. Each will be discussed briefly in order to provide the necessary background. The home of the Cañaris is in Ecuador, south of Quito. When this region was conquered by the empire-building Inkas, many Cañaris were taken as mitmaq (or mitimakuna); that is, they were resettled in sundry parts of the empire according to Inka practice.[5] The testimony of a number of Cañari mitmaq in the Cuzco region was recorded by order of Viceroy Toledo in 1571 and is known as Toledo's *Informaciones*.[6] The information gained from the questioned Cañaris helps elucidate the Cañari presence in the Cuzco region. One Cañari interviewed was Don Juan Zuay Tunba Cañar, called a "principal" (noble, leader) of the Cañaris. He testified that he descended from Cañaris who had been brought from the Quito region to the Cuzco area by Túpaq Inka Yupanki (the tenth Inka ruler, according to most dynastic lists). Don Juan's estimated age was seventy-seven or seventy-eight years, and his father had told him of the relocation. His testimony, given with that of other nobles, details how the conquering Inkas gave gifts of cloth and women to those who surrendered; those who had the "ability" and "authority" to govern were made kurakas (chiefs) in the Cuzco region (Toledo [1571] 1940, 82–85). Also testifying was Don García Chenipotela, identified as a Cañari whose father, he reported, was a kuraka in the Cañari area. He had been brought to Cuzco by Wayna Qhápaq, the son and heir of Túpaq Inka Yupanki (ibid., 133–134). Thus, the Cañari presence in Cuzco (and elsewhere in the southern Andean highlands) was owing to Inka resettlement policies and occurred in the late fifteenth and early sixteenth centuries.

The Mercedarian friar and chronicler Martín de Murúa ([1600–1611] 1986, 81, 112–113) reports that, during the Inka conquest of Cañari territory, the Cañaris gained respect as fierce fighters. Because of this, selected Cañaris were made personal guards of the Inka ruler. Murúa (ibid., 346) also describes one of the Inka's royal palaces in Cuzco as being guarded by 2,000 Cañaris who alternated with 2,000 Chacha-

poyas. Both are characterized by Murúa as "privileged soldiers" and royal guards.[7] He thus links the Cañaris in Cuzco to another Andean ethnic group—the Chachapoyas. Chachapoya territory is in the central Andean highlands and *montaña* north of Cuzco. Their late pre-Hispanic history parallels that of the Cañaris.[8] A number of Chachapoya nobles living in the Cuzco area also testified for Toledo's *Informaciones*. One of these, Martyn Vilca Chachapoya, said to be eighty years of age, reported that Wayna Qhápaq had brought Chachapoyas to the Cuzco area (Toledo [1571] 1940, 86). Another, Juan Apitauco, a ninety-year-old native of Chachapoya province, indicated that his father had served Wayna Qhápaq (ibid., 125–133). Domingo Carquín, age eighty-six, identified as a *cacique principal* of the town of Chinchaypucyo, related how his grandparents had been brought from Chachapoya territory by Túpaq Inka Yupanki and were given lands in Chinchaypucyo (ibid., 133). Similarly, Santiago Chuqui Cati, a Chachapoya interviewed in Cuzco, reported that his father, a *kuraka* of three *repartimientos de indios* (native communities), had been relocated by "Topa Inca Yupangui" (ibid., 143). Thus, the Chachapoya informants mention the same two Inka rulers as did the Cañaris above. Like the Cañaris, Chachapoyas were removed from their homelands and resettled in the Yucay Valley and in Cuzco as well as other locations in Qollasuyu (the southern Andean highlands of Peru and Bolivia).

The Cañaris and the Chachapoyas had been integrated into the Inka empire for less than fifty years at the time of Pizarro's arrival. Both groups had also attempted to gain their freedom just before the Spanish advent and had suffered Inka retribution. These two groups, like others eager to rid themselves of Inka hegemony, aided the Spaniards against the Inkas from the earliest days of the conquest. The Cañaris have a particularly well-documented history of shifting alliances as they tried to secure their survival and further their independence. Murúa's ([1600–1611] 1986, 177) portrayal of the Cañaris as duplicitous rascals and fair-weather friends is especially negative in its characterization: "Elders commonly say of the Cañaris that they have always been traitors, rebels, and liars, passing along gossip." He continues: "They still possess these characteristics, and in rebellions and fights customarily become allies of the winner, being faithful only until they determine the good or bad outcome."[9] One suspects that Murúa's informants—the "elders" of whom he speaks—were ethnically Inka. Murúa (ibid., 163–166) specifically blames the Cañari governor of Tu-

mipampa (a.k.a. Tomebamba) for fostering mistrust between Wáskar, the heir to the Inka "throne," and his half-brother and rival Atawalpa in Quito. Misunderstandings between these brothers, prompted by the Cañaris, eventually escalated into the Inka civil war.[10] Just before his capture by Pizarro in 1533, Atawalpa exacted severe punishment on the Tumipampa Cañaris for their treachery (ibid., 177). The massacre is confirmed by the chronicler Pedro de Cieza de León ([1553] 1959, 72), who found that Cañari females outnumbered males fifteen to one when he visited Ecuador prior to the middle of the sixteenth century. When, in 1534, Pizarro's captain Sebastián de Benalcázar arrived at Tumipampa, the surviving local Cañaris joined the Spanish forces as auxiliaries (Hemming 1983, 156).

Like the Cañaris, the Chachapoyas also aided Wáskar's army against Atawalpa's troops. In retaliation, Quisquis and Chalco Chima, Atawalpa's generals who occupied Cuzco, commanded that all Chachapoya and Cañari prisoners be executed (Espinoza Soriano 1966, 252, 262–268). Spaniards used both these non-Inka groups as valuable auxiliary forces in their efforts to control the Andean area. Because Cañari and Chachapoya peoples had been resettled in various parts of the empire by the Inkas, the Spaniards found native allies, with local resources at their command, throughout the southern highlands.

During the siege of Cuzco, Cañaris and Chachapoyas distinguished themselves as allies of the Spaniards. In his account of the conquest period, composed at his refuge in Vilcabamba, Manko Inka's son Titu Cusi Yupanqui ([1570] 1973, 84) wrote that the battle for Cuzco's "fortress" of Saqsaywamán "was a bloody battle for both sides because of the many natives who were supporting the Spaniards. Among these were two of my father's brothers called Inquil and Huaipai with many of their followers, and many Chachapoyas and Cañaris."[11] It was also during the course of the siege of Cuzco that the Cañari Don Francisco Chilche battled and defeated the Inka challenger as related above. Bishop Reginaldo de Lizárraga, who wrote a description and history of the Viceroyalty of Peru between 1591 and 1612, also provides an account of the indigenous revolt lead by Manko Inka. While his history is confused on a number of details, it does suggest to what extent the Cañaris were, at the time of his writing, remembered as feared and fierce allies of the Spaniards against the rebel Inka. He says that when the natives of Los Reyes (Lima), Jauja, and Cuzco rebelled and laid siege, Captain San-

doval, in Quito, joined by 4,000 to 5,000 Cañaris, marched to the aid of the besieged; when the besiegers learned that the Cañaris were on their way they rapidly retreated (Lizárraga 1908, 71–72). Another Spanish chronicler, writing in the first half of the seventeenth century, not only described the Cañaris as the "boldest" (*más arriscados*) of Andean ethnic groups, but as "faithful friends [of the Spaniards . . . who are] enamored of [the Spanish] nation, who have always been loyal and the most Catholic [of Indians]" (*fueron fieles amigos suyos . . . tan enamorados de nuestra nación, que siempre an sido leales, i los más Católicos*) (Calancha [1638] 1974–1981, 1164).

From the time of the siege of Cuzco, the Cañaris and the Chachapoyas are mentioned as auxiliaries in Spanish battles. They seem to have served primarily as scouts, guards, and sentinels. Garcilaso ([1609, 1617] 1966, 2:808), speaking from the Inka point of view, characterizes those Cañaris aiding the Spaniards as "spies, agitators, and executioners against the other Indians." The Cañaris aided the king's troops against the rebellion of Gonzalo Pizarro. In fact, the leader of the royal forces, Licenciate Pedro de la Gasca ([1548] 1921–1926, 115–116) in a letter to the king dated September 25, 1548, describes how a loyal Cañari *cacique* was drawn and quartered in Cuzco by Gonzalo's forces. According to Garcilaso ([1609, 1617] 1966, 2:808–809), the Cañaris, commanded by Don Francisco Chilche (the very same individual who would cause such a stir during the 1555 Corpus Christi celebration), aided royalists as well as rebels during the unsuccessful revolt of Francisco Hernández Girón in the early 1550s; the triumphant royalists never knew of this putative duplicity, however, and rewarded Chilche for his allegiance. The Cañaris were also distinguished participants in Toledo's campaign of 1571–1572 to defeat the still-independent Inkas of Vilcabamba (cf. Salazar [1596] 1897, 263–282; Murúa [1600–1611] 1986, 287ff; Calancha [1638] 1974–1981, 1164, 1881). The punitive expedition, "justified" by the murder of the Augustinian friar Diego de Ortiz and the interpreter Martín Pando, was ordered by Viceroy Toledo, who was at that time lodged in Cuzco. The Spanish forces were aided by some 2,000 Andean auxiliaries (*indios amigos de guerra*). Of that number, 500 Cañaris and other unspecified non-Inkas (probably including some Chachapoyas) were distinguished from the contingent of 1,500 Inka soldiers. The Cañaris and other non-Inka troops were lead into Vilcabamba by then aged "General" Don Francisco Chilche, the very

same Cañari target of Garcilaso's ire. Chilche's troops were in the vanguard that entered Vilcabamba in June 1572 (Murúa [1600–1611] 1986, 287, 295–296).

The Cañaris became, in the colonial period, famous—or, rather, infamous—as the executors of Spanish "justice" against other Andeans (especially the Inkas). When the wife of Manko Inka was captured, for example, Francisco Pizarro (as governor) had her tied to a stake and beaten by a Cañari (Hemming 1983, 254). In the most prominent case, Túpaq Amaru, the young leader of the Vilcabamba Inkas, was captured and taken prisoner to Cuzco, where he was tried and executed. On the day of execution, as he was led from imprisonment in the palace of Colcampata (San Cristóbal parish) to the plaza, where a scaffold had been erected, he was guarded both by the viceroy's Spanish troops and by 400 Cañaris armed with lances (Ocampo 1955, 8). A Cañari, too, was the executioner who beheaded this last Inka ruler. Chilche's "dance" of 1555 in which he held aloft an Inka head in the plaza of Cuzco chillingly anticipated that moment.

Spaniards referred to allied natives, such as the Cañaris and the Chachapoyas, as *indios amigos* (friendly Indians). There was profit in being "friendly" to Spanish colonial authorities. These two native groups, in particular, were rewarded by being freed from tribute and assigned as the personal guard of Spanish civic officials. This had been, in fact, their condition prior to the Spanish conquest: only the ethnic identity of the governor changed, from Inka to Spaniard. Viceroy Toledo ([1572] 1921–1926a, 119–120) discusses the position of the Cuzqueño Cañaris in his report to the king dated March 1, 1572. This letter, written prior to the execution of Túpaq Amaru, reads, in part:

In this city of Cuzco there are nearly 400 Indians, called Cañaris who, because of being a valiant and diligent people, were trusted by the Inka [ruler] as his guard. When the Spaniards entered this city [the Cañaris] obeyed them and ever since have served with fidelity. During the siege that was placed on Cuzco and the uprising of Manko Inca [the Cañaris] served as good friends [to the Spaniards] and were great persecutors of the rebellious Inkas. In remuneration, these Indians have always been free from tribute and have never been granted in *encomienda* and they have been given privileges and proclamations by the governors and Audiencia so that they render no tribute and are obliged only to serve the civic authorities.

Toledo goes on to say that these services included the provision of some natives to attend the *corregidor* and do his bidding, to guard certain prisoners, to track down those who had fled justice, and to carry governmental dispatches.[12]

Later that same year, after the conquest of Vilcabamba and the execution of Túpaq Amaru, Toledo renewed the exemption from paying tribute in his ordinances for the governance of Cuzco. Issued at Checacupe on October 18, 1572, these ordinances linked the Cañaris to the Chachapoyas in terms of service and reward (Toledo [1572–1573] 1926, 191–193). Título 24 of Toledo's ordinances codifies the type of service to be rendered to the Spanish magistrate in Cuzco. (This was an official recording of practices that were already in place.) Among other requirements, six Cañaris and Chachapoyas were to serve both day and night at the residence of Cuzco's *corregidor* in order to carry out his orders. Another four were directed to serve at the public jail; armed with lances, they were to join the *alguacil mayor* on his patrol as well as stand guard in the hall of the *cabildo* whenever council was in session. The Cañari and Chachapoya guards were to carry official dispatches on behalf of the *corregidor* and aid the execution of justice in any manner he required. Toledo also planned to assign Cañaris and Chachapoyas as the guardians of a fortress and house of munitions, to which purpose he proposed to convert the Inka palace of Colcampata (these designs were never carried out). According to a letter addressed to the king (May 8, 1572), the proposed fortress was intended to protect the city against any future rebellions (Toledo [1572] 1921–1926b). In another dispatch, Toledo described the Cañaris and Chachapoyas as a special category of vassals, who could be relied upon to defend the fortress and city (Toledo [1572] 1921–1926c, 434).

Cuzco was not the only municipality in which the Cañaris and Chachapoyas served as governmental guards. According to the report written in 1621 by Viceroy Don Francisco de Borja (1921, 239–240; Viceroys 1859, 90–93), the Cañaris, whom he describes as the former Inka guard, remained free from tribute owing to the fact that, at the time of his writing, they guarded Spanish governors throughout the viceroyalty. He states: "The Indians called Cañaris are freed from *mita* [i.e., tribute in labor] and tribute [in kind]; they were soldiers of the Inka guard and today remain in many parts, acting as aids to Spanish magistrates. They obey orders, such as constructing prisons and other duties

of this type."[13] Spanish officials, such as Toledo and Borja, classified the Cañaris and Chachapoyas who served as guards and as functionaries of Spanish civil justice as yanacona (yanakuna). In the pre-Hispanic period, the term yana (pl. yanakuna) indicated a vassal who had been removed from any kin group or communal (ayllu) tribute obligations.[14] There were clearly several categories of yanakuna, ranging from those with considerable status to others who were essentially slaves. Borja (Viceroys 1859, 90) stated that "yanacona" had the same significance at the time he was writing (1621) as it did in ancient times: it designated servants conscripted to provide specific services.[15]

Allegiance to the Spaniards afforded those ethnic groups who had been dominated by the Inkas in the preconquest period an opportunity to achieve unprecedented power and status. The position of the Cañaris and Chachapoyas as guards to the Inkas, and later the Spaniards, was clearly one of privilege and one that they sought to maintain. Their appearances as military companies in processions, such as that portrayed in the Corpus Christi canvas, was a public demonstration of their local prestige and linkage to governing authority. Nor was Cuzco the only city in which they appeared as a privileged guard. There was a Cañari battalion stationed in Lima, and it was the only notable native group present at the advent ceremony for Viceroy Don Pedro Fernández de Castro, Conde de Lemos, in 1667 (Mugaburu [1640–1697] 1975, 121).

We began our discussion of ethnic discord in Cuzco by relating the provocative actions of Don Francisco Chilche, a Cuzqueño Cañari. Because this Cañari individual figures so prominently in our discussion of the Cañaris in Cuzco, and in our discussion of the parish of Santa Ana, a brief examination of his career is called for. According to Garcilaso ([1609, 1617] 1966, 2:806), who says he knew Chilche but who is hardly an unbiased source, Don Francisco was a Cañari noble who, as a boy, had served Sapa Inka Wayna Qhápaq as a page. Whatever Chilche's pre-Hispanic position, evidence indicates that, as a Spanish ally, he prospered, becoming the most powerful non-Inka Andean in the Cuzco area. According to Diego de Trujillo ([1571] 1970, 59; see Hemming 1983, 591n301), it was Chilche who welcomed Francisco Pizarro to Cuzco in 1533, saying: "I come to serve you and will not oppose the Christians as long as I live" (Yo te vengo a servir y no negaré a los christianos, hasta que muera). He also took his Christian name from Francisco Pizarro (Garcilaso de la Vega [1609, 1617] 1966, 2:806). Garcilaso

(ibid., 2:808) attributes Cañari group allegiance to the Spanish to this single individual:

[Don Francisco Chilche] received so many favors from the Spaniards at the time of their victory and later, that the whole tribe became attached to the newcomers, and not only withdrew the love and obedience they owed the Incas as their natural lords, but became cruel enemies of them and went over to the Spaniards and served them thenceforward as spies, agitators, and executioners against the other Indians.

Murúa ([1600–1611] 1986, 268) reports that, in 1561, Chilche (called Chilche Cañar) poisoned Sayri Túpaq, the former ruler of the Vilcabamba Inkas who had retired to Cuzco after capitulating to the viceroy (the Marqués de Cañete). After spending a year imprisoned in Cuzco, Chilche was released for lack of evidence. Garcilaso ([1609, 1617] 1966, 2:809) and the seventeenth-century Jesuit chronicler Bernabé Cobo ([1653] 1979, 180) also name Chilche as the primary murder suspect. Significantly, Chilche is identified as a *cacique* of Yucay. It may not be coincidental that the doomed Sayri Túpaq had been awarded lands in the Yucay Valley (the estate of the rebel Francisco Hernández Girón) where Francisco Chilche presided. Garcilaso also tells us that, after the death of Sayri Túpaq, the Cañari leader married the dead Inka's wife and would thereby have gained control over the estate. Garcilaso ([1609, 1617] 1966, 2:809) further relates that the local Inkas "had to put up with the outrage because they were no longer in authority." Clearly Francisco Chilche's alliance with the Spaniards profited him and chagrined Inka elites who could not control his actions.

Apparently, Chilche's position of leadership in the Cuzco region was not much affected by his status as a murder suspect. He testified for Toledo's functionaries in the Valley of Yucay on March 19, 1571; in the *Informaciones* his name is given as Don Francisco Zaraunanta Chilche, his position is listed as *cacique principal*, and his age is estimated at seventy-seven years (Toledo [1571] 1940, 99–101). Not surprisingly, after forty years of allegiance to the Spaniards, he was one of very few native informants who could sign their name. In fact, he could sign his name as early as 1559; his signature can be found in the records of the Cuzco town council (Cusco Cabildo 1982, 59). These records indicate that Don Francisco Chilche was elected as the first *cacique* of the parish of Santa Ana in February 1560. At least one other ethnic Cañari was

named as an official of the parish of Santa Ana in that year. According to the records, Don Juan Cañar was named as *alguacil* along with Pedro Miguel, whose ethnicity cannot be determined (ibid., 102).

Cuzco's parish of Santa Ana was home to Francisco Chilche and, a hundred years later, home to the series of paintings depicting the Corpus Christi procession. Toledo's *Informaciones*, recorded in 1571, provide important documentation that helps link the painting of the processional finale to the ethnic Chachapoya and Cañari residents of the parish of Santa Ana. In the colonial period, that parish was commonly known as Qarmenqa (Carmenca, Carmenga, etc.). Qarmenqa was the pre-Hispanic designation for the hill in northwest Cuzco where the parish church of Santa Ana is located. Among those interviewed in Cuzco on June 19, 1571, were the following:

—Don Alonso Sacre, age seventy-five, identified as a Chachapoya of those that guard the justices of Cuzco. His residence was in the "Carmenga" district of Cuzco.

—Don García Chenipotela, age eighty, identified as a Cañari of those that guard the justices of Cuzco; he, too, resided in "Carmenga."

—Don Martín Calcazilla, age seventy-eight, identified as a Cañari of those that guard the justices of Cusco. Like those named above, he resided in Cuzco's "Carmenga" district.

—Santiago Tacuri, age seventy-six, described as a native of Atavillos. His grandparents were brought to the Cuzco region by Topa Inga Yupangui (Túpaq Inka Yupanki). According to his testimony, in pre-Hispanic times his family served as accountants in charge of the Inka's camelid herds ("fueron contadores de las ovejas del Inga"). At the time he was interviewed, he lived in Cuzco's "Carmenga" district and was said to have served the justices of Cuzco "along with the Cañari." (Toledo [1571] 1940, 133–134)

The testimony suggests that Cañaris, Chachapoyas, as well as other non-Inka Andean ethnic groups, all brought to Cuzco by the Inkas to serve the state, resided on the hill of Qarmenqa. In postconquest Cuzco, this neighborhood was renamed Santa Ana, but its pre-Hispanic appellation as well as its *mitmaq* population was retained. Cieza de León ([1553] 1959, 98), writing prior to midcentury, confirms the above testimony when he says that many ethnic Chachapoyas were brought to Cuzco, where they were given lands to cultivate and house plots "not far from a hill close to the city called Carmenga" where their descendants still reside.[16] Toledo's *Informaciones* also tell us that Santa Ana was

the parish where most, if not all, of the Spanish magistrate's Andean guards lived.

The Cañaris were still prominent members of Santa Ana parish in 1610. In that year, they performed in a local festival honoring the beatification of Saint Ignatius Loyola. They were identified by an anonymous chronicler (probably the Jesuit Bernabé Cobo) as the Inka's guard (Romero 1923, 450). Although only Cañaris are specifically mentioned, it is likely that this group included Chachapoyas as well as other non-Inkas that we know served in the magistrate's corps. According to this festivity account, the indigenous performances took place from the 2nd to the 26th of May 1610. The procession of the parishioners of Santa Ana, which took place on a Sunday, was led by 300 Cañari soldiers. The report reads: "Just before high mass the parish of Santa Ana came in procession to the plaza which was filled with Spaniards. In front were 300 well-dressed Cañari soldiers armed with pikes, halberds, and many arquebuses. They brought a castle which they set up in the plaza and they fought, skirmishing to the sound of drums."[17] The parish of Santa Ana first performed on a Sunday; they followed up that appearance the succeeding Sunday when the Cañaris again presented mock battles. That they appeared on consecutive Sundays is a sign of their local preeminence. Sunday and Thursday (the feast day) are generally the most important days of any Christian celebration. While no group performed on Thursday, the parish of Santa Ana was privileged by its Sunday exhibitions; the other native parishes performed on other weekdays and on Saturday.[18] That both their public festive presentations highlighted their military capabilities suggests that Santa Ana parish was identified strongly with the guard of Cañaris (and others) that resided there. Their public performances were orchestrated so as to emphasize their reputation as fierce fighters as well as their service to their overlords (the Inkas in the past and Spaniards at that time).

Three-quarters of a century after this 1610 performance, the parish of Santa Ana was still home to these non-Inka Andeans—and they were still acting as the magistrate's messengers and providing him with personal vassalage. A document from 1691 details the arrangements for vassals to serve six-month terms in the corregidor's service as well as to aid the parish priest and fiscales. Orchestrating the terms was the cacique principal y gobernador of the parish of Santa Ana, who was named as being of the ayllu Chachapoya.[19] In the midcolonial period, one of Santa Ana's ayllus (probably elsewhere referred to as that of the Yana-

kunas or Yanaconas) was sometimes named as the *ayllu* of "Yndios Cañares Chasqueros," or Cañari Indian messengers; the *cacique* of that *ayllu* was known as the *cacique de chasqueros* ("chief of messengers") or *cacique de correos* ("chief of the mail") (e.g., ADC, Francisco Maldonado, leg. 200, 1712). At the end of the eighteenth century, the Cañaris were still operating as royal mail carriers; this was, apparently, one of their most valued services.[20]

In the seventeenth century, two of the strongest and most cohesive *ayllus* in Cuzco were Santa Ana's "Chachapoyas" and that parish's Yanacona *ayllu* (Gibbs 1979, 27, 271). The stability of these two groups' leadership and populations is remarkable considering the tremendous economic pressures operating against *ayllu* cohesion in urban Cuzco. Chachapoya *ayllu* was undoubtedly made up of descendants of those Chachapoyas brought to Cuzco and resettled in Qarmenqa some fifty years before the advent of the Spaniards. Yanacona *ayllu* may have been composed, at least in part, by the Cañaris who served the Inkas as *yana-kuna* and who were referred to as such by Spanish authorities (recall that Viceroys Toledo and Borja used the term *yanakuna* to describe such Cañaris). Yanacona *ayllu* and the *ayllu* of Cañari messengers probably refers to the same group. Their status as privileged ethnic groups, freed from conventional tribute obligations, would have provided a compelling reason to maintain ethnic and group cohesion and identity.[21] Certainly there was a strong identification of Santa Ana with its Cañari residents—so strong, in fact, that in legal documents from the second half of the seventeenth century, the parish of Santa Ana was sometimes referred to as the "parroquia de los cañares" (e.g., ADC, Corregimiento, Pedimentos, leg. 82, 1582–1699).

While they were not the only inhabitants of the parish of Santa Ana, the Cañaris and Chachapoyas seem to have been its most renowned representatives, having leading roles in civic festivals. The canvas of the processional finale may be understood as documenting the prominent participation of these non-Inka Andeans from the parish of Santa Ana in Cuzco's Corpus Christi. Corpus Christi, the single celebration of the Roman Catholic festive cycle that calls for all groups in a diocese to assemble in a triumphal procession, sets the stage for competition between participants. The order of the procession ranks the celebrants; corporate groups are judged by the lavishness of their display. The triumphal framework of Corpus Christi encourages explicit references to sacred as well as profane militaristic activity. Chilche's words (as

related by the witness Garcilaso), that he quite naturally chose to commemorate his defense of the Christian Spaniards "on such an occasion as [Corpus Christi]" underscores this aspect of the colonial festival. Garcilaso ([1609, 1617] 1966, 2:1416) stresses the "ethnic" diversity expressed in Cuzco during Corpus Christi as each community dressed distinctly to emphasize its unique heritage. Apparently, both Inka and non-Inka Andeans of Cuzco regarded Corpus Christi as the appropriate occasion on which to showcase their diverse ethnic identities, historical importance, and status in the community.

The appearance of the Cañari and Chachapoya arquebus corps in the festival of Corpus Christi serves as a reminder of the historical alliance of these non-Inka natives and Spaniards. It also put them at odds with the colonial-period Inkas who, as Garcilaso said, would have preferred to forget the resistance some of their ancestors had offered the Spanish conquerors. Moreover, colonial-period Inkas were claiming the same accomplishments as the Cañaris and others in order to secure privileges for themselves. Like the Cañaris and the Chachapoyas, colonial Inkas commonly claimed that their ancestors at the time of the conquest were the very first to serve Pizarro. For example, a 1679 land claim filed by Don Francisco Sayri Topa, a descendant of Sapa Inka Lloque Yupanqui, includes the avowal that his ancestors escorted Francisco Pizarro from Cajamarca to Cuzco, building bridges and roads to facilitate their journey (ADC, Corregimiento, Causas Ordinarias, leg. 20, 1677–1679). Another Inka noble swore that one of his ancestors had escorted Pizarro and been loyal to the Spanish king and that, "in all the troubles caused by Manko Inka and in the Spanish uprisings and in all the battles against the crown that happened at that time, he [had] served as a loyal vassal."[22] Reminiscent of the stories that Chilche had been first to welcome the Spaniards to Cuzco and to accept Christianity, colonial Inka elites also claimed to have among their ancestors the first converts to Christianity. Recall how the Chiguan Topa family, for example, claimed that their ancestor Don Alonso was the very first in the Andes to receive Christ—and the posthumous portrait they had made of him underscores that assertion (Fig. 29).

Inkas, Cañaris, Chachapoyas, and no doubt others, sought to authorize their competing versions of the past. This they did through festive performances that commanded the attention of Spanish colonial officials. Thus do we find Chilche still rehearsing his triumph in 1555, the noble Inka Túpaq Atau assuming the role of Sapa Inka and

commemorating a pre-Hispanic military victory in 1610, and scores of other choreographed advocations. Commissioning canvases for the Corpus Christi series also afforded Inkas and non-Inkas an opportunity to showcase that in which they took considerable pride. Hanging on parish walls, these images reached not only the multiethnic residents of Santa Ana, but Spanish authorities, who were themselves featured in various canvases of the series. So, while the Inkas displayed their imperial heritage, the Cañaris and Chachapoyas underscored their service to the Spaniards.

Processional Finale, the last and largest canvas of the Corpus Christi series, offers eloquent testimony to the active role taken by Andeans in forging new postconquest identities that, although they drew on the past, were keyed to colonial audiences. Because native prestige in colonial society depended on affiliation with Europeans, services performed, and ethnic heritage, the "native" insignia and costume have been modified. Feathered headbands have been jewel-encrusted in the manner of European crowns (much as the Inkas did with their *llawt'us*). Tunics, while of a native cut, are of the finest European materials and are decorated with European patterning.

Because the paintings of Corpus Christi hung in the parish church of Santa Ana, it is fitting that the culminating canvas of the series—that of the processional finale—features the parish of Santa Ana as well as its Cañari and Chachapoya representatives. The positioning of the patron saint, the standard-bearer's finery, and the prominence of the military corps are all manifestations of Santa Ana parish pride in their leaders. They can also be understood as challenges to other Andean parishes and to Cuzco's Inka nobles. Given the history of ethnic discord during Corpus Christi in Cuzco, it is significant that this canvas, in its depiction of the assembled Andean parishes, contradicts the paintings of the individual parishes sponsored by the colonial-period Inkas. In the final canvas, the status and ethnicity of the Inka *caciques* is denied. Whereas the indigenous leaders wear imperial costume in the individual canvases of which they were probably patrons, in the finale they do not. And while the postconquest Inkas, in their individual canvases, wear *maskapaychas* on their brows and thus appear as heirs to the imperial title, here they have broad-brimmed European hats (which they have doffed as the Blessed Sacrament passes).

Surely it is no coincidence that, in the same canvas where the Inka nobility are stripped of their ethnic identity, the Cañari members of the

magistrate's guard display theirs. This canvas, the culmination of the procession, concludes the series with a visual contradiction, creating tension between the "Cañari canvas" and those of the Inkas. The pictorial dialectic participates in an ongoing argument between Andean ethnic groups about their relative status in colonial society. Following the polemical threads, we can see the pictorial contradictions as traces of conflicting cultural strategies which themselves arose from social discord between Andean ethnic groups vying for the favor of local Spanish colonial authority. This canvas suggests that native Andeans saw each other as rivals and were intensely aware of ethnic differences. The Spaniards, by grouping all natives together as "indios," obscured this distinction. The canvases of the Corpus Christi procession, however, reveal that, for the Cuzqueño Andeans, ethnic distinctions were critical to their prestige and position in colonial society. And so, more than a hundred years after the Cañari Don Francisco Chilche used the festive occasion of Corpus Christi to commemorate his service to the Spaniards and insult the Inkas, we find Chilche's descendants in the parish of Santa Ana continuing to throw down his gauntlet.

Postscript

To this day some residents of the parish of Santa Ana maintain Cañari identities. In 1996, as I ascended toward the parish church, stopping at the candle shops for which the district is renowned, I asked shopkeepers about the history of the parish and its Cañari residents. Several individuals told me of Cañari neighbors and friends living in the parish. In contrast, Cuzqueños elsewhere in the city know very little about the Cañaris and, in fact, I was told on more than one occasion that the city was "Inka only." Speaking primarily of modern Mexico, Néstor García Canclini (1983, 10–11) observes that contemporary states often self-simplify, turning lo étnico, reflective of subaltern heterogeneity, into lo típico, generic alterity. García Canclini implicates the tourist industry in this homogenizing move; as we shall explore in the following chapter, the superficial and seeming triumph of Inka identity in modern Cuzco responds both to internal and external pressures.

Chapter 9

The Inka Triumphant

"El Inca" Garcilaso de la Vega's description of the Inkas' pre-Hispanic celebration of Inti Raymi (or Intip Raimi), the festival of the sun, purposefully echoes his description of Corpus Christi in Cuzco. Garcilaso maintains that the solar celebration had been held during the Inka equivalent of the month of June, and thus at approximately the same time as the Christian festival of Christ's Body. In Garcilaso's ([1609, 1617] 1966, 1:357) words, in attendance at the pre-Hispanic Inti Raymi ceremony were chiefs dressed

exactly as Hercules is depicted, clad in a lion's skin, with the Indian's head inside the lion's, since they boasted of their descent from a lion. Still others appeared in the guise in which angels are depicted, with the great wings of a bird called the *cuntur*. [. . .] The Indians in question pretended to originate and descend from a *cuntur*.

For Cuzco's Corpus Christi, he writes:

Some [Indians] came dressed in lionskins, as Hercules is depicted, with their heads in the lion's head, since they claim descent from this animal. Others had the wings of a very large bird called *cuntur* fixed on their shoulders, as angel's wings are in pictures, for it was from this bird that they boasted of descending. (ibid., 2:1416)

Garcilaso's descriptions of Inti Raymi and Corpus Christi are intentionally analogous. For this *mestizo* author, writing in the early seventeenth century, the presence of Inti Raymi in colonial Cuzco's Corpus Christi

celebration served to bolster one of the primary aims of his chronicle: namely, to demonstrate how the Inkas had prepared the way for Christianity in the Andes. He wanted to show how easily Inkaic festive practices were Christianized and therefore how harmless was the alterity of Andeans. The diverse Andean "nations"—people of the puma, people of the condor—were brought together to celebrate the transubstantiated Christ housed in a solar monstrance as they had once feted the Inka sun. Christians and Inkas were not all that different: both knew the "proper" way to revere a single, supreme deity.

According to Garcilaso's strategic essentializing of Inka religious practices, the Andean festive forms he observed in colonial Cuzco were understood as "unadulterated." For Garcilaso (and many others), native costume, songs, and dances allowed one to vicariously witness Inka festivals such as Inti Raymi. Contrary to his purpose, though, he helped lay the foundation for those anxious moments of the seventeenth and late eighteenth centuries in which Inti Raymi threatened not to evince the triumph of Corpus Christi but, rather, to triumph over it. Garcilaso's legacy, in fact, has been the revival of Inti Raymi in the twentieth century. In this final chapter our attention turns to the Sapa Inka, who is performed today not within Corpus Christi but following it, and who in many ways triumphs over it.

"El Inca's" Legacy

Because of the authority with which Garcilaso, the son of an Inka noblewoman and a Spanish *hidalgo*, wrote, his understandings, motives, and desires are essential to any consideration of how Inti Raymi became identified with Corpus Christi. Although Garcilaso had no formal schooling in Spain, he was an accomplished autodidact in the humanist tradition. He focused on the history of classical and Christian antiquity; he knew Latin and probably at least some Greek. Garcilaso sought to reconcile the contradictions he perceived between Andean and Western European cultural practices and discourses. Achieving the Renaissance ideal of *concordia* (the conciliation of opposites) was one of his primary concerns (Zamora 1988). By insisting on parallels and commonalities between the cultures of the Andes and those of Europe, Garcilaso opened up Western discourse to allow for the possibilities of "harmless" difference. While some have interpreted his work as sub-

verting the process of conquest, he more often altered Andean cultural precepts to accommodate Western notions than the other way around. He thus figured the Andean as implicitly subordinate to the European.[1]

However, from an Andean perspective, Garcilaso can be seen to have poised the Andean in complementary opposition to the European. In the same way that Andean communities were commonly divided into *anan* (upper) and *urin* (lower) sectors—*anan* being conditionally identified with masculinized victors and *urin* with the feminized vanquished —Garcilaso described the viceregal Andes as the *urin* to Europe's *anan*. According to the Andean schema, *urin* is vitally necessary to *anan;* since neither can exist without the other, the superiority of *anan* is always dependent and relational rather than total and absolute. As Zamora (1988, 3) notes, "In the final analysis, [Garcilaso's] interpretation of [Inka] civilization strives to demonstrate the fundamental complementarity of New World and Christian histories." For our specific interests, Inti Raymi served Garcilaso as the subordinate *but necessary* complement to Corpus Christi. In his eyes, Corpus Christi would not just have been inadequate in the Andes, but would not have *been* without Inti Raymi both to prefigure it and to give it Andean form.

Interestingly, Garcilaso's chronicle first appeared in print in Spain at approximately the same time that the discovery of covert idolatry was prompting extirpatory campaigns in Peru. What to Garcilaso in Spain was evidence of delightful cultural complementarity suggested wicked duplicity in the Andes. While El Inca's account was widely read in Europe, it made little impact in Peru until the eighteenth century (J. Rowe 1954, 24–26). After the second edition was issued (1723), Garcilaso's words were more readily available to Peruvian elites, both Hispanic and Andean. They certainly had a lasting impact on how Corpus Christi was thought of in Cuzco. His words kept alive the numerous sixteenth-century efforts to substitute Corpus Christi for a variety of pre-Hispanic festivals and hinted at the failure of that project. They also solidified a vague association of the festival of Christ's Body with several different Andean festivals into a certain, albeit uneasy, partnership with Inti Raymi.

Because Garcilaso's work was so widely read from the eighteenth century on, Hispanics continued to think of Corpus Christi as a festive space in which Andeans revived their reverence of the sun even though the colonial festival looked nothing like Garcilaso's description of it. In fact, Garcilaso's linkage of Inti Raymi and Corpus Christi, which was

tenuous at best in the colonial period, was consolidated after Peru's independence and codified early in the twentieth century.

Inti Also Rises

The light of the Inka sun dawned for Peruvian intellectuals in the first half of the twentieth century.[2] Alberto Flores Galindo (1986a), echoing the conventional division of the pre-Hispanic Andes into early, middle, and late horizons, coins the term "Utopian horizon" to describe the period beginning in 1920 during which Peruvian intellectuals reinvented the pre-Hispanic past as a national past. Pre-Hispanic motifs were adopted as political symbols by mestizo elites, and some indigenistas reinvented themselves as Indians.[3] Ezequiel Urviola, for example, donned a poncho and ojotas (Indian sandals) and spoke Quechua. He, José Carlos Mariátegui, and others argued for seeing a continuity between the rebellions of the late nineteenth century and those of the colonial period, most notably that of Túpac Amaru II (1780–1781). They created a noble, romantic, resistant Indian whose struggle was that of all Peru (Flores Galindo 1986a, 293).

Indigenistas, searching for the resilient Inka in contemporary Peru, looked through Garcilaso's eyes to Corpus Christi in Cuzco. Prompted by the mestizo author who called himself "El Inca," they too saw Inti Raymi in Corpus Christi, although their motivations were vastly different. As we have seen in previous chapters, in the early colonial period Hispanics saw Inti Raymi (and other pre-Hispanic rites) in Corpus Christi because its subjected presence testified to the triumph of Corpus Christi; later, the specter of Inti Raymi hinted at evangelical failure and confirmed their fears. Ironically, in the early twentieth century, Inti Raymi was heralded as triumphant, as having "survived" beneath the stifling mantle of Corpus Christi.

Writing at the beginning of the era of indigenismo José Uriel García (1925, 71) concluded that Cuzco's Corpus Christi has "a sensual character derived from the obvious and enormous influence of the indigenous spirit. The Raimis of the ancient empire are reproduced in certain disguised forms in the Corpus processions as well as in the subsequent unbridled sentiment which characterizes both Corpus and idolatrous agricultural festivals."[4] García finds that although Andean bodies were conquered and militarily, politically, and economically oppressed for

centuries, the disembodied indigenous spirit "survived" inside Corpus Christi. Significantly, he characterizes the "native" as an ethereal thing of emotion and sentiment. His "native" is not a body of substance and rational thought, but a spiritual quality that he severed from the bodies of real Indians (who exist in great numbers in Peru) so that it could be felt by all Peruvians (including the urban middle and upper classes). While Hispanic evangelizers sought to convert the native body and soul, modern Peruvians sought a pure disembodied spirit that they could evoke for nationalist purposes.

Given the widely held notion expressed by García that the "Indian" can be *felt* around Corpus Christi, it is not surprising that in the 1920s President Augusto B. Leguía y Salcedo, responding to the *indigenismo* movement, named June 24 the "Día del indio y festividad cívica nacional" (Day of the Indian and National Civic Festival). The 24th is, of course, *after* rather than *on* the June solstice: why the delay? Setting the date as the 24th means that the modern Inti Raymi is always necessarily celebrated on the heels of Corpus Christi, which is celebrated between May 20 and June 23. Corpus Christi and Inti Raymi are thus inextricably linked by modern understandings of the colonial past.

The period around Corpus Christi and the June solstice has become the occasion to recognize the Indian in Peru—to herald not the indigenous body (of which there are many) but, rather, the elusive native soul of Peru. Of Cuzco's Corpus Christi celebration Jorge Cornejo Bouroncle (1946, 91–92) wrote: "[T]he festival of the Corpus, which is celebrated in the month of June, is the most deeply rooted popular solemnity, as well as the most colorful and most deeply felt, because it is none other than the memory of Inti Raymi, the festival of the sun, the major rite of the Inka cult from the happy and golden centuries of the empire."[5] Significantly, Cornejo Bouroncle wrote these words shortly after Inti Raymi was revived in Cuzco. In 1944 Inti Raymi was reintroduced as the central act in the city's celebration of Peru's indigenous inheritance. The elements of the celebration have changed over time: initially what was known as "The Day of the Indian" came to be called at midcentury (when the word "Indian" was out of favor) "The Day of Cuzco." The celebration has expanded over time as well. By midcentury, the day celebrating the indigenous heritage had become a Jubilee week and it has now, at the end of the century, blossomed into El Mes Jubilar (Jubilee month). Currently, festivities begin in May, the month preceding the June solstice; they include parades, "folkloric" dances, art and craft

exhibitions, civic fairs, and concerts. Although evocations of the Inka past continue throughout tourist season (May through August), the celebrations reach their zenith at noon on June 24 with the purported reenactment of the pre-Hispanic festival of Inti Raymi, the Inka winter solstice festival. Whereas the festival of Corpus Christi is currently a production of local parishes and is thus increasingly decentralized, Inti Raymi is the city's major official civic production.[6]

The modern Inti Raymi and the activities surrounding it (the Semana Jubilar, or Jubilee week) were the brainchild of the Cuzqueño journalist Humberto Vidal Unda, who first organized the festival in 1944. As an *indigenista*, Vidal looked to the Inkaic past for inspiration in modern nationbuilding. While Vidal's idea did indeed spur tourist activity and was/is an economic boon to the city, he was not motivated solely or even primarily by economic motives. Like many intellectuals of his era, reviving Inti Raymi was a nationalist gesture; it was designed to make the Inkaic past a source of pride not only to "Indians," but to all Peruvians, and thereby recognize Inka history as Peru's history. Like all modern states, Peru defines itself in relation to a prenational past that it must continually re-create.

Whatever Vidal's multiple and complex motivations, Inti Raymi must also be recognized as the centerpiece of the city's tourist program. The economic potential of the past showcased in Inti Raymi was soon recognized. The first performance of Inti Raymi was attended by Peru's president (Manuel Prado), whose presence attracted national attention and was designed to stimulate both national and international tourism (Fiedler 1985, 339). In 1996, Inti Raymi was organized by Cuzco's Empresa Municipal de Festejos, Actividades Recreacionales y Turísticas (EMUFEC) in conjunction with a variety of local, regional, and national organizations. The two largest sponsors were the Compañía Cervecera del Sur del Perú, makers of Cerveza Cusqueña (a brand of beer), and Industrial Cusco, the local producers of Coca-Cola; these beverages were named the official drinks of Inti Raymi.

Cuzco's mayor in 1996 (Raúl Salízar Saico) penned a brief introduction to the program of Inti Raymi events. Continuing the confusion about pre-Hispanic festivals by identifying Inti Raymi as the Inka harvest festival, he suggests that what Inti Raymi really celebrates is Inka industry—in agriculture and engineering in particular. Clearly the current potential for industrial development of the Cuzco region is a screaming subtext of his statement. He also acknowledges and cele-

brates the *indigenista* desire to evoke the greatness of the past so as to protect Cuzco's future. His words suggest that the future may be secured by packaging and selling the city's past to "our visitors who arrive at this sanctuary [i.e., Cuzco]." [7]

In colonial Cuzco, Inka edifices, shrines, and burials were systematically looted and stripped of valuables. The fate of Saqsaywamán is best known (Dean 1998), but contracts also exist in the Departmental Archives that tell of discoveries and "excavations" of minor *wak'as* and burials.[8] Even in the eighteenth century, Cuzqueños could still hope to uncover the wealth of the Inkas in their own backyards. And today *campesinos* still commonly suggest that a golden corn cob or other precious object might be found while poking around in the Inka countryside. Their urban compatriots have found more substantial gold in the Inka past, although it is not the wealth of objects but of imaginations. It seems that tourists will flock to Cuzco to experience the imagined past and to imagine the Inkas for themselves.

Inti Raymi 1996

The activities of June 24, 1996, were initiated at 8:00 a.m. with a flag-raising in the *plaza mayor* and special mass in the cathedral. The theatrical presentation of Inti Raymi itself began at the Qorikancha (the church and convent of Santo Domingo), where costumed performers impersonated representatives of the four provinces of the Inka empire (Tawantinsuyu, or "quartered land"). They gathered along with "priests," *aqllas* ("chosen women" who, in pre-Hispanic times, served Inka royalty and in Inka temples), and other members of the royal court. The high priest and the Sapa Inka both uttered prayers to the rising sun; the Sapa Inka, with the Qoya at his side, made an offering to the sun by pouring *chicha* onto the Inka stones that once were part of the Qorikancha, the Inka's main temple, but now are part of the wall of the church of Santo Domingo (Fig. 49).

After the hour-long introductory drama, the Inka and his large retinue moved in procession to the *plaza de armas*. There, in front of the cathedral, dances were performed. After another hour or so, the performance proceeded to *chukipampa*, the large open space surrounded by the ruins of Saqsaywamán for the "Majestuosa evocación del Inti Raymi." While wealthier tourists and Cuzqueño elites occupied the privileged

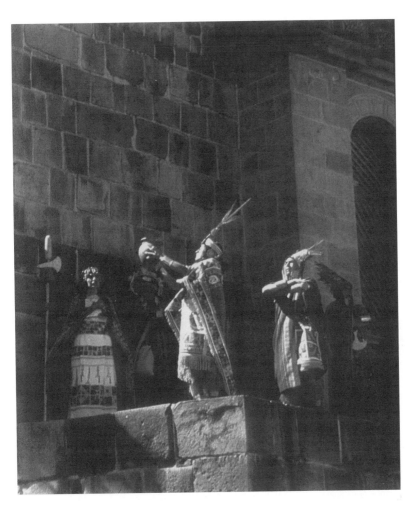

49. Inti Raymi ceremonies at Santo Domingo, June 24, 1996, Cuzco

bleachers, most of the tens of thousands who attended the event at Saq-saywamán scrambled for seating on the rocks and boulders of the Inka ruins. The impressive remains of Inka edifices made a grand setting for this modern re-creation of the pre-Hispanic solar feast which included offerings of chicha and a theatrical llama sacrifice.

Spending the day at Saqsaywamán has become a family tradition for many Cuzqueños. Seeing the theatrical production is only a small part of a day devoted to picnicking, playing fútbol, and visiting with friends and acquaintances. The enactment of Inti Raymi 1996 was followed at 3:00 p.m. by a fair, sponsored by Cerveza Cusqueña at the Huancaro

Fairgrounds in town. This latter event was part of a series of events held at Huancaro and sponsored by various Peruvian breweries; that the local company had the day of Inti Raymi for its presentation is, of course, not a coincidence. The fairs, with music to entertain the crowds, showcase regional agriculture, husbandry, and artisanal industries.

Renaissancing Inti Raymi

Carol Ann Fiedler (1985, 338–354) offers a description and analysis of the Inti Raymi of 1980; in many respects, her observations are pertinent to the Inti Raymi of 1996 which I witnessed. She emphasizes how the modern Inti Raymi was, from its inception, a "marketing strategy for local industry, especially tourism." The role of Sapa Inka in the 1980 Inti Raymi, for example, was played by a major hotel owner and business entrepreneur who spoke English and French as well as Spanish and Quechua.[9] The ceremony itself was performed by local semiprofessional dance troupes who regularly perform for tourists. Fiedler also notes that the Cuzqueño upper class controls all major public activities and positions, the middle class profits somewhat, and the poor (who are mostly Indians) are negatively affected owing to a rise in food prices during the time the city is inundated by tourists, and to the fact that their economic activities (which are pursued in the streets) are restricted. Inti Raymi can fairly be called the "official" evocation of the Inka, and the local sociopolitical order is reflected in its organization.

There have been some changes over the past decade. While in the 1980s few women participated at the higher levels of organization, by 1996 the board of the organizing body consisted of four men and three women. The organization is undeniably patriarchal, however, and the imagined Sapa Inka—the wise, omnipotent father of his people—is consistent with present patriarchal values and political organization.

The celebratory acts have changed in the years since 1944, and each year sees variations in the rites and dances. Whereas the Inti Raymis of the mid-twentieth century were held on the municipal margins in the ruins of Saqsaywamán, today the show moves through the very heart of the city, like the rising sun, before reaching its zenith in the pre-Hispanic ruins above the city. The culminating offerings and sacrifices have remained a constant feature of the festival, however. Inti Raymi in the twentieth century is, of course, not the Inkas' festival, nor could it

approximate the pre-Hispanic rites even if that were desired. According to Bernabé Cobo ([1653] 1990, 142–143), Inti Raymi, which was held in June, included a certain dance (the *cayo*) and the sacrifice of two llamas to the creator deity Wiraqocha on the hill of Manturcalla; few chroniclers tell us any more about the actual rites. In the 1960s a professor at the local university was called upon to script the modern Inti Raymi; although he used the chroniclers as his source, the reenactment required considerable invention. Fiedler (1985, 352) quotes him as saying that the ceremony is "five percent documentary, ninety-five percent fantasy." Of course, who knows how much of the 5 percent that was drawn from colonial sources was a fantasy of the chroniclers.

Perversely, and certainly ironically, what was known of colonial-period Corpus Christi celebrations was used by twentieth-century historians to access Inti Raymi. Cornejo Bouroncle (1946, 96, 98) writes:

In general the colonial clergy didn't try to eradicate the tradition of Inti Raymi and looked for a Catholic rite that coincided with the time of the solar festival. The Corpus Christi, then, was the best designation and, because of this, this celebration is held with more pomp than in any other city and the tradition maintains the feeling of both festivals in juxtaposition: the pantheism of the people of Tawantinsuyu and the Catholicism of the emperors with the saints of the different churches; the royal *ayllus* reappeared in the guise of various parishes. The [Sapa Inka] was replaced by the standard-bearer, who was an Indian of noble blood, and the imperial family was represented by the many priests and bureaucratic personnel of the local viceregal government.[10]

Cornejo Bouroncle presents Corpus Christi in Cuzco as Inti Raymi slightly revised and fails to understand how the Christian festival implicated Inti Raymi in its need to demonstrate triumph. He looks through the paintings of Cuzco's Corpus Christi (discussed in Chapter 4 above) to see a pre-Hispanic act. Many other scholars have done likewise. Although for very different reasons, twentieth-century scholars followed the "pen-prints" of colonial-period authors who once evoked Inti Raymi to discuss the "problem" of the transculturated Corpus Christi. Fiedler (1985) was perhaps the first to question seriously the equation of Inti Raymi and Corpus Christi; since her work, other insightful discussions of modern Corpus Christi celebrations have successfully explored their "Indian" aspects (Huayhuaca Villasante 1988, Flores Ochoa 1990).

Still, it is because of colonial-period ambivalence and twentieth-century romanticization that modern Cuzqueños and tourists (Peruvian and foreign alike) can find an Inka in late June in Cuzco. Very few celebrants are unaware of the fact that Inti Raymi is a fabulous example of an "invention of tradition" (Hobsbawm and Ranger 1992). The modern Inti Raymi has always been understood locally as an evocation (*evocación*), a commemoration rather than a memory. In midcentury, for example, one student of Cuzco's history expressed the sentiments of her generation when she wrote of the Inti Raymi celebration: "[Cuzco during Inti Raymi] is not just a city, nor only a memory, it is a possibility of the Peruvian soul, an ideal" (*No solo es una ciudad, ni tan solo un recuerdo, es una posibilidad del alma peruana, un ideal*) (Camacho Delgado 1953, 3). The imagined Inti Raymi is an opportunity to imagine Cuzco. Ronal Hermoza Muñiz (1996, 3), the president of the board of directors of EMUFEC, echoes popular sentiments when he writes: "Beloved Cuzco, there are few opportunities in life that permit us to express publicly our love for and pride in our land; [Inti Raymi] is one of these." [11]

Inti Raymi appeals primarily to Peruvians, especially tourists from Lima and Arequipa. European and North American tourists may attend the events of the 24th, but tend to scoff that the show is "just for tourists." One early visitor, a scholar of colonial Latin America, dismissed the modern Inti Raymi as a "parody" and a "costume party for tourists." [12] Currently, North Americans, ever hoping for an "authentic" experience, prefer New Age shaman tours or the increasingly popular Qoyllur Rit'i festival, which occurs in the days prior to Corpus Christi. Qoyllur Rit'i is a truly composite event in which more than ten thousand *campesinos* from regional communities gather to celebrate at a boulder (surely a pre-Hispanic *wak'a*) on which an image of the Christ child is said to have appeared in 1785. The festival, which honors regional *apus* (mountain deities) as well as Christ, has been described and analyzed by many scholars including Efraín Morote Best (1957–1958, 159–160), Andrés Ramírez (1969), Rosalind Gow and Bernabé Condori (1976), David Gow (1976 and 1980), Robert Randall (1982 and 1987), Michael J. Sallnow (1987, 207–242), and Catherine Allen (1988, 108–110). In many of its aspects, Qoyllur Rit'i is the rural festive complement to urban Cuzco's Corpus Christi. Honoring (male) mountain deities complements the Corpus Christi focus on harvest in the productive (feminine) Cuzco Valley. [13]

The complementary relationship of Corpus Christi and Qoyllur Rit'i

is never acknowledged or promoted in the way that Inti Raymi's relationship to Corpus Christi is, however. The modern Inti Raymi, in fact, depends on that association as a "survival." Foreigners, who claim (with a certain amount of superiority) to recognize it as merely an invented tradition, though, fail to realize that few Peruvians are "fooled" by the Inti Raymi show. Inti Raymi does not claim—except in the most hyperbolic advertising—to be "authentically Inka." The word "evocation" in the festival's "Majestuosa evocación del Inti Raymi" carefully signals this. The modern Inti Raymi is a scripted, organized tribute to an irretrievable past. It is precisely because of the irretrievability that it strikes nationals and foreigners differently. North Americans absurdly think of "their Indians" (natives of North America) as vanished; they look to Peru's *campesinos* (those who *look* and *act* the least Europeanized) for the "Indian experience." For Peruvians, "Indians" are all around, if not in their own genes, but debased; their noble soul has been obfuscated by centuries of oppression. Inti Raymi allows the *mestizo* nation to discover the noble savage in themselves, the festive alter ego by which their daily, modern selves are defined. Although interpreted by foreign tourists as being a show *for them*, Inti Raymi has always appealed much more to regional and national tourism than to international tourism.

The Transient Triumph

Thomas Abercrombie (1990) offers many useful observations in his consideration of Indianness and the performative culture of Carnival in Oruro (Bolivia). Both Inti Raymi in Cuzco and Carnival in Oruro celebrate indigenous culture and co-opt the Andean past on behalf of nationalist projects. Both festivals attract thousands of tourists, and in both cases those tourists are primarily national and urban. Abercrombie (1990, 116) notes that although thousands of Bolivians adopt native dress and dance indigenous dances for Carnival, "nary an Indian" actually participates; he defines "Indian" as those who do not (or cannot) take off their identification with the costume at the end of the festival. "Indians," no matter what the genetic composition, are thus "permanent and self-professed."

The performed "Indian" is an urban construction that depends on the notion that the Indian resides in the past and thus has no (and is denied any) agency in the present (Abercrombie 1990, 111). Urban

Bolivians, therefore, can "put on" an indigenous identity for a festival. Abercrombie (ibid., 120) concludes that they externalize the Indian within themselves through dance and "re-repress" him/her at festival's end. The *campesino* is thus doubly silenced through the performance of the indigenous past. In Peru, Inti Raymi provides a time when all Peruvians can be (royal) Inkas. As Fielder (1985, 54) observes, Inti Raymi is an occasion on which the "contemporary, culturally Mestizo elite literally clothe themselves in Incan ethnicity, but they do so only to acknowledge it as part of a distant idealized past." Being Inka is today a proud, if transient, state; indeed, I would argue that celebrants can be proud precisely because the "Inka inside" *is* transient. It is the ability to shed Indian identity that defines the modern celebrants of Inti Raymi. The festival affirms the modernity of Cuzco by evoking a past so distant and remote that its legacy can be denied. To paraphrase Dipesh Chakrabarty (1992), Inti Raymi points to a certain Cuzco as the primary habitus of ancient history. The modern Sapa Inka, the primary actor in and center of the new Inti Raymi, is nostalgia incarnate; as such, he is the very opposite of the colonial *caciques* who donned antiquarian dress to haul history into their here and now. In contrast, the new Inti Raymi confirms the colonialist severance of pre- and post-Hispanic Peru.

The new Inti Raymi also allows the popular myth of Inkarrí to be performed annually. Briefly, the legend of Inkarrí (derived from the Spanish "Inka Rey," or Inka king), formulated during the colonial period, promises that the beheaded Inka king will be reassembled and will rise from the earth to preside over a utopian Andean future.[14] Inkarrí, or the promise of Inkarrí, is resurrected every Inti Raymi; his transcendental presence is seen in the utopian rhetoric that characterizes the festival. Modern Peruvians do not wait for Inkarrí to regenerate himself, however: they create him. The creation rises not only in the Inti Raymi celebration but in the modernist equation of progress, if not salvation, with industrialization. As it turns out, waiting for Inkarrí means working for a prosperous future through industrialization. Hence the mayor's words, cited above, that the Inkas were skilled engineers resonates in profoundly modernist ways. The imagined Inka of Cuzco's Inti Raymi encourages urbanites to see themselves as Inkarrí's subjects. It also encourages them to dismiss the living, impoverished Indian — the *campesino* of the rural, nonindustrial hinterland — in favor of gold-bedecked ghostly ones.

Although modern Peru looks through colonialism to the pre-

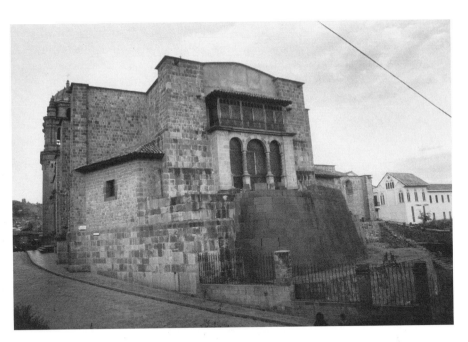

50. Church of Santo Domingo, Cuzco

Hispanic past, resuscitating Inti Raymi does not mean confronting the legacy of colonization. The move to "overlook" or even deny colonialism's impact is implicated in the very setting of Inti Raymi. The opening act of Inti Raymi is staged at a building identified in the official program as the Qorikancha, the Inkas' main temple. Following the Spanish occupation of Cuzco, the Qorikancha was given over to the Dominicans, who built their church and convent over and around the Inka masonry. Subsequent earthquakes and excavations have uncovered the Inka foundations, and today the architectural complex of the Qorikancha–cum–Santo Domingo is truly a composite structure (Fig. 50). Not many years ago the Qorikancha/Santo Domingo complex became the center of a debate about how the city would "face" its past. The archaeologist Raymundo Béjar Navarro and others favored the destruction of the colonial edifice in order to thoroughly excavate the Inka temple on which (and of which) it was built. Archaeological erasure of the colonial-period edifice, of course, could not have undone the violence of the colonial building projects.

The compromise resolution has produced controversial but striking results wherein the rear of Santo Domingo opens onto a sort of "ruins

garden," bordering on the Avenida El Sol. It is in this open space that the "diverse nations of Tawantinsuyu" gather for Inti Raymi. Oddly, during the opening rites of the modern Inti Raymi, the best views are obtained by friars from their windows overlooking their church-cum-Qorikancha. They are the living palimpsests who cannot be erased even as the "Inkas" occupy once again their Temple of the Sun. As the walls of the colonial church of Santo Domingo blend into its Inka foundations and the worked masonry empties into a "park" comprising scattered blocks of worked stone, it is not clear to the casual observer just where Inka masonry ends and colonial masonry (prepared and placed by indigenous workers) and modern reconstruction begin. Are not these blurred lines the lesson of Cuzco itself? In fact, reviving Inti Raymi to follow Corpus Christi rather than *replace* it (as Corpus Christi attempted to do with Inti Raymi) was a performative parallel to the resolution of the Santo Domingo–Qorikancha debate. Both exist and both complement and contradict one another.

Facing the Past

Dialogue continues about how best to show the city's pre-Hispanic Inka face to visitors and still make it a face that Cuzqueños can put on *and* take off. The imaginary Inkas of Inti Raymi, irrevocably past through they may be, have changed over time. Though still heavily romanticized, the Inka is less fictionalized than when the festival was inaugurated. The change in appearance, especially costume and regalia, has been most dramatic. In previous years, the Sapa Inka has worn an upside-down "flower pot" headdress—without so much as a hint of a red fringe—based on fictive colonial-period depictions of Inka rulers by European artists.[15] In 1996, in contrast, the *maskapaycha* was closely modeled on that drawn by the indigenous chronicler Felipe Guaman Poma de Ayala (e.g., Fig. 26). Although the *llawt'u* was imitation gold, the fringe, *tupaqochor*, and *suntur pawqar* were all readily recognizable (Fig. 51). The Sapa Inka of 1996 continued to wear a solar pectoral loosely modeled on forms that may predate the Inkas by as much as twenty centuries (see J. Rowe 1971 and 1976), but his *unku* (with its all-over *tokapu* pattern) more closely mimicked fancy Inka textiles. In previous Inti Raymis the tunic, made of beige cloth, was cut with fringed

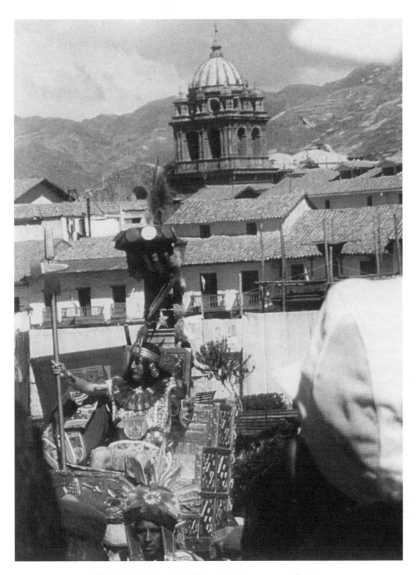

51. The Sapa Inka, Inti Raymi, June 24, 1996, Cuzco

sleeves and appeared to imitate the clothing style of the stereotypical eighteenth- and nineteenth-century North American Plains Indian.

The face of the Inka put on for Inti Raymi is still more imagined than not, but it is less obviously fictitious than in previous decades. In part, this suggests that the audience for Inti Raymi has become increasingly

sophisticated. They want their Inka to more closely resemble the pre-Hispanic Inka. What comfort is there in the fact that currently there is some greater accuracy in particular aspects of Andean history? Well, if the Inkas are less romanticized, then they will be less "irretrievable," less removed from their living descendants. "Indians" may still be "fossilized," to use Abercrombie's word, but they are becoming easier to recognize. It is true that we can only write, or in this case, perform histories consistent with the present. That those histories are becoming more filled with detail is a sign that the present is becoming more aware of the past. That is why colonial connections established by Inka nobles were so significant to the Inka nobles themselves. If the imagined Inkas are imagined as once-living, active individuals, then agency cannot be so easily denied their descendants, even those now called *campesinos*.

Although Peruvians can still "take off" the face of the Inka, there is greater visibility of that Inka face in Cuzco today than at any time since the sixteenth century. Under the leadership of the three-term mayor Daniel Estrada Pérez, who went on to be elected to national office in 1995, official status for the "Quechua spelling" of Cuzco as Qosqo was won. Under Estrada, the city experienced a face-lift with the addition of dozens of fountains and, in particular, a forty-foot statue of the pre-Hispanic Sapa Inka Pachakuti, who is known as the empire builder and the remodeler of ancient Cuzco. Pachakuti now stands atop a hundred-foot stone tower at the end of Avenida El Sol, facing his ancient, modern city.

The face-lift, in keeping with our cosmetic metaphor, has been largely carried out as an exfoliation in which layers of colonial and modern alterations to the city have been scrubbed away, revealing the Inka inside. Names endowed during the colonial period and which helped efface the Inka city are themselves being erased: the former Calle Loreto, named after an advocation of the Virgin Mary, is now labeled Intik'ijllu; and Avenida Triunfo, named after the miraculous appearance of the Virgin Mary during an Inka rebellion in the sixteenth century, is now marked Sunturwasi. The plaza regocijo is the kusipata, and the plaza de armas is designated the haukaypata. Interestingly, nobody but tourists and newcomers to the city actually use the new names. In fact, one shopowner on the plaza told me that the new street signs were not meant to designate new names, but rather to serve as reminders of the Inkaic origins of the city. Needless to say, that is not helpful to tourists

who are directed to a shop on Avenida Arequipa when its only label is currently "Q'aphchik'ijllu."

Once the city put on and took off its "Indian" face annually; with these permanent adjustments, parts of that face are now affixed year-round. The "Indian" in Abercrombie's sense is still largely invisible; but, should the trend continue, she or he will be harder to ignore. Although upper and middle classes still profit most from the imagined Inka, the public at large also participates and finds fulfillment in participation. It should be noted that no admission is charged for viewing the Inti Raymi rites at the Qorikancha and the *plaza de armas*; the majority pay nothing to witness the climactic events at Saqsaywamán. Partaking of and imagining the Inka past is something all can do—and something that all *do* do. Once the imagining starts, it is impossible to know where it will end. As colonial authorities once found out, hearts and minds can be neither legislated nor controlled. So long as the past is present, it provides multiple and differing hopes for the future.

It might also be wise to keep in mind the Andean notion that one moves through time looking backward (i.e., facing) history while the future, the unseeable, comes from behind (Allen 1988, 226). One cannot face the future, but one can envision it by *seeing* history.

Epilogue

In June 1996, the sun of Inti Raymi dawned brightly, promising a glorious day; by midafternoon, though, ominous gray clouds tumbled across the sky, threatening the culmination of the celebration. Almost on the closing words of the ceremony, rain and hail pelted the crowds gathered at Saqsaywamán. The following week, I jokingly observed to some Cuzqueño friends that obviously Inti had not been entirely pleased with the *raymi* held in his honor. My friends, who are bilingual (Quechua and Spanish) and who now identify themselves as *indígenas* (Indians),[16] looked at me oddly; they were even more perplexed when I explained that the hail had seemed to me to be an indication that Inti had not been much impressed by the festival. They shook their heads and asked, "What rain? What hail? The day of Inti Raymi was sunny, cloudless, and perfect *just as it has always been.*" My friends reminded me that memories are creations; we can remember (and perhaps can *only*

remember) the past in ways that affirm our present selves. Certainly Inka nobles of the colonial period showed us that. And so while I, like many others (including many Peruvians), do not remember that day as having been "perfect," I can at least begin to appreciate how, to many others, it could not have been anything else.

Notes

Introduction

1 The low rate at which Andeans partook of the Eucharist owes more to the infrequency of the visits made by clergy to indigenous communities, especially in the hinterlands, than it does to ongoing concerns about how well Andeans were prepared for the sacrament of Holy Communion. A useful, if not entirely unbiased, synopsis of the debates over administering the sacrament of the Eucharist to Indians is offered by the Jesuit scholar Constantino Bayle (1951, 461–556).

2 Mignolo (1989a, 1989b, 1995) proffers the term "colonial semiosis" as more appropriate than the often used "colonial discourse" for the very reason that texts constitute only a small fraction of the significations produced during the colonial period.

3 Although Andean converts adopted many Spanish or European Christian precepts and practices, they did not surrender their ways of understanding and interpreting their lives and their world. "Christian" and "Andean" ought not to be considered antithetical, for a majority of Andeans considered (and consider) themselves Christian and Andean without recognizing any contradiction in identities. For several interesting essays on how Native North American Christians have recognized both their ethnicity (cultural heritage) and their Christianity, see Treat 1996.

4 The works of Michael Taussig (1987 and 1993) and Vicente L. Rafael (1993) have been particularly inspiring and instructive as they approach the study of colonial and postcolonial cultures in deeply historicized ways.

1. Corpus Christi Triumphant

1 My thanks to Richard C. Trexler, who first drew my attention to the triumphal character of the Corpus Christi procession and inspired this avenue of investigation both through personal encouragement and in his numerous studies of early modern performative culture, particularly his illuminating *Public Life in Renaissance Florence* (1980).

2 See Rubin 1991 for a comprehensive study of how and why the Eucharist became a the "central symbol" of Western Christendom in the late Middle Ages. She argues that the Eucharist served as the ultimate symbol of mediation in an increasingly diverse society; it also enforced and reinforced the role of the church as the unifier.

3 For further details on the introduction and institution of the festival of the Corpus Christi, see Herbermann et al. 1908, 4:390–391, and Rubin 1991, 176–212.

4 For example, adherents to the views of Berengar, an eleventh-century archdeacon in Angers who denied literal transubstantiation, plagued the Roman Catholic church for centuries (Addis and Arnold 1951, 57–76, 224). For a summary and discussion of the "critiques" of transubstantiation, which were termed heresies, see Rubin 1991, 319–334.

5 In his commentary on Teresa Gisbert's 1983 analysis of viceregal festivals in Peru, Manuel González Galván (1983, 181–182) classifies Corpus Christi — as well as the activities marking the canonization of a saint, the consecration of a church, and patron saint days — as *fiestas* (festivals). The word *celebración* (celebration), he maintains, better describes an activity such as an auto-da-fé. He also argues that Semana Santa and processions held during times of need (e.g., after earthquakes or during droughts) are not *fiestas*, but *conmemoraciones*. For the purposes of my general discussion, fine distinctions between "festival" and "celebration" will be ignored, and Corpus Christi — joyous in nature — clearly was not a "commemoration."

6 See Rubin 1991, 185–196, for a discussion of Thomas's contributions to the celebration of Corpus Christi.

7 Like all Catholic festivals, the day itself is preceded by the preparatory activities of the novena (the nine days prior to the feast day, a Thursday) and the octave (the eight days following the feast day). The final day, also known as the octave, usually has a small celebration to officially close the festival.

8 See Very 1962 for a history and description of various Corpus Christi processions in Spain. For additional descriptions of Corpus Christi in pre- and early modern Spain, see the following: Rubio García 1983, documenting Corpus Christi traditions of fifteenth-century Murcia in southeastern Spain; Garrido Atienza 1889, examining the Corpus Christi of Granada in southern Spain; and Gascón de Gotor 1916, Azorín García 1984, Más y Prat

1885, and Hoyos Sancho 1963 for accounts of Corpus Christi traditions in Madrid, Valencia, Toledo, and elsewhere.

9 For a study of the Roman performative and its antecedents see Smith 1978.

10 Rich descriptions of some advent celebrations in Madrid, from 1336 through the beginning of the seventeenth century, may be found in Quintana 1629. See also Christian 1981, 53.

11 For the history, discussion, and analysis of *autos sacramentales* in early modern Spain, see Arias 1980.

12 One significant difference between advent ceremonies and religious triumphs was the processional path. While the former consisted of welcoming the dignitary at, or outside, the city limits and inviting him into its confines, the latter customarily removed the religious icon from its home in the city (a church or chapel) and toured it around parts of the community.

13 Here I am thinking of *communitas*, as defined by Victor W. Turner (1969).

14 The regulation itself is reproduced in Rubio García's appendix, pp. 99–100.

15 This monstrance was covered by a new, more elaborate model in 1524, and is still in use.

16 Some scholars, despite evidence to the contrary, have maintained that the Spaniards did not willingly allow pre-Hispanic symbols or symbolic acts into postconquest festive life. Felipe Cossío del Pomar (1928, 62) is not alone in declaring that the Spanish motto was "intolerance." His interpretation has been echoed by Castedo (1976, 33), Benavente (1995, 1), and others. Mario Buschiazzo (1950, 12), however, arrived at more temperate conclusions, finding the Spaniards to have been "aesthetically tolerant" after the first century of colonization. He states: "I believe that native aesthetic values were used consciously by the Spanish monks as a most valuable aid in propagating the faith."

17 Because Segovia was misidentified early on, he is commonly referred to as Cristóbal de Molina, "El Almagrista," to distinguish him from Cristóbal de Molina, "El Cuzqueño," the *cura* (priest) of the parish of the Hospital de los Naturales in Cuzco who also authored ethnohistorical accounts. The quoted section reads: "[A]unque esto es abominable y detestable cosa, por hacerse estas fiestas [gap in manuscript] a la criatura, dejado el Criador a quien se habían de hacer gracias debidas, es cosa de gran ejemplo para entender las gracias que somos obligados a dar a Dios, verdadero Señor Nuestro, por los bienes recibidos, de lo cual nos descuidamos tanto cuanto más le debemos."

18 See the festive accounts in Carvajal y Robles [1632] 1950, Mugaburu and Mugaburu [1640–1697] 1975, and Arzáns de Orsúa y Vela [c. 1735] 1965. Also see Gisbert and Mesa 1985, 27–39, for an excellent discussion of how some Greco-Roman-cum-Christian deities/personages were represented in the art of viceregal Peru.

19 The *ordenanza* reads, in part: "que en las fiestas del corpus xpi e en otras, se recaten mucho los curas y miren que los indios, fingiendo hacer fiestas de xpianos, no adoren ocultamente sus ídolos y hagan otros ritos" (Vargas Ugarte 1951, 252, constitución no. 95).

20 Teresa Gisbert (1983, 153; reiterated in Gisbert and Mesa 1985, 209–229) has identified the formal elements of standard viceregal Peruvian festivals as triumphal arches, altars or tables, triumphal carts, masked performers, dancers, brief didactic plays, and fireworks. These are the same elements as identified for Spanish festivals of the same period.

21 Mugaburu's diary, which was completed by his son in the years 1686–1697, was transcribed and published in 1917 and 1935 and translated into English in 1975.

22 Arzáns's *Historia de la villa imperial de Potosí*, written in the first third of the eighteenth century, covers the years 1545–1737. He died in 1735, at which time his son took up the pen. Transcribed and edited by Lewis Hanke and Gunnar Mendoza, the monumental work was published in three volumes in 1965.

23 The chronicler of this triumphal entry, Vasco de Contreras y Valverde, was the sixth *deán* of Cuzco's cathedral. His history of Cuzco, written in the mid-seventeenth century, covers the years 1532–1649.

24 "La entrada de los religiosos bethlemitas, en esta ciudad, fue domingo 29 de junio de 1698, día de los gloriosos Apóstoles San Pedro y San Pablo, a las cuatro de la tarde, viniendo con ellos su general fray Rodrigo de la Cruz, con acompañamiento de ambos caudillos y lo más ilustre ciudadanos y vecinos, desde la parroquia de la gloriosa Santa Ana, estando los calles bien adornadas de tapicerías y pasadizos que llaman arcos, pero no hubo triunfales, ni música en los balcones, como pone la *Historia bethlemita*."

25 Trexler (1984, 194) informs us that triumphal entries for religious orders were not common in Europe, although the practice did exist in New Spain (Mexico).

26 There are a number of contracts for *arcos triunfales* for Corpus Christi in the Archivo Departamental del Cuzco, Libros Notariales. Transcriptions of some of these may be found in Cornejo 1960 and Gisbert and Mesa 1985.

27 The Jesuit chronicler Bernabé Cobo (1979, 131), writing in 1653, states that archways covered in floral cloth decorated the passage of important personages in pre-Hispanic times. There is no evidence to support his assertions, however. Rather, the construction of temporary triumphal arches in viceregal Peru seems to have been based solely on European models.

28 "Recibiole el Cabildo, Justicia y Regimiento, de esta ciudad con grandeza de palio." The viceroy had been in Puno, restoring order to that province following a rebellion led by the miners José and Gaspar Salcedo. He passed through Cuzco on his return to Lima.

29 The following year, after the Marquis of Mancera was appointed viceroy of Mexico, both he and Salvatierra sat outside the canopy at a meeting in Lima (Mugaburu and Mugaburu [1640–1697] 1975, 24).

30 In pre-Hispanic times, high-status individuals were also shaded from the sun, usually by feathered parasols. This practice continued into the colonial period when members of Inka nobility appeared in processions sheltered by parasols "of attractive feathers" (Cobo [1653] 1979, 101). The feathered sunshade was also extended by the Andean faithful to statues of female saints. Andean and European traditions converged to make usage of the canopy significant in colonial Peru.

31 In 1733, Cuzco's bishop and *deán* had the first triumphal cart made in Cuzco to transport the consecrated host in the Corpus Christi procession.

32 See, for example, Dean 1996b, 180, in which two paintings featuring triumphal carts (in the collection of the Brooklyn Museum) are derived from the same original print.

2. The Body of Christ in Cuzco

1 See, for example, the chronicle of Gregorio Martín de Guijo (1952, 1:214–215; 2:149–151, 198–200), who kept a diary of notable events in New Spain from 1648 to 1664. He mentions a sermon given by Miguel Sánchez in which the significance of the festival of Corpus Christi in Mexico is emphasized. See Lohmann Villena 1950 and 1994 for the importance of Corpus Christi in Peru in general and Lima in particular.

2 The city's epithet was later aggrandized; in 1784, shortly after the quashed uprising of José Gabriel Condorcanqui Túpac Amaru (1780–1781), Cuzco was given the right to refer to itself as "extremely faithful" (*fidelísima*) (ADC, Intendencia, Gobierno, leg. 139, 1790–1791). In documents after that date, it is not unusual to find the city referred to as the "very noble, great, loyal, and extremely faithful city of Cuzco, ancient metropolis of the empire of Peru" (*mui noble gran leal y fidelísima ciudad del Cuzco antigua metropoli del ymperio del Perú*).

3 See Cummins 1996 for additional comparisons of colonial Lima with Cuzco.

4 Part of Murúa's description is contained in book 3, chapter 10; the missing chapters, 11 and 12, were also apparently devoted to a description of Cuzco.

5 "La que esta historia pudiera dar y, aunque el día de hoy la Ciudad de los Reyes, la principal, de más autoridad y ostentación de todo el Perú, por la residencia de los visorreyes, Audiencias, Arzobispo e Inquisición, y otras circunstancias que la enoblecen todavía, me ha parecido hacer primero mención y tratar de la gran ciudad del Cuzco, pues fue Cabeza de estos reinos, y el día de hoy por privilegios reales tiene este título, y en las escrit-

uras y contratos de los españoles la nombran con este renombre, y porque de ella salió toda la policía y urbanidad, que dieron los Yngas a las provincias que conquistaron, y en ella tuvieron su asiento, casa y corte y, en fin, fue cabeza de toda la monarquía de los Yngas."

6 "Llamase cabeza destos reynos y prouincias, asi por ser antiquíssima y nobilíssima en todo género de cosas, como por la gran multitud de yndios que en ella habitan y su contorno, y más particularmente por auer sido antiguo asiento y corte de los reyes Ingas, donde estubo y ha permanecido hasta oy la pulicía y nobleza de los yndios del Pirú."

7 In describing Cuzco as an imagined city, I am drawing on the definition offered by Benedict Anderson (1991), who argued that to imagine is to create rather than falsify. In this case, Cuzqueños imagined their city as both colonial and imperial, Spanish and Inka, and thereby created, built, and inhabited a paradoxical place.

8 "Es de suerte que todos los edificios modernos que después se han hecho en la ciudad por los españoles, han alido de la piedra de allí, aunque a las piedras grandes y toscas no han llegado, por no poder llevarlas a otro lugar sin costa excesiva e infinito trabajo de los indios."

9 Cobo ([1653] 1990, 229–230) describes the method of dragging large stones to construction sites and the use of earthen ramps to place them, saying: "I saw this method used for the Cathedral of Cuzco which is under construction. Since the laborers who work on this job are Indians, the Spanish masons and architects let them use their own methods of doing the work, and in order to raise up the stones, they made the ramps mentioned above, piling earth next to the wall until the ramp was as high as the wall." See Lee 1986 and Protzen 1985 and 1986 for a more detailed analysis of Inka building methods.

10 This story bears striking similarity to a story from the battle for Tenochtitlán in Mexico. According to a well-known legend, on the Noche Triste (July 1, 1520, when the Spaniards were driven from the city) the Virgin saved the fleeing Spaniards by appearing before the startled Mexica and throwing dust in their eyes. It was also said that Santiago appeared with her. For further discussion, see Poole 1995, 24–25. For more information on the building of Cuzco's cathedral, see Harth-terré 1949.

11 In 1766, the bishop of Cuzco requested permission to celebrate Mary's apparition with the same festivities and pretensions conceded to the church of San Juan de Letran in Rome and granted to the image of the Virgin of Guadalupe in Mexico. Clearly he saw a similarity between Mary's two miraculous appearances at former indigenous capitals. The requested jubilee would have signaled an official recognition of the miracle; in 1767, however, the king denied their full request on the grounds that they had not demonstrated universal public acclaim for the celebration (ACC, caja LXXIV, paq. 1, exp. 9, 1767).

12 Cuzco was revered by Andeans as a sacred site even before the Inkas established their capital there (MacCormack 1991, 192).

13 Recently, the Andeanist Laura Laurencich Minelli has brought to light a Jesuit manuscript entitled *Historia et Rudimenta Linguae Piruanorum*, found in the family papers of the Neapolitan historian Clara Miccinelli (Domenici and Domenici 1996). In it one finds the claim that the Andean Felipe Guaman Poma de Ayala merely lent his name to a work that was actually written (and illustrated?) by the *mestizo* Jesuit and Indian advocate Blas Valera. The portion of the manuscript containing this allegation was likely written by the Jesuit Juan Antonio (or Anello) Oliva, who was involved in a legal battle with Guaman Poma. His allegation, possibly motivated by personal antagonisms or interests, may well be false. Certainly, given the very self-referential nature of the *Nueva corónica y buen gobierno*, it is hard to believe that Guaman Poma was not primarily, if not solely, involved in its production. Because the matter has yet to be sorted out, let us assume for now that the work—both text and image—is that of Guaman Poma.

14 This smaller plaza was also called the *plaza del tianguez* (also often spelled *teanquiz*), as it was the site of an Andean market; *tianquiz* is the Nahuatl (central Mexican) word for market.

15 Polo de Ondegardo ([1571] 1916b, 111) writes that "lo prinçipal fué quitarles la reverençia grande que se tenya a aquella plaça por esta rrazón: la horden que dizen los viejos que tuvieron en traerla fué por tambos e provinçias, acudiendo toda la tierra al camyno rreal, e cada provincia la ponya e llevaua por sus térmynos, lo qual se les mandaua hacer en tiempos desocupados; e ansí no solamente en el Cuzco, pero en todo el rreyno se tubo gran beneraçión a esta plaça; por esto e por las fiestas e sacrifiçios que en ella se haçían de ordinario por la salud del todo el rreyno, rreservadas solamente a los yngas, que por averlo tratado en su lugar no se haçe rrelaçión."

16 "[L]a fiesta y procesión de Corpus Xpi es la principal que se hace en todo el año, así por lo que representa como por ir en ella el cuerpo de nuestro Señor Xpo, Dios y Hombre verdadero."

17 Toledo's título 8 for the governance of Cuzco reads, in part: "[E]n [Corpus Christi] se ha de poner más cuidado en la representación, por ser estos indios plantas nuevas y darles doctrina y ejemplo para que entiendan y çean lo que es necesario para salvarse, de lo cual vienen en algún conocimiento de las cosas que se les predican y enseñan por el autoridad que ven con que se hace, porque para el verdadero conocimiento, es menester mas tiempo del que ha pasado para su conversión, para lo cual encargando, como encargo, a la Justicia y Regimiento que tengan especial cuidado de no dejar cosa por hacer de las posibles en lo que toca a celebrar y honrar la dicha fiesta" (Toledo [1572–1573] 1926, 87–91).

18 In documents (*probanzas*) filed with the government to establish descent from pre-Hispanic royalty, it is clear that Corpus Christi was one of the few

occasions on which native nobility provided tribute in service (e.g., AGI, Lima, no. 472, 1579). Ordinarily, indigenous royalty were exempt from personal service.

19 "[H]ase de advertir que esta fiesta cae quasi al mismo tiempo que los Christianos hazemos la solemnidad de Corpus Christi, y que en algunas cosas tienen alguna apariencia de semejanza (como es en las danzas, representaciones, ó cantares) y que por esta causa á auido y ay oy día entre los Indios que parecen celebrar nuestra fiesta de Corpus Christi, mucha superstición de celebrar la suya antigua del Intiraymi."

20 See Flores Ochoa 1994 for a review of the colonial literature linking Corpus Christi with pre-Hispanic feasts.

21 Zuidema (1966, 1977b, 1992, and elsewhere) has made the most complete study of the Inka calendar. Fiedler (1985) looked specifically at the festival of Inti Raymi in her elucidating analysis of the modern Corpus Christi festival in Cuzco.

22 The Vilcabamba state was established by Manko Inka, who had been a puppet ruler for the Spaniards until he led an uprising in 1535. Once the rebellion failed to unseat the Spaniards, Manko and his followers fled to the north and east of Cuzco, establishing their headquarters in the heavily forested and not easily penetrated Andean *montaña*. Following Manko's death, his son Sayri Túpaq took the reins of state. When Sayri Túpaq abdicated, his brother Titu Cusi Yupanqui was left in charge temporarily.

23 "Este mes hazían la moderada fiesta del *Ynti Raymi* y se gastaua mucho en ello y sacrificauan al sol. Y enterraua al sacrificio llamado *capac ocha* que enterrauan a los niños ynosentes quinientos y mucho oro y plata y *mullo*."

24 See, for example, Wachtel 1973, 175–181; Adorno 1979a, 1979b, 1981, 1982, 117–133, 1986; and López-Baralt 1979, 88.

25 He writes: "es rrey el sol y ací *capac; capac* quiere dezir rrey, *ynti*, sol, *raymi*, gran pascua, más que Ynti Raymi."

26 Molina "El Cuzqueño" ([1574] 1943, 25, 48) correlates the Inka month Hacicay Llusque to May rather than June; he also places Qhápaq Raymi in November rather than December. Fiedler (1985, 246–247) notes that Molina's list of months differs from that of other chroniclers by one month throughout. His placement of Qhápaq Raymi in November and of Inti Raymi in May may be understood as December and June, respectively.

27 The choirmaster was acting in accord with the Spanish practice of taking groups of small boys into church custody, giving them room and board, and training them to sing and dance for religious celebratory occasions (Ivanova 1970, 90). The Seises of Seville—the young boys who, since the papal bull of 1439, have danced before the high altar of Seville's cathedral on religious occasions—are a well-known product of this tradition.

28 González de Holguín ([1608] 1901, 113), in his early seventeenth-century Quechua dictionary, defines *haylli* as a "song of triumph in war; of satis-

faction when agricultural labor has been finished" (*canto triunfal en guerra: de satisfacción cuando terminan la labor de una sementera*). See Bauer 1996 for a fine discussion of the Inka linkage of warfare and harvest.

29 Bartolomé de Segovia's description (as Molina [1553] 1943, 50–53) of the plowing ritual of the harvest celebration of 1535 indicates that the Inka ruler (Manko II) took up the *chakitaclla* in a plowing rite. Other Andean lords joined him after he began to break the earth "in order that, from this time on, this would be done in all the realm" (*para que de allí adelante en todo su señorío hiciesen lo mismo*).

30 Romero (1940, 13), in the introduction to his transcription of the anonymous report, suggests that the hidden agenda of the natives was to commemorate and celebrate past triumphs in reaction against colonial repression. Further, he maintains that Spanish authorities did not recognize native intentions. The demonstrations of submission, however, tend to mitigate the subversive element of native triumphs and, while I will argue that native agendas were not fully apprehended by Spaniards, the performances seem to have been designed to appeal to Spanish authorities while working against those of other native groups.

31 These "yanaconas" were probably ethnic Cañaris and Chachapoyas who formed a magistrate's guard and who were commonly referred to as the *yanacona* (*yanakuna*) of Spanish officials. For more information about this group, see Chapter 8 below.

32 The Canas, inhabitants of Qollasuyu to the south of Cuzco, were incorporated into Tawantinsuyu prior to the Inka conquest of the Cañari area. The choreographed skirmish of 1610, which was described by the anonymous author as an ancient battle, may have reenacted a Cana rebellion against the Inkas late in pre-Hispanic Andean history. It is also possible that the 1610 witness confused ethnic designations.

33 For a description of such a procession in Potosí, see Arzáns de Orsúa y Vela [c. 1735] 1965, 1:244; for Lima, see Romero 1936.

34 For analysis of numerous series of portraits, which were based on an engraving by the Lima artist Alonso de la Cueva, see Gisbert 1980, 128–140.

35 The pre-Hispanic "Inka" costume and the modifications made to it will be discussed in Chapter 6 below.

36 Many scholars have addressed the Andean versions of Santiago. See, for example, Choy 1979, Gisbert 1980, 196–198, Silverblatt 1988, and Navarro Castro 1991.

37 Native communities in the modern Andes have adapted the Corpus Christi framework in such a way as to express their own ideas about triumph. Billie Jean Isbell (1978, 201) reports that in Chuschi, in the central highlands near Ayacucho, *sallqa* herders (those who leave their agricultural plots in the care of family members in order to serve one year in the puna looking after the herds that belong to the local *cofradía*) ride recklessly into the village on

horseback, symbolizing a savage horde in contrast to the civilized villagers who have organized the Corpus Christi festival.

38 Falassi (1987, 3) concludes that the purpose of festival is to "to renew periodically the lifestream of a community." Further, "the symbolic means to achieve [this renewal] is to represent the primordial chaos before creation, or a historical disorder before the establishment of the culture, society, or regime where the festival happens to take place." In colonial Cuzco, Andean elements within Christian festivals can be understood to represent the disorder before the Spanish advent and introduction of Christianity which, in Spanish eyes, brought a new and proper order to the Andes. It is not insignificant that Spanish Cuzco, like most Spanish cities in the colonies, was founded on a *rollo* (pillar) the symbol of Spanish jurisdiction as well as justice because it could serve as a *picota*, or gallows. (See Fraser 1990, 57, for a discussion of the significance and symbolism of the *picota*; on the founding of Cuzco, see Porras Barrenechea 1948, 90.) The erection of the *rollo* announced the imposition of Spanish order. Colonial festivals repeatedly revived that moment and reimposed Spanish and Christian order in Cuzco.

39 A detailed description of the 1623 Corpus Christi procession in Madrid provides such an order (Hoyos Sancho 1963, 9–10). See also Garrido Atienza 1889, 109–120; Gascón de Gotor 1916, 11–17; and Very 1962.

40 As Rubin (1991, 263) notes in her thorough study of Corpus Christi in late premodern Europe, "The story of Corpus Christi processions is . . . one of disorder, of law-suits generations long, of disputes over precedence and riots."

3. An Ambivalent Triumph

1 In 1573, for example, the Justice of the Natives (Francisco Núñez) was specifically instructed to ensure that the natives turned out to receive the new bishop in Cuzco with their "dances and celebrations" (*danzas y regocijos*) (Cornejo Bouroncle 1960, 325).

2 While the present chapter focuses on the Hispanic posture, Chapters 5 through 7 will consider the Inka response—the ways in which the Inkas of colonial Peru deftly straddled the cultural divide and handled the command that they be like the Spanish, only different. For a splendid study of how the Cunas of Panama have coped with and countered European and Euro-American cultural hegemony by using both mimesis and alterity, see Taussig 1993.

3 See Mills 1997 for an excellent discussion of the waxing, waning, and shifting terrain of extirpatory activity in the midcolonial period.

4 See, for example, Molina "El Almagrista" [1553] 1943, 50–53; Betanzos

[1551] 1987, 71–72; Molina "El Cuzqueño" [1574] 1943, 25–28; Guaman Poma ([1615] 1988, 220–221, 232–233; and Murúa [1600–1611] 1986, 451.

5 Zuidema (1989) has written most extensively on *qhápaq ucha*, which means "royal sin." He explains that in this rite a victim—young, immaculate, and sinless—was buried alive, thus taking on the sins of the Inkas.

6 Murúa ([1600–1611] 1986, 453) is one of the exceptions in that he mentions Andean rites (such as fasting, sexual abstinence, special offerings, and prayers) in addition to songs and dances associated with viceregal Corpus Christi celebrations; he also indicates that Andeans surreptitiously varied the practices, but gradually they were dying out. Writes Murúa: "Toda la gente se juntaba, ayunando dos días arreo, y en ellos, no llegaban a sus mujeres y no comían cosa con sal, y así, ni bebían chicha y, acabado el ayuno, se juntaba en una plaza, donde no había de haber ningún forastero ni rastro de animales. Para esta fiesta tenían dedicadas ciertas mantas, vestidos y aderezos, que sólo servían en ella, y así cubiertas las cabezas, andaban en procesión muy despacio, sin hablar uno con otro, tocaban sus atambores. Eso duraba un día y una noche, y el día siguiente comían y bebían en grandísima abundancia, dos días con sus noches, danzando y bailando y diciendo que su oración había acepta al Sol y al Hacedor, y que por eso se holgaban y alegraban, y hacían fiesta en demostración de su contento. El día de hoy, al disimulo en las fiestas del Corpus Christi, traen a la memoria esta fiesta del ytu, aunque variando las ceremonias por no ser descubiertos; pero en efecto ya se van poco olvidando."

7 Interestingly, Fiedler (1985, 271), who examined the Corpus Christi of modern Cuzco, concluded that Cuzco's twentieth-century Corpus Christi celebration is structurally similar to the Inka festive sacrifice of *qhápaq ucha.* She recognizes a structural similarity between the sacrificial order of *qhápaq ucha,* which was generated in Cuzco and spread to the provinces, and the festive organization of Cuzco's modern Corpus Christi in which, during the weeks and months following the octave, a number of the participating parishes hold their own parish's "Corpus" celebrations echoing those of the ecclesiastic and municipal center. This festive configuration is not European and succeeds in acknowledging the cathedral of Cuzco as the regional ceremonial center just as *qhápaq ucha* acknowledged Cuzco as the preconquest center of imperial ceremonial activity. Fiedler concludes: "That Corpus Christi should resemble the Inca Capacocha far more than the Incan winter solstice festival [of Inti Raymi] is not surprising. Inti Raimi as such was performed by and for the Incan nobility exclusively, honoring their lineage ancestor, the sun. Both the hegemony of the nobility and the supremacy of their totemic deity were effectively destroyed by the Conquest. Capacocha, on the other hand, involved the entire social community dependent to Cuzco in a ritual of sacred and secular power focusing on that

center. Certainly in the hands of the Spanish and the Catholic Church, colonial Cuzco commanded a comparable socio-religious position, and, in the mythology of the area, has never lost its precolumbian significance."

Unfortunately, there is no documented indication of when the festive configuration in which Cuzqueño parishes began celebrating their own "Corpuses" was instituted. Spanish sources make no mention of the practice, and parish records available for the Hospital de los Naturales parish from the early seventeenth century do not indicate that that particular parish planned such a ceremony (ACC, Parroquia San Pedro Libro de Cabildo y Ayuntamiento del Hospital de los Naturales, 1602–1627). Records from San Jerónimo parish do mention a "Corpus del Pueblo" in the late seventeenth century that was sponsored by the cofradía devoted to the parish patron; this may be an early manifestation of a parish "Corpus" celebration (ACC, Parroquia San Jerónimo, 1661–1768). However, it seems likely that this "qhápaq ucha–like" pattern was introduced after control over the Corpus Christi presentation went from the cathedral to the parishes. While in viceregal times the ecclesiastic council and the municipal council organized the Corpus Christi celebration, in the nineteenth century (when the centralized authority of the Catholic church diminished) the organization of Corpus Christi passed to the parishes. By the time of Fiedler's (1985, 92) study, Cuzco's Feast of the Holy Sacrament was essentially a parish production. So, if she is correct in her identification of some structural similarity between qhápaq ucha and Corpus Christi, it was introduced in modern times.

8 It is interesting to note that even though other groups performed in this celebration (including the Basque miners), the anonymous witness — probably the Jesuit Bernabé Cobo — wrote only about the native contributions to the celebration. It would seem that Spanish audiences were especially enchanted by these local customs.

9 Mason (1990, 7) explains: "Before America was discovered it already had a place in the European imaginary. The myth of the Golden Age, the Wild Man and Wild Woman, Atlantis, the travels of Marco Polo, the 'travels' of Sir John Mandeville — these had all prepared the ground for an encounter with the New World in which the New was already familiar." Mason goes on to examine how the so-called monstrous human races known to the Greeks as well as to the Elder Plinius (termed the Herodotean and Plinian races) served as models for American natives in the minds of Europeans.

10 Following his visita, the bishop ordered "Que se quite al Niño Jesús que está en un altar del cuerpo de la Yglesia la mascapaicha y el sol que tiene en el pecho y se le dexen solamente los rayos que estan en la cabeza" (ACC, San Jerónimo, Libro de la Fábrica, 1672–1814, f. 26v). It is a tantalizing fact that in the mid-eighteenth century, Cuzco's parish of Belén housed "a statue of the Christ child in the vestments of an Inka" ("un niño jesus de bulto vestido de Ynga"); by 1778, the statue was no longer mentioned in parish invento-

ries (ACC, Belén, Libro de Inventarios, 1743–1869). When the statue first appeared and whether it bore the royal headdress and sun pectoral associated with Inka rulership in the colonial period are, unfortunately, unknown.

11 The Inka sun deity Punchao (the daytime sun) may well have been depicted anthropomorphically. Duviols (1976, 171) argues that an image of the sun god wore large ear spools and an Inka headdress; thus he may well have resembled the Inka ruler.

12 See AGI, Audiencia del Cuzco, leg. 35, exp. 28, 1786, in which Mata Linares writes of the need to abolish the fringe since it was one of the most pronounced "pretensions" of native nobility.

13 "Pasquas y dansas taquies de los Yngas y de capac apoconas y prencipales y de los yndios comunes destos rreynos, de los Chinchay Suyos, Ande Suyos, Colla Suyos, Conde Suyos. Los quales dansas y arauis no tiene cosa de hechisería ni ydúlatras ni encantamiento, cino todo huelgo y fiesta, rregocixo."

14 Nor was Corpus Christi the only festival to raise government suspicions in the late colonial period. In 1819, for example, Cuzco's *fiscal* (public prosecutor) urged the governor to prohibit Andean dances from all religious festivals in Cuzco, saying that in "almost all its religious festivals" (*casi todas sus fiestas religiosas*) native dances are responsible for "innumerable moral and political injuries" (*daños morales y políticos . . . sin número*) (ACC, Correspondencia, caja XLIII, paq. 3, exp. 53).

15 See Bakhtin 1968 for the implicit threat in festive inversion.

16 Taylor 1979 remains the classic study of the complex relationship between drinking and antisocial behavior on the part of Indians under Spanish colonial rule.

17 Inebriation certainly contributed to festive mishaps and discord. See, for example, ADC, Francisco Maldonado, leg. 194, 1702, fols. 1034r–1035v, which reports on the alcohol-related death of an Andean master barber (Joseph Usca) who had been drinking *aguardiente* on the vespers of Corpus Christi, 1702, with his fellow *maestros*.

18 "[En] 17 de junio de 1700 día de la octava de Corpus Christi, por la tarde a tiempo de la procesión, los indios de las parroquias por la mayor parte ebrios, formaron una reñida competencia sobre el lucimiento de sus danzantes, único baile y regocijo de esta fiesta: y se trabó entre ellos un desordenado reencuentro de piedras y hondas, que interrumpió la procesión. Castigó el corregidor la insolencia con doscientos azotes que hizo el día siguiente, prohibiendo en adelante éste género de bailes; y así se hizo el año siguiente de 1701 en que solamente se permitieron por la festividad de Corpus de otros bailes menos ruidosos."

19 It should be noted that Viceroy Toledo, who issued restrictions on native festive drinking, also attempted to control female behavior during Corpus Christi, prohibiting women from watching the procession from balconies ("because they distract those [men] in the cortege") and from wearing *rebo-*

zos and "trajes desonestos" (shawls that women used to cover their faces, thus disguising themselves from their husbands and/or family while they supposedly carried out assignations) (Toledo [1572–1573] 1926, 90). The effort to control women's dress met with about as much success as the effort to control native drinking. Viceroy Don Juan de Mendoza y Luna, the Marquis of Montesclaros (1607–1615) (see Viceroys 1859, 35) admitted that all attempts to prevent women from covering their faces had failed.

20 Although Zuidema (1991) suggests that some parish performances, particularly choreographed battles, were organized by the Hispanic parish priest following the Spanish tradition of Christians and Moors, the records from the Hospital de los Naturales parish indicate that it was usually indigenous parish leaders who instigated, organized, and often performed in these festive productions (ACC, Parroquia San Pedro, Libro de Cabildo y Ayuntamiento, 1602–1627). My thanks to Lynn Lowry for first bringing the Libro de Cabildo from the Hospital de los Naturales parish to my attention.

4. Envisioning Corpus Christi

1 As early as 1922 the series was hailed by the eminent Cuzqueño scholar José Uriel García (1922, 214–218) and, as such, has been the subject of considerable scholarship. Although individual paintings of the series have been considered in the context of various studies, the Peruvian art historian Ricardo Mariátegui Oliva (1951, 1954, and 1983) was the first scholar to offer any substantial analysis of the paintings as a coherent series. His studies were followed by those of Gisbert and Mesa (1962 and 1982) and Dean (1990). Recently, Jorge Flores Ochoa (1994) and Luis Eduardo Wuffarden (1996) have authored essays about those paintings from the series which remain in Peru.

2 An inventory of the parish church of Santa Ana, dated 1836, lists "diez y ocho lienzos de la procesión de corpus con sus chorcholas doradas entre grandes y pequeños." Later, probably 1851 (the year of a subsequent inventory), a note in a different hand added that only seven of the paintings still had their frames (ACC, Libro de Inventarios de Parroquia de Santa Ana, 1836–1861). In the nineteenth century, gilded frames were commonly harvested from churches as a means of raising much-needed funds. Only later were the paintings themselves parted with. Thus, it is fairly certain that the original number of canvases in the series was eighteen. Because this inventory was not brought to light until 1998, there has been considerable confusion in the scholarship about the number of canvases belonging to the series. For a discussion of the twentieth-century literature before I came across the 1836 inventory, see Dean 1990, 7–9.

3 The twelve canvases still hanging in the parish of Santa Ana were moved

from their parochial home to the Museo Arzobispal in 1968. Mariátegui Oliva (1954 and 1983) identified the four "Santiago" canvases as part of the series on the basis of obvious stylistic linkages between these works and the dozen canvases in Cuzco. It is not known exactly when the four paintings were removed from the parish church of Santa Ana or how they came to be in Chile. Mariátegui (1983, 19) reports two rumors: one that they were removed from Cuzco in 1895 and another that they were sold in 1907 by the parish priest of Santa Ana in an effort to raise funds for the church. Records of sale name the provenance as Cuzco (Mariátegui, personal communication, 1987). Three of the paintings now in Santiago were purchased by Carlos Peña Otaegui from Loreto Morandé de Alessandri, an antiquities dealer. Peña was ignorant of the origin of these canvases until Mariátegui identified them in 1952 (Mariátegui 1954, 5). The paintings were recently sold by the Peña family to another collector in Santiago. The fourth "Santiago" canvas of the Cuzco series was acquired by Monsignor Julio Rafael Labbó, a collector, who kept it in his residence in Santiago. After Labbó's death in 1943 it went to Eduardo Berguecio Barros and then to Carlos Sánchez García de la Huerta in 1955; Claro Valdés acquired the canvas in 1969 (Mariátegui 1983, 23). Recently, Wuffarden (1996, 89) has suggested that a painting in the Biblioteca del Palacio Municipal in Lima ought to be recognized as part of the series. This painting depicts the Virgin of Belén, the patron of one of Cuzco's parishes, on a processional cart led by an Andean dressed in modified pre-Hispanic Inka vestments. The subject is certainly related to those known canvases of the series that represent Cuzqueño parishes; however, on clear and obvious stylistic grounds, both Mariátegui (1983, 28–33) and I (Dean 1990, 54) exclude the "Belén" parish from the series proper. Although many of the figures and the processional cart appear to have been copied from various canvases of the Corpus Christi series (most particularly that of the parish of San Sebastián), the color, proportions, perspective, and modeling of figures are not at all similar. If this painting "belongs" to the series—i.e., if it once hung in the parish church of Santa Ana alongside the other sixteen known canvases—then it was produced later by hands unrelated to those that originally contributed to the Corpus Christi paintings. This scenario is not altogether unlikely. The parish of Belén may well have been tardy in contributing to the series and, therefore, may have been forced to turn to a different *maestro pintor* than those used by her fellow parishes. That later artist may have relied on the canvas of San Sebastián parish as his model. If the Belén canvas is number 17, then there is still one canvas missing from the series.

4 For measurements and a complete description of each canvas, see Dean 1990, 19–63.

5 This painting is unique in the series in that it does not depict the procession itself. Rather, the citizenry of Cuzco gazes at what has been identified as a

processional altar with a scene of the Last Supper (Mariátegui Olivia 1951, 21; Gisbert and Mesa 1982, 177; Gisbert and Mesa 1983, 159). Because the Last Supper represents the introduction of the doctrine of transubstantiation, this canvas provides an instructive preamble to the celebration of Corpus Christi. In 1677, the Andean sculptor Lorenzo Machucama contracted with a confraternity located in the Augustinian church of Cuzco to create a scene of the Last Supper; Mariátegui (1951, 21) and Gisbert and Mesa (1982, 177) identify the tableau depicted in the painting as Machucama's work. Except for the addition of two angels who attend the banquet, the contract describes the images occupying the altarlike platform depicted in the canvas.

6 *Andas* (portable platforms) carrying the statues of saints pass in front of the Jesuit church, La Compañía. A group of Jesuit priests in their black robes watches the passing procession. Both Jesuit saints dress in the black robes of the order and carry the Jesuit symbol of a cross with Christ's monogram in their hands. The figure on the left, holding a book containing the rules of the order, can be identified as Saint Ignatius Loyola, the founder of the Society of Jesus. The other Jesuit saint may be either Saint Francis Xavier or Saint Francis Borja. The identification of the second pair of saints is more problematic. Mariátegui (1951, 30) identifies them as Saints Isidore (Isidro) and Matthew (Mateo). His identification of the image farthest from the viewer (in green robes with red drapery) as Isidore the Laborer is based on the small sickle-shaped implement that the figure holds. Isidore, according to traditional Christian symbology, is usually shown holding farmer's implements. Mariátegui (ibid.) identifies the attributes held by the saint closest to the viewer (wearing pink robes with a blue mantle) as a spindle and a book. Mariátegui argues that this saint, the author of one of the Gospels, is shown here not only as an author but as patron of the guild of weavers of tents and canopies. Gisbert and Mesa (1982, 178; also Gisbert 1983, 160) identify this pair as Isidore and Saint James (Santiago, the patron saint of Spain) without explanation. I favor identifying the two as Saints Cosmas and Damian (San Cosme and San Damian), who were always paired as the patron saints of *barberos* (barbers/surgeons). The implements they hold, two types of cutting instruments, may well be barber's tools. In Cuzco, the Andean guild of *barberos* was located in the chapel of the Virgin of Loreto in La Compañía (Gibbs 1979, 30); teaming this *cofradía* with that of the Jesuit saints and locating them in front of this church in the painting is appropriate. Another possible identification, which I first offered in 1990, is of Saints Crispin and Crispinian, as they were the patron saints of the shoemakers' guild, are always paired, and are often shown with cutting tools. Their guild was headquartered in the cathedral, however, and thus does not make as compelling a case. Recently, Wuffarden (1996, 102) has suggested that the first two saints represent Cosmas and Damian, and the second pair Crispin and Crispinian.

7 The *andas* carrying the statues pass in front of La Merced, the Mercedarian church. The distinctive shield of the Mercedarian order is seen above the entrance in the background, and two robed friars have come out to watch the passing cortege.

8 The saint placed atop the processional cart was identified as Saint Augustine by Mariátegui (1983, 21). Mariátegui's identification rests primarily on the subject matter of the carriage: a scene of the Annunciation. There was a native confraternity dedicated to Our Lady of the Annunciation which had its chapel in the Augustinian church in Cuzco; this advocation of the Virgin was, in fact, the patron of the Augustinian order. As with the other *carros* pictured in the Corpus Christi paintings, this one was copied from a 1663 Spanish festivity book (Dean 1996a). The details of the *carro*, however, which have been copied directly from prints in an account of a Valenican festival, have no apparent relationship to the Cuzqueño parish with which they have been paired by the Andean artist. Thus, the association of Saint Augustine with the Annunciation does not necessarily support Mariátegui's argument. Furthermore, all the other canvases of the series featuring *carros* represent Cuzqueño parishes; it is likely that this canvas, too, depicts leaders of a local parish with their patron saint. The only possibilities are Saint Jerome, patron of San Jerónimo parish, and Saint Blaise, patron of San Blas parish. The Chilean historian Gabriel Guarda (1987, 88) prefers Saint Jerome. However, the saint pictured is clearly a bishop, as he appears with diagnostic miter and crosier; and Jerome, a canon and doctor of the church, was not a bishop. Saint Blaise *was* a bishop and therefore is the most likely candidate for this canvas. Moreover, in the Museo de Osma in Lima a painting of Cuzco's Corpus Christi procession, unrelated to the Santa Ana series, shows the parishes of San Jerónimo and San Blas with their patron saints. Both are elderly, bearded men; Saint Blaise is dressed as a bishop just as he is in the Corpus Christi series painting, while Saint Jerome, in distinctive red robes, is not.

9 The patron of the Hospital de los Naturales parish was the Virgin of the Purification (La Purificada), often referred to as La Candelaria because of the candle Mary clasps in this advocation.

10 According to a 1572 ordinance issued by Viceroy Francisco de Toledo ([1572–1573] 1926, 87–91), the *corregidor* (the chief administrative officer of a province, exercising both political and judicial authority) was to carry the standard of the Holy Sacrament in Cuzco's Corpus Christi. The standard-bearer in this painting displays the Maltese cross, which identifies him as a member of the Order of San Juan, also known as the Order of Malta. Pérez de Guzmán was the only *corregidor* of Cuzco to have belonged to that knightly order; he served as magistrate of Cuzco from 1670 to 1676. Mariátegui (1951, 22) identified the painted *corregidor* as either Don Pedro Balbín (1682–1690), who was named *corregidor* in 1680 but did not arrive in Cuzco until

1682, or Don Antonio Calderón de la Barca (1696–1698). Calderón was a Knight of Calatrava; Balbín was apparently not a member of any order (ADC, Libros del Cabildo, nos. 18 and 19). In the last quarter of the seventeenth century, when these paintings were created, there is only one mention of another Knight of San Juan in the civic records: Captain Don Lucas de Contreras Infante, a *regidor* (councilman) in 1676 (ADC, Libros del Cabildo, no. 17).

11 Bishop Don Manuel de Mollinedo y Angulo is readily recognizable owing to several portraits of him that date to this period. Many portraits of the bishop, including those in Almudena and in the churches of San Sebastián and Huanoquite, feature this same three-quarter view (Gisbert and Mesa 1982, 180). It is likely that artists of the period relied on some official portrait of the bishop as their source.

12 Gisbert (1980, 98) has offered a date for the series on the basis of the portraits of the Spanish king Carlos II which appear in two of the canvases of the series (*Saint Rose and La Linda* and *Augustinian Friars*). Approximating the age of the youthful king in these portraits to be twelve, Gisbert derives 1675 as the likely date of the series. Carlos II turned fourteen on November 6, 1675, and therefore would have been thirteen at the time of that year's Corpus Christi celebration. In a later study she revises this estimation to 1680–1690 without explanation (Gisbert 1986, 27).

13 She wears a black veil, which indicates that the "dowry" paid by her family when she entered her profession was enough to ensure her full participation in the affairs of the convent. The price for the black veil in Cuzco, set early in the seventeenth century, was 3,300 pesos; because of the steep rate, almost only women of Spanish heritage were able to don the black veil (Burns 1997, 186). The white veil, worn by most indigenous and *mestizo* nuns, reflected their lesser dowries and signaled their limited participation and prerogatives in the convent.

14 *Saint Rose and La Linda* includes an inscription reading, in part, "aqui ba el Alferes con su padre Don baltazar tupa Puma [remainder illegible]." *San Cristóbal Parish* includes the inscription "Vitor D. Carlos Guainacapac ynga Alferes Real de su Mgtad."

15 José Uriel García (1937, 1) attributed the series to Alvaro de Alas y Valdez, without rationale, but probably because Alvaro de Alas was a favorite of Bishop Mollinedo. Rubén Vargas Ugarte (1947) attributed the series to Ignacio Chacón, an artist working in Cuzco during the mid-eighteenth century. In his initial study, Mariátegui (1951) did not attribute the series to any one known artist and instead concluded that it was done by several artists. Later he suggested that the depiction of a bald man with European features who appears in the foreground audience in both the *Franciscan Friars* and the *Dominican Friars* might be a self-portrait of the artist (Mariátegui Oliva 1954, 21). He has recanted this suggestion and notes the influence of Basilio de

Santa Cruz Pumacallao on the anonymous artists of the Corpus Christi series (Mariátegui Oliva 1983, 17, 19; personal communication, 1987).

16 Gisbert (1983, 159) argues that the Corpus Christi paintings were stylistically related to the works of Quispe Tito.

17 It is lamentable that many of the contracts for works of art have been removed from the notarial notebooks in the ADC. Fortunately, Cornejo Bouroncle (1960) transcribed and/or summarized many of the documents before they disappeared. See Benavente Velarde 1995 for a discussion of all named artists known to have been working in Cuzco during the seventeenth and eighteenth centuries; see Damian 1995, 44–49, for a general discussion of the status of Indian artists in midcolonial Cuzco.

18 See Dean 1990, 78–82, for the complete argument.

19 Hontón was the nephew of the Limeño chronicler Josephe de Mugaburu.

20 In 1704, for example, Don Phelipe Sicos, "Alcalde Mayor de las Ocho Parroquias de Cuzco," hired a painter for a full year to do no work other than that which he required for the eight parishes. Unfortunately, the contract specifies neither the subject of the canvases nor the parishes for which they were destined; but it does indicate that the paintings, which are described only as being both large and small, were to be copied from prints (estampas) that Don Phelipe gave to the painter (ADC, Gregorio Basquez Serrano, leg. 51, 1704, fols. 496r–497v).

21 For example, Polo de Ondegardo ([1571] 1916b, 107), corregidor of Cuzco at the time Santa Ana was founded, described the parish as being on the hill of Qarmenqa, "where Cuzco commences" (donde empieça el Cuzco); and Contreras y Valverde [(1649) 1982, 169), writing nearly a century later, also located Santa Ana "at the entrance to the city."

22 Jerónimo de Quintana (1629, 386), the seventeenth-century chronicler of Madrid, described that city's procession as incorporating music, dances, and short religious mystery or morality plays (autos sacramentales).

23 The bishop's nephew, Don Andrés de Mollinedo, was the cura of this parish and the two of them sponsored the building of its church.

24 The inscription credits Mollinedo for his "promossion incansable del culto diuino a que fingularísimamente aplicado como lo aclamó las muchas i riceas alajas de que dotó, las mas Yglesias del obispado." In 1682, he instructed the parish of San Jerónimo to found a Cofradía del Santísimo Sacramento and, in 1685, sanctioned the second founding of San Cristóbal parish's Cofradía del Santísimo Sacramento as well as its linkage to the sodality of Las Ánimas del Purgatorio (ACC, Parroquia San Jerónimo, Libro de la Fábrica, 1672–1814; ACC, Parroquia San Cristóbal, Libro de las Cofradías del Santísimo Sacramento y Ánimas del Purgatorio, 1662–1747).

25 Esquivel relates the episode as follows: "por complacer al obispo los colegiales de San Antonio en día de Corpus Christi prendieron a la fimbría posterior de la capa del dicho corregidor (Pedro Balbín) un cola de animal,

con la cual salió algún trecho en la procesión, llevando el Guión. Y habiendose deprehendido el desacato, y que los autores de él eran colegiales de San Antonio el corregidor, con la Justicia y Regimiento trató de castigar este crimén tan execrable, y feo. Mas el obispo ordenó de orden sacro a todos los cómplices y reos en este delito, por librarlos de la afrontosa muerte."

26 The magistrate and municipal council could show their anger with the bishop and ecclesiastic council by refusing to participate in religious processions in the customary fashion. In the 1677 celebrations of Lent, for example, the *corregidor* (Don Nuño Espinola Villavisencio) declined to carry the standard in procession, claiming to be sick with a painful right arm ("enfermo y dolorido del braso derecho y que asi no ama de poder llevar el guion"). The bishop publicly chastised the civic authorities, and as a result of this and a similar incident during the previous year (in the procession of Saint Mark, March 1676), the municipal council declared its intention not to attend any public acts in which the bishop appeared ("se escuse esta cauildo de asistir en los actos que asistiere su señoria illma [illustrísima]") (ADC, Libros del Cabildo, no. 17, fols. 216v–217v).

27 The bishop did not always work harmoniously with his ecclesiastic council. In fact, Hontón, the former *cura* of Santa Ana who had been promoted to the council by Mollinedo, was involved along with other ecclesiastic authorities in an uprising against the bishop; see Guibovich Pérez 1994. Nor were the *corregidor* and the municipal council always on the best of terms. "Internal" disputes not infrequently manifested themselves during festive presentations as well. See, for example, ACC, Quejas, caja XXX, paq. 1, exp. 14, fol. 61. Also see AAL, Expedientes sobre apelaciones del Cusco: Años 1676–1678, leg. 24; Años 1679–1681, leg. 26; Años 1681–1686, leg. 27; Años 1686–1688, leg. 28.

28 Gisbert (1980, 80) writes specifically about paintings featuring triumphal carts in concert with representations of the four continents. This theme was painted by the artists Leonardo Flores, Juan Ramos, and their followers between 1690 and 1703 in the Callao (southern highlands).

29 For additional examples of triumph paintings featuring allegorical carts, see Dean 1996b, 180; Gisbert 1980, 80–82, figs. 72, 73, 198; Gisbert 1983, 162–166; Gisbert and Mesa 1972, 251; and Gisbert and Mesa 1985, 217–218.

30 For published contracts, see Cornejo Bouroncle 1960, 83–84; there are also numerous contracts for *andas* in the notarial books in the Archivo Departamental del Cuzco. While processional *carros* such as those depicted in the paintings were probably not used in seventeenth-century Cuzco, they were not unfamiliar to colonial audiences, since they were constructed for special ceremonial appearances elsewhere in the viceroyalty. *Carros* were also the settings for allegories of triumph in two-dimensional colonial art, as discussed above.

31 Gisbert and Mesa (1985, 234, 242–243) first identified Valda as the source

of the *carros* depicted in the canvases of San Sebastián and the Hospital de las Naturales parish. As I have shown elsewhere, the Valencian festivity book was clearly the source of all five *carros* featured in the Corpus Christi series (Dean 1996a).

32 Pilar Pedraza (1982) reproduces and analyzes Valda's festivity account.

33 For more on Caudí, see Pérez Sánchez 1981b, 266–273.

34 Valencia's processional *carros* were known as *roques* or *rocas*. They were carts that functioned as mobile stages in processions. See Más y Prat 1885, 322, and Gascón de Gotor 1916, 25–26.

35 Triumphal carriages had first appeared in Madrid's Corpus Christi festivals during the early seventeenth century (Quintana 1629, 386).

36 Gilt brocade, sometimes called *estofado*, has been applied to the monstrance in both these canvases. The gold reflects light (especially in a dimmed, candlelit church interior) and thus draws attention toward Mollinedo and the monstrance he holds.

37 See Dean 1995 for a discussion of the disruptive Corpus Christi children.

38 In *Bishop Mollinedo Leaving the Cathedral*, the cathedral of Cuzco dominates the background. To the immediate left of the cathedral is the churchyard and buildings that housed the ecclesiastic court and the Tribunal of the Inquisition. To the right of the cathedral is the old Temple of the Triumph (El Triunfo), as it appeared in the late seventeenth century; the two attached temples—those of El Triunfo and La Sagrada Familia—which flank the cathedral today had not been built at the time this painting was done. The grand portal of the cathedral also serves as the backdrop to the *Processional Finale*.

39 The Jesuit church, looking much as it does at the present time, can be readily identified in the *Four Saints* painting by the distinctive white cross visible behind the red drapery in back of the temporary altar. The shield of the Mercedarian order can be seen above the entrance to the building in the background of *Saint John the Baptist and Saint Peter*.

40 The elaborate portal of Cuzco's town hall is visible in the background of *San Sebastián Parish*; a portion of the town hall is also depicted in the *Augustinian Friars* canvas. Casa Garcilaso de la Vega is visible in *Santiago Parish* (Mariátegui Oliva 1951, 29). In the left background of *Bishop Mollinedo Leaving the Cathedral*, one can spot the Palacio del Almirante with its distinctive shields.

41 José Uriel García (1922, 214), for example, writes: "Artistically, [the canvases] have little merit as the creole drawing has serious technical deficiencies, but the paintings are of immense documentary value" (*Artísticamente no tienen mucho mérito: pincel criollo con faltas graves de técnica; pero son lienzos de inmenso valor documental*).

42 Saint Rose was born Isabel Flores de Oliva in Lima on April 20, 1586, and died there on August 24, 1617. She was a mystic, an ascetic, and a virgin. A member of the Third Dominican order, she is known for wearing a crown of

thorns under her veil and a crown of roses over it. She was beatified by papal bull in 1668 and canonized in 1671. In 1669, she was chosen as patron of Lima and later became patron of the Americas, the Indies, and the Philippines. "La Linda" was one of the patrons of Cuzco. The statue shown in the painting refers to the miraculous appearance of Mary during the 1535–1536 siege. For a discussion of other aspects of the competition and dialogue between Lima and Cuzco, see Cummins 1996.

43 The portrait of Carlos II appears to have been based on an official court portrait, many of which paired the child king with the symbolic lion (see Young 1984 and 1986).

44 Unfortunately, the patrons of most of the altars and arches cannot be determined. The Andean *cofradía* devoted to the Christ child, located in the Jesuit church, is probably the sponsor of the altar depicted in *Confraternities of Four Saints*; the altar dedicated to the Eucharist outside the town hall, depicted in *Augustinian Friars*, was the responsibility of members of the city council (usually the two *alcaldes*).

45 For example, the *mayordomos* of the *cofradía* of San Cristóbal (in that parish) hired a *maestro borador* to embroider a red satin mantle and tunic for the statue of the saint in time for the 1703 Corpus Christi procession (ADC, Cristóbal Bustamante, leg. 63, 1703, fol. 998r–v). The contract specifies that 320 pesos be paid for the cost of the thread and labor; the *mayordomos* provided the satin. They carefully specified that the embroidery was to be done in gold thread, silver being used only for shading.

46 See, ADC, Pedro López de la Cerda, leg. 131, 1698, fols. 988v–989v. The relevant passage reads: "[Las andas] a de ser mas ancho del que se saca al Glorioso San Sebastian."

47 Even when the Valencian prototype shows four wheels, the native artist copied only two (Dean 1996a).

48 It was a Spanish practice in this and earlier periods to make a record, usually in the form of a written text, of spectacular festivals. Most commonly, the celebrations recorded were "extraordinary"; that is, not part of the "ordinary" cycle, but special productions to commemorate important occasions.

49 See Alendra y Mira [1865] 1903 for a list of many of the festival accounts composed in Spain during the seventeenth century. See also Carreres Zacarés 1925, which documents (for Valencia alone) 798 books of festivals dating from 1481 to 1885.

5. Inka Bodies

1 This was not the first occasion on which the royal Inka lineage had been performatively actuated. The first recorded procession occurred in the Bolivian mining center of Potosí in April 1555 (Arzáns de Orsúa y Vela [c. 1735] 1965,

1:96). The Andean inhabitants impersonated the Sapa Inkas from Manko Qhápaq, the founder, through Atawalpa, the ruler at the time of the Spanish advent (". . . con toda majestad venían de dos en dos todos los monarcas ingas hasta el poderoso Atahuallpa"). A couple of weeks later, Andeans impersonated the Sapa Inka from Manko Qhápaq through Sayri Túpaq, who was then the leader of an independent and (for the Spaniards) troublesome Inka state occupying territory beyond Spanish control (ibid., 1:98–99).

2 In 1721, and in subsequent years, the royal houses were identified as those of Manko Qhápaq, Sinchi Roqa, Lloque Yupanki, Qhápaq Yupanki, Mayta Qhápaq, Inka Roqa, Yawar Wákaq, Viraqocha, Pachakuti, Inka Yupanki, Túpaq Inka Yupanki, and Wayna Qhápaq (ADC, Corregimiento, Causas Ordinarias, leg. 29, 1711–1721, exp. 620). The twelve royal houses also corresponded to six of the eight Cuzqueño parishes (Belén, Hospital de los Naturales, San Cristóbal, San Blas, San Sebastián, and San Jerónimo). As will be discussed in Chapter 8, the parish of Santa Ana was home to primarily non-Inka Andeans. The parish of Santiago, which likewise had no official royal Inka representatives, did in fact boast royal Inka residents who served on the council of twenty-four. Don Tomás Pascac y Lara, principal of Santiago parish and descendant of Lloque Yupanki, for example, was appointed to the twenty-four in 1721 (ADC, Corregimiento, Causas Ordinarias, leg. 29, 1711–1721, exp. 620). The parish of Santiago was split off from that of Belén by Viceroy Toledo (1570–1571); perhaps the Inka nobility residing in the parish of Santiago were identified with royal houses seated in Belén.

3 Each elector passed his position to his eldest legitimate male offspring or nearest male relative. See, for example, ADC, Juan Bautista Gamarra, leg. 130, 1746–1781, n.f., in which an aged and infirm elector, Don Ysidro Suta Rauraua of San Jerónimo parish (descendant of the ruler Sinchi Roqa), ceded his position on the council of twenty-four to his nephew Don Miguel Suta Rauraua. Although Don Ysidro had a living legitimate son (Don Dionicio), mental incapacity rendered him unable to assume the office ("se halla encapas de servir dicho cargo por ser inepto de Natural"). For a more straightforward succession from father to son, see ADC, Juan Bautista Gamarra, leg. 127, 1739–1742, n.f. The twenty-four positions could not always be filled immediately. In 1721, for example, owing to a spate of deaths following an epidemic, there were only seven electors who had held their positions the previous year. Many of the remaining positions were filled by interim electors because the designated heir (the deceased's son) was too young to assume office. In cases where there was no son, the position went to an adult male relative of the deceased; or, if there were no relatives, the electors nominated replacements—always a parochial principal and always from the same royal house (ADC, Corregimiento, Causas Ordinarias, leg. 29, 1711–1721, exp. 620). For more on the electors, see J. Rowe 1951.

4 In 1659, fourteen Inka noblemen, probably all electors, authorized Don Francisco Quiso Mayta to represent them in Lima before the viceroy and Audiencia in order to protect and further the rights and prerogatives of the "Alférez Real de los Yngas" (ADC, Martín López de Paredes, leg. 142, 1659, fol. 921r–v). ADC, Corregimiento, Causas Ordinarias, leg. 29, 1711– 1721. exp. 620, contains election results for *alféreces reales* for most of the years between 1721 and 1820. The nominations followed an acknowledged pattern so that the six parishes officially having electors would be regularly represented in turn. The fixed order, which repeated, was as follows: Belén, Hospital de los Naturales, San Cristóbal, San Blas, San Sebastián, and San Jerónimo.

5 See, for example, ADC, Corregimiento, Pedimentos, leg. 82, 1582–1699, where the *alférez real*, chosen for the feast day of Santiago in 1685, is said to have been "un yndio de los mas principales de la mascapaycha" and an "Ynga lexitimo de la mascapaicha."

6 Titu Kusi Yupanki, another son of Manko, who had headed the Vilcabamba Inkas since Sayri Túpaq's departure, acted in the young Túpaq Amaru's stead. Titu Kusi died in 1571, a year after composing his account of the conquest and rebellion (Titu Cusi Yupanqui [1570] 1973), leaving Manko's youngest son Túpaq Amaru as paramount Inka.

7 The wedding of Doña Beatriz to Don Martín García Loyola is the subject of a famous painting found in the Jesuit church in Cuzco, and copies were made for other Jesuit facilities in Peru as well as for private collections (discussed below). In the painting, both Sayri Túpaq and Túpaq Amaru are pictured wearing the *maskapaycha*.

8 See Hemming 1983 for a more detailed account of the history of the Vilcabamba Inkas.

9 Cristóbal Paullu resided in the section of Cuzco known as Colccampata, where he founded the chapel of San Cristóbal in honor of his saintly namesake.

10 For more discussion of the postconquest royal Inka lineages, see Bustos Losada 1951–1953; Cúneo-Vidal 1925; Loayza 1946; Lohmann Villena 1947, 1:198–200, and 1949; Pumacahua Inca 1956; J. Rowe 1951; and Temple 1937, 1937–1946, 1942, 1948, 1949, 1950a, and 1950b.

11 The Spaniards, relying on their own cultural precepts, believed that Inka rules of succession operated like those of Europe. We are still unsure of exactly how the title passed from one Sapa Inka to the next.

12 My thanks to Kathryn Burns for bringing this document to my attention.

13 Proofs of nobility offered in the eighteenth century by the Cayo Gualpa Yupanki family, descendants of the ruler Viraqocha Inka (from the Sucso *ayllu* in San Sebastián parish, Cuzco), aver this. In statements from 1690, offered by the family as evidence, witnesses swore that they knew the nobles in question were legitimate descendants of Inka rulers in part because they

had worn the *maskapaycha* on public occasions without challenge ("y sin rre-pugnancia alguna en todas las funciones publicas se an puesto la insignia de la mascapaicha de vorla colorada que es permitida solo a los que son le-gitimamentte nobles"). In July 1995, this document was uncatalogued in the ADC but marked for Corregimiento, Causas Ordinarias; see folios 17r–28v. There is similar eyewitness testimony from 1686 in ADC, Intendencia, Gobierno, leg. 133, 1786.

14 In part the accord reads: "[N]o se ponian las armas ynsignias de los dhos yngas que es una borla colorada que se ponen en la frente en dhos actos publicos ni pretenderan sacar el dhos estandarte rreal de santiago . . . so pena de ser quitadas dhas armas y estandarte rreal y ser castigados por todo rrigor derecho."

15 Earlier in the century, Guaman Poma similarly used the wearing of the *maskapaycha* to indicate supremacy. Rolena Adorno (1981, 97–98) notes that of all of Guaman Poma's portraits of the Inka dynasty, only in the portrait of Sinchi Roqa does the ruler fail to display the imperial fringe on his fore-head. She notes that this Sapa Inka reigned, according to Guaman Poma's inventive chronology, at the time of Christ's birth. "[T]he missing masca paycha," she states, "is an invisible indicator that points to the incorpora-tion of the seminal event in Western spiritual history into the ebb and flow of ancient Andean history." Guaman Poma, as a Christian Andean, thus in-ferred the contemporaneous existence of a "true" king during the reign of Sinchi Roqa by denying this Inka head-of-state the sign of preeminence.

16 For discussion of seventeenth- and eighteenth-century portraits of colo-nial Inka elites in which modified Inkaic crowns are worn by Sapa Inka descendants who, according to the inscriptions, held a variety of political positions, see J. Rowe 1951; Gisbert 1980, 149–153; and Cummins 1991.

17 ADC, Intendencia, Gobierno, leg. 133, 1786, consists of proofs of nobility offered in the late eighteenth century by the legitimate sons of Don Sebas-tián Guambo Thupa (an elector from San Cristóbal) who traced their de-scent from the ruler Túpaq Yupanki (and Atawalpa). As part of the series of documents, they included copies of a 1686 "proof" in which their ancestors had successfully established their royal lineage; the approval of the twenty-four was the last step in that process.

18 Doña Lorenza identifies the headdress as a "llaito del Inga." She is probably referring to the *llawt'u* (headband) to which the *maskapaycha* was attached (see the discussion of headdress parts in Chapter 6 below). Murúa ([1600–1611] 1986, 349–350) also refers to the Inka headband as a "llaito."

19 Quispe Tito depicts an Inka ruler wearing the *maskapaycha* in purgatory next to a pope and a European king; an angel gestures toward them, inviting the group into heaven. Very near the befringed Inka, the artist signed and dated the painting, leading to the interpretation that the allegorical Inka is a self-portrait of Quispe Tito himself. Like Quispe Tito, many Cuzqueño artisans

claimed noble Inka descent, as is indicated by their use of the appellation "Inga" (Inka), as in Don Juan Sapaca Inga, an artist who may well have contributed to the painting of the Corpus Christi series (Dean 1990, 75–77). The well-known native sculptor Don Juan Tomás Tuiro Túpaq is another example of a noble Inka craftsman; he was married to Doña Petrona Ygnacia Ñusta, her surname meaning "princess." Some artisans, such as the painter Don Joseph Usca Mayta of San Cristóbal, were *principales* in their parishes.

20 Interestingly, while the nomination of *alférez real* usually proceeded without incident, occasionally the electors disagreed among themselves; the *corregidor* seems to have selected the nominee having the majority of votes. Sometimes electors ceded their votes to the *corregidor* and thereby avoided acting in favor of individuals whose "turn" it clearly was, but for whom they apparently felt some degree of animosity. At the same time as the *corregidor* approved the nomination of *alférez real*, he also approved the nominations of *alcalde mayor de la real corona* and *alguacil mayor de los Ingas nobles* from among the twenty-four. See ADC, Corregimiento, Causas Ordinarias, leg. 29, 1711–1721, exp. 620. The ADC also has (in its collection of uncatalogued documents) a record of the nomination of Don Phelipe Auqui Guaman, *cacique principal* of San Blas, to the position of *alcalde* for 1746. The dates and names given in the document match those of ADC, Corregimiento, Causas Ordinarias, leg. 29, 1711–1721, exp. 620.

21 This testimony is included in later proofs of nobility offered by the descendants of Don Melchor (ADC, Intendencia, Gobierno, leg. 133, 1786).

22 See Mills 1997 for an analysis of the extirpation effort from 1640 to 1750.

23 For a more detailed discussion of Garcilaso, his life and his work, see Zamora 1988. See also Klaiber 1976, 518–519.

24 John H. Rowe (1954), however, has argued that Garcilaso was not widely read in Peru until the eighteenth century. Garcilaso's work drew heavily on that of the *mestizo* Jesuit Blas Valera, who was a staunch Inka advocate, and is in many ways echoed by the native Andeans Felipe Guaman Poma de Ayala and Joan de Santa Cruz Pachacuti, both of whom were writing in the first decade of the seventeenth century. It may well be that, by the second decade of the seventeenth century, Peruvian religious were receptive to the many voices (including those of Valera, Garcilaso, Guaman Poma, and Pachacuti) who were attempting to draw parallels between Inka religious practices and Christianity. As Klaiber (1976, 520) concludes "It was not the more learned Spanish missionaries, but rather the native sons of Peru who first established a Christian dialogue with the [Inka] culture and history." For a thorough analysis of the conversion effort and the many conversations it prompted, see MacCormack 1991 and Mills 1997.

25 See Gisbert 1980, 153–157, for discussion of this painting and the known copies of it.

26 This piece of information comes from Doña Josepha's will (ADC, Juan Bau-

tista Gamarra, leg. 130, 1746–1781, n.f., Testamento de Doña Josepha Villegas Cusipaucar y Loyola Ñusta, February 12, 1777).

27 The relationship between the Jesuits and the Inka nobility is a rich and interesting topic for discussion, but one that is beyond the scope of this book. Marie Timberlake (personal communication) is attending to aspects of this complex theme in her doctoral dissertation, "Negotiating the Sacred: Jesuit Art and the Colonization Process in the Andes" (Art History, UCLA).

28 One document describes Toledo's commission as "pintado en bara y media de tafetan blanco de la china El Arbol Real desendiendo desde Manco Capac hasta Guaina Capac y su hijo Paullo en que bebian los Yngas pintados en su traxe antiguo de los pechos arriba en las cauesas la borla colorada en las orexas y en las manos sendas partesanas todo lo qual dirigio el referido Garcilaso" (ADC, Corregimiento, Causas Ordinarias, leg. 49, exp. 1125, Instrumento e información dada de su nobleza por Don Manuel Alanya Guariloclla, 1768).

29 Chroniclers often compared the Inka dynasty and aspects of their culture to that of ancient Rome. Their texts were paralleled by images that suggested the similarity of pre-Christian empires. See, for example, the Cuzco resident who owned "nuebe liensos de los emperadores romanos" (ADC, Martín López de Paredes, leg. 133, Inventario de los bienes de Alonso Dias de Leyba, July 27, 1650).

30 Modern scholarship has raised some serious questions about the historical accuracy of colonial-period accounts, including the possibility that Andean rulership was dual. See, in particular, Duviols 1979 and Zuidema 1964 and 1990a.

31 Although Cobo ([1653] 1990, 37) states that wawkis (guauques) "depicted" their owners, they were not fashioned as physiognomic likenesses or even necessarily as anthropomorphic forms. The wawki of Sapa Inka Sinchi Roqa, for example, was a stone shaped like a fish (Sarmiento de Gamboa [1572] 1943, 63). See Duviols 1978, Van de Guchte 1996, and Dean n.d. a for a more detailed discussion of wawkis.

32 This piece of information comes from Doña Juana's will (ADC, Alejo Fernández Escudero, leg. 100, fols. 877r–895r, Inventario de los bienes de Doña Juana Engracia Cuzi Mantar Rocca, October 1, 1720).

33 See ADC, Francisco Raya y Andrade, leg. 235, 1724–1726, fols. 415r–417r, Testamento de Don Pedro Sapero, November 5, 1725. Hispanics owned similar portrait series, though for very different reasons. In 1721 Captain Cristóbal de Rivas y Velasco, described as a citizen of Cuzco and evidently Hispanic, hired the Cuzqueño painter Captain Agustín de Navamuel to paint twenty-four paintings: specifically, the twelve Inka kings and the twelve queens with all their attributes and insignias and their names at their feet (ADC, Matias Ximénez Ortega, leg. 290, 1721–1722, fols. 92r–93v, Pacto y consierto del Capitán Agustín Navamuel, maestro pintor, con el Capitán

Cristóbal de Rivas, April 1, 1721). The cost was 336 pesos, or 14 pesos each. See Gisbert 1980, 117–120, 124–140, for a discussion of colonial-period portrait series.

34 Interestingly, in her 1662 will Doña Isabel bequeathes her father's "ynsignias y armas del ynga" to her eldest illegitimate daughter, Joana Vichic, possibly because her only legitimate children were *mestizos;* she indicates that it was her father's wish for Joana to inherit these items. Doña Isabel's second will, dated in 1665, does not mention Joana, who may have died in the interim. Although the eight paintings of Inkas are listed among her goods in 1665, no special dispensation is made of them. Her two legitimate daughters are named as her universal heirs. See ADC, Lorenzo Messa Andueza, leg. 195, 1662, fols. 1354r–1378r and ADC, Lorenzo Messa Andueza, leg. 199, 1665, fols. 1159r–1176v.

35 See ADC, Mariano Meléndez Paez, leg. 181, 1812–1813, fols. 529r–531r, Inventario de los bienes de Doña Martina Chihuantupa de la Paz, January 12, 1803. Her will identifies her as the daughter and heir of Don Marcos Chiguan Topa, a parishioner of San Cristóbal; her brother (deceased) was Don Luis Chiguan Topa.

36 See ADC, Juan de Dios Quintanilla, leg. 231, 1755–1762, fols. 260r–267v, Testamento de Doña Antonia Loyola Cusi Tito Atau Yupanqui, May 30, 1759. Both paintings were valued at 6 pesos.

37 Roach (1996, 36–42) has coined the useful term "performed effigies" as a way of thinking about a likeness (effigy) that is manufactured from the flesh of a performer.

38 Flores Galindo (1986a, 67) suspects that Arzáns is fabricating or mistaken about the date, as "it doesn't seem likely that at such an early date the Inka could have been exalted before a Spanish audience and before a memory of the Andean past had been reconstructed in the collective memory." However, because the play ultimately confirmed the Spanish conquest, Arzáns may well be correct. Other early works by Hispanics about the Inka past are known of, but the contents are not preserved. Between 1580 and 1585, for example, Miguel Cabello de Balboa wrote several dramatic works, one of which was titled *La comedia del Cuzco;* as Flores Galindo suggests, its theme was probably a history of the Inkas. See Lohmann Villena 1945 and 1950.

39 Peterson (1995, 18) has suggested that native responses to Spanish cultural hegemony can be characterized generally either as "juxtaposition" or as "convergence or syncretism." The two responses are not mutually exclusive and were often employed simultaneously.

6. Inka (In)vestments

1 Roland Barthes (1972, 111) has usefully characterized objects as speech "if they mean something."

2 The Jesuit Bernabé Cobo ([1653] 1979, 244–245) writes: "The Inca wore a cloak and a shirt, with *ojotas* on his feet; in this respect he followed the custom of the common people, but his clothing was different from the usual in that it was made of the finest wool and the best cloth that was woven in his whole kingdom, with more brilliant colors and finer quality weaving."

3 Of the known colonial-period portraits of Sapa Inkas, those by Guaman Poma strike us as being the least Europeanized and thus are useful in our attempts to envision how Inka leaders of the colonial period refigured pre-Hispanic imperial costume.

4 Some colonial-period *cumbi* may, in fact, have been manufactured from imported silk. For example, an inventory of the belongings of the deceased Doña Juana Engracia Cusi Mantar includes "una lliclla de cumbe de seda" (ADC, Alejo Fernández Escudero, leg. 100, 1720, fols. 877r–895r, October 1). For a technical discussion of Inka *cumbi* tunics, see A. Rowe 1978; for a general discussion of transitions in both design and production from pre- to post-Hispanic Andean weaving, see Niles 1992.

5 Gisbert and Mesa (1985, 222) transcribe a document from the Departmental Archives in Cuzco which concerns the loss or theft of a piece of colored *cumbi*, one of a pair of textiles that had been loaned to the painters' guild for the decoration of a triumphal arch for Corpus Christi. All those concerned with the arch have Spanish surnames: Pascual Moncada, Mauricio García, Diego Carrasco, and Miguel de Castro. The owner of the pair of *cumbi* was Doña María Albarez.

6 Iriarte's comprehensive study deals with sixty-two tunics as depicted in colonial-period images (including the Corpus Christi series) as well as ten actual colonial tunics.

7 Forty-seven of the sixty-two tunics Iriarte (1993, 68–70) considers have decoration on the body of the garment.

8 See, for example, the testament of Don Pedro Sapero, the *cacique principal* of the *ayllu* Guanca Chinchay Suio of Santa Ana parish (ADC, Francisco Raya y Andrade, leg. 235, 1724–1726, fols. 415r–417r).

9 Zuidema (1990b, 169) argues that the feathered collars worn by noble lords were akin to the grass roof of the *sunturwasi*, a distinctive, sacred circular building used for solar observations. He writes: "Other data from the chroniclers more particularly support the comparison of a roof, or of a collar of feathers worn by a noble lord over his skirt, to people dependent on him in an intricate network of kinship relations. The sunturhuasi demonstrated, for all inhabitants of Cuzco to see, the braiding of their kin alliances."

10 For the complete testaments, see ADC, Alonso de Bustamante, leg. 11, 1676–1678, fols. 270r–273v, Testamento de Don Martin Quispe Topa Ynga; and Juan de Dios Quintanilla, leg. 231, 1755–1762, fols. 260r–267v, Testamento de Doña Antonia Loyola Cusi Tito Atau Yupanqui.

11 Duviols (1976) argues that Punchao, the Inka deity of the day sun, was in fact depicted in anthropomorphic form with rays of the sun emerging from his head or shoulders. The solar pectoral worn by midcolonial *caciques*, however, is anthropomorphized in the European manner.

12 Constitución 103 reads: "que se quite el abuso supersticioso que tienen los indios orejones de horadarse las orejas y traer en ellas colgadas aquellas rodajuelas" (Vargas Ugarte 1951, 253).

13 According to Cieza de León ([1553] 1959, 35), the Inka wore a fillet-like crown, called a *pillaca*, from which gold earrings hung, suggesting that the standard-bearer of San Blas may, in some regard, be following a preconquest practice. Betanzos ([1551] 1987, 68) calls the Inka headband a "pillaca-llauto."

14 "Este yndio se ponía en la caueça unos *llautos*, que son unas trenças hechas de lana de colores, de grosor de un medio dedo, y de anchor de uno, que son unas trenças como digo, hecho esto una manera de corona, y no con puntas, sino rredonda, de anchor de una mano, que encaxaua en la caueça; y en la frente una borla cosida en este llauto, de anchor de una mano, poco más, de lana muy fina de grana, cortada muy ygual, metida por unos cañutos de oro, muy subtilmente hasta la mitad; esta lana hera hilada, y de los cañutos parauajo destorçida, que hera lo que caya en la frente, que los cañutillos de oro hera quanto tomaban todo el *llauto*. Cayale esta borla hasta empçima de las cexas, de un dedo de grosor, que le tomaba toda la frente."

15 Zuidema (1964, 196) translates *maskapaycha* as "insignia of the Maska." The Maskas were a pre-Inka people who lived in the Cuzco area (Pardo 1953, 7).

16 The feathered parasol as an emblem of Inka royalty is represented in numerous colonial-period images. For example, Guaman Poma ([1615] 1988, 98ff) shows feathered parasols shading several *qoyakuna* (Inka queens). Similar sunshades are depicted in eighteenth-century portraits of female descendants of royal blood (Gisbert 1980, figs. 157, 158, 160–162). Additionally, a feathered parasol shades the Inka ruler Túpaq Amaru in the well-known painting of the marriage of his niece, Doña Beatriz, to his captor Don Martín García de Loyola (ibid., 153–157). Cobo ([1653] 1979, 101) witnessed the use of actual sunshades "of attractive feathers" used as royal Inkaic insignia in a viceregal procession in Cuzco in 1610. Arzáns de Orsúa y Vela ([c. 1735] 1965, 3:46–50) reports a parasol used to shade an Andean noble impersonating a pre-Hispanic Inka emperor in Potosí in 1716.

17 See Gisbert 1980, 117–146, for a detailed discussion of colonial-period portraits of Inka royalty.

18 The portraits of Sapa Inka that accompany the finished version of Murúa's text (known as the Wellington manuscript) do not show elaborate jeweled headbands, however, and the plumage is sparse (Murúa [1611] 1985, plates III, IV, VII, IX, XVI, XXII–XXV, XXVIII, XXIX, XXXI, XXXII, XXXIV, XXXVII). The artist(s) of these images thus seems to have been less affected by post-conquest modifications in Inka regalia than Murúa.

19 The document is the testament of Doña Nicolasa Siancas y Quispe. The relevant portion reads: "[D]eclaro por mis bienes un bestido entero de Ynga con su mascapaycha, y la capa esta guarnesida con frangas de plata mas un llayto guarnesido con corales y quentas asules y su sol de plata" (ADC, Tomás Villavisencio, 1774–1775, leg. 276, fols. 437r–440v).

20 This description was offered in 1716 by a witness who provided an account of the festive appearance of the Inka cacique of San Blas during the time Corregidor Don Fernando de la Fuente y Rojas served, 1702–1703 (ADC, Intendencia, Gobierno, leg. 133, 1786).

21 "Plancha de oro, adornada de piedras preciosas, engastadas, en ésta se ponía la gran borla púrpura de preciosas plumas. Ésta era la corona imperia del Inca."

22 Specifically, Zuidema identifies the *casana* textile design on some colonial-period *tupaqochors*.

23 Cobo ([1653] 1979, 245–246) echoes Pizarro when he writes: "From the middle up, this fringe was very carefully put through some little gold tubes, and the wool inside them was spun and twisted, and from the little tubes on down, which was what dropped down on the forehead, the wool was un-twisted and not spun."

24 Cobo ([1653] 1990, 151) also identifies a "small pouch" carried by youth during the Itu festival as "sundorpauca." Since Inka vassals often carried pouches aloft on sticks as emblems of authority, Cobo may be identifying any symbol of rank and power as *suntur pawqar*.

25 Gisbert (1980, fig. 158) reproduces Francis de Castelnau's (1850–1859) copy of this portrait. The central elements are the same, but the banners have disappeared and have been replaced by what appear to be feathers.

26 A copy of this painting was made by Castelnau before it was lost. That copy is illustrated by Gisbert (1980, fig. 155).

27 As discussed in Chapter 5 above, this portrait was made posthumously in the eighteenth century, probably by Don Marcos. The headdress is almost certainly anachronistic; the artist likely reproduced the headdress that the Chiguan Topa family used in the eighteenth century. Like Don Marcos Chiguan Topa, Don Alonso is shown with the coat of arms of Cristóbal Paullu, the son of Sapa Inka Wayna Qhápaq who, after the rebellion of Manko II, was selected by the Spaniards to be the postconquest Sapa Inka.

28 For a detail of the three donors, see Gisbert 1980, fig. 100; for the central

portion of this painting, see Gisbert 1980, fig. 99, and Gisbert and Mesa 1982, 2:fig. 315).

29 Cobo ([1653] 1990, 130) identifies "yauri" as a palm wood staff with a copper blade resembling a hatchet. He says they were decorated with woolen tassels and that gold blades were featured on *tupa yawri*, or royal staffs.

30 Guaman Poma contributed illustrations for at least two of Murúa's manuscripts; he may well have painted the crest reproduced in Fig. 41 as it so closely resembles the coat of arms in his own work (Ossio A. 1982, 568–569; Ossio A. 1985, iii, vi). For further discussion of the relationship between Guaman Poma and Murúa, see Mendizábal Losack 1963 and Murra 1992.

31 For further discussion of the symbolism of the rainbow in the pre-Hispanic and colonial Andes, see Cummins 1988, 357, 486–496.

32 Today in some parts of the Andes, the rainbow, which is likened to a giant serpent that lives underground, is thought to facilitate the distribution of locally available water; when filled with water after a rain, he flies out of one spring, arching across the sky to sink his head in a second spring, thereby transferring water from spring to spring (Allen 1988, 53). The serpents appended to the ends of rainbows in colonial-period headdresses and blazons likely express similar meanings.

33 "En Madrid XIX dias del mes de julio de MDXL años se despachó un previllegio de armas para la ciudad del cuzco en que se le dieron por armas un escudo que dentro del esté un castillo de oro en campo colorado en memoria que la dha ciudad y el castillo della fueron conquistados por fuerza de armas en nro. servicio e por orla ocho condures que son unas aves grandes a manera de buytres que ay en la provincia del perú en memoria que al tiempo que la dha ciudad se ganó abaxaron las dichas aves a comer los muertos que en ella murieron los quales esten en campo de oro" (Montoto de Sedas 1928, 75).

34 Santiago, the patron saint of Spain, was said to have appeared astride his white charger to aid the Spaniards in their reconquest of Saqsaywamán. Although the taking of the "fortress" was not the decisive event in ending the siege, it took on great symbolic value and was held to be the point when momentum shifted from the Inkas to the Spanish side.

35 How much, if any, of the circular tower survived into the seventeenth century is unknown; for, however much Saqsaywamán may have been admired by the Spaniards, it was plundered both in the search for treasure and for the worked masonry of which it was constructed. See Dean 1998 for a discussion of the process through which the Inka architectural complex of Saqsaywamán was turned into a ruin.

36 Gisbert (1980, 158) states that the tower was the specific symbol of the ruler Pachakuti Inka; Pachakuti, according to some chroniclers, began the construction of Saqsaywamán and remodeled the city of Cuzco. By the mid-

colonial period, though, the castle clearly no longer referred to any specific person.

37 This blazon is illustrated in the *Revista del Archivo* (Archivo Departamental del Cuzco) 3(1952): between 140 and 141.

38 Cúneo-Vidal (1925, 173) transcribes the grant as reading, in part: "un escudo hecho en dos partes, que, en la una de ellas esté un águila negra rampante en campo de oro, y a los lados, dos llaves verdes, y en la otra parte baja, un tigre de su color y, encima, una borla colorada que solía tener por corona Atalibar su hermano, y, a los lados del dicho tigre dos culebras coronadas de oro en campo azul; y por orla, unas letras, ocho cruces de oro de Jerusalén an campo colorade, con perfiles de oro, y por timbre un yelmo cerrado, e por timbre de él un águila negra que sustente sus trascoles y plumajes, éstas de oro y azul." Other scholars have interpreted the royal grant as saying "palmas" rather than "llaves." The *cédula* and a brief discussion are to be found in Temple 1940, 66–68n190.

39 A royal *cédula* of May 9, 1545, granted this coat of arms to Don Gonzalo Uchu Gualpa (a.k.a. Pichogualpa) and Don Filipe Tupa Iupanqui for being not only royals, but "fieles y leales amigos y hermanos y buenos católicos cristianos." In part, the grant reads: "un escudo hecho en dos partes que en la una de ella esté un águila real en campo rosado, y a los lados leones reales que cojan arco iris, y encima una borla carmesí que solían tener por armarita, y a los 2 lados culebras coronadas en campo rosado. Y por la una letra que dice, Ave Maria en el medio; y en el otro lado un castillo en campo amarillo, y por divisa un águila real con sus trabales, dependencias afollages de azul engarzadas en ellos quarenta y dos coronas imperiales al rededor con otras tantas reales, que son la una parte de las coronas de dichos señores Reyes naturales de esos dhos. Reinos y Provincias del Perú tuvieron sugetos a su Dominio y Corona" (Montoto de Sedas 1927, 300). A copy of this grant with only minor differences (e.g., "tigres" instead of "leones") can be found in the proofs of nobility offered by the sons of Don Sebastián Guambo Thupa, "Indio noble y elector de la parrochia de San Cristóbal" (ADC, Intendencia Gobierno, leg. 133, 1786).

40 This according to three witnesses whose testimony was recorded in 1716 and included in the proofs of nobility offered by descendants of Don Francisco in the late eighteenth century (ADC, Intendencia, Gobierno, leg. 133, 1786).

41 The Chiguan Topas traced their royal lineage to the third Inka ruler, Qhápaq Lloque Yupanki. By the mid-eighteenth century, J. Rowe (1951, 293) concludes any member of the royal house felt free to avail himself of Paullu's crest.

42 See, for example, the inventory of the belongings of Don Matthias Tthopa Orco Guarancca Ynga, whose brother was *cacique principal* of San Jerónimo

parish and one of the twenty-four electors; Don Matthias owned five paintings of coats of arms (ADC, Matías Ximénez Ortega, leg. 287, 1717–1718, fols. 281r–290v).

43 Morcillo, the archbishop of Charcas, served as interim viceroy in 1716 and then again from 1720 to 1724. The relevant passage of Doña Juana's inventory reads: "[E]n otro quarto alto se hallaron los bienes siguientes— . . . tres retratos de Yngas = Unas armas en lienzo que son del Sr. Virrey Don frai Diego Morsillo" (ADC, Alejo Fernández Escudero, leg. 100, 1720, fols. 877r–895r, Inventorio de los bienes de Doña Juana Engracia Cusi Mantar Rocca, October 1, 1720).

44 Gisbert (1980, 157–162) discusses the importance of coats of arms to colonial Inka nobles (and others).

45 Murúa ([1600–1611] 1986, 70) also describes two different coats of arms which he says adorned the palace of Qoya Kusi Chimpu, the primary wife of the ruler Inka Roqa. The icons composing these blazons (the *maskapaycha*, the *curiquenque*, a jaguar transversed by a tree, and two serpents) are identical both to those featured in the coat of arms which Guaman Poma ([1615] 1988, 65, no. 85) illustrates as his second arms of the Inka (Fig. 40). That Murúa's informants apparently identified this particular set of motifs with an Inka queen suggests that Guaman Poma's blazon may represent a complement to his first "arms of the Inka." Likely, his two blazons reflect *anan/urin*, upper/lower, male/female complements.

46 Although evidence indicates that most of those who invented Inka blazons were Andeans (who claimed aristocratic roots), Europeans aided the effort. Some of the portraits of Sapa Inkas and Qoyas contained in the copy of Murúa's chronicle known as the Wellington manuscript also include coats of arms; the artist of some of these was likely Hispanic (Dean n.d. c).

47 Gisbert (1980, 162) summarizes the 1759 testament of Don Bernardo Cayetano Orco Guamán Díaz, a *principal* of the parish of Belén. Because he had no heirs, he left Antonio Mandartupa, the "arms of the Great Tupac Yupanqui with its gilded frame and all the proofs of the nobility of this house because he belongs to it."

48 Gisbert (1980, 168) has identified this lintel as the one now displayed in Cuzco outside the Savoy Hotel on the Avenida El Sol.

49 Gisbert (1980, 168) suggests that this edifice either belonged to a *cacique principal* of Juli or was a community building under Jesuit management.

50 Tokapu have been interpreted as personal symbols and as a form of writing. See Rojas y Silva 1979 and 1981 for a concise summary of various interpretations of *tokapu*. His own argument, that *tokapu* designs on royal garments represent a kind of genealogical tree, with each individual design referring to a specific lineage, is both intriguing and appealing, but ultimately unsupported by reliable data.

51 In the copy hanging in Arequipa, the *maskapaycha* can be seen in the *tokapu* on the lower left part of Beatriz's dress.

52 Pachacuti's drawing, and the chronicle of which it is a part, is traditionally dated to 1613, but Pierre Duviols (in Pachacuti 1993, 18–19) argues that it might date closer to 1620. The "cosmic diagram" with glosses in Spanish, Quechua, and Aymara is on folio 13v of his manuscript. It is doubtful that Pachacuti's drawing actually represents an interior wall of the Qorikancha (Duviols in Pachacuti 1993). What matters for the present discussion, however, is the Andean structure of the "wall" as depicted by the native author and artist.

53 Garcilaso de la Vega ([1609, 1617] 1966, 1:374) states that the feathers were to come from a single bird. The left/right distinctions were carefully maintained, however, as the feather from the right wing was to be worn on the right side of the *maskapaycha* and that from the left wing was to be worn on the left.

54 See Allen 1988, 250, for an excellent discussion of the concept of *tinkuy* as used today in the southern Andean Quechua community of Sonqo, northeast of Cuzco. For additional connotations and explication of *tinkuy* as used in pre-Hispanic times, see Stern 1982, 8–16.

55 A special appreciation of the in-between continues up to the present. See Classen 1993, 14, for an excellent discussion of the importance of in-between spaces and mediative zones.

56 See Martínez Cereceda 1995 for an analysis of how the pre-Hispanic Inka ruler's symbols of power—specifically, his seat, *andas*, feather adornments, and musical accompaniment—combined to proclaim the leader's intermediacy.

7. The Composite Inka

1 The notion of authenticity has been the subject of numerous recent critiques; one of the most useful for postcolonial subjects is that offered by Gareth Griffiths (1994).

2 The Quechua word *chaupi*, meaning "middle," is the Andean equivalent of the unrecuperated Nahua *nepantla*.

3 Majluf links Rowe's understanding of colonial Inka evocations of their pre-Hispanic ancestry to those of Buntinx and Wuffarden (1991). I would add Flores Galindo (1986a) and Burga (1988) to the list of scholars whose interpretations of the so-called Inka renaissance fundamentally conflict with Cummins's opinions as expressed in his 1991 article.

4 Following Barthes (1972, 11), José Rabasa (1993, 9) suggests that cultural products be considered as "rhetorical articles," a linguistic metaphor that has proved extremely useful. My thinking along these lines has been in-

formed by postcolonial theorizing on the use of the colonizer's language by authors such as Kachru (1986), Brathwaite (1984), New (1978), and Zabus (1991).

5 "Dialect," points out Brathwaite (1984), carries implicit pejorative overtones. It conveys a notion of impurity, which, as we have already said, is better avoided.

6 Rafael (1993, 55–83) demonstrates how the Tagalog printer Tomas Pinpin, in the early seventeenth-century Philippines, "construed translation in ways that tended less to oppose than to elude the totalizing claims of Spanish signifying conventions" (ibid., 55).

7 Hal Foster (1985, 168) defines cultural appropriation as a process of "abstraction whereby the specific content or meaning of one social group is made over into a general cultural form or style of another."

8 Stern (1982, 169–170) has described how, "in a society where 'cultural' and 'economic' dimensions of life interpenetrated one another deeply, Indian Hispanicism had profound symbolic importance. Andean culture esteemed cloth highly as a ritual article and as an emblem of ethnic affiliation and social position. Natives who wore fine Hispanic clothes vividly expressed an aspiration to move beyond a condemned Indian past and merge into the upper strata of colonial society."

9 Serge Gruzinski (1993, 229–281) uses the term "composite," without explication, to describe indigenous cultures in New Spain.

10 The frequent appearance of birds in colonial-period canvases, especially those produced in Cuzco, has been commented on by many scholars of viceregal Andean painting. Opinion as to the significance of the pronounced avian presence differs. Martin Soria (in Kubler and Soria 1959, 397n101), for example, concludes that the birds which are frequently seen near or above indigenous personages in viceregal paintings "may have special, possibly magic, meaning" while Castedo (1976, 59) suggests that they reflect "a nostalgia for the tropics."

11 Cobo ([1653] 1990, 185) writes: "The majority of [their] ornaments were made of feathers which came in a variety of attractive colors. Above the forehead they put a large diadem of feathers standing up high in the form of a crown or garland; it was called *pilcocata*."

12 The dancers can be recognized as "Inka" owing to the scarlet fringe that hangs from their crownlike headdresses. A reproduction of this painting may be found in Vandenbroeck 1991, 440.

13 Although not very descriptive, the Book of the Cabildo of the Hospital de los Naturales parish indicates that in parochial celebrations early in the seventeenth century Andeans were to wear festive regalia with much featherwork ("besturia y mucha plumeria") (ACC, Parroquia San Pedro, Libro de Cabildo y Ayuntamiento del Hospital de los Naturales, 1602–1627). There is no indication of whether these feathers were of Amazonian origin or were the more

Hispanicized white plumage. Interestingly, one of the Hospital *ayllus*, that of the Yanaconas, introduced a dance of the Chunchos ("Chuncho taqui") in 1615. It cannot be established that these Yanaconas had any connection to the inhabitants of the forested east Andean slopes. In fact, two years later they performed an "alarde Mexicano." For possible insights into how Amazonian peoples themselves (as opposed to the highlanders imitating them) may have regarded feathers as part of costume, see Terence Turner's (1980) elegant study of contemporary Kayapo body adornment.

14 Arzáns de Orsúa y Vela ([c. 1735] 1965, 3:46–50) refers to a festive impersonation of an Inka in which the "ruler" was shaded by a feathered parasol. Pre-Hispanic rulers were still, at least at times, associated with colorfully feathered accouterments.

15 According to Allen (1988, 216), male Andeans in the Quechua community of Sonqo, northeast of Cuzco, recognize that their adoption of *mestizo* clothing (*misti p'acha*) is symptomatic of the disappearance of the traditional Andean way of life. One male informant, however, stated: "We'll be fine. The girls haven't changed their clothes. As long as the women stay with the *Runa p'acha* [traditional Andean clothing], our way of life won't disappear."

16 However, battles between Inkas and Chunchos, also found on colonial-period *k'eros*, expressed the *confrontation* of complements and highlighted the male activity of warfare which would bring order to chaos.

17 The Caranquis, a.k.a. Caranques and Carangues, are referred to in Romero's text as the Cananapes of Quito. For more on the Inka conquest of the Caranquis, see Murra 1946.

18 Many chroniclers relate the events of Yawarqocha. Garcilaso ([1609, 1617] 1966, 1:566–567), owing to a printing error, gives the name as Pahuarcocha, but still translates it as "lake or sea of blood." While Garcilaso says that 2,000 rebels were put to death in the lake's waters, Cieza ([1553] 1959, 21) puts the number of executed at 20,000.

19 In April 1782 a *pragmática* was drafted whereby Andeans were prohibited from using arms of nobility that were not approved by the Cámara de Indias; the *pragmática* was ratified in November 1795. Certain clothing was also prohibited as was the display of paintings of Inka royalty. After independence, the reinvention of the Inkaic past was again taken up and continues today (as will be discussed in Chapter 9). See Gisbert 1980, 169–186, and Flores Galindo 1986a and 1986b for more on this topic.

8. Choreographed Advocacy

1 The standard-bearers of San Cristóbal, Belén, and San Sebastián wear tunics with colorful borders of indigenous design, showing them to be of Andean manufacture. These tunics are untailored according to the native tradition.

The standard-bearers of Santa Ana and the Hospital de los Naturales parish, in contrast, wear tailored, belted clothing. The testaments of some native elites confirm that they owned such garments. See, for example, the will of Don Fernando Guayparttupa Oclucana, "casique principal y governador de la Parroquia de Santa Ana de los ayllos Chachapoyas y Yanacunas," in which an outfit consisting of a long jacket, an under jacket, breeches, and cape, all of Castilian wool, were listed among his possessions (ADC, Joseph Fernández Cattaño, leg. 104, 1728–1731, fols. 1181r–1187v).

2 Julia Herzberg (1986, 62n1), in her study of Andean paintings of angels with guns, observes that the rendering of firearms is not detailed enough to allow the type of gun to be identified. That is also the case in this particular painting. I use the term "arquebus" following convention.

3 Charles V (Carlos I of Spain), son of Philip, the Duke of Burgundy, had introduced the red saltire into Spanish heraldry more than a century earlier to evoke his patrilineage.

4 Mariátegui Oliva (1951, 32) identified this group of Andeans as dancers performing what Esquivel y Navia ([c. 1749] 1980, 173) described as the "unique dance and noteworthy performance in this festival [of Corpus Christi]" (único baile y particular lucimiento de esta fiesta). Esquivel indicates that the dancers wore costumes of Spanish styling with masks as they danced to the sound of a drum and flute. Andeans engaged in this masked performance do appear in the background of another of the Corpus Christi canvases (Dean 1990, 332–337); the military corps, however, lacks masks and does not appear to be dancing. Gisbert (1980, 87) compares the uniforms of these musketeers to those of distinctive viceregal-period paintings of archangels, who are often shown bearing firearms. She tentatively identifies the corps as an indigenous confraternity devoted to Saint Michael, the archangel most frequently associated with militaristic activity. While I agree that their manner of presentation is indeed similar (though not identical) to that of the unique Andean archangels, that similarity can be credited to the fact that the angel imagery was probably based on companies of Spanish "arquebusiers" which were a common feature of many viceregal processions. Thus the resemblance owes to the fact that both the painted archangels and this indigenous corps were patterned, in part, after Spanish arquebus companies. For additional discussion of the armed archangels, see the following: Gisbert 1980, 86–88, and 1986; Gisbert and Mesa 1983; and Herzberg 1986.

5 The Inkas resettled conquered populations in part to defuse conspiracy and rebellion. Resettled populations were known as mitmaq. See J. Rowe 1982 for an excellent discussion of this term. Some Cañari mitmaq were deposited in Cuzco, Yucay (the Urubamba Valley), Copacabana, and Chuquisaca (later called La Plata, today known as Sucre, Bolivia).

6 Toledo drew up a series of questions about the Inkas, their manner of administration, succession, and conquest. Answers were sought from Andean

nobles in Jauja, Cuzco, the Yucay Valley, and elsewhere. Toledo's purpose was to show that the Inka empire had not existed long before the arrival of the Spaniards and that it had been won by conquest, that the Inkas were tyrants and not true lords of the land—in the words of Toledo's secretary at the time, "tiranos y no verdaderos señores" (Salazar [1596] 1867, 263). Another set of questions, also asked of native nobility, concerned Andean religious customs, sacrifices, "idolatries," burial rites, and work administration.

7 Murúa states: "A la primera puerta, en la entrada della, había dos mil indios de guarda con su capitán un día, y después entraba otro con otros dos mil, que se mudaban de la multitud de los cañares y de chachapoyas. Estos soldados eran privilegiados y exentos de los servicios personales; los capitanes que los gobernaban eran indios principales de mucha autoridad, y cuando el Ynga iba a la Sierra, iban junto a su persona, y se les daban las raciones ordinarias y pagas aventajadas." He goes on to describe how the second door to the palace was guarded by Cuzqueño natives and relatives of the Inka ruler.

8 For a detailed study of Chachapoya relations with the Inkas and the Spaniards, see Espinoza Soriano 1966. He concludes that the Chachapoyas (Chachas) were conquered by Túpac Inka around 1475.

9 "Dicen comúnmente, los antiguos, desta nación de los cañares, que ha sido siempre traidora, revoltosa y embustera, llevando y trayendo chismes. . . . Aún ahora tienen la misma costumbre, y de ordinario en las revueltas y diferencias andan a unirse a quien vence, no teniendo más firmeza que la que descubren los buenos o males sucesos."

10 According to Murúa ([1600–1611] 1986, 163–166), the Cañari governor of Tumipampa (whom he names Ocllo Calla, Ulco Colla, Ullco Colla, and Uelco Colla) sent word to Wáskar (who was in Cuzco celebrating his coronation) that Atawalpa was constructing fine palaces in Quito and acting as if he were the ruler. Wáskar reprimanded his brother for his excesses. The Cañari governor and one of his captains then encouraged a confused Atawalpa (who didn't understand how he had offended Wáskar) to think of himself as more worthy of rule than Wáskar and to contemplate rebellion. The duplicitous governor and captain then sent word to Wáskar that Atawalpa had taken the litter, regalia, and accouterments of Wayna Qhápaq and that he was planning an uprising.

11 The section reads: "Fue esta batalla de vna parte y de otra, ensangrentada, por la mucha gente de indios que ffavoresçián á los españoles, entre los quales estaban dos hermanos de mi padre, llamados el vno Inguill y el otro Vaipai con mucha gente de su bando y chachapoyas e cañares."

12 Toledo's letter reads, in part: "En esta ciudad del cuzco ay hasta quatrozientos yndios que llaman cañares y por ser gente valiente y de diligencia se fiaua dello el ynga para su guarda y quando los españoles entraron en esta ciudad les dieron estos la obediencia y despues aca siempre han seruido

con fidelidad y en el cerco que hizen del cuzco y leuantamiento de mango
ynga seruieron como buenos amigos y fueron grandes perseguidores de los
yngas alzados en rremunerazion desto siempre esos yndios fueron libres de
tributo y nunca sencomendaron antes por los gouernadores y avdiencias les
an sido dados preuilegios y ejecutorias para que no tributen obligandoles
solamente a que seruan a la justicia lo qual se a guardado ansi hasta aora
llegado a esta ciudad quize entender que hera esto y halle ser uerdadera la
relacion que he dicho y quel seruicio que hazen a la justicia es dar de hordi-
nario algunos yndios que asistan con el corregidor para lo que les mandare
y guarder quando es menester algun delinquente queste rretraido en lugar
sagrado o algun preso que sea necesario tenelle con guarda y seguir a los
delinquentes que huyeren y lleuar cartas y despachos que toquen a la ese-
cuzion de la justicia hasta las ciudades que confinan con los limites desta y
otras cosas a este rrespeto les quales todas son obligados a hazer de balde
avnque quando ay condenaciones de algun culpado en quellos an entendido
se les suele dar alguna ayuda entiendo que es gente que ayuda mucho a la
justicia y que mediante esta ayuda se hazen algunas buenas diligencias que
no se hazian sin ella y que con no paga solamente tributo se tienen estos
yndios por contentos."

13 According to the transcription by Ricardo Beltrán (in Borja y Aragón 1921,
239–240), Borja's report reads: "Los indios que llaman Cañares, están rele-
vados de mitas y tributos; éstos eran soldados de la guarda del Inga, y hoy
se conservan en muchas partes, ocupándose en asistir a los Justicias, ejecu-
tando lo que les ordana, así en hacer prisiones como en otros ministerios
de este genero." In *Memorias de los virreyes* (Viceroys 1859, 93) the word "rele-
vados" is transcribed "reservados."

14 The Quechua term *yanakuna* literally translates as "blacks." Its meaning
here, "vassals" or "servants," may derive from the black-colored headband
that, according to Garcilaso ([1609, 1617] 1966, 1:56), was worn by some of
the earliest Inka subjects. See J. Rowe 1982 for a thorough discussion of the
term.

15 Borja says: "Los Indios yanaconas, cuyo nombre tomándose en su verdadera
y propia significación es el mismo que el derecho antiguo dió á los siervos
ascripticios, que son los que están en particular ministerio de ocupación
servil en lugar y parte determinada."

16 Cuzco was not the only city where the Inkas resettled Chachapoyas, Cañaris,
and other ethnic groups in a special district which then became a viable
parish during colonial times. In Chuquisaca, Cañaris and Chachapoyas lived
with several other ethnic groups in the barrio of San Lázaro; they had origi-
nally been settled in that area by the Inkas (Gisbert and Mesa 1985, 169).
The Cañaris and Chachapoyas in Chuquisaca, as in Cuzco, were linked. Gis-
bert and Mesa (ibid., 179n26) refer to a document in the Bolivian National
Archives (dated 1538) that identifies a Chuquisaca resident as being "from

the Cañari Chachapoyas." Furthermore, in the Archives of the University of La Paz is a reference to the "ayllu Cañaris Chachapoyas" in Copacabana in 1757 (ibid., 179n27).

17 "[V]ino la parochia de Santa Ana poco antes de la Missa mayor, entro la procession por la plaza que estaba llena de Españoles, metio delante trezientos soldados cañares, armados de picas, alabardas y mucho arcabuzes, y muy bien vestidos, sitiaron en la plaza un castillo que trahian, combatieronlo haziendo sus escaramuzas al son de las caxas."

18 Also appearing on one of the Sundays of the celebration was the guild of Basques, who were probably miners. Of all the Cuzqueño guild exhibitions, we are told that theirs was the "most sumptuous" (Romero 1923, 447), confirming our suspicion that the Sunday performances were the most elaborate.

19 The agreement, dated February 10, 1691, reads in part: "Francisco Volucana, casique principal y gobernador de la parroquia de Sra Sta Ana del ayllu chachapoya [y] Don Martín Chalata . . . casique del ayllu hanansaya [y] Don Joan Saquinaula casique del ayllu hurinsaya . . . dixieron que por quanto tienen obligasion de dar un indio al señor Corregidor de esta ciudad para rrepostero por semanas y agora an benido en consierto de que cada uno por lo qual le toca sin entremeterse con el dho don francisco Volucana . . . [un] yndio por seis meses conforme el turno que han tenido . . . para el servicio de la iglesia como para su cura y correxidor y los fiscales. [Caso de incumplimiento de este acuerdo, pagarán como] pena de doze pesos para la sera de señora Santa Ana" (ADC, Lorenzo Xaimez, leg. 309, 1687–1691, lib. 2, fol. 19).

20 Their service was not without problems. In 1796, for example, the Spanish colonial administrator of mail complained about his lack of direct control over individual carriers owing to the fact that he had to go through the Cañari *cacique de correos* in Cuzco, who he claimed protected irresponsible and dishonest carriers (ADC, Intendencia, Gobierno, leg. 143, 1796–1797). He proposed that he be allowed to jail the *cacique* until such time as he revealed the names and handed over the delinquent mail carriers.

21 It is ironic that in the mid-eighteenth century, the great-great-great-grandson of Paullu Inka, Don Ascencio Ramos Titu Atauchi, was *cacique* and *gobernador* of both the Chachapoya and the Yanacona *ayllus* in the parish of Santa Ana in Cuzco, a position probably acquired by marriage as it was not held by his father (Temple 1949, 56).

22 "[A]compañado el Marques Don Francisco Pisarro . . . y en todas las alteraciones causadas por Mango Ynga y en las revelaciones que hisieron los Españoles y en todas las batallas que se ocacionaron en aquel tiempo contra la real corona, cuyo servicio le hizo como leal basallo" (ADC, Corregimiento, Causas Ordinarias, leg. 49, exp. 1125, Instrumento e información dada de su nobleza por Don Manuel Alanya Guarillocha, 1768).

9. The Inka Triumphant

1 Zamora (1988, 3) writes: "[P]erhaps the most transcendental aspect of [Garcilaso's] work is that in opening up Western discourse to accommodate Amerindian elements, the *Comentarios reales* in effect inverted the process of conquest in its discursive dimension."

2 See Flores Galindo 1986a and 1986b for insightful and thorough studies of the history of Peruvian *indigenismo* and its differing goals in the first half of the twentieth century. He shows how the idea of the Inka (memory and imagination) served twentieth-century needs. Baudin's effort in 1928 to describe the Inka as a socialist state is a salient example (Flores Galindo 1986a, 16).

3 It should be noted — as has Flores Galindo (1986a, 321) — that this was an urban move led by elites. While things indigenous had considerable valence in the cities, from the perspective of the *campesinos* themselves there did not exist an "imagined community," to borrow a useful phrase from Benedict Anderson (1991), that was Peru. For the most part, rural Indians did not recognize themselves in national symbols such as the flag or national hymn. See also Flores Galindo 1986b.

4 "Las fiestas del CORPUS, encambio, tienen un carácter, puedo decirse, sensualista, de evidente y enorme influjo del alma indígena. Las fiestas de los RAIMIS del antiguo imperio se reproducen en ciertas formas veladas en las procesiones del Corpus, igualmente que aquel desborde de los sentidos que seguía a la celebración de dichas fiestas agrícolas e idolátricas, como una forma de culto a las bellezas de la naturaleza."

5 "[L]a fiesta del Corpus, que se celebra en el mes de junio, es la solemnidad popular de más arraigo, de más color y de más hondo sentido, porque no es sino el recuerdo del Intiraymi, la fiesta del sol, la mayor solemnidad del culto incaico en los dorados y felices siglos del Imperio."

6 For analyses of the contemporary Corpus Christi festival in Cuzco, see García 1938, Huayhuaca Villasante 1970 and 1988, Fiedler 1985, González Gamarra 1987, and Flores Ochoa 1990 and 1994.

7 Salízar (1996, 5) writes: "El dios Sol, inspiró a la maravillosa Civilización Inka y a su influjo el hombre andino cultivó la Pachamama, extrajo la riqueza del subsuelo y abrió los caminos para su desarrollo. Es por eso que el Inti Raymi, era la fiesta de la cosecha, de la abundancia. Quienes la recuperaron el 8 de enero de 1,944 para la cultura universal, lo hicieron como una evocación de un pasado de grandeza, proyectándola al futuro para restituirle a Cusco, su protagónica presencia en el contexto nacional y mundial.

"En estas fiestas jubilares, la Municipalidad de Cusco, saluda a los conciudadanos que habitan esta milenaria ciudad y recibe con alegría a todos nuestros visitantes que llegan a este Santuario, para recoger el mensaje de

honestidad, veracidad y laboriosidad para que cada vez seamos más soli-
darios en la difícil búsqueda de la paz."

8 See, for example, ADC, Gregorio Serrano Basquez, leg. 54, 1707, fol. 116r–
v, Fiansa de guaca; ADC, Matias Ximemez Ortega, leg. 291, 1723–1727, fol.
127r–v, Compañía para descubrir entierros del tiempo antiguo.

9 In 1996, a Cuzqueño engineer, Alfredo Inca Roca, was named Sapa Inka.

10 "En general, el clero colonial trató de no violentar la tradición del Inti
raymi y buscó una solemnidad católica que coincidiera con la época de la
fiesta solar. El 'Corpus Christi' era, pues, la mejor designación y, por esto,
esta celebración cobró mayor realce en el Cuzco que en cualquier otra ciu-
dad, y la tradición conserva el sentido de ambas fiestas yuxtapuestas, la
panteísta de los tahuantinsuyanos, y la católica de los conquistadores. Se
reemplazaron las momias o huacas de los emperadores con los santos de
las diferentes iglesias; los ayllus reales concerrieron bajo el disfraz de las
varias parroquias aledañas; el Inca fué substituído por el 'Alférez,' cargo
que recaía precisamente en un indio de noble sangre, y la nobleza imperial
fué representada por el abundante clero y el personal burocrático de las de-
pendencias virreinales."

11 "Cusco amado, son pocas las oportunidades en la vida que nos permiten ex-
presar públicamente amor y orgullo por nuestra tierra; ésta es una de ellas."

12 Castedo (1976, 36) writes: "Our first visit to Cuzco, in 1952, coincided with
the beginning of a costume party for tourists, organized by the authorities
and repeated far too frequently: a parody of the 'Inti-Raimi' in the ruins of
Sacsahuaman. Cuzco's Plaza de Armas was aglitter with the ornaments and
costumes of a crowd of Quechua Indians from the sierra and Aymaras from
the Collao. We intruders dressed as North Americans and Europeans were
few."

13 Because streams issuing from mountains, which are gendered male in the
Andes, are analogous to semen (Bergh 1993 and Dean n.d. a), the ice
gathered from the glaciers at the end of Qoyllur Rit'i may be seen as crys-
tallized semen. It is taken to the steps of the cathedral in Cuzco and dis-
tributed on the night prior to Corpus Christi. Significantly, the patron of
Cuzco's cathedral is the Virgin Mary and the Corpus Christi procession is
dominated by a series of female saints including several different advoca-
tions of the Virgin. Thus, the final act of the mountain festival of Qoyllur
Rit'i may well be the fertilization of the female saints of the Cuzco Valley
during Corpus Christi. The complementary relationship between Qoyllur
Rit'i and Corpus Christi was suggested to me by Jean-Jacques Decoster in a
lecture he delivered at the University of California, Santa Cruz, in 1996 and
in subsequent conversations.

14 For a history and development of the Inkarrí myth(s), see Millones 1973,
Curatola 1977, Wachtel 1977, Pease 1978, and Flores Galindo 1986a, 180.

Rosalind Gow (1982) has written on the symbolic import of the Inkarrí legend in the twentieth century.

15 Colonial depictions of Sapa Inkas wearing the "flower pot" headdress seem to have been derived from an early eighteenth-century engraving by the Limeño artist Alonso de la Cueva. His inspiration apparently came from the turbans of Muslim elites to whom Spaniards often compared the Inkas. Over time, the pseudo-turban was solidified and highly stylized. See Gisbert 1980, 128–135, for an analysis of Cueva and his influence.

16 When I first met them, nearly ten years ago, they did not self-identify as indígenas.

Bibliography

Archival Sources

AAL Archivo [Histórico] Arzobispal de Lima
ACC Archivo de la Venerable Curia del Cuzco (Archivo Arzobispal)
ADC Archivo Departamental del Cuzco
AGI Archivo General de Indias (Seville)

Published Sources

Abercrombie, Thomas. 1990. To Be Indian, to Be Bolivian: "Ethnic" and "National" Discourses of Identity. In Nation-States and Indians in Latin America, edited by G. Urban and J. Sherzer, 95–130. Austin: University of Texas Press.

Addis, William E., and Thomas Arnold. 1951. A Catholic Dictionary Containing Some Account of the Doctrine, Discipline, Rites, Ceremonies, Councils, and Religious Orders of the Catholic Church. 15th ed. Edited by T. B. Scannel and P. E. Hallett. London: Routledge & Kegan Paul.

Adorno, Rolena. 1979a. Of Caciques, Coyas, and Kings: The Intricacies of Point of View. Dispositio 4(10):27–47.

———. 1979b. Paradigms Lost: A Peruvian Indian Surveys Spanish Colonial Society. Studies in the Anthropology of Visual Communication 3(2):78–96.

———. 1981. On Pictorial Language and the Typology of Culture in a New World Chronicle. Semiotica 36:51–106.

———. 1982. The Language of History in Guaman Poma's Nueva corónica y buen gobierno. In From Oral to Written Expression: Native Andean Chronicles of the Early Colonial Period, edited by R. Adorno, 109–173. Syracuse: Syracuse University, Maxwell School of Citizenship and Public Affairs.

———. 1986. Guaman Poma: Writing and Resistance in Colonial Peru. Austin: University of Texas Press.

Alendra y Mira, Jenaro. [1865] 1903. *Relaciones de solemnidades y fiestas públicas de España*. 2 vols. Madrid: Sucesores de Rivadeneyra.

Allen, Catherine J. 1988. *The Hold Life Has: Coca and Cultural Identity in an Andean Community*. London and Washington: Smithsonian Institution Press.

Anderson, Benedict. 1991 [1983]. *Imagined Communities*. 2nd rev. ed. London and New York: Verso.

Angles Vargas, Víctor. 1990. *Sacsayhuamán: portento arquitectónico*. Lima: Industrialgráfica.

Anzaldúa, Gloria. 1987. *Borderlands/La Frontera: The New Mestiza*. San Francisco: Spinsters/Aunt Lute.

————. 1993. Chicana Artists: Exploring Nepantla, el Lugar de la Frontera. *NACLA Report on the Americas* 27(1):37–42.

Archivo Departamental del Cuzco. 1952. *Revista del Archivo* 3.

Arias, Ricardo. 1980. *The Spanish Sacramental Plays*. Twayne's World Authors Series, edited by J. W. Díaz and G. E. Wade. Boston: Twayne.

Arriaga, Pablo Joseph de. [1621] 1968. *The Extirpation of Idolatry in Peru*. Translated by L. Clark Keating. Lexington: University Press of Kentucky.

Arzáns de Orsúa y Vela, Bartolomé. [c. 1735] 1965. *Historia de la villa imperial de Potosí*. Edited by L. Hanke and G. Mendoza. 3 vols. Providence: Brown University Press.

Avendaño, Fernando de. [1617] 1904–1907. Relación sobre la idolatría. In *La imprenta en Lima (1584–1824)*, edited by J. T. Medina, 380–383. Santiago de Chile: Casa del Autor.

Avila, Francisco de. [1648] 1904–1907. Relación de los pueblos de indios de este arzobispado donde se ha descubierto la idolatría y hallado gran cantidad de ídolos, que los dichos indios adoraban y tenían por sus dioses. In *La imprenta en Lima (1584–1824)*, edited by J. T. Medina, 386–388. Santiago de Chile: Casa del Autor.

Azorin García, Francisco. 1984. *El Madrid devoto y romero*. Madrid: Avapiés.

Bakhtin, Mikhail Mikhailovich. [1965] 1968. *Rabelais and His World*. Translated by Helene Iawolsky. Cambridge: MIT Press.

Barnes, Monica. 1994. The Gilcrease Inca Portraits and the Historical Tradition of Guaman Poma de Ayala. In *Andean Oral Traditions: Discourse and Literature*, edited by M. Beyersdorff and S. Dedenbach-Salazar Sáenz, 223–256. Bonn: Holos.

Barthes, Roland. [1957] 1972. *Mythologies*. Translated by Annette Lavers. New York: Noonday Press.

Baudin, Louis. 1928. *L'empire socialiste des Inka*. Travaux et Memoires de l'Institut d'Ethnologie, Université de Paris, no. 5. Paris: Institut d'Ethnologie.

Bauer, Brian S. 1996. Legitimization of the State in Inca Myth and Ritual. *American Anthropologist* 98(2):327–337.

Bayle, Constantino. 1951. *El culto del Santísimo en Indias*. Biblioteca "Missiona-

lia Hispanica," ser. B, vol. 4. Madrid: Consejo Superior de Investigaciones Científicas, El Instituto Santo Toribio de Mogrovejo.

Benavente Velarde, Teófilo. 1995. *Pintores cusqueños de la colonia.* Qosqo [Cuzco]: Municipalidad del Qosqo.

Bergh, Susan E. 1993. Death and Renewal in Moche Phallic-Spouted Vessels. *Res* 24:78–94.

Bernales Ballesteros, Jorge. 1987. *Historia del arte hispanoamericano.* Vol. 2: *Siglos XVI a XVII.* Madrid: Editorial Alhambra.

Betanzos, Juan de. [1551] 1987. *Suma y narración de los Incas.* Edited by M. del Carmen Martín Rubio. Madrid: Atlas.

Bhabha, Homi K. 1984. Of Mimicry and Man: The Ambivalence of Colonial Discourse. *October* 28(spring):125–133.

———. 1988. The Commitment to Theory. *New Formations* 5:5–23.

———. 1994. *The Location of Culture.* London and New York: Routledge.

Borja y Aragón, Francisco de. 1921. Relación que el Príncipe de Esquilache hace al Señor Marqués de Guadalcázar sobre el estado en que deja las provincias del Perú. In *Colección de las memorias o relaciones que escribieron los virreyes del Perú acerca del estado en que dejaban las cosas generales del Reino,* edited by R. Beltrán y Rozpide, 216–295. Madrid: Imprenta de Asilo de Huérfanos del S. C. de Jesús.

Brathwaite, Edward Kamau. 1984. *History of the Voice: The Development of Nation Language in Anglophone Caribbean Poetry.* London and Port of Spain: New Beacon.

Bucher, Bernadette. 1981. *Icon and Conquest: A Structural Analysis of the Illustrations of De Bry's Great Voyages.* Translated by Basia Miller Gulati. Chicago: University of Chicago Press.

Buntinx, Gustavo, and Luis Eduardo Wuffarden. 1991. Incas y reyes españoles en la pintura colonial peruana: la estela de Garcilaso. *Márgenes* 4(8):151–210.

Burga, Manuel. 1988. *Nacimiento de una utopía: muerte y resurrección de los Incas.* Lima: Instituto de Apoyo Agrario.

———. 1992. El Corpus Christi y la nobleza inca colonial. Memoria e identidad. In *Los conquistados: 1492 y la población indígena de las Américas,* edited by H. Bonilla, 317–328. Bogotá: Facultad Latinoamericana de Ciencias Sociales (FLACSO, Sede Ecuador), Ediciones Libri Mundi, and Tercer Mundo Editores.

Burns, Kathryn. 1997. Nuns, Kurakas, and Credit: The Spiritual Economy of Seventeenth-Century Cuzco. *Colonial Latin American Review* 6(2):185–203.

Buschiazzo, Mario J. 1950. Indigenous Influences on the Colonial Architecture of Latin America. In *Art in Latin America,* 10–15. Washington, D.C.: Pan American Union.

Bustos Losada, Carlota. 1951–1953. Las hijas de Huainacapac: expediente de

méritos y servicios de Vicente de Tamayo, Diego de Sandoval y Gil Rengifo. *Museo Histórico* (Quito) 3(9):19–36, 3(10–11):37–53, 4(12–13):19–31, 4(14–15):42–56, 5(16):50–66, 5(17):16–28.

Cahill, David. 1986. Etnología e historia. Los danzantes rituales del Cusco a fines de la colonía. *Boletin del Archivo Departamental del Cuzco* 2:48–54.

Calancha, Antonio de la. [1638] 1974–1981. *Crónica moralizada.* Edited by I. Prado Pastor. 6 vols. Lima: Universidad Nacional Mayor de San Marcos.

Camacho Delgado, Blanca Dora. 1953. "El Día del Cuzco i la fiesta del 'Inti Raymi.'" Monografías hechas por los alumnos del curso de geografía humana general y del Perú sobre temas de carácter social, 15(24). Catedrático: Dr. Jorge Cornejo Bouroncle, Geografía humana, Universidad de San Antonio Abad, Cuzco.

Carreres Zacarés, Salvador. 1925. *Ensayo de una bibliografía de libros de fiestas celebradas en Valencia y su antiguo reino.* Valencia: Imprenta Hijo de F. Vives Mora.

Carvajal y Robles, Rodrigo de. [1632] 1950. *Fiestas de Lima por el nacimiento del Príncipe Don Baltasar Carlos (Lima, 1632).* Edited by F. López Estrada. Publicaciones de la Escuela de Estudios Hispano-Americanos de Sevilla, ser. 7, reediciones no. 5. Seville: Escuela de Estudios Hispano-Americanos.

Castedo, Leopoldo. 1976. *The Cuzco Circle.* New York: Center for Inter-American Relations and American Federation of Arts.

Castelnau, Francis, comte de. 1850–1859. *Expedition dans les parties centrales de l'Amerique du Sud, de Rio de Janeiro a Lima, et de Lima au Para.* Paris: P. Bertrand.

Chakrabarty, Dipesh. 1992. Postcoloniality and the Artifice of History: Who Speaks for "Indian" Pasts? *Representations* 32(winter):1–26.

Choy, Emilio. 1979. De Santiago Matamoros a Santiago Mata-indios. In *Antropología e historia,* edited by E. Choy, 333–437. Lima: UNMSM.

Christian, William A., Jr. 1981. *Apparitions in Late Medieval and Renaissance Spain.* Princeton: Princeton University Press.

Cieza de León, Pedro de. [1553] 1959. *The Incas.* Edited by V. W. Von Hagen. Norman: University of Oklahoma Press.

Classen, Constance. 1993. *Inca Cosmology and the Human Body.* Salt Lake City: University of Utah Press.

Cobo, Bernabé. [1653] 1979. *History of the Inca Empire: An Account of the Indians' Customs and Their Origins Together with a Treatise on Inca Legends, History, and Social Institutions.* Translated and edited by Roland Hamilton. Austin: University of Texas Press.

———. [1653] 1990. *Inca Religion and Customs.* Translated and edited by Roland Hamilton. Austin: University of Texas Press.

Contreras y Valverde, Vasco de. [1649] 1982. *Relación de la ciudad del Cusco, 1649.* Edited by M. del Carmen Martín Rubio. Cuzco: Imprenta Amauta.

Cornejo Bouroncle, Jorge. 1946. *Por el Perú incaico y colonial.* Buenos Aires: Sociedad Geográfica Americana, Editorial y Cultural.

———. 1952. Arte cuzqueño. *Revista del Archivo Departamental del Cuzco* 3:66–140.

————. 1960. *Derroteros de arte cuzqueño: datos para una historia del arte en el Perú.* Cusco: Ediciones Inca.

Cossío del Pomar, Felipe. 1928. *Pintura colonial (Escuela cuzqueña).* 2nd rev. ed. Cuzco: H. G. Rozas.

Cummins, Thomas Bitting Foster. 1988. Abstraction to Narration: Kero Imagery of Peru and the Colonial Alteration of Native Identity. Ph.D. diss., Art History, University of California, Los Angeles.

————. 1991. We Are the Other: Peruvian Portraits of Colonial Kurakakuna. In *Transatlantic Encounters: Europeans and Andeans in the Sixteenth Century,* edited by K. J. Andrien and R. Adorno, 203–270. Berkeley: University of California Press.

————. 1995. The Madonna and the Horse: Becoming Colonial in New Spain and Peru. In *Native Artists and Patrons in Colonial Latin America,* edited by E. Umberger and T. Cummins. *Phoebus* 7:52–83. Tempe: Arizona State University.

————. 1996. A Tale of Two Cities: Cuzco, Lima, and the Construction of Colonial Representation. In *Converging Cultures: Art and Identity in Spanish America,* edited by D. Fane, 157–170. New York: Brooklyn Museum and Harry N. Abrams.

Cúneo-Vidal, Rómulo. 1925. *Historia de las guerras de los últimos Incas peruanos contra el poder español (1535–1572).* Barcelona: Casa Editorial Maucci.

Curatola, Marco. 1977. Mito y milenarismo en los Andes. Del Taki Onqoy a Inkarri: la visión de un pueblo invicto. *Allpanchis* 10:65–93.

Cusco Cabildo. 1982. *El libro del cabildo de la ciudad del Cusco.* Edited by L. González Pujana. Lima: Instituto Riva-Agüero.

Damian, Carol. 1995. *The Virgin of the Andes: Art and Ritual in Colonial Cuzco.* Miami Beach: Grassfield Press.

Dean, Carolyn Sue. 1990. Painted Images of Cuzco's Corpus Christi: Social Conflict and Cultural Strategy in Viceregal Peru. Ph.D. diss., Art History, University of California, Los Angeles.

————. 1993. Ethnic Conflict and Corpus Christi in Colonial Cuzco. *Colonial Latin American Review* 2(1–2):93–120.

————. 1995. Who's Naughty and Nice: Childish Behavior in the Paintings of Cuzco's Corpus Christi Procession. In *Native Artists and Patrons in Colonial Latin America,* edited by E. Umberger and T. Cummins. *Phoebus* 7:107–126. Tempe: Arizona State University.

————. 1996a. Copied Carts: Spanish Prints and Colonial Peruvian Paintings. *Art Bulletin* 78(1):98–110.

————. 1996b. The Renewal of Old World Images and the Creation of Colonial Peruvian Visual Culture. In *Converging Cultures: Art and Identity in Spanish America,* edited by D. Fane, 171–182. New York: Brooklyn Museum and Harry N. Abrams.

————. 1997. Another Other: Chuncho Dances in Colonial Peru. Paper pre-

sented at Converging Cultures symposium, Phoenix Art Museum, Phoenix, January 25.

—. 1998. Creating a Ruin in Colonial Cusco: Sacsahuamán and What Was Made of It. *Andean Past* 5:159–181.

—. n.d. a. Andean Androgyny and the Making of Men. In *Envisioning Gender in Pre-Columbian America, Proceedings of the 1997 Dumbarton Oaks Pre-Columbian Symposium*, edited by C. F. Klein. Washington, D.C.: Dumbarton Oaks. Forthcoming.

—. n.d. b. Martial Art: Festive Fighting in Colonial Peru. In *Proceedings of the Spanish Colonial Symposium, Denver Art Museum, Oct. 20–24, 1993*, edited by T. Cummins. Forthcoming.

—. n.d. c. Inka Queens and Gender Paradigms in the Work of Waman Puma. Typescript.

Derrida, Jacques. 1967. *L'écriture et la différence*. Paris: Editions du Seuil.

Domenici, Viviano, and Davide Domenici. 1996. Talking Knots of the Inka: A Curious Manuscript May Hold the Key to Andean Writing. *Archaeology* 49(6):50–56.

During, Simon. 1987. Postmodernism or Post-colonialism Today. *Textual Practice* 1(1):32–47.

Duviols, Pierre. 1976. "Punchao," idolo mayor del Coricancha. Historia y tipología. *Antropología Andina* 1–2:156–183.

—. 1977. *La destrucción de las religiones andinas (conquista y la colonia)*. Translated by Albor Maruenda. Mexico City: Universidad Nacional Autónoma de México.

—. 1978. Un symbolisme andin du double: la lithomorphose de l'ancêtre. *Actes du XLIIe Congrès International des Américanistes, Congrès du Centenaire, Paris, 2–9 septembre 1976*, 4:359–364.

—. 1979. La dinastía de los incas: monarquía o diarquía? Argumentos heurísticos a favor de un tésis estructuralista. *Journal de la Société des Américanistes* 66:67–83.

—. 1986. *Cultura andina y represión. Procesos y visitas de idolatrías y hechicerías, Cajatambo, siglo XVII*. Cuzco: Centro de Estudios Rurales Andinos "Bartolomé de Las Casas."

Epton, Nina. 1968. *Spanish Fiestas (Including Romerías, Excluding Bullfights)*. London: Cassell.

Errington, Shelly. 1990. Recasting Sex, Gender, and Power: A Theoretical and Regional Overview. In *Power and Difference: Gender in Island Southeast Asia*, edited by J. M. Atkinson and S. Errington, 1–58. Stanford: Stanford University Press.

Espinosa, Carlos. 1995. Colonial Visions: Drama, Art, and Legitimation in Peru and Ecuador. In *Native Artists and Patrons in Colonial Latin America*, edited by E. Umberger and T. Cummins. *Phoebus* 7:84–103. Tempe: Arizona State University.

Espinoza Soriano, Waldemar. 1966. Los señoríos étnicos de Chachapoyas y la alianza hispano-chacha: visitas, informaciones y memoriales inéditos de 1572–1574. *Revista Histórica* 30:224–332.

Esquivel y Navia, Diego de. [c. 1749] 1980. *Noticias cronológicas de la gran ciudad del Cuzco.* Edited by F. Denegri Luna, H. Villanueva Urteaga, and C. Gutiérrez Muñoz. 2 vols. Lima: Fundación Augusto N. Wiese, Banco Wiese.

Falassi, Alessandro, ed. 1987. *Time Out of Time.* Albuquerque: University of New Mexico Press.

Fiedler, Carol Ann. 1985. Corpus Christi in Cuzco: Festival and Ethnic Identity in the Peruvian Andes. Ph.D. diss., Tulane University, New Orleans.

Flores Galindo, Alberto. 1986a. *Buscando un Inca: identidad y utopía en los Andes.* Havana: Casa de las Américas.

———. 1986b. *Europa y el país de los Incas: la utopía andina.* Lima: Instituto de Apoyo Agrario.

Flores Ochoa, Jorge. 1990. *El Cuzco. Resistencia y continuidad.* Qosqo [Cuzco]: Centro de Estudios Andinos Cuzco.

———. 1994. Historia, fiesta y encuentro en el Corpus Christi cuzqueño. In *La fiesta en el arte,* 39–59. Lima: Fondo Pro Recuperación del Patrimonio Cultural de la Nación, Banco de Crédito del Perú.

Foster, Hal. 1985. *Recodings: Art, Spectacle, Cultural Politics.* Port Townsend, Wash.: Bay Press.

Foucault, Michel. 1980. *Power/Knowledge. Selected Interviews and Other Writings, 1972–1977.* Edited and translated by C. Gordon. New York: Pantheon.

———. [1978] 1990. *The History of Sexuality.* Translated by R. Hurley. New York: Vintage.

Fraser, Valerie. 1986. Architecture and Imperialism in Sixteenth-Century Spanish America. *Art History* 9(3):325–335.

———. 1990. *The Architecture of Conquest: Building in the Viceroyalty of Peru.* Cambridge: Cambridge University Press.

García Canclini, Néstor. 1983. Las políticas culturales en América Latina. *Materiales para la Comunicación Popular* 1:3–19.

García, José Uriel. 1922. *La ciudad de los Incas.* Cuzco: H. G. Rozas.

———. 1925. *Guía histórico-artística del Cuzco.* Lima: Editorial Garcilaso.

———. 1937. Notas sobre la pintura colonial del Cuzco. *La Prensa,* March 20, sec. 3.

———. 1938. La procesión del Corpus. In *Antología del Cuzco,* edited by R. Porras Barrenechea, 438–441. Lima: Librería Internacional del Perú.

Garcilaso de la Vega, "El Inca" [Gómez Suárez de Figueroa]. [1609, 1617] 1966. *Royal Commentaries of the Incas and General History of Peru.* Translated by Harold V. Livermore. 2 vols. Austin and London: University of Texas Press.

Garrido Atienza, Miguel. 1889. *Las fiestas del Corpus.* Granada: Imprenta de D. José López Guevara.

Gasca, Pedro de la. [1548] 1921–1926. Carta del licenciado Gasca al Consejo

de S.M. acerca de castigos, tasción de tributos y otras medidas (Los Reyes, 25 de septiembre de 1548). In *Gobernantes del Perú*, edited by R. Levillier, 14 vols., 1:114–116. Madrid: Sucesores de Rivadeneyra.

Gascón de Gotor, Anselmo. 1916. *El Corpus Christi y las custodias procesionales de España*. Barcelona: Tipografía la Académica de Serra.

Gibbs, Donald L. 1979. Cusco, 1680–1710: An Andean City Seen through Its Economic Activities. Ph.D. diss., University of Texas, Austin.

Gisbert, Teresa. 1979. Los Incas en la pintura virreinal del siglo XVIII. *América Indígena* 39(4):749–772.

———. 1980. *Iconografía y mitos indígenas en el arte*. La Paz: Talleres Escuela de Artes Gráficas de Colegio "Don Bosco."

———. 1983. La fiesta y la alegoría en el virreinato peruano. In *El arte efímero en el mundo hispánico*, 145–181. Mexico City: Universidad Nacional Autónoma de México.

———. 1986. Andean Painting. In *Gloria in Excelsis: The Virgin and Angels in Viceregal Paintings of Peru and Bolivia*, 22–31. New York: Center for Inter-American Relations.

Gisbert, Teresa, and José de Mesa. 1962. *Historia de la pintura cuzqueña*. Anales del Instituto de Arte Americano e Investigaciones Estéticas 15. Buenos Aires: University of Buenos Aires.

———. 1971. Lo indígena en el arte hispanoamericano. *Boletín del Centro de Investigaciones Históricas y Estéticas* (Caracas) 12:32–38.

———. 1972. *Escultura virreinal en Bolivia*. La Paz: Academia Nacional de Ciencias de Bolivia.

———. [1962] 1982. *Historia de la pintura cuzqueña*. 2nd rev. ed. Lima: Fundación A. N. Wiese, Banco Wiese.

———. 1983. *Los ángeles de Calamarca*. La Paz: Compañía Boliviana de Seguros.

———. 1985. *Arquitectura andina: 1530–1830, historia y análisis*. Colección Arzáns y Vela. La Paz: Embajada de España en Bolivia.

González de Holguín, Diego. [1608] 1901. *Arte y diccionario Qquechua-Español corregido y aumentado por los RR. PP. Redentoristas al que en 1608 publicó el rvdo. p. Diego González de Holguín, S.J. en esta ciudad de los Reyes*. Lima: Imprenta del Estado.

González Galván, Manuel. 1983. Comentario [on "La fiesta y la alegoría en el virreinato peruano" by Teresa Gisbert]. In *El arte efímero en el mundo hispánico*, 181–186. Mexico City: Universidad Autónoma Nacional de México.

González Gamarra, Francisco. 1987. *Cuzco Corpus Christi. Acuarelas inéditas*. Lima: Okura.

Gow, David. 1976. Taytacha Qoyllur Rit'i. *Allpanchis* 7:49–100.

———. 1980. The Roles of Christ and Inkarrí in Andean Religion. *Journal of Latin American Lore* 6(2):279–296.

Gow, Rosalind C. 1982. Inkarri and Revolutionary Leadership in the Southern Andes. *Journal of Latin American Lore* 8(2):197–223.

Gow, Rosalind, and Bernabé Condori. 1976. *Kay Pacha*. Biblioteca de la Tradi-

ción Oral Andina, no. 1. Cuzco: Centro de Estudios Rurales Andinos "Bartolomé de Las Casas."

Gramsci, Antonio. 1973. *Selections from the Prison Notebooks of Antonio Gramsci*. Edited by Q. Hoare and G. N. Smith. New York: International Publishers.

Greenblatt, Stephen. 1991. *Marvelous Possessions: The Wonder of the New World*. Chicago: University of Chicago Press.

Griffiths, Gareth. 1994. The Myth of Authenticity. In *De-Scribing Empire: Postcolonialism and Textuality*, edited by C. Tiffin and A. Lawson, 70–85. London: Routledge.

Gruzinski, Serge. [1988] 1993. *The Conquest of Mexico: The Incorporation of Indian Societies into the Western World, 16th–18th Centuries*. Cambridge: Polity Press.

Guaman Poma de Ayala, Felipe. [1615] [1980] 1988. *El primer nueva corónica y buen gobierno*. Edited by J. V. Murra and R. Adorno. Quechua translated by J. L. Urioste. 2nd ed., 3 vols. Mexico City: Siglo Veintiuno.

Guarda, Gabriel. 1987. *Los laicos en la cristianización de América*. Santiago: Ediciones Universidad Católica de Chile.

Guibovich Pérez, Pedro. 1994. "Mal obispo o mártir," El obispo Mollinedo y el cabildo eclesiástico del Cuzco, 1673–1699. In *La venida del reino: religión, evangelización y cultura en América, siglos XVI–XX*, edited by G. Ramos, 151–198. Cuzco: Centro de Estudios Regionales Andinos "Bartolomé de Las Casas."

Guido, Angel. 1941. *Redescubrimiento de América en el arte. Edición especial*. Rosario: Universidad del Litoral.

Guijo, Gregorio Martín de. 1952. *Diario, 1648–1664*. Edited by M. Romero Terreros. 2 vols. Mexico City: Editorial Porrúa.

Harris, Olivia. 1978. Complementarity and Conflict: An Andean View of Women and Men. In *Sex and Age as Principles of Social Differentiation*, edited by J. S. La Fontaine, 21–40. London, New York, and San Francisco: Academic Press.

Harth-terré, Emilio. 1949. Las tres fundaciones del catedral de Cuzco. *Anales de Instituto de Arte Americano e Investigaciones Estéticas* (Buenos Aires) 2:29–69.

Hemming, John. [1970] 1983. *The Conquest of the Inca*. Rev. ed. London: Penguin.

Herbermann, Charles G., et al. 1908. *The Catholic Encyclopedia*. 15 vols. New York: Robert Appleton.

Hermoza Muñiz, Ronal. 1996. Presentación. In *Inti Raymi 1996: Programa general*, 3. Cuzco: Empresa Municipal de Festejos, Actividades Recreacionales y Turísticas del Cusco, Imprenta Amauta.

Herzberg, Julia P. 1986. Angels with Guns: Image and Interpretation. In *Gloria in Excelsis: The Virgin and Angels in Viceregal Paintings of Peru and Bolivia*, 64–77. New York: Center for Inter-American Relations.

Hobsbawm, Eric, and Terence Ranger, eds. 1992. *The Invention of Tradition*. Cambridge and New York: Cambridge University Press.

Hoyos Sancho, Nieves de. 1963. *Las fiestas del Corpus Christi*. Madrid: Publicaciones Españolas.

Huayhuaca Villasante, Luis A. 1970. La festividad del Corpus Christi en el Cusco. Ph.D. diss., Universidad Nacional San Antonio Abad del Cuzco.

———. 1988. *La festividad del Corpus Christi en el Cusco.* Cuzco: Self-published.

Hutcheon, Linda. 1989. Circling the Downspout of Empire: Post-colonialism and Postmodernism. *Ariel* 20(4):149–175.

Iriarte, Isabel. 1993. Las túnicas incas en la pintura colonial. In *Mito y simbolismo en los Andes: la figura y la palabra*, edited by H. Urbano, 53–86. Cuzco: Centro de Estudios Regionales Andinos "Bartolomé de Las Casas."

Isbell, Billie Jean. 1976. La otra mitad esencial: un estudio de complementariedad sexual en los Andes. *Estudios Andinos* 5(1):37–56.

———. 1978. *To Defend Ourselves: Ecology and Ritual in an Andean Village.* Latin American Monographs, vol. 47. Austin: Institute of Latin American Studies, University of Texas.

Ivanova, Anna. 1970. *The Dance in Spain.* New York: Praeger.

JanMohamed, Abdul R. 1984. Humanism and Minority Literature: Toward a Definition of Counter-Hegemonic Discourse. *Boundary 2* 12(3)/13(1):281–299.

Kachru, Braj B. 1986. *The Alchemy of English: The Spread, Functions, and Models of Non-Native Englishes.* Oxford: Pergamon Institute.

Klaiber, Jeffrey L. 1976. The Posthumous Christianization of the Inca Empire in Colonial Peru. *Journal of the History of Ideas* 37(3):507–520.

Klor de Alva, J. Jorge. 1982. Spiritual Conflict and Accommodation in New Spain: Toward a Typology of Aztec Responses to Christianity. In *The Inca and Aztec States, 1400–1800: Anthropology and History*, edited by G. A. Collier, R. Rosaldo, and J. Wirth, 345–366. New York: Academic Press.

Kubler, George, and Martin Soria. 1959. *Art and Architecture in Spain and Portugal and Their American Dominions, 1500–1800.* Pelican History of Art. Baltimore and Harmondsworth: Penguin.

Lee, Vincent R. 1986. The Building of Sacsahuaman. *Ñawpa Pacha* 24:49–60.

Le Goff, Jacques. 1986. *Histoire et imaginaire.* Paris: Poiesis, Diffusion Payot.

León-Portilla, Miguel. 1974. Testimonios nahuas sobre la conquista espiritual. *Estudios de Cultura Nahuatl* 11:11–36.

Lizárraga, Reginaldo de. [1591–1612] 1908. *Descripción y población de las Indias.* Edited by C. A. Romero. Lima: Imprenta Americana.

Lleó Cañal, Vicente. 1980. *Fiesta grande: el Corpus Christi en la historia de Sevilla.* Seville: Biblioteca de Temas Sevillanos.

Loayza, Francisco A. 1946. *Genealogía de Tupac Amaru, por José Gabriel Tupac Amaru.* Los Pequeños Grandes Libros de Historia Americana, ser. 1, vol. 10. Lima: Editorial Domingo Miranda.

Lockhart, James. 1985. Some Nahua Concepts in Postconquest Guise. *History of European Ideas* 6(4):465–482.

Lohmann Villena, Guillermo. 1945. *El arte dramático en Lima, publicaciones de la*

Escuela de Estudios Hispanoamericanos de la Universidad de Sevilla no. 12. Madrid: Estades.

———. 1947. *Los americanos en las órdenes nobiliarios (1529–1900)*. 2 vols. Madrid: Consejo Superior de Investigaciones Científicas, Instituto "Gonzalo Fernández de Oviedo."

———. 1949. El señorío de los Marqueses de Santiago de Oropesa en el Perú. *Anuario de Historia del Derecho Español* 19(1948–1949):347–458.

———. 1950. Las comedias de Corpus Christi en Lima en 1635 y 1636. *Mar del Sur* 11(May–June):21–23.

———. 1994. El Corpus Christi, fiesta máxima del culto católico. In *La Fiesta en el arte*, 13–37. Lima: Fondo Pro Recuperación del Patrimonio Cultural de la Nación, Banco de Crédito del Perú.

Lopes Don, Patricia. 1997. Carnivals, Triumphs, and Rain Gods in the New World: A Civic Festival in the City of México-Tenochtitlán in 1539. *Colonial Latin American Review* 6(1):17–40.

López-Baralt, Mercedes. 1979. La persistencia de las estructuras simbólicas andinas en los dibujos de Guaman Poma de Ayala. *Journal of Latin American Lore* 5(1):83–116.

MacCormack, Sabine. 1985. The Fall of the Incas: A Historiographical Dilemma. *History of European Ideas* 6(4):421–445.

———. 1991. *Religion in the Andes: Vision and Imagination in Early Colonial Peru*. Princeton: Princeton University Press.

Majluf, Natalia. 1993. Review of *Transatlantic Encounters: Europeans and Andeans in the Sixteenth Century*. In *Revista Andina* 11(1):241–243.

Mannheim, Bruce. 1991. *The Language of the Inka since the European Invasion*. Texas Linguistics Series, edited by W. P. Lehmann. Austin: University of Texas Press.

Mariana, Juan de. [1609] 1950. Tratado contra los juegos públicos. In *Obras del padre Juan de Mariana*, edited by D. F. P. y M. Madrid: Real Academia Española.

Mariátegui Oliva, Ricardo. 1951. *Pintura cuzqueña del siglo XVII. Los maravillosos lienzos del Corpus existentes en la iglesia de Santa Ana del Cuzco*. Lima: Alma Mater.

———. 1954. *Pintura cuzqueña del siglo XVII en Chile. Los valiosos lienzos del Corpus cuzqueño de propiedad de D. Carlos Peña Otaegui en Santiago*. Lima: Alma Mater.

———. 1983. *Nuevo lienzo auténtico del Corpus cuzqueño. Un falso lienzo; mas consideraciones acerca de los maravillosos cuadros del siglo XVII*. Lima: Self-published.

Martínez Cereceda, José L. 1995. *Autoridades en los Andes, los atributos del Señor*. Lima: Fondo Editorial de la Pontificia Universidad Católica del Perú.

Mason, Peter. 1990. *Deconstructing America: Representations of the Other*. London and New York: Routledge.

Más y Prat, Benito. 1885. Los carros del Corpus. *La Ilustración Española y Americana* (Madrid) 29(20):332.

Mateos, F., ed. [1600] 1944. *Historia general de la Compañía de Jesús en la provincia del Perú (crónica anónima de 1600 que trata del establecimiento y misiones de la Compañía de Jesús en los paises de habla española en la América meridional.* 2 vols. Madrid: Consejo Superior de Investigaciones Científicas, Instituto "Gonzalo Fernández de Oviedo."

Mendizábal Losack, Emilio. 1963. Las dos versiones de Murúa. *Revista del Museo Nacional* (Lima) 32:153–185.

Mignolo, Walter D. 1989a. Afterword: From Colonial Discourse to Colonial Semiosis. *Dispositio* 14:333–338.

———. 1989b. Colonial Situations, Geographical Discourses and Territorial Representations: Towards a Diatopical Understanding of Colonial Semiosis. *Dispositio* 14:93–140.

———. 1995. *The Darker Side of the Renaissance: Literacy, Territoriality, and Colonization.* Ann Arbor: University of Michigan Press.

Millones, Luis. 1973. Un movimiento nativista del siglo XVI: El Taki Onquoy. In *Ideología mesiánica del mundo andino*, edited by J. M. Ossio, 83–103. Lima: Ignacio Prado Pastor.

———. 1995. The Inka's Mask: Dramatisation of the Past in Indigenous Colonial Processions. In *Andean Art: Visual Expression and Its Relation to Andean Beliefs and Values*, edited by P. Dransart, 11–32. Worldwide Archaeology Series 13. Aldershot, Brookfield, Hong Kong, Singapore, Sydney: Avebury.

Mills, Kenneth. 1997. *Idolatry and Its Enemies: Colonial Andean Religion and Extirpation, 1640–1750.* Princeton: Princeton University Press.

Mogrovejo de la Cerda, Juan. [1660] 1983. *Memorias de la gran ciudad del Cusco, 1690.* Edited by M. del Carmen Martín Rubio and H. Villanueva Urteaga. Cuzco: Imprenta Amauta.

Molina (El Almagrista), Cristóbal de [Bartolomé de Segovia]. [1553] 1943. Destrucción del Perú. In *Las crónicas de los Molinas*, edited by F. A. Loayza, with bio-bibliography by C. A. Romero and commentary by R. Porras Barrenechea. Lima: Domingo Miranda.

Molina (El Cuzqueño), Cristóbal de. [1574] 1943. Fábulas y ritos de los Incas. In *Las crónicas de los Molinas*, edited by Francisco A. Loayza, with bio-bibliography by C. A. Romero and commentary by R. Porras Barrenechea. Lima: Domingo Miranda.

Molinié Fioravanti, Antoinette, ed. 1996. *Le Corps de Dieu en fêtes.* Paris: Editions du Cerf.

Montoto de Sedas, Santiago. 1927. *Nobiliario hispano-americano del siglo XVI.* Colección de Documentos Inéditos para la Historia de Ibero-América, vol. 3. Madrid: Compañía Ibero-Americana de Publicaciones.

———. 1928. *Nobiliario de reinos, ciudades y villas de la América española.* Colección de Documentos Inéditos para la Historia de Hispano-América, vol. 3. Madrid: Compañía Ibero-Americana de Publicaciones.

Morote Best, Efraín. 1957–1958. El oso raptor. *Archivos Venezolanos de Folklore* 5:135–179.

Mugaburu, Josephe de, and Francisco de Mugaburu. [1640–1697] 1975. *Chronicle of Colonial Lima: The Diary of Josephe and Francisco Mugaburu, 1640–1697*. Translated and edited by R. R. Miller. Norman: University of Oklahoma Press.

Murra, John V. 1946. The Historic Tribes of Ecuador. In *Handbook of South American Indians*, edited by J. H. Steward, 7 vols., 2:785–822. Washington, D.C.: GPO.

———. 1992. Guaman Poma's Sources. In *Guaman Poma de Ayala: The Colonial Art of an Andean Author*, 60–66. New York: Americas Society.

Murúa, Martín de. [1600–1611] 1986. *Historia general del Perú*. Edited by M. Ballesteros Gaibrois. Crónicas de América no. 35. Madrid: Historia 16.

———. [1611] 1985. *Los retratos de los Incas en la crónica de Fray Martín de Murúa*. Edited by J. M. Ossio A. Lima: Oficina de Asuntos Culturales de la Corporación Financiera de Desarrollo.

Navarro Castro, Gustavo. 1991. Latin American Iconography of Saint James. In *America, Bride of the Sun: 500 Years, Latin America and the Low Countries*, edited by P. Vandenbroeck, 189–196. Antwerp: Royal Museum of Fine Arts.

New, W. H. 1978. New Language, New World. In *Awakened Conscience: Studies in Commonwealth Literature*, edited by C. D. Narasimhaiah, 361–377. New Delhi: Sterling; London: Heinemann.

Niles, Susan A. 1992. Artist and Empire in Inca and Colonial Textiles. In *To Weave for the Sun: Ancient Andean Textiles in the Museum of Fine Arts, Boston*, edited by R. Stone-Miller, 50–65. New York: Thames & Hudson; Boston: Museum of Fine Arts.

Ocampo, Baltasar de. 1955. Descripción de la provincia de Vilcabamba y prisión y muerte del D. Felipe Tupac Amaru [excerpt from "Descripción y sucesos históricos de la provincia de Vilcabamba"]. Edited by J. Cornejo Bouroncle. *Revista del Archivo Histórico del Cusco* 6:6–26.

Ossio A., Juan M. 1982. Una nueva versión de la crónica de Fray Martín de Murúa. *Revista de Museo Nacional* (Lima) 46:567–575.

———. 1985. Introducción. In *Los retratos de los Incas en la crónica de Fray Martín de Murúa*, iii–ix. Lima: Oficina de Asuntos Culturales de la Corporación Financiera de Desarrollo.

Pachacuti Yamqui Salcamaygua, Joan de Santa Cruz. [1613] 1950. Relación de antigüedades deste Reyno del Pirú. In *Tres relaciones de antigüedades peruanas*, edited by M. Jiménez de la Espada, 207–281. Asunción: Editorial Guarania.

———. [1613] 1993. *Relación de antigüedades deste Reyno del Pirú*. Edited by P. Duviols and C. Itier. Travaux de l'Institut Français d'Etudes Andines, vol. 74. Cuzco: Institut Français d'Etudes Andines and Centro de Estudios Regionales Andinos "Bartolomé de Las Casas."

Pardo, Luís A. 1953. Los vestidos del inca y de la ccoya. *Revista del Museo e Instituto Arqueológico* (Cuzco) 9(15):3–55.

Pease, Franklin. 1978. *Del Tawantinsuyo a la historia del Perú*. Lima: Instituto de Estudios Peruanos.

Pedraza, Pilar. 1982. *Barroco efímero en Valencia*. Publicaciones del Archivo Municipal de Valencia, 3rd ser., vol. 15. Valencia: Ayuntamiento de Valencia.

Pérez Sánchez, Alonso E. 1981a. José Caudí, arquitecto y decorador. In *Calderón: Actas del congreso internacional sobre Calderón y el teatro español del Siglo de Oro* (Madrid, 8–13 de junio de 1981), edited by L. García Lorenzo, 3 vols. 3:1651–1672. Madrid: Consejo Superior de Investigaciones Científicas.

———. 1981b. José Caudí, un olvidado artista decorador de Calderón. *Goya* 161–162:266–273.

Peterson, Jeanette Favrot. 1995. Synthesis and Survival: The Native Presence in Sixteenth-Century Murals of New Spain. In *Native Artists and Patrons in Colonial Latin America*, edited by E. Umberger and T. Cummins. *Phoebus* 7:14–35. Tempe: Arizona State University.

Pizarro, Pedro. [1571] [1978] 1986. *Relación del descubrimiento y conquista de los reinos del Perú*. 2nd ed., edited by G. Lohmann Villena. Lima: Pontificia Universidad Católica del Perú.

Platt, Tristan. 1986. Mirrors and Maize: The Concept of *Yanantin* among the Macha of Bolivia. In *Anthropological History of Andean Polities*, edited by J. V. Murra, N. Wachtel, and J. Revel, 228–259. Cambridge: Cambridge University Press.

Polo de Ondegardo, Juan. [1571] 1916a. De los errores y supersticiones de los indios, sacadas del tratado y averiguación que hizo el Licenciado Polo. In *Informaciones acerca de la religión y gobierno de los Incas*, edited by H. H. Urteaga. Colección de Libros y Documentos Referentes a la Historia del Perú 3:3–43. Lima: Imprenta y Librería Sanmartí.

———. [1571] 1916b. Relación de los fundamentos acerca del notable daño que resulta de no guardar a los indios sus fueros. In *Informaciones acerca de la religión y gobierno de los Incas*, edited by H. H. Urteaga. Colección de Libros y Documentos Referentes a la Historia del Perú 3:45–188. Lima: Imprenta y Librería Sanmartí.

Poole, Stafford. 1995. *Our Lady of Guadalupe: The Origins and Sources of a Mexican National Symbol, 1531–1797*. Tucson: University of Arizona Press.

Porras Barrenechea, Raúl. 1948. Dos documentos esenciales sobre Francisco Pizarro y la conquista del Perú. *Revista Histórica* (Lima) 17:9–95.

Protzen, Jean-Pierre. 1985. Inca Quarrying and Stonecutting. *Ñawpa Pacha* 21 (1983):183–214.

———. 1986. Inca Stonemasonry. *Scientific American* 254(2):94–105.

Pumacahua Inca, Mateo. 1956. Papeles de Pumacahua en el Archivo de Indias. *Revista del Archivo Departamental del Cuzco* 7(7):249–447.

Quintana, Jerónimo de. [1629] 1961. *A la mvy antigua, noble y coronada villa de Madrid, Historia de sv antigvedad, nobleza y grandeza*. Microfilm copy from

the original manuscript in the Biblioteca Vaticana. Madrid: Imprenta del Reyno.

Rabasa, José. 1993. *Inventing* A-M-E-R-I-C-A: *Spanish Historiography and the Formation of Eurocentrism*. Norman and London: University of Oklahoma Press.

Rafael, Vicente L. [1988] 1993. *Contracting Colonialism: Translation and Christian Conversion in Tagalog Society under Early Spanish Rule*. Durham: Duke University Press.

Ramírez, Andrés. 1969. La novena al Señor de Qoyllur Rit'i. *Allpanchis* 1:61–88.

Randall, Robert. 1982. Qoyllur Rit'i, an Inca Fiesta of the Pleiades: Reflections on Time and Space in the Andean World. *Bulletin de l'Institut Français d'Etudes Andines* (Lima) 11(1–2):37–81.

———. 1987. Return of the Pleiades. *Natural History* 96(6):42–53.

Rappaport, Joanne, and Tom Cummins. 1998. Between Images and Writing: The Ritual of the King's *Quillca*. *Colonial Latin American Review* 7(1):7–32.

Rendon, Maximiliano. 1937. Los cañari. *Revista del Instituto Arqueológico del Cusco* 3:51–57.

Roach, Joseph. 1996. *Cities of the Dead: Circum-Atlantic Performance*. New York: Columbia University Press.

Rojas y Silva, David Vicente de. 1979. Los tokapu: sistemas de graficación del parentesco inka. Master's thesis, Universidad Nacional de San Antonio Abad de Cusco.

———. 1981. Los tocapu: un programa de interpretación. *Arte y Arqueología* 7:119–132.

Romero, Carlos A. 1936. Una supervivencia del Inkanato durante la colonia. *Revista Histórica* (Lima) 10:76–94.

———. 1940. *Los orígenes del periodismo en el Perú: de la relación al diario, 1594–1790.* Lima: Librería y Imprenta Gil.

———, ed. 1923. Festividades del tiempo heróico del Cusco. *Inca* 1(2):447–454.

Romeu Figueras, J. 1957. Notas al aspecto dramático de la procesión del Corpus en Cataluña. *Estudios Escénicos* 1:30–40.

Rowe, Ann Pollard. 1978. Technical Features of Inca Tapestry Tunics. *Textile Museum Journal* 17:5–28.

Rowe, John Howland. 1946. Inca Culture at the Time of the Spanish Conquest. In *Handbook of South American Indians*, edited by J. H. Steward, 7 vols., 2:183–330. Washington, D.C.: GPO.

———. 1951. Colonial Portraits of Inca Nobles. In *The Civilization of Ancient America. Selected Papers of the XXIX International Congress of Americanists*, edited by S. Tax, 258–268. Chicago: University of Chicago Press.

———. 1954. El movimiento nacional inca del siglo XVIII. *Revista Universitaria* (Cuzco) 7:17–47.

———. 1957. The Incas under Spanish Colonial Institutions. *Hispanic American Historical Review* 37(2):155–199.

————. 1971. The Influence of Chavín Art on Later Styles. In *Dumbarton Oaks Conference on Chavín*, edited by E. P. Benson, 101–124. Washington, D.C.: Dumbarton Oaks Research Library and Collection, Trustees for Harvard University.

————. 1976. El arte religioso del Cuzco en el horizonte temprano. *Ñawpa Pacha* 14:1–30.

————. 1979. Standardization in Inca Tapestry Tunics. In *The Junius B. Bird Pre-Columbian Textile Conference*, edited by A. P. Rowe, E. P. Benson, and A. Schaffer, 239–264. Washington, D.C.: Textile Museum and Dumbarton Oaks, Trustees for Harvard University.

————. 1982. Inca Policies and Institutions Relating to the Cultural Unification of the Empire. In *The Inca and Aztec States 1400–1800: Anthropology and History*, edited by G. A. Collier, R. Rosaldo, and J. Wirth, 93–118. New York: Academic Press.

Rubin, Miri. 1991. *Corpus Christi: The Eucharist in Late Medieval Culture*. New York: Cambridge University Press.

Rubio García, Luis. 1983. *La procesión de Corpus en el siglo XV en Murcia y religiosidad medieval (Discurso leído el día 7 de junio de 1983)*. Murcia: Academia Alfonso X el Sabio.

Salazar, Antonio Bautista de. [1596] 1867. De virreyes y gobernadores del Perú: Virrey D. Francisco de Toledo, Virrey Marqués de Cañete, D. García Hurtado de Mendoza, etc. In *Colección de documentos inéditos relativos al descubrimiento, conquista y organización de las antiguas posesiones españoles de América y Oceanía*, edited by L. Torres de Mendoza, 8:212–421. Madrid: Real Academia de la Historia.

Salízar Saico, Raúl. 1996. Al Cusco, símbolo de la patria. In *Inti Raymi 1996: Programa general*, 5. Cuzco: Empresa Municipal de Festejos, Actividades Recreacionales y Turísticas del Cusco, Imprenta Amauta.

Sallnow, Michael J. 1987. *Pilgrims of the Andes: Regional Cults in Cusco*. Smithsonian Series in Ethnographic Inquiry, edited by I. Karp and W. L. Merrill. Washington, D.C.: Smithsonian Institution Press.

Salomon, Frank. 1982. Chronicles of the Impossible: Notes on Three Peruvian Indigenous Historians. In *From Oral to Written Expression*, edited by R. Adorno, 9–39. Syracuse, N.Y.: Maxwell School.

Santisteban Ochoa, Julián, ed. 1963. Documentos para la historia del Cuzco existentes en el Archivo General de Indias de Sevilla. *Revista del Archivo Histórico del Cuzco* 11:1–118.

Sarmiento de Gamboa, Pedro. [1572] [1942] 1943. *Historia de los Incas*. 2nd ed. Edited by A. Rosenblat. Buenos Aires: Emecé.

Seed, Patricia. 1991. Colonial and Postcolonial Discourse (review essay). *Latin American Research Review* 26(3):181–200.

Sharpe, Jenny. 1989. Figures of Colonial Resistance. *Modern Fiction Studies* 35(1): 137–155.

Silverblatt, Irene. 1980. Andean Women under Spanish Rule. In *Women and Colonization: Anthropological Perspectives*, edited by M. Etienne and E. Leacock, 149–185. Brooklyn: J. F. Bergin.

———. 1988. Political Memories and Colonizing Symbols: Santiago and the Mountain Gods of Colonial Peru. In *Rethinking History and Myth: Indigenous South American Perspectives on the Past*, edited by J. D. Hill, 174–194. Urbana and Chicago: University of Illinois Press.

———. 1995. Becoming Indian in the Central Andes of Seventeenth Century Peru. In *After Colonialism: Imperial Histories and Postcolonial Displacements*, edited by G. Prakash, 279–298. Princeton: Princeton University Press.

Smith, E. Baldwin. [1956] 1978. *Architectural Symbolism of Imperial Rome and the Middle Ages*. New York: Hacker Art Books.

Spivak, Gayatri. 1988. Can the Subaltern Speak? In *Marxism and the Interpretation of Culture*, edited by C. Nelson and L. Grossberg, 217–313. Urbana: University of Illinois Press.

Stastny, Francisco. 1993. El arte de la nobleza inca y la identidad andina. In *Mito y simbolismo en los Andes: la figura y la palabra*, edited by H. Urbano, 137–156. Cuzco: Centro de Estudios Regionales Andinos "Bartolomé de Las Casas."

Stern, Steve J. 1982. *Peru's Indian Peoples and the Challenge of Spanish Conquest: Huamanga to 1640*. Madison: University of Wisconsin Press.

Taussig, Michael T. 1987. *Shamanism, Colonialism, and the Wild Man: A Study in Terror and Healing*. Chicago: University of Chicago Press.

———. 1993. *Mimesis and Alterity: A Particular History of the Senses*. New York and London: Routledge.

Taylor, William B. 1979. *Drinking, Homicide, and Rebellion in Colonial Mexican Villages*. Stanford: Stanford University Press.

Temple, Ella Dunbar. 1937. La descendencia de Huayna Cápac: introducción. *Revista Histórica del Instituto Histórico del Perú* 11:93–165.

———. 1937–1940. La descendencia de Huayna Cápac: Paullu Inca. *Revista Histórica del Instituto Histórico del Perú* 11:284–333, 12:204–245, 13:31–77.

———. 1942. Los caciques Apoalaya. *Revista del Museo Nacional* (Lima) 11(2):147–178.

———. 1948. Don Carlos Inca. *Revista Histórica del Instituto Histórico del Perú* 17:134–179.

———. 1949. Un linaje incaico durante la dominación española: los Sahuaraura. *Revista Histórica del Instituto Histórico del Perú* 18:45–77.

———. 1950a. El testamento inédito de Doña Beatriz Clara Coya de Loyola, hija del Inca Sayri Túpac. *Fenix* 7:109–122.

———. 1950b. Los testamentos inéditos de Paullu Inca, Don Carlos y Don Melchor Carlos Inca; nuevos datos sobre esta estirpe incaica y apuntes para la biografía del sobrino del Inca Garcilaso de la Vega. *Documenta* 2(1):630–651.

Titu Cusi Yupanqui, Inga Diego de Castro. [1570] 1973. *Relación de la conquista del Perú*. Lima: Ediciones de la Biblioteca Universitaria.

Toledo, Francisco de. [1571] 1904-1907. Carta al Rey. In *La imprenta en Lima (1584-1824)*, edited by J. T. Medina, 174. Santiago de Chile: Casa del Autor.

———. [1571] 1940. Informaciones que mandó levantar el Virrey Toledo sobre los Incas. In *Don Francisco de Toledo, supremo organizador del Perú*, edited by R. Levillier, 2 vols., 2:1-204. Buenos Aires: Espasa-Calpa.

———. [1572] 1921-1926a. Carta a S. M. (Cusco, 1 de marzo de 1572). In *Gobernantes del Perú*, edited by R. Levillier, 14 vols., 4:48-208. Madrid: Sucesores de Rivadeneyra.

———. [1572] 1921-1926b. Carta a S. M. (Cusco, 8 de mayo de 1572). In *Gobernantes del Perú*, edited by R. Levillier, 14 vols., 4:363-367. Madrid: Sucesores de Rivadeneyra.

———. [1572] 1921-1926c. Carta a S. M. (Cusco, 24 de septiembre de 1572). In *Gobernantes del Perú*, edited by R. Levillier, 14 vols., 4:432-448. Madrid: Sucesores de Rivadeneyra.

———. [1572-1573] 1926. Las ordenanzas de la ciudad del Cusco. In *Fundación española del Cusco y ordenanzas para su gobierno*, edited by H. H. Urteaga and C. A. Romero, 5-242. Lima: Talleres Gráficos Sanmartí y Cía.

———. [1575] 1921-1926d. Ordenanzas para los indios de la provincia de Charcas (Arequipa, 6 de noviembre de 1575). In *Gobernantes del Perú*, edited by R. Levillier, 14 vols., 8:304-382. Madrid: Sucesores de Rivadeneyra.

Treat, James, ed. 1996. *Native and Christian: Indigenous Voices on Religious Identity in the United States and Canada*. New York: Routledge.

Trexler, Richard C. 1980. *Public Life in Renaissance Florence*. New York: Academic Press.

———. 1984. We Think, They Act: Clerical Readings of Missionary Theatre in Sixteenth Century New Spain. In *Understanding Popular Culture: Europe from the Middle Ages to the Nineteenth Century*, edited by S. L. Kaplan, 189-227. Berlin and New York: Mouton.

Trujillo, Diego de. [1571] 1970. Relación del descubrimiento del reyno del Perú que hizo Diego de Trujillo en compañía de gobernador Don Francisco Pizarro y otros capitanes desde que llegaron a Panamá el año de 1530, en que refieren todas las derrotas y sucesos hasta el día 15 de abril de 1571. In *Una relación inédita de la conquista, la crónica de Diego de Trujillo*, edited by R. Porras Barrenechea, 41-60. Miraflores (Lima): Instituto Raúl Porras Barrenechea.

Turner, Terence S. 1980. The Social Skin. In *Not Work Alone: A Cross-Cultural View of Activities Superfluous to Survival*, edited by J. Cherfas and R. Lewin, 112-140. London: Temple Smith.

Turner, Victor W. 1969. *The Ritual Process: Structure and Anti-Structure*. Ithaca: Cornell University Press.

Valcárcel, Luis E. 1935. Sajsawaman redescubierto (3a parte). *Revista del Museo Nacional* (Lima) 4(2):161–203.

Valda, Juan Bautista de. 1663. *Solemnes fiestas que celebró Valencia a la Inmaculada Concepción de la Virgen María por el supremo decreto de N. S. Pontífice Alexandro VII.* Valencia: n.p.

Van de Guchte, Maarten. 1996. Sculpture and the Concept of the Double among the Inca Kings. *Res* 29/30:256–268.

Vandenbroeck, Paul, ed. 1991. *America, Bride of the Sun: 500 Years, Latin America and the Low Countries.* Exhibition catalogue. Antwerp: Royal Museum of Fine Arts.

Vargas Ugarte, Rubén. 1943. *De nuestro antiguo teatro.* Biblioteca Histórica Peruana, vol. 4. Lima: Compañía de Impresiones y Publicidad.

————. 1947. *Ensayo de un diccionario de artífices coloniales de la América meridional.* Lima (?): Talleres Gráficos A. Baiocco y Cía.

————, ed. 1951. *Concilios limenses.* Vol. 1: 1551–1772. Lima: S. A. Rávago e Hijos.

Very, Francis George. 1962. *The Spanish Corpus Christi Procession: A Literary and Folkloric Study.* Valencia: Tipografía Moderna.

Viceroys. 1859. *Memorias de los virreyes que han gobernado el Perú durante el tiempo del coloniaje español.* Lima: Librería Central de Felipe Bailby.

Villanueva Urteaga, Horacio. 1959. Nuevos datos sobre la vida y obras del Obispo Mollinedo. *Revista del Instituto Americano de Arte* (Cuzco) 9:24–60.

————, ed. 1986. Dos codicilos de Don Manuel de Mollinedo obispo mecenas del Cusco. *Boletín del Archivo Departmental del Cuzco* 2:55–63.

Wachtel, Nathan. 1973. *Sociedad e ideología.* Lima: Instituto de Estudios Peruanos.

————. 1977. *The Vision of the Vanquished: The Spanish Conquest of Peru through Indian Eyes.* New York: Barnes & Noble.

Wuffarden, Luis Eduardo. 1996. Piadoso Cuzco: El Corpus de Santa Ana. *FMR* 32:72–108.

Xérez, Francisco de. [1534] 1985. *Verdadera relación de la conquista del Perú.* Edited by C. Bravo. Madrid: Historia 16.

Young, Eric. 1984. Portraits of Charles II of Spain in British Collections. *Burlington Magazine* 126(977):488–493.

————. 1986. Retratos pintados de Carlos II en el Museo Lázaro Galidiano. *Goya* 193–195:126–130.

Zabus, Chantal. 1991. *The African Palimpsest: Indigenization of Language in the West African Europhone Novel.* Cross Cultures 4. Amsterdam and Atlanta: Rodopi.

Zamora, Margarita. 1988. *Language, Authority, and Indigenous History in the "Comentarios Reales de Los Inca."* Cambridge: Cambridge University Press.

Zuidema, R. Tom. 1964. *The Ceque System of Cuzco: The Social Organization of the Empire of the Inca.* Leiden: E. J. Brill.

————. 1966. *El Calendario Inca. Proceedings of the 36th International Congress of Americanists* 2:25–30.

————. 1971. Meaning in Nazca Art. In *Göteborgs Etnografiska Museum Årstryck*, 35–54. Göteborg: Gothenburg Ethnographic Museum.

————. 1977a. Inca Kinship. In *Andean Kinship and Marriage*, edited by R. Bolton and E. Mayer, 240–281. American Anthropological Association Special Publications, no. 7. Washington, D.C.: American Anthropological Association.

————. 1977b. The Inca Calendar. In *Native American Astronomy*, edited by A. F. Aveni, 219–259. Austin: University of Texas Press.

————. 1982. Bureaucracy and Systematic Knowledge in Andean Civilization. In *The Inca and Aztec States, 1400–1800: Anthropology and History*, edited by G. A. Collier, R. Rosaldo, and J. Wirth, 419–458. New York: Academic Press.

————. 1983. The Lion in the City: Royal Symbols of Transition in Cuzco. *Journal of Latin American Lore* 9(1):39–100.

————. 1989. At the King's Table: Inca Concepts of Sacred Kingship in Cuzco. *History and Anthropology* 4:249–274.

————. 1990a. *Inca Civilization in Cuzco*. Translated by Jean-Jacques Decoster. Austin: University of Texas Press.

————. 1990b. The Royal Whip in Cuzco: Art, Social Structure, and Cosmology. In *The Language of Things: Studies in Ethnocommunication in Honour of Professor Adrian A. Gerbrands*, edited by P. ter Keurs and D. Smidt, 159–172. Leiden: Rijksmuseum voor Volkenkunde.

————. 1991. Batallas rituales en el Cuzco colonial. In *Cultures et sociétés Andes et Méso-Amérique: mélange en hommage à Pierre Duviols*, edited by R. Thiercelin, 811–834. Aix-en-Provence: Université de Provence.

————. 1992. El encuentro de los calendarios andino y español. In *Los conquistados: 1492 y la población indígena de las Américas*, edited by H. Bonilla, 297–316. Bogotá: Facultad Latinoamericana de Ciencias Sociales (FLACSO, Sede Ecuador), Ediciones Libri Mundi, and Tercer Mundo Editores.

————. 1993. De la tarasca a Mama Huaco. In *Religions des Andes et langues indigènes*, edited by P. Duviols. Aix-en-Provence: Université de Provence.

Zumalde, Ignacio. 1964. *Ensayos de historia local vasca*. San Sebastián: Editorial Auñamendi.

Index

Caudí, José, 85

Chachapoya Indians, 4, 182–192, 194–198, 227 n.31

Charles V (Holy Roman Emperor). See Carlos I

Chiguan Topa, Alonso, 119–121, 139, 197, 251 n.41

Chiguan Topa, Marcos, 115, 119, 139, 149

Chilche, Francisco Zaraunanta, 58–60, 180–182, 188–190, 192–194, 196–197, 199

Chuncho Indians, 58, 172–174, 176, 255 n.16

Clement V (pope), 8, 83

Coat(s) of arms, 153–154, 158; colonial Andean, 145, 148–154, 185–186, 246 n.34, 249 n.27, 250 n.32; of Cuzco, 145–147; in Guaman Poma de Ayala, 142–143, 149–150; in Murúa, 143, 252 n.45, 252 n.46; of Viceroy Morcillo, 149. See also Heraldry

Cofradía. See Confraternity

Colegio de San Borja (Cuzco), 112–114, 151, 158

Compañía, la. See Jesuit(s): church

Complementarity, 157, 158, 173–174, 202, 210

Confraternity, 44; of the Annunciation (Cuzco), 235 n.8; of the Archangel Michael, 185; of Barberos (Cuzco), 234 n.6; of the Christ child (Cuzco), 51, 55, 87, 100, 240 n.44; of Chuschi, 227–228 n.37; of La Linda (Cuzco), 104; of Las Animas del Purgatorio (Cuzco), 237 n.24; of San Cristóbal parish (Cuzco), 240 n.45; of San Jerónimo (Cuzco), 229–230 n.7; of the Santíssimo Sacramento (Cuzco), 82

Coricancha. See Qorikancha

Crest(s). See Coat(s) of arms

Cumbi, 124, 125, 154

Cuzco, 210, 212; cathedral, 25, 26–28, 38, 182–183, 206; coat of arms (see Coat(s) of arms: Cuzco); foundation of, 24; as Inka capital, 22–25, 32, 58, 147, 216; siege of, 102, 140, 148, 181, 189; as Spanish city, 80; urban plan, 28–31 (see also Plaza de armas [Cuzco])

Cuzco cabildo, 26, 30

Cuzco municipal council. See Cuzco cabildo

Dance(s), 40, 43; and Advents, 10; Chuncho, 58, 172–174, 176; and Corpus Christi, 10, 13, 15, 32, 39, 44–50, 52–53, 60–61, 171, 256 n.4; and drinking, 59–61; and idolatry, 56–58; militaristic, 40, 43, 60–61, 195, 232 n.20; and violence, 61

Dominican Order, 64, 92; church and convent of (Cuzco), 206, 213–214 (see also Qorikancha)

Drinking: and Indians, 58–61, 108, 180–181

Ecclesiastic Council (Trent): and Corpus Christi, 1, 8

Ecclesiastic Councils (Lima), 1, 16, 53

Estrada Pérez, Daniel (mayor of Cuzco), 216

Evangelization: in the Andes, 15–17, 27, 48, 110, 204. See also Religious conversion

Feather(s), 170–175, 253 n.56; and costume, 126, 131–142, 156–157, 198; parasol(s), 129, 223 n.30

Festivity literature, 9, 94–95

Flower(s), 135, 139, 140, 154

Franciscan Order, 64, 92, 119

Fuente y Rojas, Fernando de la (corregidor of Cuzco), 109, 249 n.20

García de Loyola, Martín, 102, 112, 248 n.16

Garcilaso de la Vega, El Inca (Gómez Suárez de Figueroa), 110–111, 180–

Carolyn S. Dean is Associate Professor in
the Department of Art History at the University
of California, Santa Cruz.

Library of Congress Cataloging-in-Publication Data
Dean, Carolyn.
Inka bodies and the body of Christ : Corpus Christi in colonial
Cuzco, Peru / Carolyn Dean.
p. cm.
Includes bibliographical references and index.
ISBN 0-8223-2332-X (hardcover : alk. paper). —ISBN 0-8223-2367-2
(pbk. : alk. paper)
1. Corpus Christi Festival—Peru—Cuzco. 2. Incas—Religion.
3. Incas—Rites and ceremonies. 4. Incas—Missions—Peru—Cuzco.
5. Catholic Church—Missions—Peru—Cuzco. 6. Cuzco (Peru) —
Religious life and customs. 7. Cuzco (Peru) —Social life and
customs. I. Title.
GT4995.C6D43 1999
394.266—dc21 98-56544

LE